SHŌNEN MANGA
ACTION-PACKED!

SHŌNEN MANGA: ACTION-PACKED!

Copyright © 2012 Harper Design and Monsa Publications

All rights reserved. No part of this book may be used or reproduced in any manner whatsoever without written permission except in the case of brief quotations embodied in critical articles and reviews. For information address Harper Design, 10 East 53rd Street, New York, NY 10022.

HarperCollins books may be purchased for educational, business, or sales promotional use. For information please write: Special Markets Department, HarperCollins*Publishers*, 10 East 53rd Street, New York, NY 10022.

First published in 2012 by
Harper Design
An Imprint of HarperCollins*Publishers*
10 East 53rd Street
New York, NY 10022
Tel: (212) 207-7000
Fax: (212) 207-7654
harperdesign@harpercollins.com
www.harpercollins.com

Distributed throughout the world by
HarperCollins*Publishers*
10 East 53rd Street
New York, NY 10022
Fax: (212) 207-7654

Editor and project director:
Josep Mª Minguet

Art direction, text, and layout:
Rubén García Cabezas
(Kamikaze Factory Studio)
for Monsa Publications

Illustrations:
Akane, Arhiee, Carlos Anguís, David Velásquez, Eva Lara, Eva Criado, Frederick Francis, Gina Chacón, Laura Garijo, Lolita Aldea, Marta Valentín, Marta Salmons, Noiry and Patricia Velázquez.

Page four artwork "Good.Night.Mare" courtesy of Frederick Francis.

Translation:
Babyl Traducciones

ISBN: 978-0-0-6211547-8

Library of Congress Control Number 2011945503

Printed in Spain
First Printing, 2012

SHŌNEN MANGA
ACTION-PACKED!

KAMIKAZE FACTORY STUDIO

HARPER
DESIGN
An Imprint of HarperCollinsPublishers

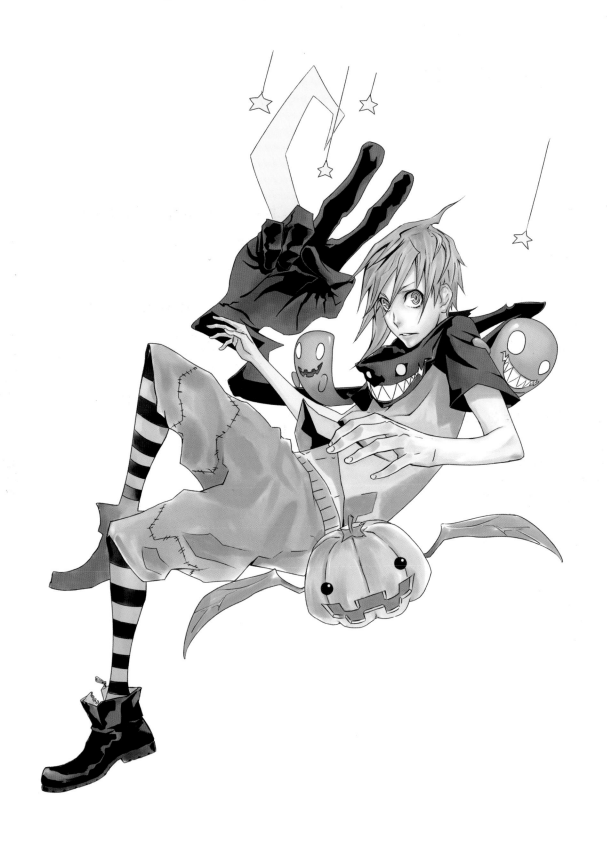

CONTENTS

INTRODUCTION

PREFACE
DIGITAL WORKSHOP

PREFACE

THE SHŌNEN MANGA SUCCESS STORY

Shōnen is the Japanese word for boy, so we can consider *shōnen manga* to be Japanese tales aimed at a young male audience. For years this has been the most popular type of manga, and also the one most widely exported overseas.

Osamu Tezuka's *Astro Boy*, *Mazinger Z* by Go Nagai, *Dragon Ball* by Akira Toriyama, Rumiko Takahashi's *Ranma 1/2*, *Akira* by Katsuhiro Otomo, Eiichiro Oda's *One Piece*, and Masashi Kishimoto's *Naruto* are just some of the great *shōnen manga* that have excited generation after generation of readers.

Although most of these success stories can be traced to *Shōnen Jump*, the world's best-selling manga magazine, we can also find tremendously popular *shōnen manga* series in other publications, such as *Shōnen Ace*, *Shōnen Magazine*, *Shonen Sunday*, *Dragon Age*, and *Gangan Comics*.

The manga for boys tend to be action packed with titanic battles and heroes who have an insatiable desire to better themselves, sometimes in a rather archetypal fashion. The stories themselves touch upon a multitude of themes, such as martial arts, science fiction, detectives, sports, romantic comedy, terror, robots, and mythological beings.

The most widely-acclaimed series among the general public end up making the jump onto film and televisions, where the *anime* productions generate an enormous flood of related merchandising, all while promoting the volume collections of the manga episodes originally issued in magazines. But it is also true that many videogames, novels, toys, and original anime series end up getting converted into comics.

The live-action film industry has also set its sights on *shōnen manga*, such as in the *Death Note* saga, based on Tsugumi Oba and Takeshi Obata's work of the same name, or the Wachowski brothers's film *Speed Racer*, based on the original manga and anime created by Tatsuo Yoshida.

SHŌNEN STEP BY STEP

Although *shoñen manga* was originally intended for a male audience, its readers and artists represent both sexes. This is why we set out to make this manga drawing manual from a modern point of view, giving it a more general appeal and making it practical for all those wanting to improve their illustration and digital coloring skills.

In the twenty-two original exercises, divided into five chapters, a total of fourteen fantastic artists from all over the world will be giving their personal and far-ranging views of manga that includes everything from shōnen's more fantastical side to its most realistic interpretations. The illustrations run from the more adult-oriented and experimental to the more child-like, also including ones influenced by European comics, together creating a wide variety of illustrations made from all types of manga drawing and illustration styles.

The exercises are laid out from an initial story created expressly for this book, which could easily be told in one of the typical genres of *shōnen manga*.

With all this in mind, the book is truly useful both to comic artists and fans of manga and anime, plus all types of designers (graphics, advertising, video game...) or creators from other fields, as it can be used as a way of documenting the birth of creative illustrations.

Rubén García
Art Director
Kamikaze Factory Studio

DIGITAL WORKSHOP

The coloring section of this book relies on using digital programs, and in it we will be focusing on the range of possibilities opened to us by Adobe Photoshop, although we also use programs such as Corel PHOTO-PAINT, PaintTool SAI, and IllustStudio.

SCANNING

To begin with, it is essential to have a good scan of the paper image. If we begin with a black and white drawing, we should import it using a gray-scale, which will digitalize it quicker.

The image resolution must be at least 300 dpi, although in this book all the drawings have been set to 600 dpi in order to have better quality and definition.

If we scan it in as a bitmap, in pure black and white, then the resolution should be 1200 dpi.

Once we have the line drawing on our computer, we can then clean it up so that the black and white areas have enough contrast.

In the Image menu, in the Adjustments section, we can calibrate the drawing using the levels and curves until our lines are as black as possible and the background is all white and no spots.

Once the line drawing is ready, we can return to the Image menu and change to CMYK Mode, as now we will be working toward the final printing, which means we need the four types of ink. If you prefer to start with RGB and in the end change to CMYK, the colors may vary.

It is also essential, naturally, to have our computer screens properly adjusted and calibrated.

Once the drawing has been edited, we can then color it in using Adobe Photoshop or save it as a .psd or .tiff and continue in another program.

DIGITAL COLORING

Our line drawing will appear as a locked background layer in the Layer panel. We can unlock it by double-clicking on it, converting it into Layer 0. Now we can start adding new layers over it where we will be applying the color.

In standard coloring, these layers use a Multiply or Darken Layer Blend Mode. In this way, the color will be set on top of the black line as if the white were transparent. There are other ways of working, but this is the simplest, fastest, and most efficient.

Several digital coloring tools can be used: selection, brushes, fill, etc. Any method is good as long as we use different layers, keeping in mind the utilities of the different options in the Layer Blend Modes. It is also a good idea to name these layers or groups of layers to keep better track of our work.

The resulting effects of applying the Blending Options in Layer Styles can be extremely useful to create gradient overlays, embossed outlines, shadows, glows, and a long list of other effects. However, it is best not to abuse these types of features, as the finished product could end up looking too stiff or digitalized.

To give the coloring an especially traditional look, it is useful to apply texture overlays and watercolor brushes at different opacities.

Finally, it is good to point out that graphics tablets are not essential in digital coloring, but it is true that once you get used to them, they can speed up the process and let you work with brushes more fully and efficiently.

The authors of this book recommend any tablet made by Wacom. In comparison to other brands, they are the most affordable and get the most out of the graphics features of digital coloring programs without encountering problems.

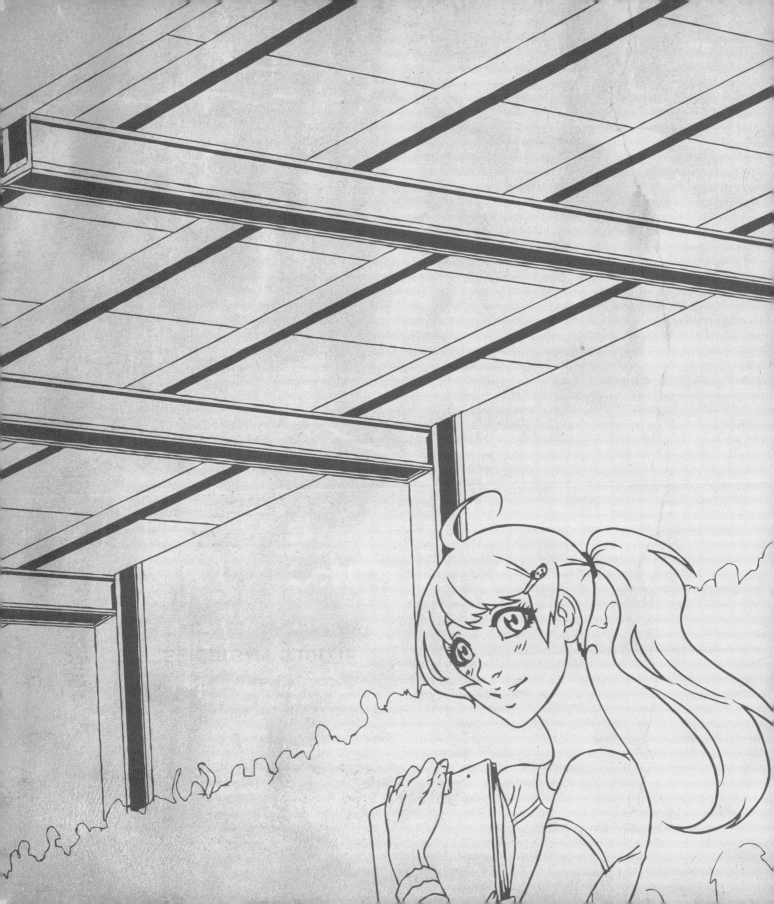

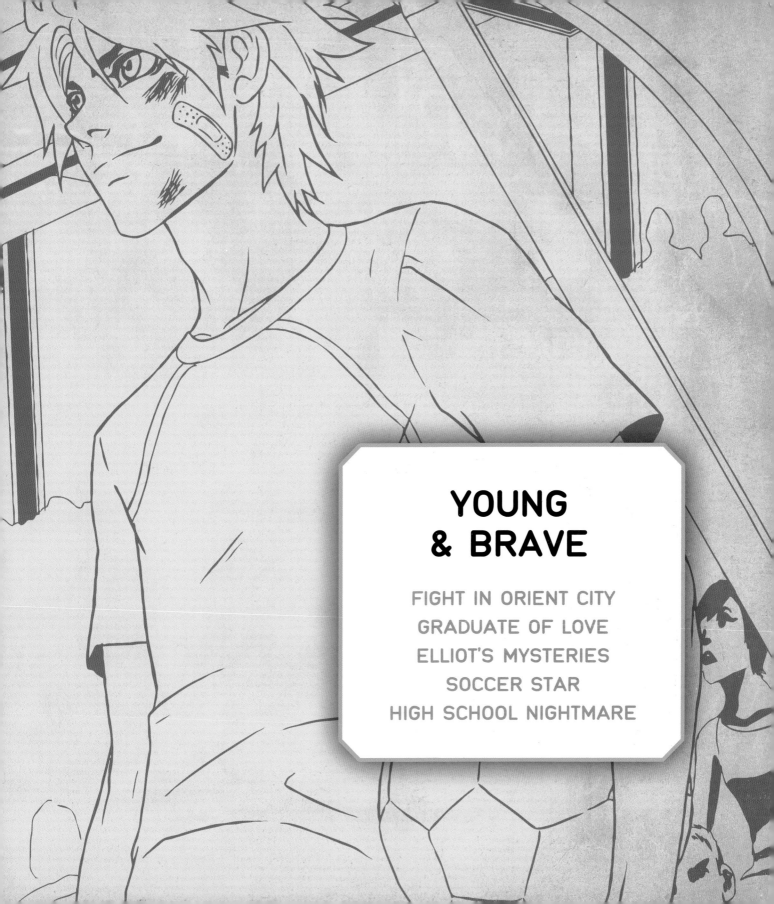

YOUNG
& BRAVE

FIGHT IN ORIENT CITY
GRADUATE OF LOVE
ELLIOT'S MYSTERIES
SOCCER STAR
HIGH SCHOOL NIGHTMARE

FIGHT IN ORIENT CITY

Xiao and Jin are two orphans living on the streets of Orient City. Over time both have developed incredible fighting and survival skills. But now they must face off against a dangerous mafia clan who is ravaging the city and threatening to destroy their neighborhood, and along with it the *doujou* where they have trained, grown up, and taken shelter all these years. Their fight has just begun and they have no plans to give up any time soon.

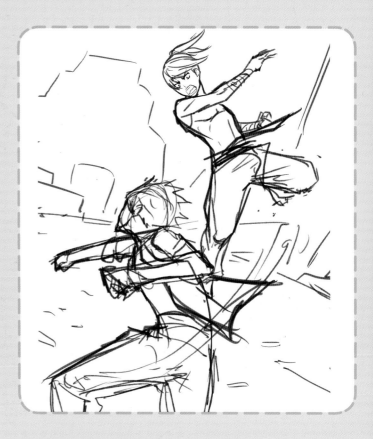

1. SKETCHES

Our original idea was to set a combat scene in a traditional Japanese *doujou* used for martial arts, but at the last minute we opted for a setting in the outskirts of an oriental city with younger characters.

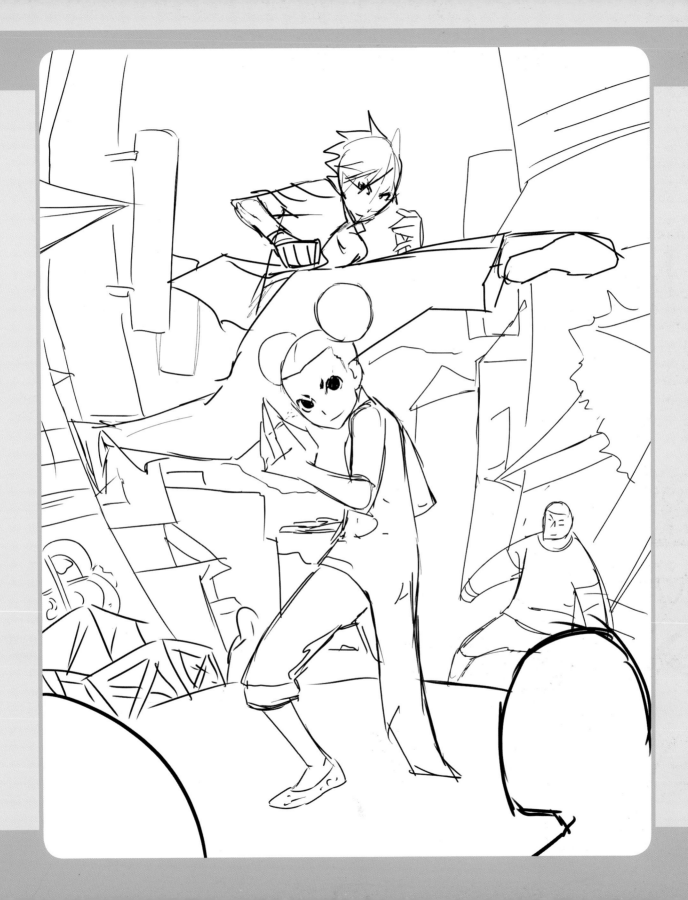

2. STRUCTURE

We first outlined the characters' skeletons in such a way that their fighting postures would be dynamic, forming a triangular composition.

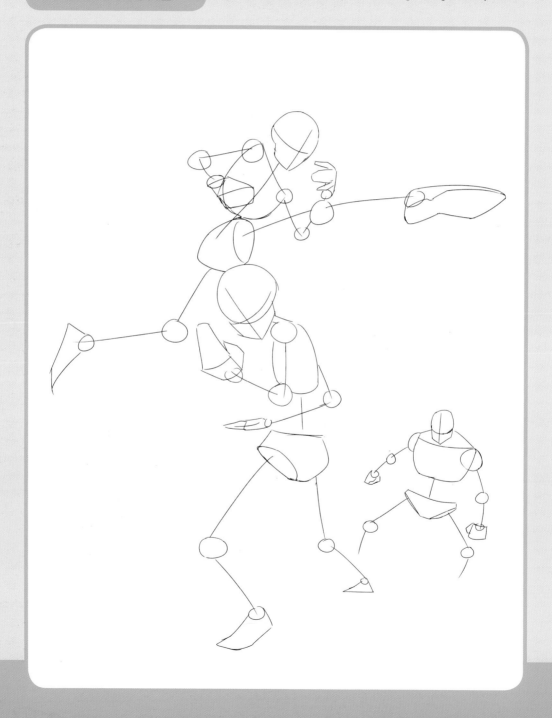

3. VOLUME

As well as differentiating the body shapes of the characters according to age and physique, we had to carefully consider perspective when drawing the girl's legs.

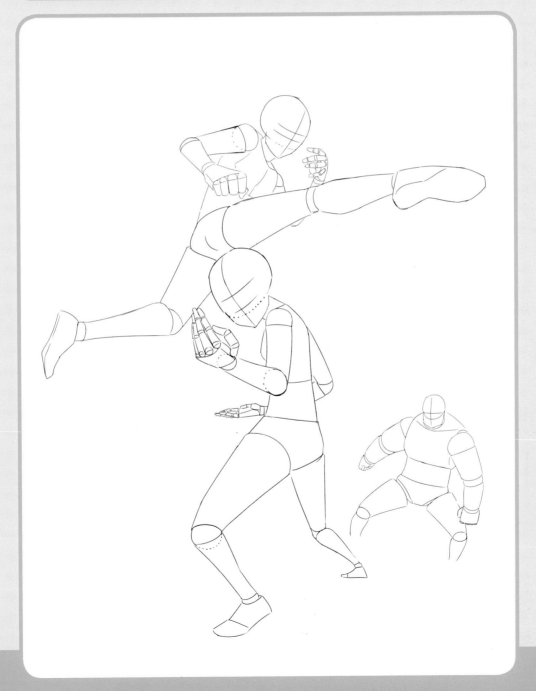

4. ANATOMY

To get a better perspective of the characters, we played with the size of their extremities, warping them to attain the desired optical effect.

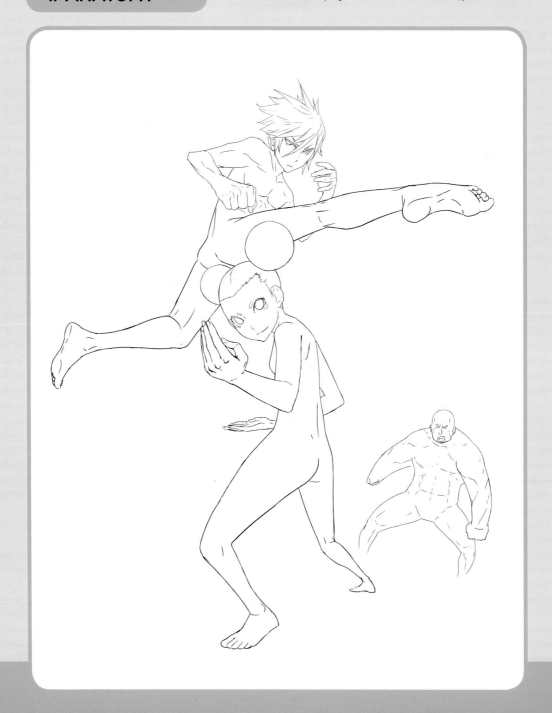

5. DETAILS

We added in Japanese and Chinese inspired outfits and morphed the scene into an oval shape, as if we were viewing it through a fish-eye lens.

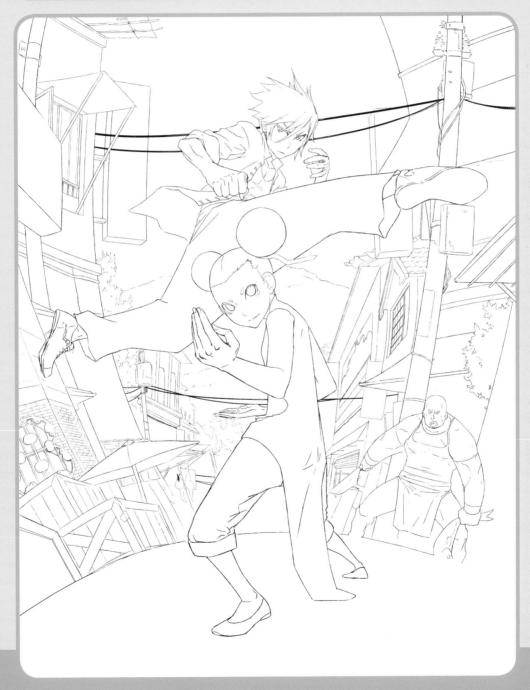

6.1. COLOR

We applied the plain colors in a new layer in the Multiply Blend Mode, using a range of warm yet lightly saturated tones.

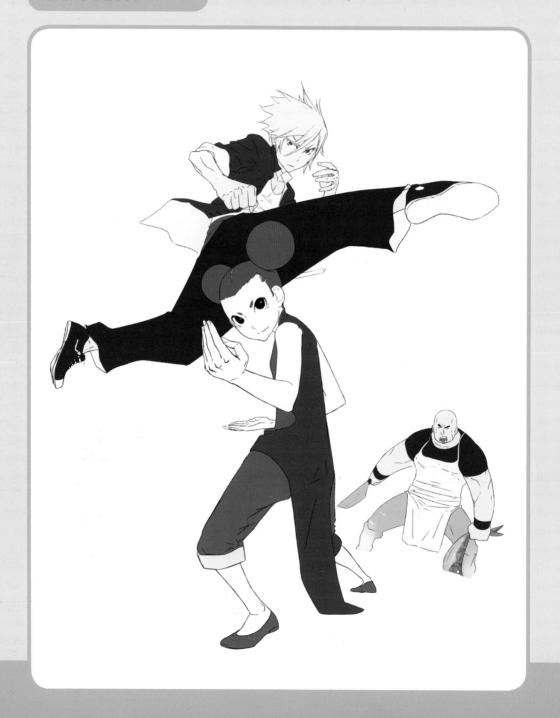

6.2. COLOR

On a new layer we added in the shadows using the Brush tool, keeping in mind that the light source is on the upper right.

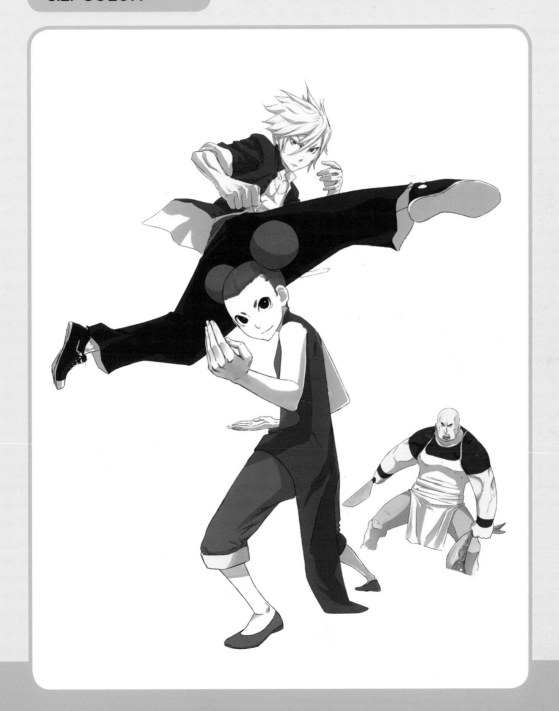

6.3. COLOR

We added the highlights, the girl's make-up, and some extra details in a darker tone to provide the characters with greater volume and a sense of three-dimensionality.

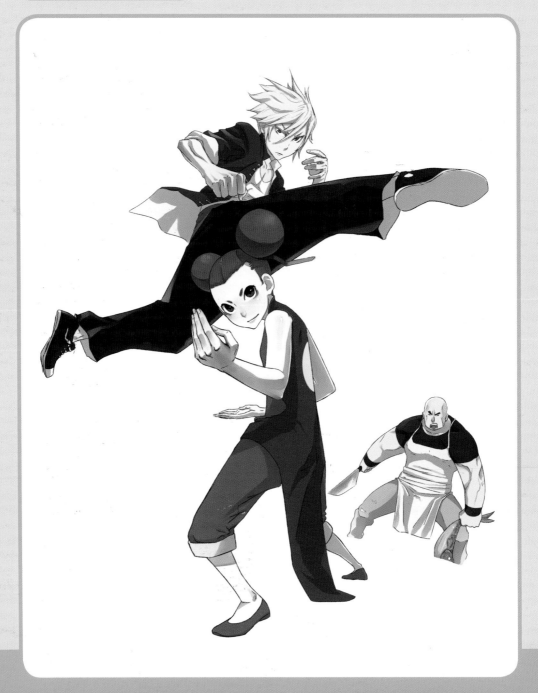

6.4. COLOR

We made visible the background drawing we had made on a separate layer and applied a base color of reds, yellows, and greens.

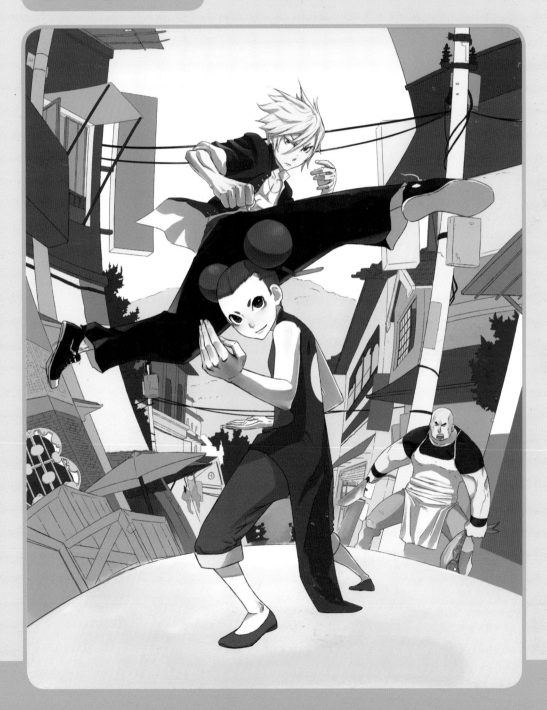

6.5. COLOR

We pasted in the shop signs with the Text Tool and brushed in shadows on the ground and buildings.

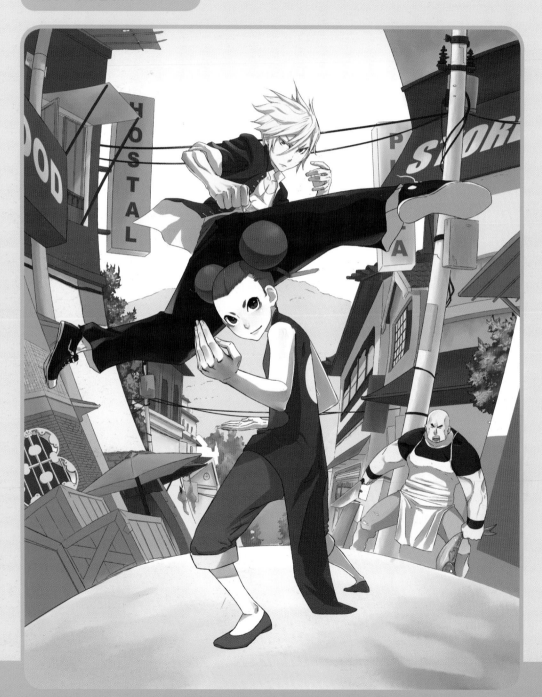

6.6. COLOR

We defined the details of the buildings using different brushes and textures to simulate damp patches and dirt, making the background more realistic.

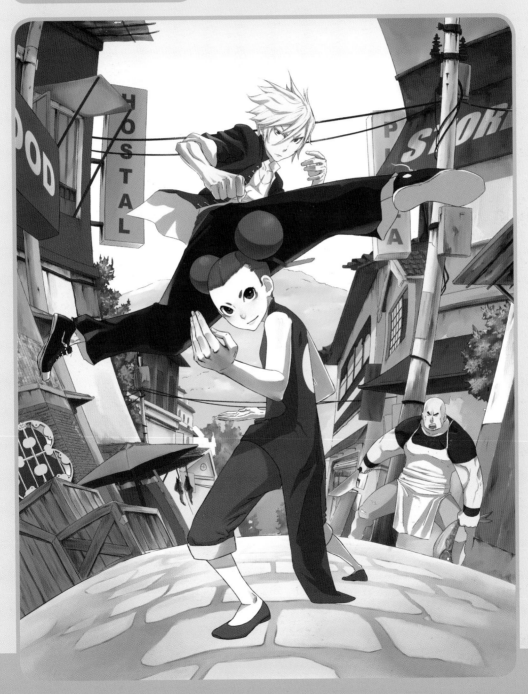

Finishing touches

- We gave a few lightly colored brushstrokes to areas of the background to finish defining the points of light.

- On a new layer in the Multiply Blend Mode, we drew a shadow on the ground that fades out.

Tips & tricks

- With the aim of making it easier to organize the image's layers and coloring, we can create several separate groups containing the different elements, such as ones for the characters or the background.

- To choose the illustration's colors, it is good to try out some general tones on the initial sketch and use them as a guide for the range color range you settle on.

- For the shadowing, there are darker brushstrokes that separate the light and shadow, which we used to strengthen the characters' volumes.

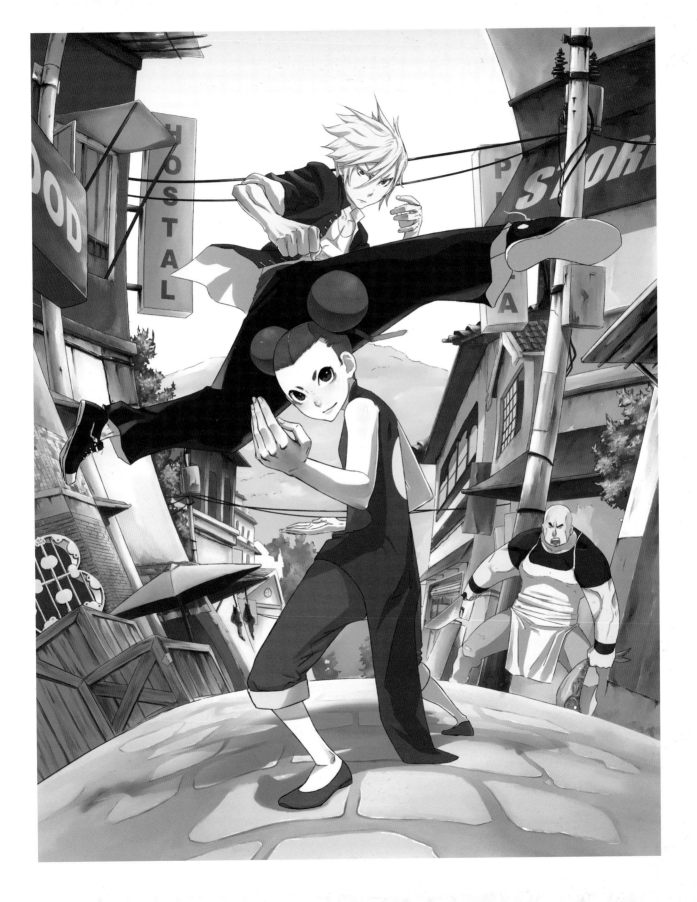

GRADUATE OF LOVE

Kotaro is the most popular boy at the city's top high school. All the girls want to be his girlfriend someday, but he'd prefer not to commit. However, things suddenly take a turn for the worst for this unabashed ladies' man when the school principal, tired of the school's poor image thanks to Kotaro's neverending flings, tells him he must choose a steady girlfriend once and for all before the school year is up or he won't be able to graduate.

1. SKETCHES

Harems is a typical genre in boy mangas, usually featuring a male hero surrounded by a wide range of female characters. We chose an image showing how the school principal tries to control the movements of her unruly student.

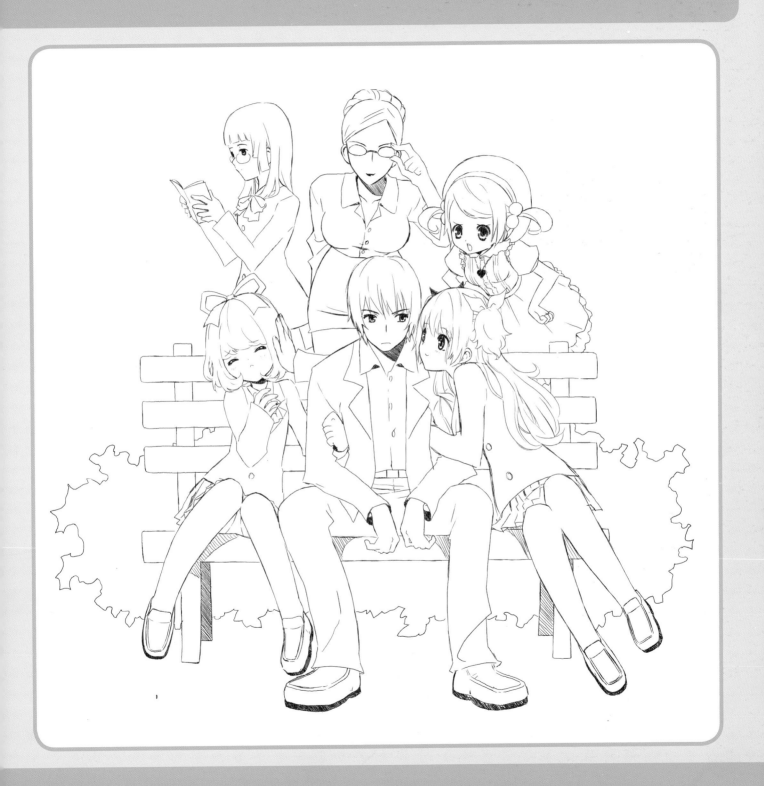

2. STRUCTURE

We arranged the characters in the scene so that each naturally fits into the other.

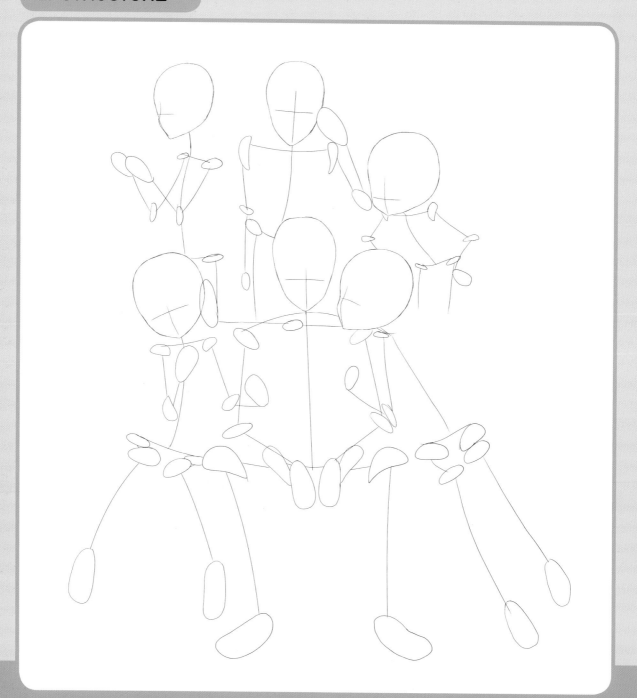

Consider the different levels of depth when drawing out the sizes of the characters.

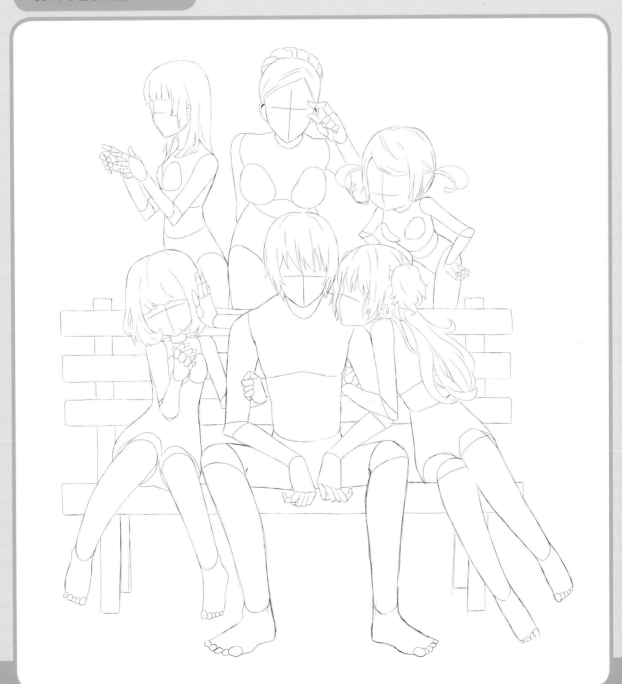

4. ANATOMY

The characters have to look juvenile, except the principal, meaning their bodies should be delicate and slender.

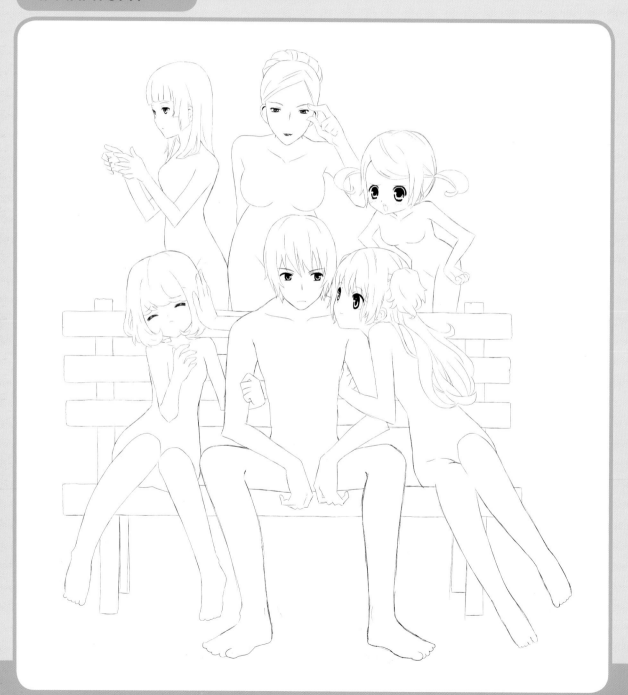

5. DETAILS

Although all are dressed in the school uniform, we gave each character their own personality by adding different elements.

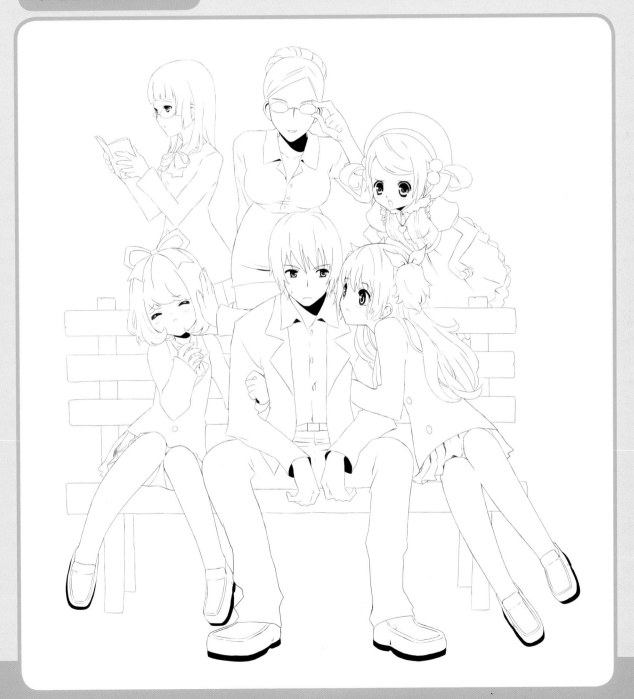

6.1. COLOR

We put the base colors on a new layer using the Fill Tool on closed surfaces, and the brushes to give the colors a final touch.

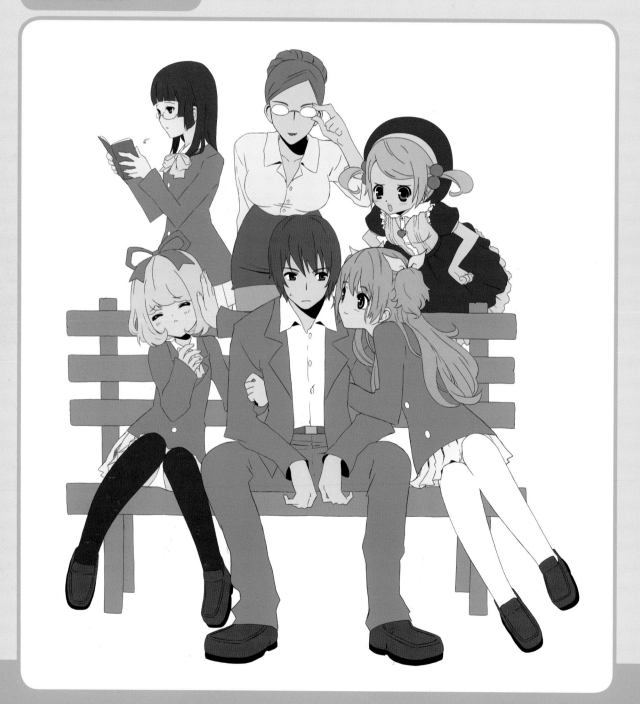

6.2. COLOR

With the brush, we applied the shadows on a new layer using a grayer and darker tone than the base color.

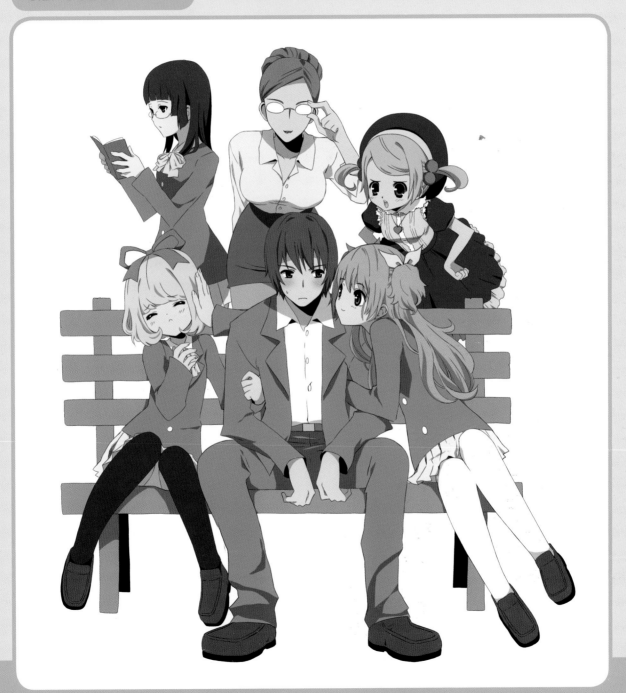

6.3. COLOR

We painted in the highlights on a new layer with short, light-colored brushstrokes.

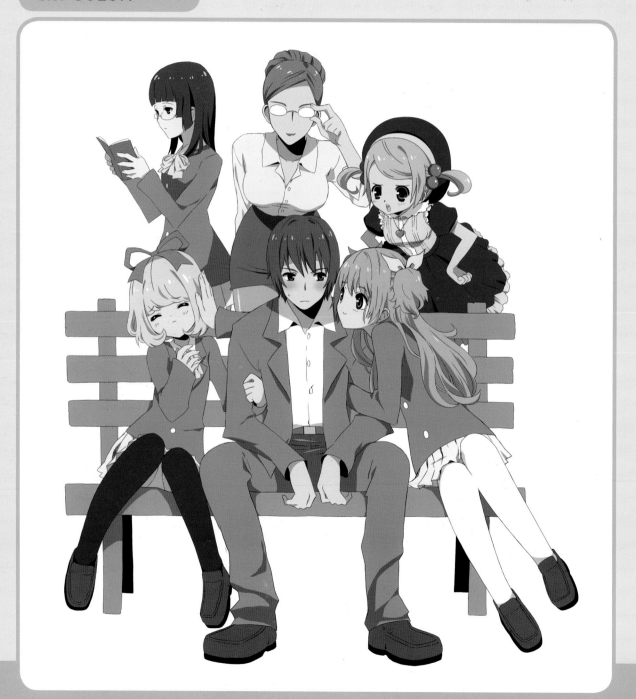

7. BACKGROUND

We drew a bush right behind the bench with a personalized leaf-shaped brush, using different tones of green and textures to give it a sense of volume. We filled in the background with a yellow and white gradient, clipping the main images with a white Outer Trace from the Layer Blending Options.

Finishing touches

- We placed a dotted screen in the Color Burn Layer Blend Mode.

- We drew in the stars using the Polygon Tool, marking the Star option in the Polygon Options.

- We applied a light blurring effect by duplicating the final flattened image, applying a Gaussian Blur Filter, placing the layer in the Overlay Blend Mode and lowering its Opacity.

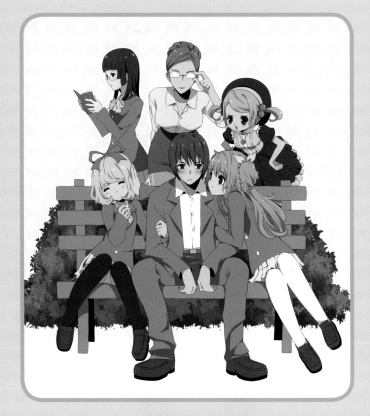

Tips & tricks

- This illustration was colored in with Illust Studio, but the background and effects were created using Adobe Photoshop.

- In order to color in areas more easily, when we fill areas it is important to make sure they have been closed off as much as possible.

- For a type of coloring such as this, which uses flat colors, if we don't know how to use a graphics tablet, we can make the shadows and highlights by selecting them with the Polygon Lasso Tool.

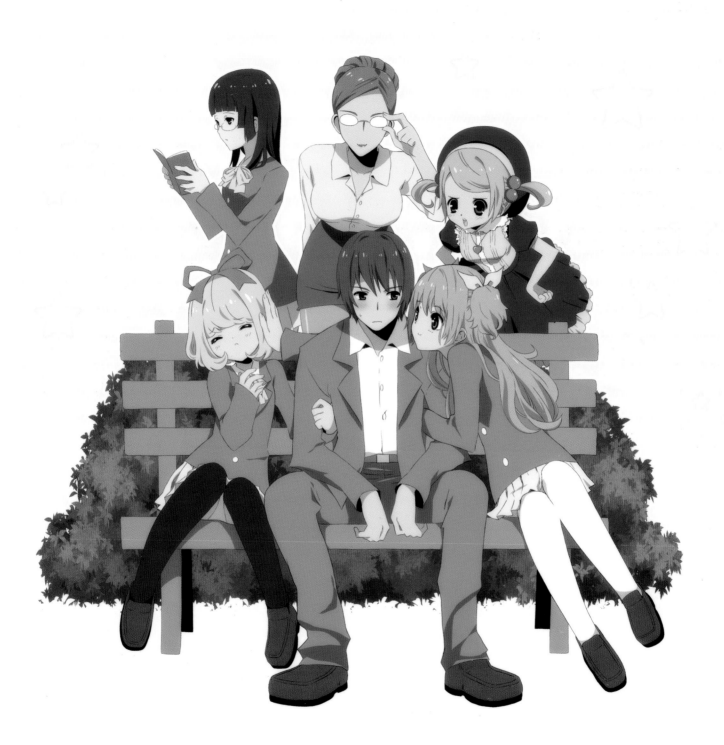

ELLIOT'S MYSTERIES

Elliot is an orphaned young heir to a great fortune. Although he lives with his aunt and uncle in a fabulous palace outside London, he prefers the city streets and solving cases as a detective. Because of his youth, he is always accompanied by his tutor Adele, who tries as hard as she can to keep him from getting into too much trouble. His signature accessory is the monocle over his right eye, a reminder of his deceased father, which allows him to magnify details that for others would go unnoticed.

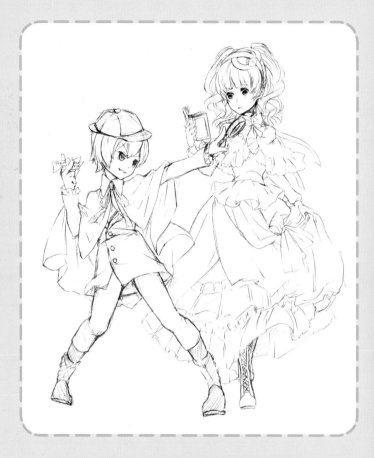

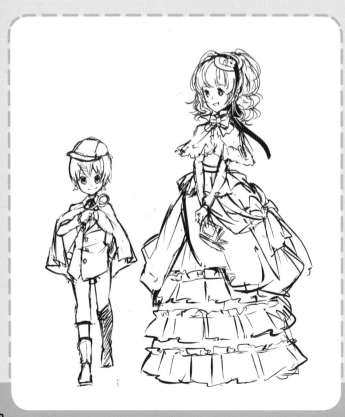

1. SKETCHES

Our initial character designs had somewhat static postures, so we tried out different scenes until we found one with enough live action to bring out their personalities.

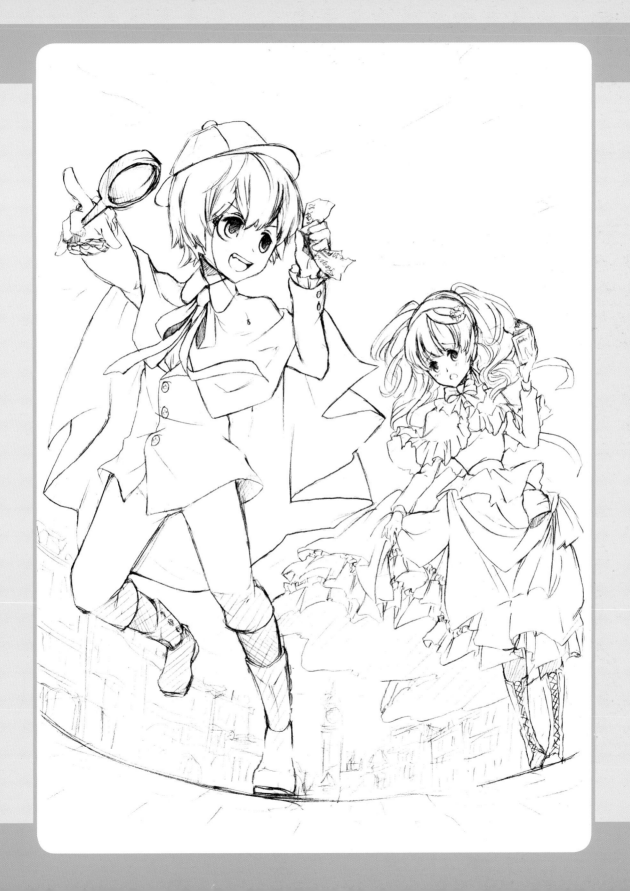

2. STRUCTURE

We traced out the image skeleton, taking special care to mark out the curve of the central axis, which is what gives the characters movement.

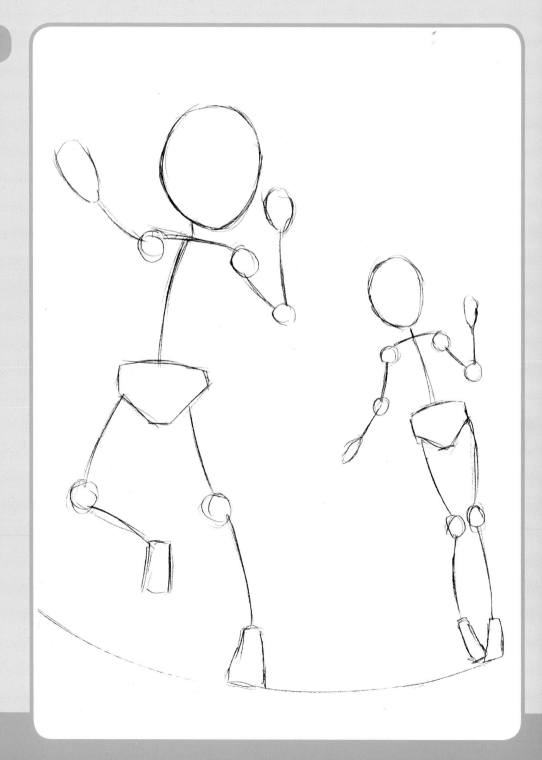

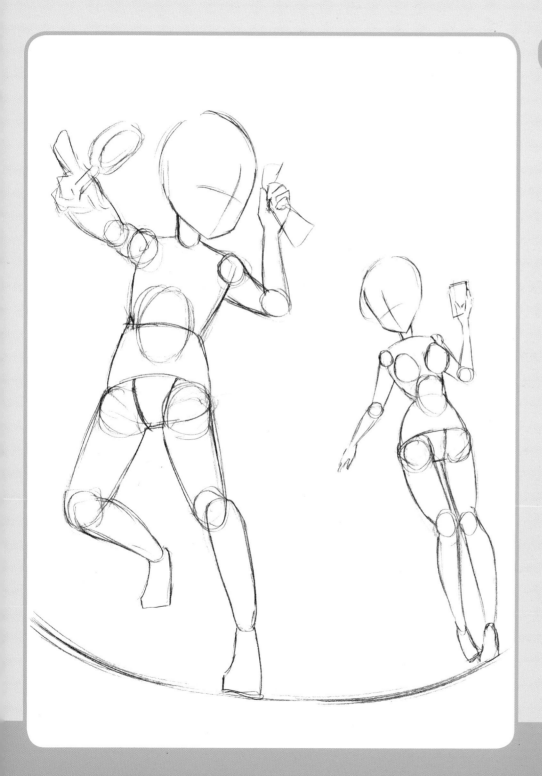

3. VOLUME

The girl's posture is delicate with sinuous shapes; the boy should be sturdier.

4. ANATOMY

Women's bodies tend to be shaped like a type of guitar, with a slender waist and wide hips. Boys' bodies, on the other hand, are much straighter.

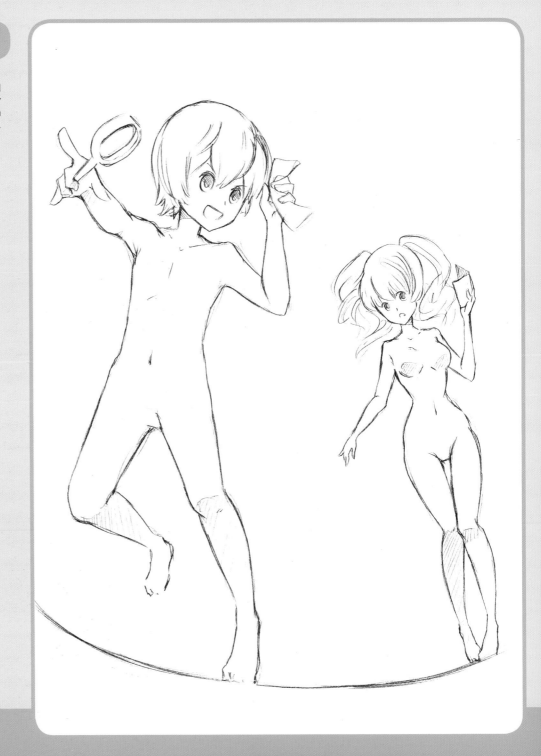

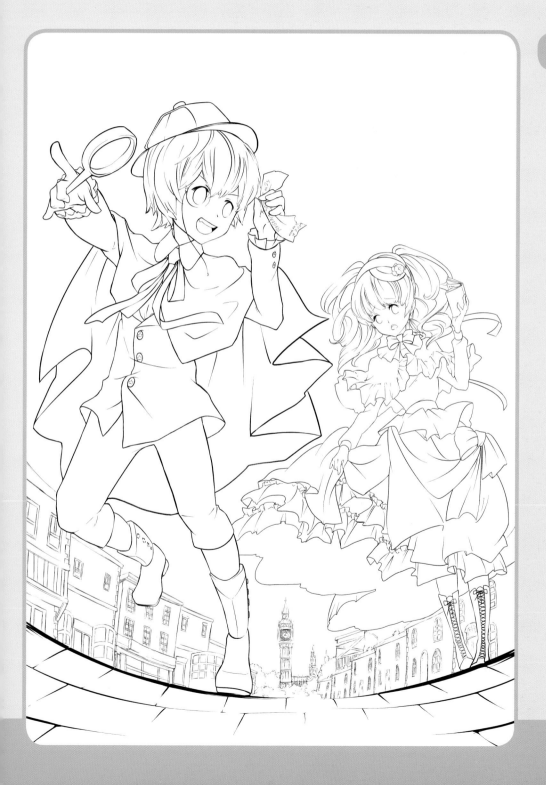

5. DETAILS

The Victorian-style clothes represent the epoch when the story takes place. It is important that the clothes be full, forming waves that follow the lines the characters move in.

6.1. COLOR

We painted the illustration's base colors using a range of ochres, plus a couple of bluish tones.

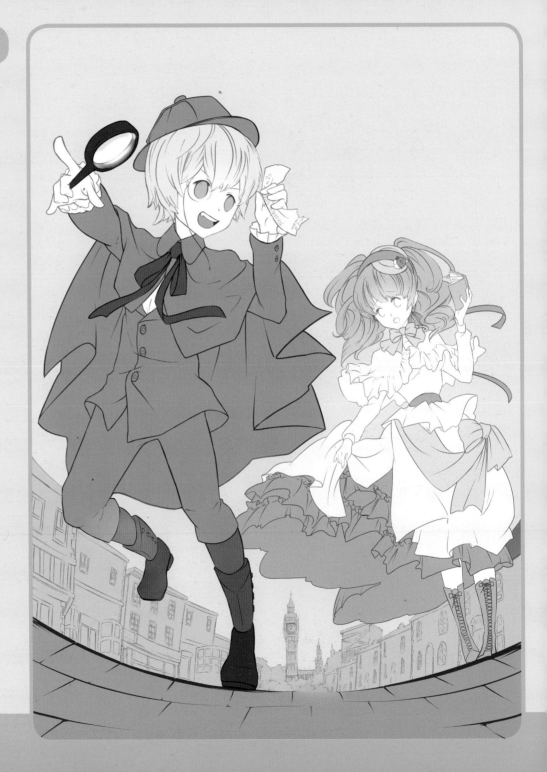

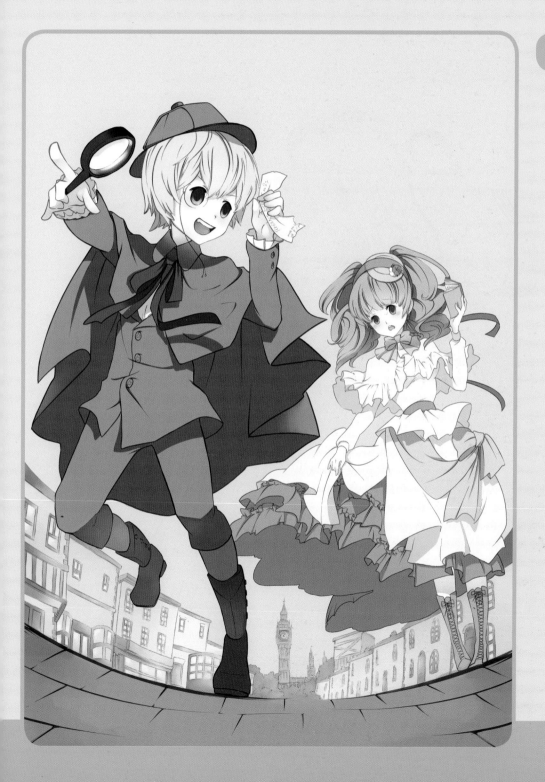

6.2. COLOR

We added the shadows in a darker tone, fading out certain areas with different brush opacities to soften the effect.

6.3. COLOR

We added in the highlights very subtly, respecting the cloud-filled atmosphere. We marked some areas of light with small gradients using the brush.

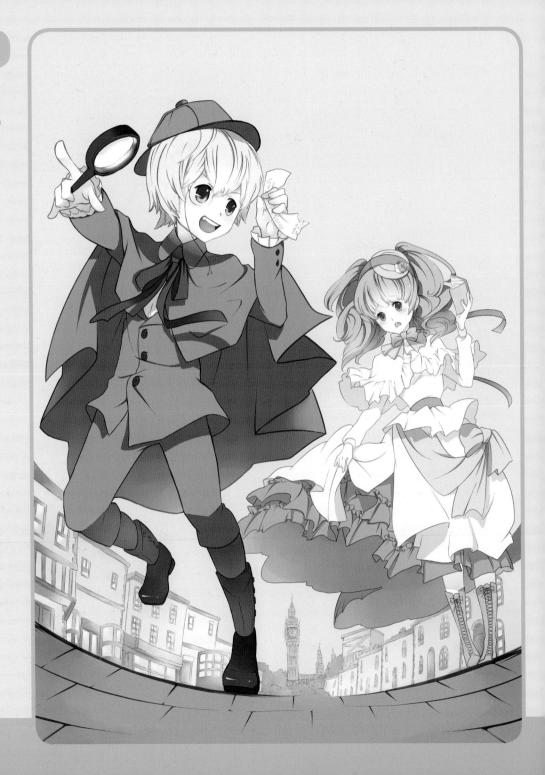

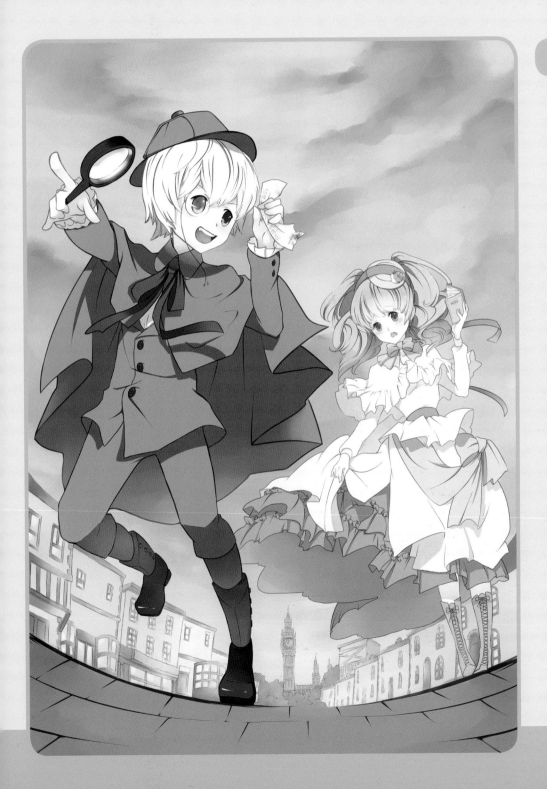

6.4. COLOR

We painted in the clouds in the sky using different opacities of brushstrokes, shifting the colors of the images toward bluer tones with a Photo Filter and adjusting the color of the characters' hair using a Gradient Map in the Overlay Layer Blend Mode.

6.5. COLOR

We added textures in the characters' clothes and background using the Overlay Layer Blend Mode, causing the drawing to look as if it was done with watercolors.

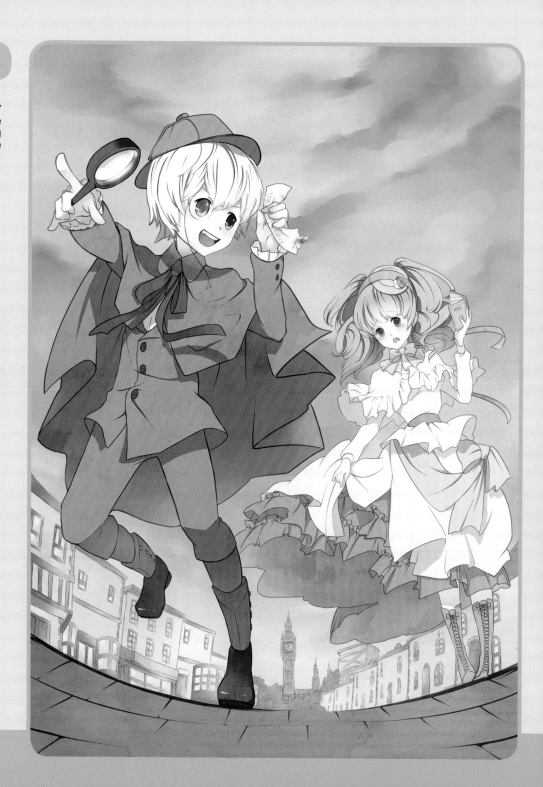

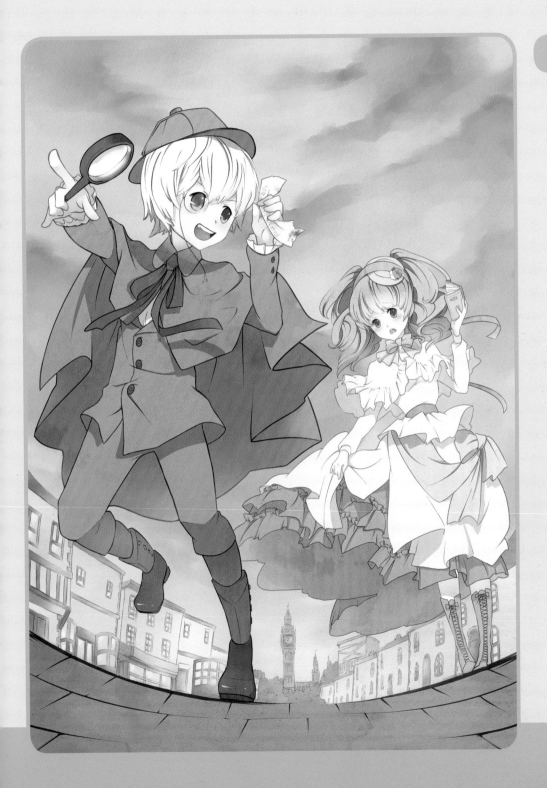

6.6. COLOR

We added the final touches to the drawing and once again readjusted the colors in the image with various Color Filters to balance and bring out the image's warm tones.

Finishing touches

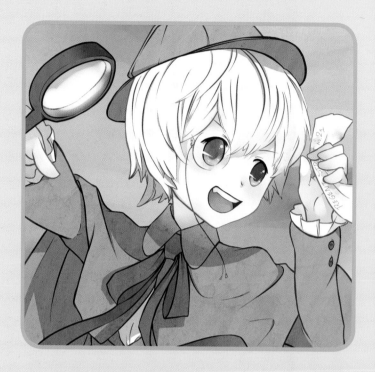

- We overlaid a gradient in the background using the Layer Blending Options to represent fall colors.

- With two new adjustment layers, Tone/Saturation and Color Balance, we evened out the colors and made them livelier.

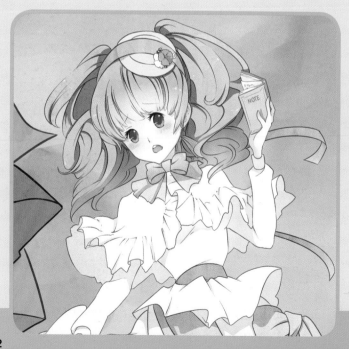

Tips & tricks

- Adobe Photoshop provides us with a wide range of resources to correct the colors of the layers. The most effective ones tend to be dynamic, meaning we can adjust them as we go, such as the ones created using Fill or Adjustment Layers.

- Textures make it easy to give the illustration a more organic final touch. There are thousands of textures available on the Internet. We could also scan them in or create them ourselves.

- Using the Layer Masks, we can apply textures to different areas in various degrees of roughness.

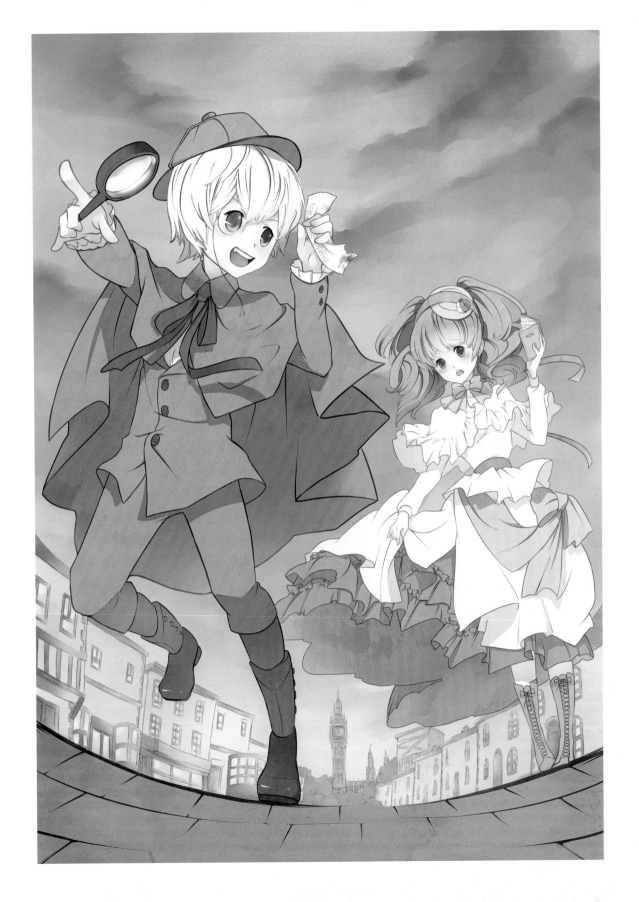

SOCCER STAR

Markus, a young German football talent, has spent a year getting over a bad knee injury that has kept him off the field. Although he thinks he still isn't a hundred percent better, his physiotherapist, Angie, believes he is physically ready to make a comeback. His city's modest football team, led by his physiotherapist's father, is on the edge of being relegated and urgently needs a striker such as him to stay in the division. Markus has to fight off his fears and start tearing up the field as he used to.

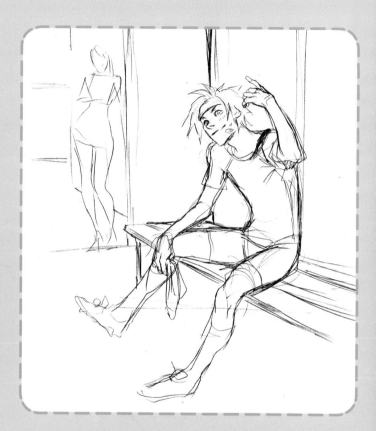

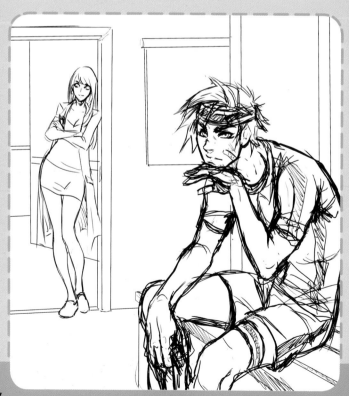

1. SKETCHES

We first opted for two locker room images, but in the end we decided on an image of the main character's triumphal entrance onto the field with his physiotherapist looking on.

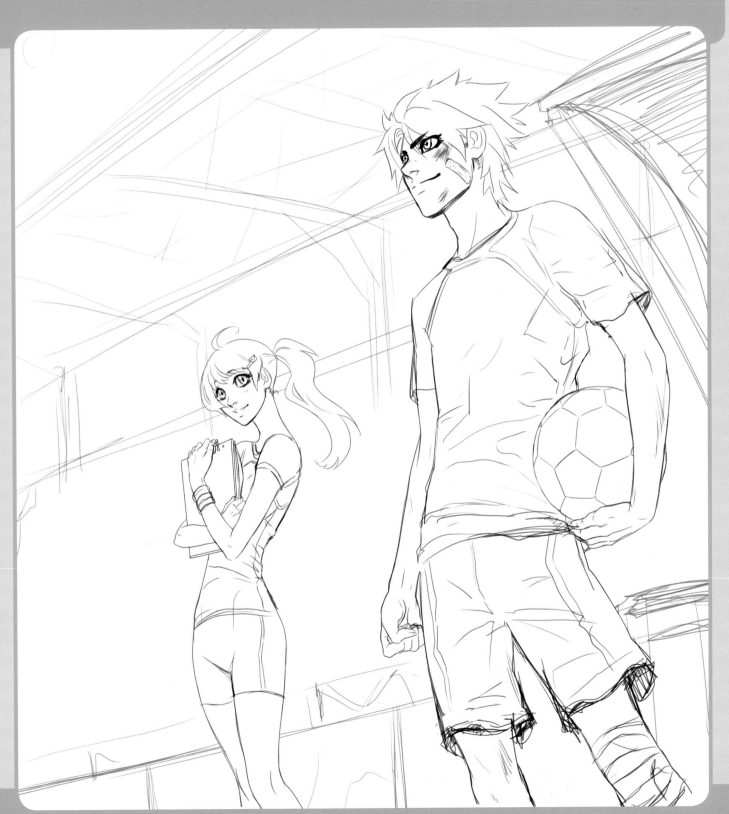

2. STRUCTURE

There is a low angle view of the characters, so we had to keep that perspective in mind when outlining their skeletons.

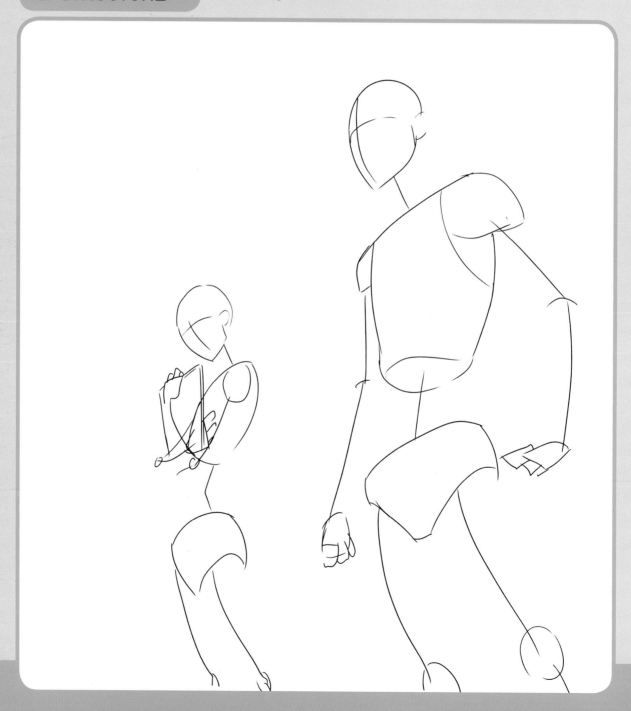

3. VOLUME

Although the characters are static, their bodies can't be straight because the image would lose strength. This is why we decided to curve their postures with more sinuous lines.

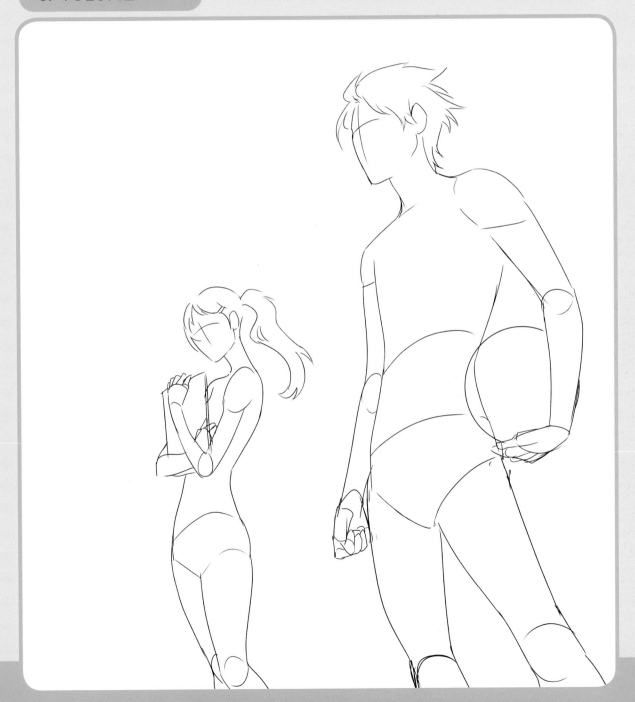

4. ANATOMY

As these are athletes, we drew in bodies that were athletic but not excessively muscular, making them wirier instead.

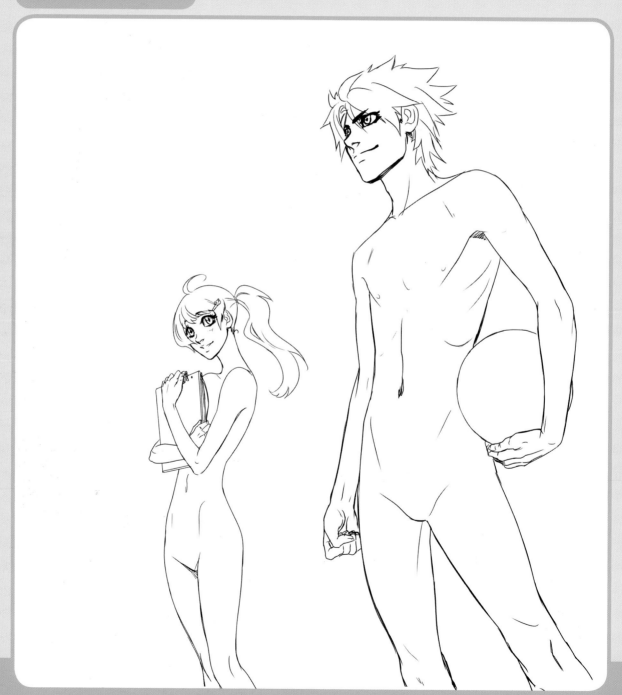

5. DETAILS

We dressed the characters in football gear and digitally applied the background we had previously sketched.

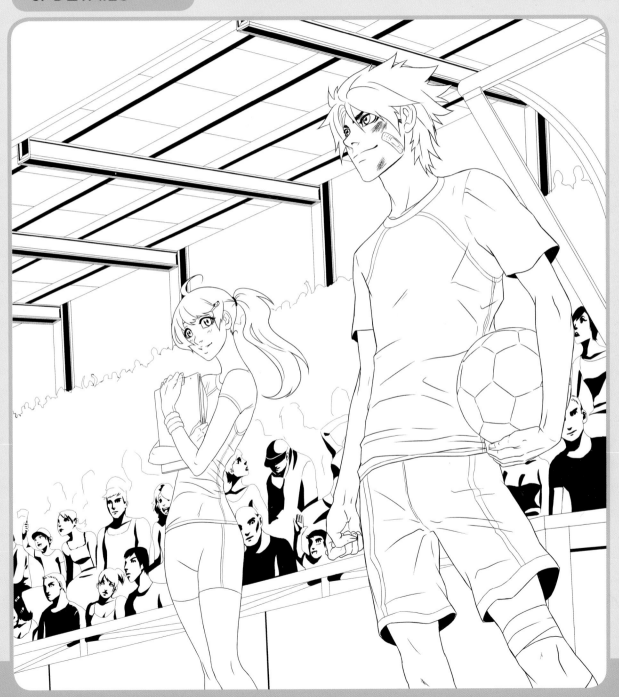

6.1. COLOR

We painted in the image's base colors, using a red for their uniforms and a green for the stadium.

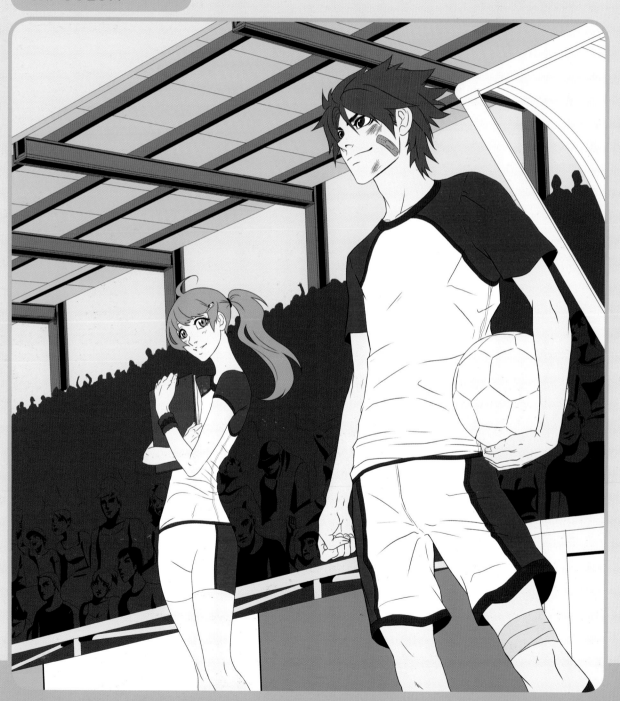

6.2. COLOR

We applied gradients with faint brushstrokes of color to mark the image's shadows.

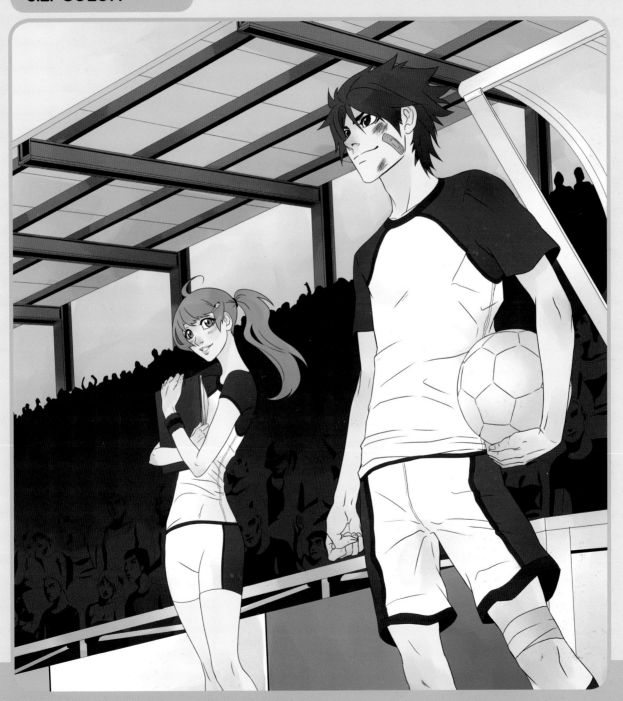

6.3. COLOR

We bordered the solid shadows on a separate layer in the Multiply Layer Blend Mode. We outlined the colors of the crowd watching the game.

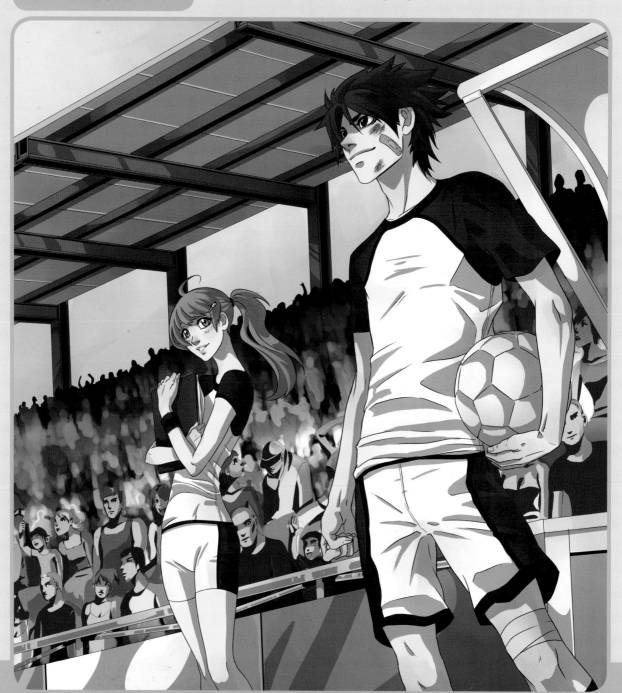

6.4. COLOR

We added in the highlights on a new layer in the Burn Blend Mode (Add). We recreated clouds in the sky with brushstrokes and we added details to the stadium.

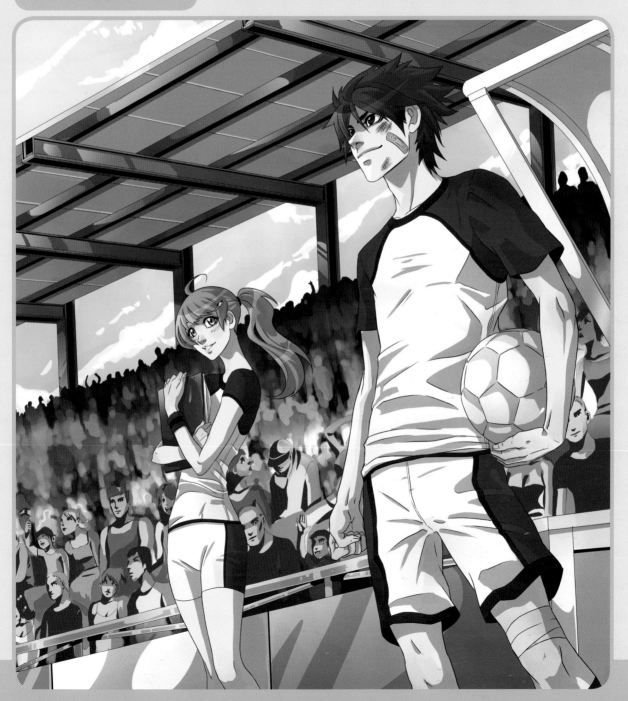

6.5. COLOR

We adjusted the color saturation levels and added in the final details, such as the confetti.

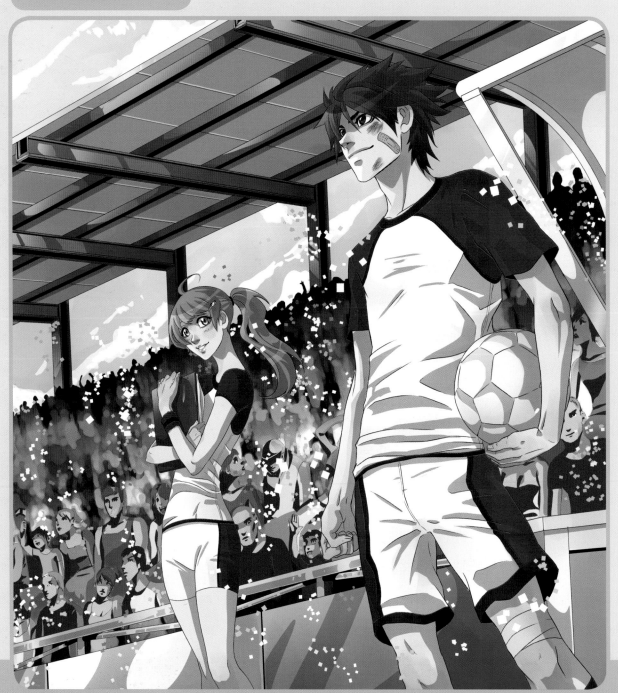

6.6. COLOR

We took the crowd out of focus and overlaid the rays of sunlight and points of light that illuminate the scene, creating a more triumphal look. We painted parts of the ball black to make it look like a traditional soccer ball and prevent it from overlapping the softer parts of the player's uniform.

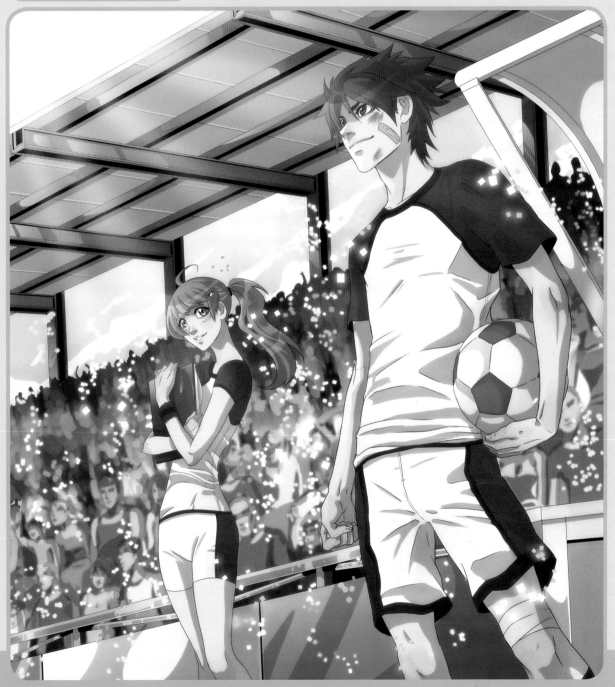

Finishing touches

- We took the crowd out of focus using a Gaussian Blur Filter, giving them a tone that separates them from the characters in the foreground.

- We reduced the intensity of the spotlight and made the final color corrections using the Adjustment Layers separated by Layer Masks.

- With the Layer Blending Options, we created a black outline around the character silhouettes.

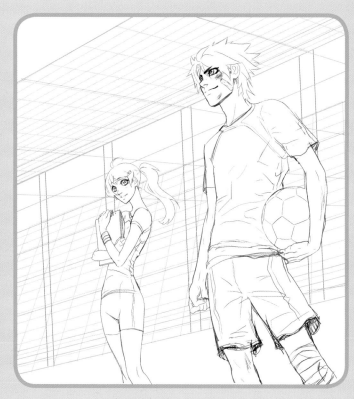

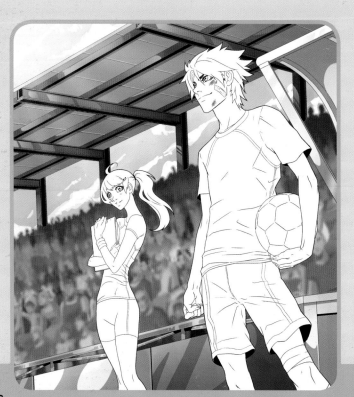

Tips & tricks

- To create the background, first trace the vanishing point and guides based on the preliminary sketch and then define the elements in the background.

- Although it is best not to abuse them, the Layer Blending Options allow us to easily create effects such as the Outer and Inner Glow of the confetti.

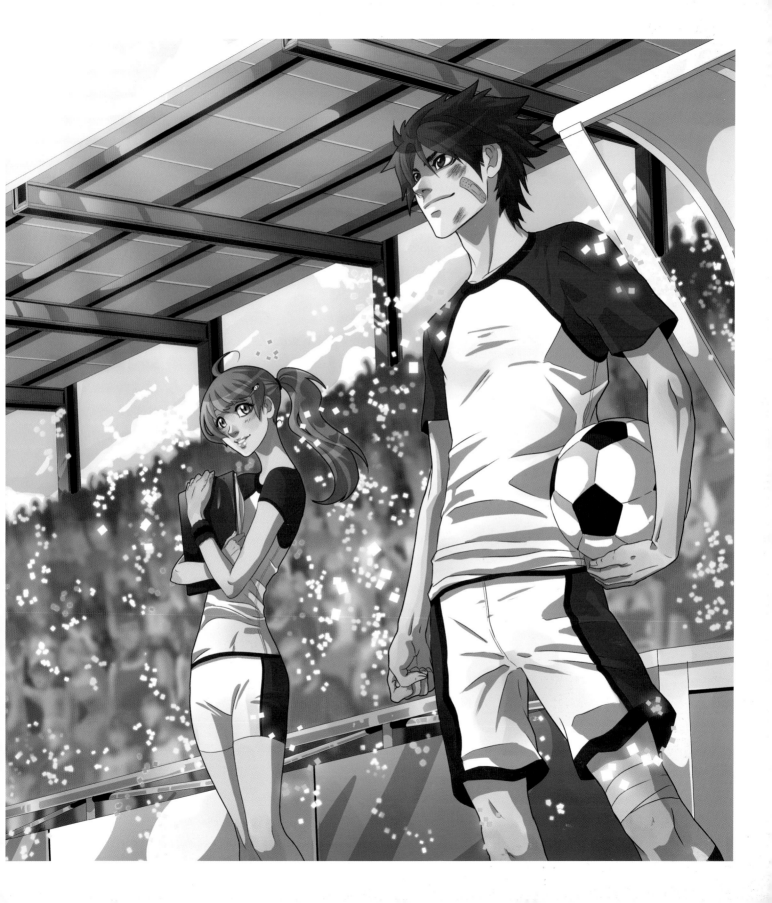

HIGH SCHOOL NIGHTMARE

Basho and Haruhi are two passionate fans of the occult that lead their high school's paranormal science club. Not surprisingly, both are descendants of two famous Shinto priests who in their day faced off against all sorts of supernatural creatures. Now that someone has opened the gate that separated the real world from the spirit world, every night at school they live through a new nightmare.

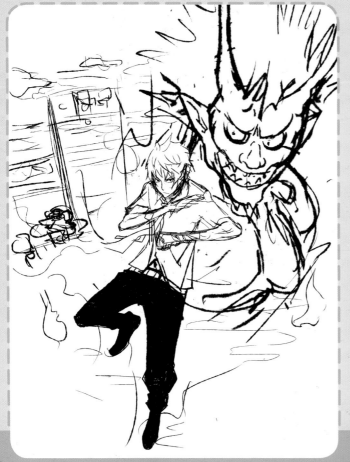

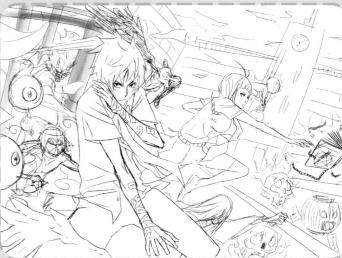

1. SKETCHES

The sketches show the way the graphics evolved in developing the idea set out for the exercise. The composition and arrangement of the characters and other elements were polished and polished until reaching the final proposal chosen for the step-by-step exercise.

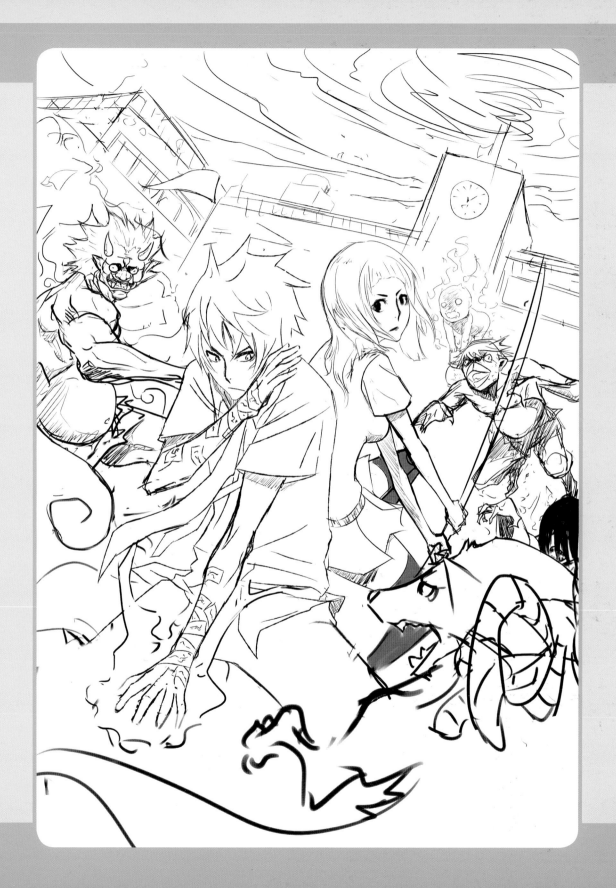

2. STRUCTURE

We arranged the characters in the image by fitting their figures into the space and positioning them in a way that balances the drawing's composition.

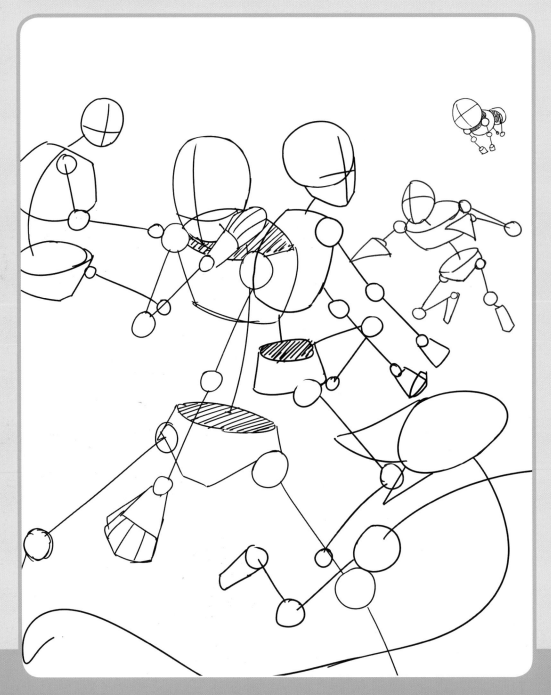

3. VOLUME

We completed the figures, taking into account the perspective and the positions we wanted the characters to be facing.

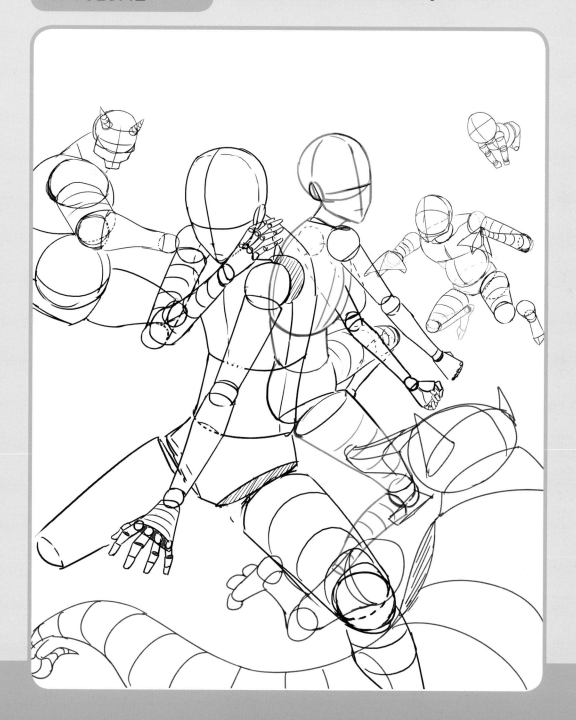

4. ANATOMY

We struck a clear difference between the slim yet strong and slender bodies of the teens and the big, muscular, and ferocious monsters attacking them.

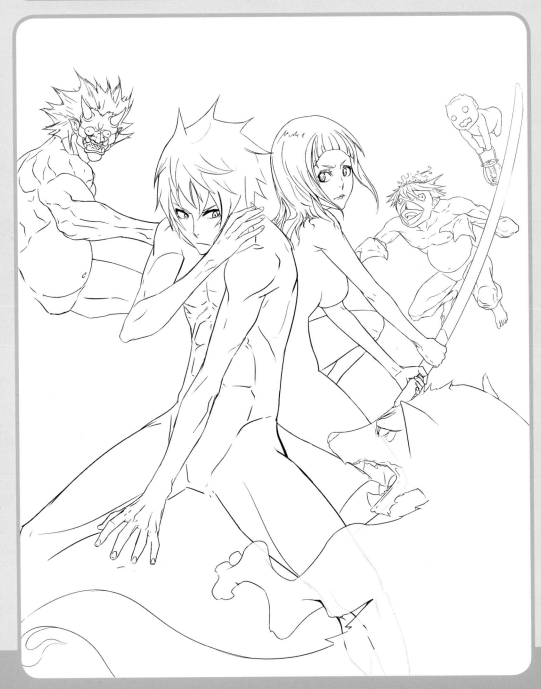

5. DETAILS

We gave the students a typical Japanese school uniform and added the more exotic garb of the supernatural monsters. The final coloring was done digitally using SAI.

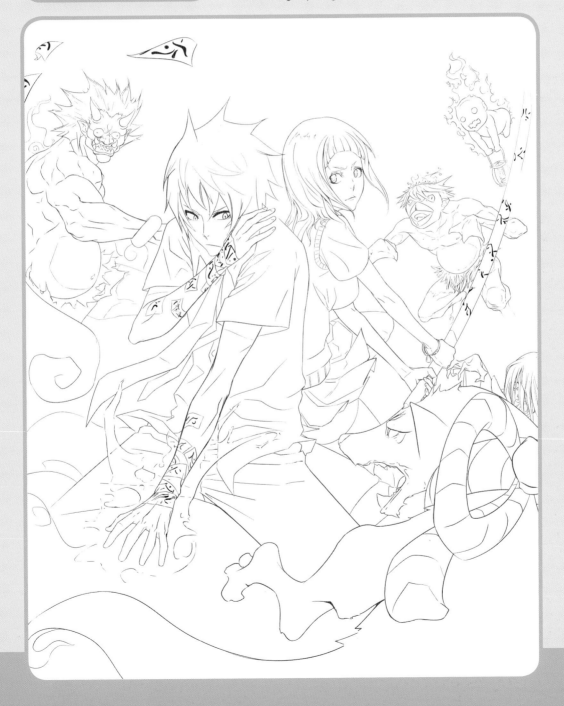

6.1. COLOR

We applied the illustration's base colors using the Brush tool in a new layer. We started with softer tones and marked out some of the light areas of the monsters.

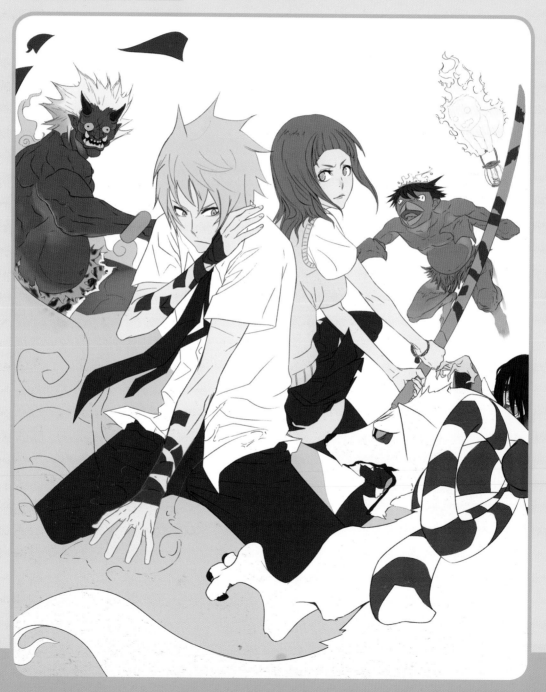

6.2. COLOR

With a watercolor brush we painted in the shadows using a lilac gray color on a new layer in the Multiply Blend Mode. The key here lies in properly using the brush and graphics tablet.

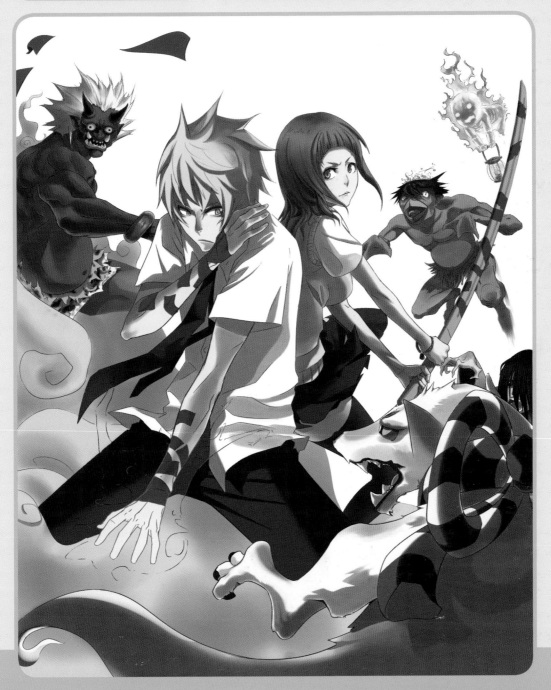

6.3. COLOR

We brushed in the highlights in a new layer in the Lighten Blend Mode, paying attention to the different light sources.

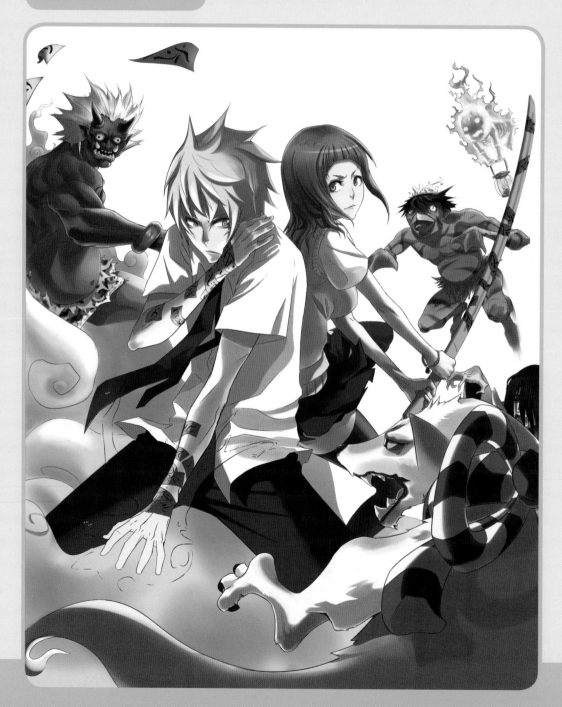

6.4. COLOR

We created magical effects by using different brush opacities and layer transparencies.

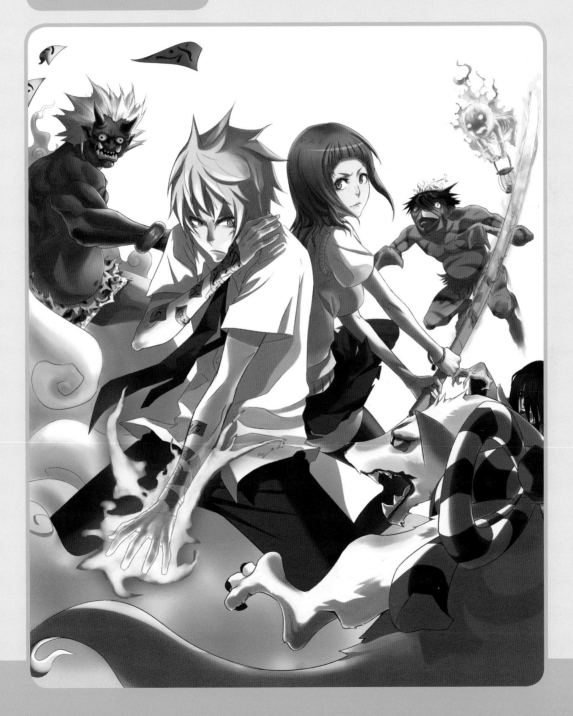

7.1. BACKGROUND

We created the background in a separate group of layers. We activated the lines of the buildings and painted the areas of light and shadow on the scene along with the first sketch of the sky.

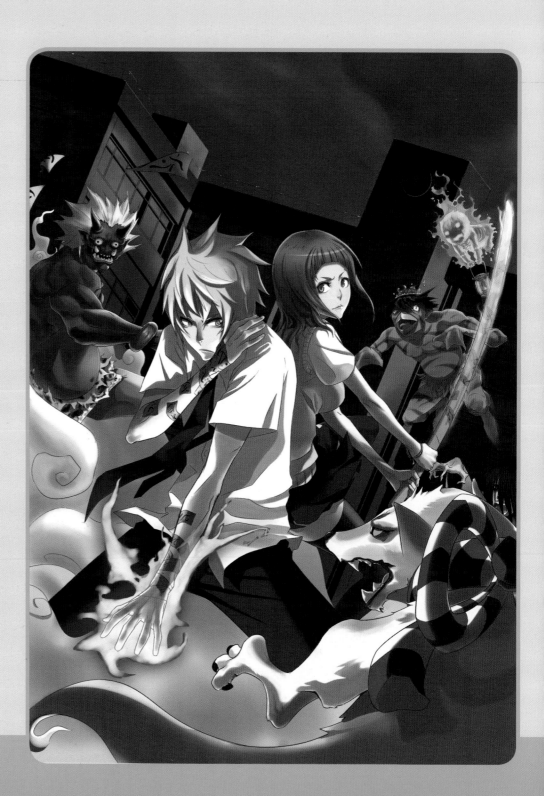

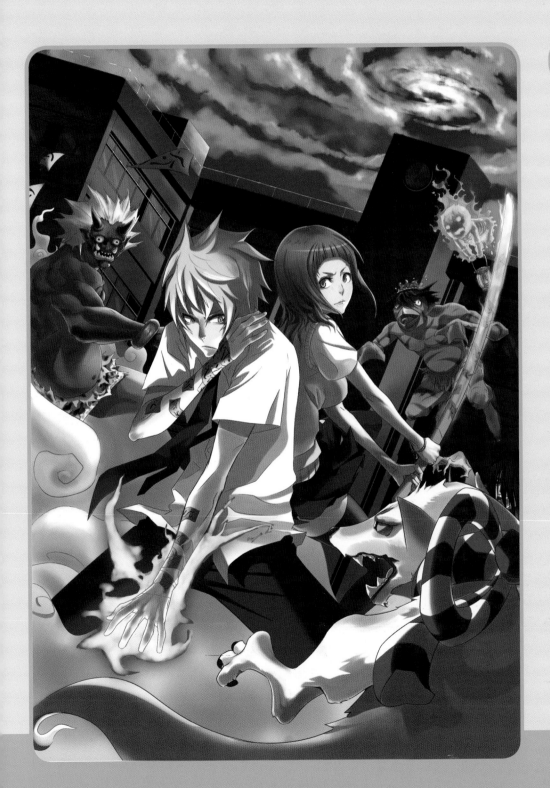

7.2. BACKGROUND

We finished up by adding highlights to the school and using different brush opacities to draw the spiraling clouds.

Finishing touches

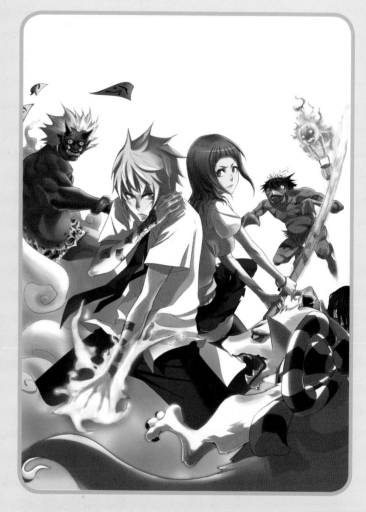

- We lowered the opacity in the line of the hand in order to heighten its magical shine.

- We drew the rays shooting through the sky on a new layer.

- We added in light effects using the Outer and Inner Glow Layer Blending Options.

Tips & tricks

- This illustration was colored in SAI, using the basic brush at 60 and 70% opacity, and the Oil Water brush for the background details and textures.

- It is essential to always begin with less saturated and softer pastel tones and then add in light and shadow details.

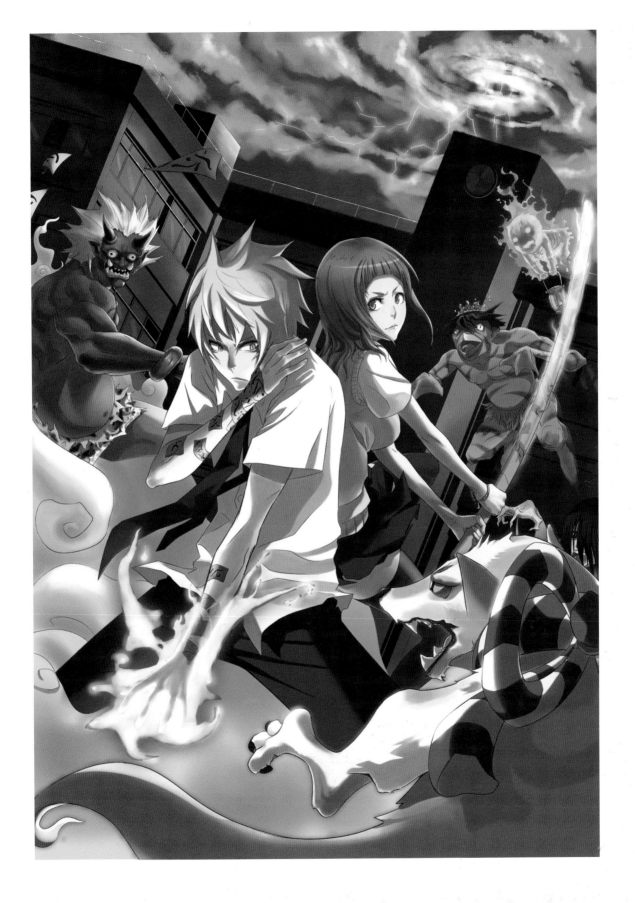

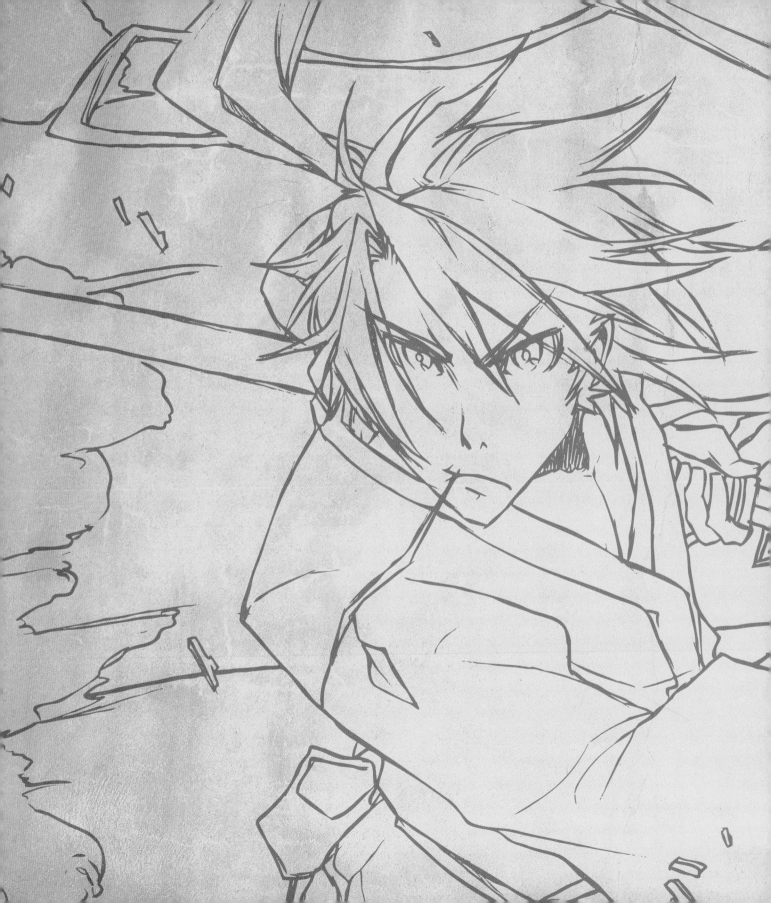

SWORDS
& DEMONS

RONIN

Makoto is the son of one of feudal Japan's many samurai. After losing his master, he became a wandering swordsman. But now, after traipsing from one end of his country to another without being able to join up with any clans, he decides to follow in the footsteps of the famous samurai warrior Miyamoto Musashi and become a true legend by abiding by the teachings described in Miyamoto's *Book of the Five Rings*.

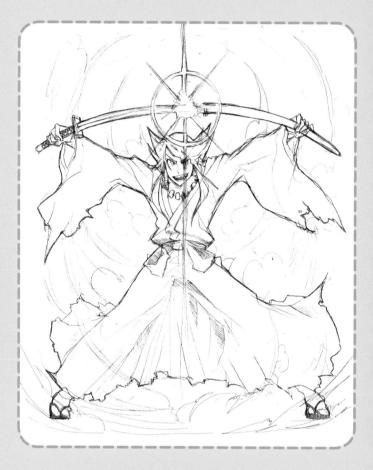

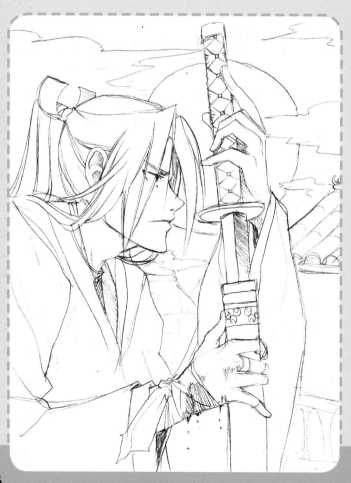

1. SKETCHES

We sought a posture in which the character would emerge with his whole body, one that would be as serious and defiant as it was dynamic and youthful.

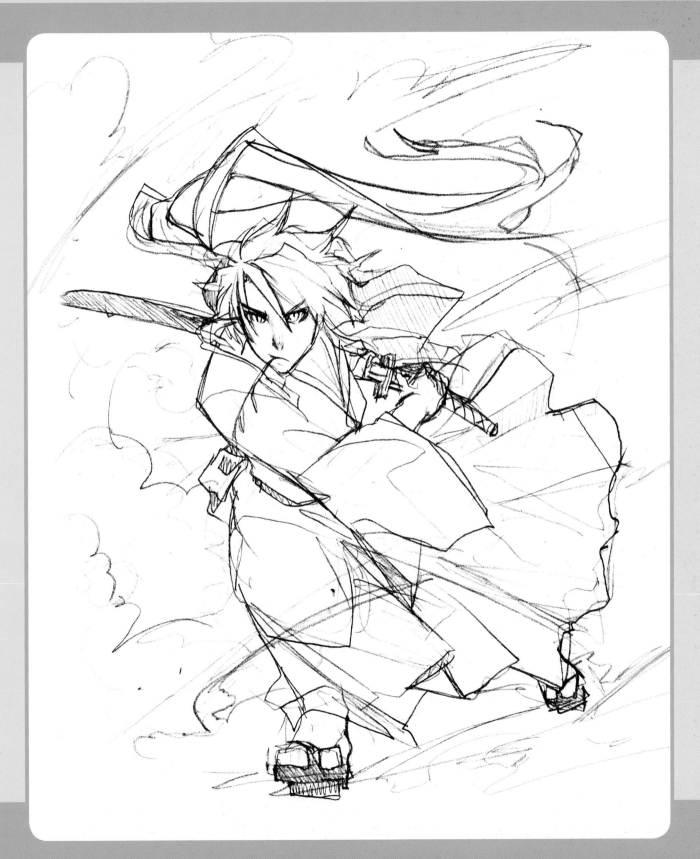

2. STRUCTURE

His articulations are drawn in such a way that the arm, although not completely seen in the final illustration, would not take on an unlikely position.

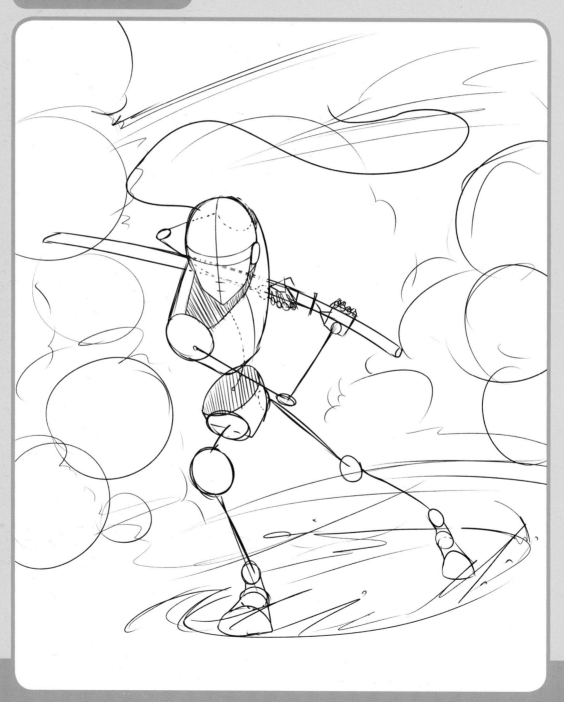

3. VOLUME

We sketched in how we wanted the dust clouds to be, so that they, along with the ponytail, would make the illustration more dynamic.

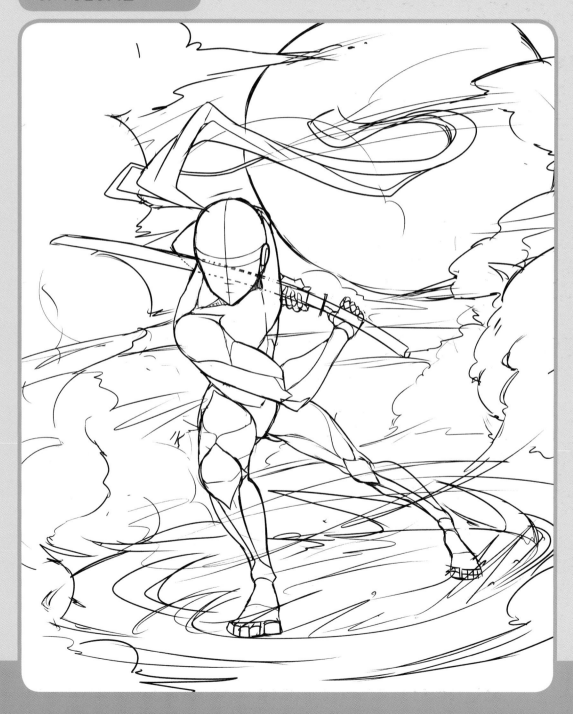

4. ANATOMY

Although the character would be completely dressed, it was important to mark out his joints that create folds in the clothing.

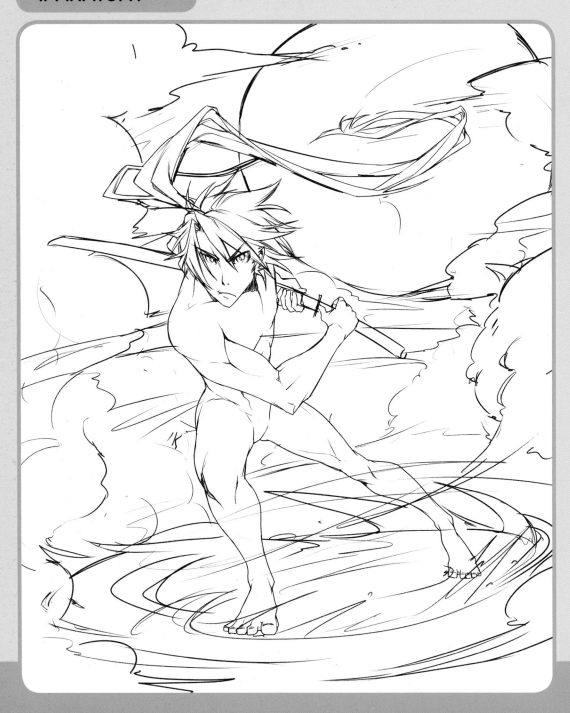

5. DETAILS

We drew in the kimono, keeping in mind the way it would fall over his body, and adding details in the form of dust and small floating bits.

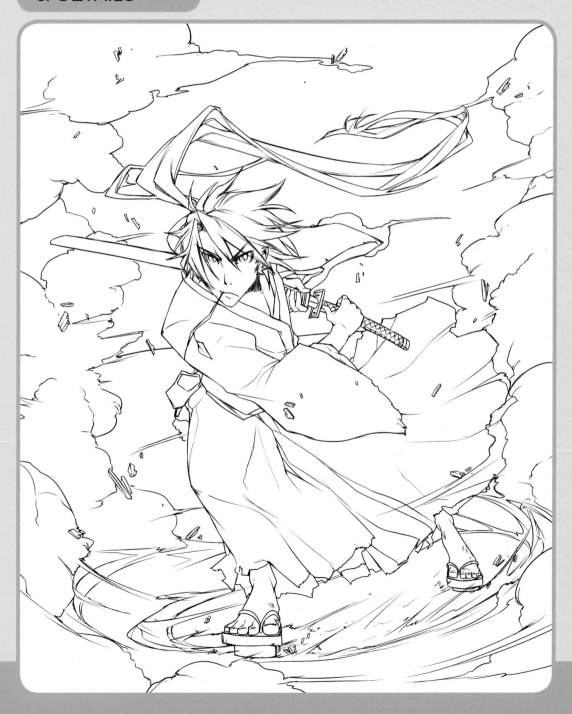

6.1. COLOR

We created two layers for the base color: one for the character and the other for the background. This helped us to organize the subsequent coloring steps.

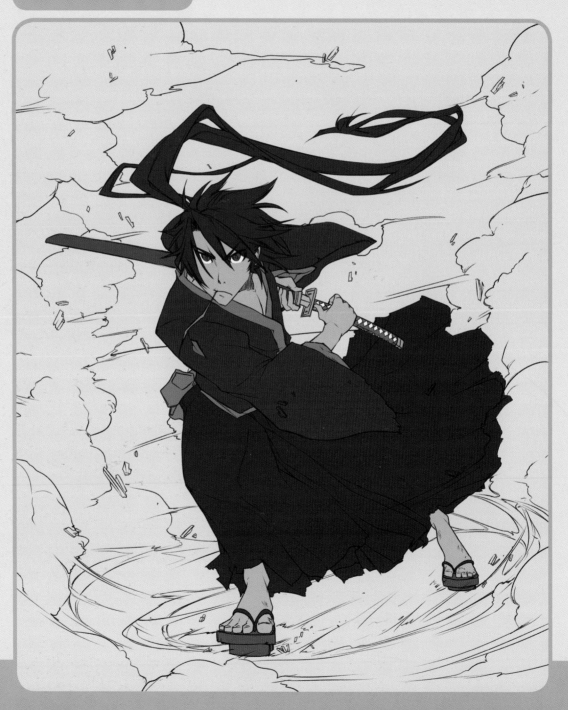

6.2. COLOR

We duplicated the base color layer. With the Magic Wand Tool, we selected each swath of color and added shadows with the Watercolor Brush.

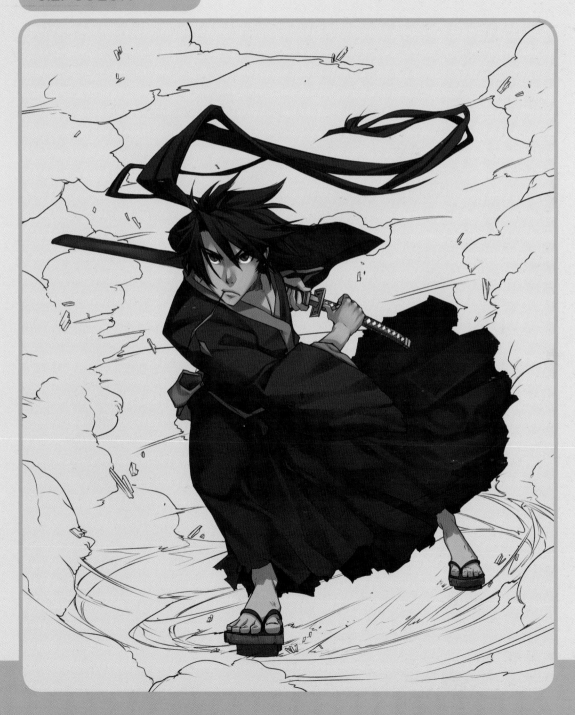

6.3. COLOR

The main light source comes from the yellow moon that glows behind the character, so this color would be the tone used to define the highlights.

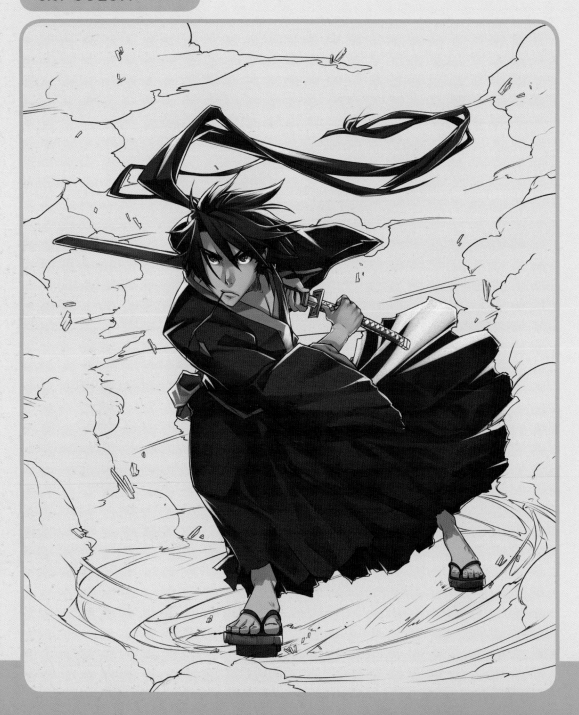

6.4. COLOR

Using gradients, we demarcated the areas for the sky and ground. We drew the moon using the Ellipse Tool.

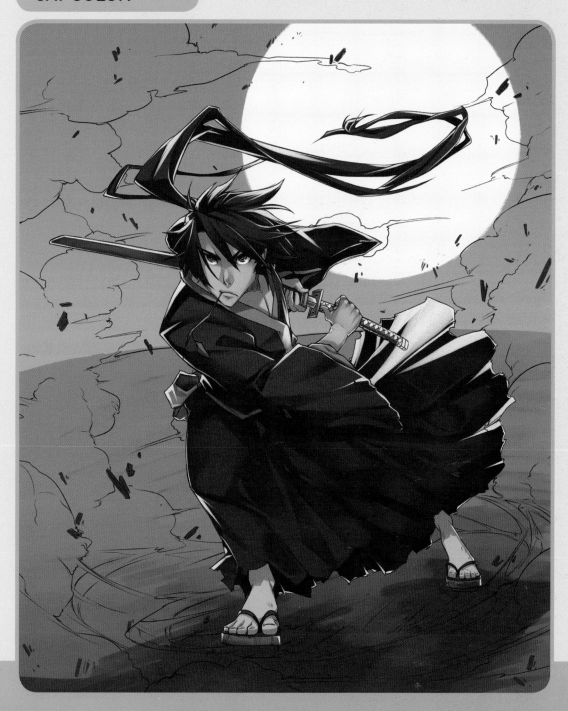

6.5. COLOR

The effect of the dust cloud was attained by lowering its opacity to 60%, using brushstrokes to mark out the highlights caused by the moon on its outer edges.

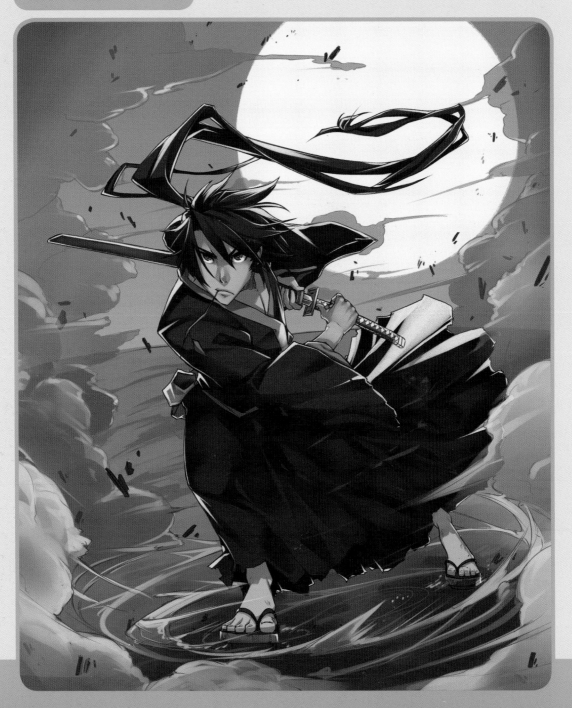

6.6. COLOR

We calibrated the color balance with a coffee-colored layer in the Overlay Blend Mode at 66% opacity, while at the top of the drawing we added a bluish gradient to give the appearance of night.

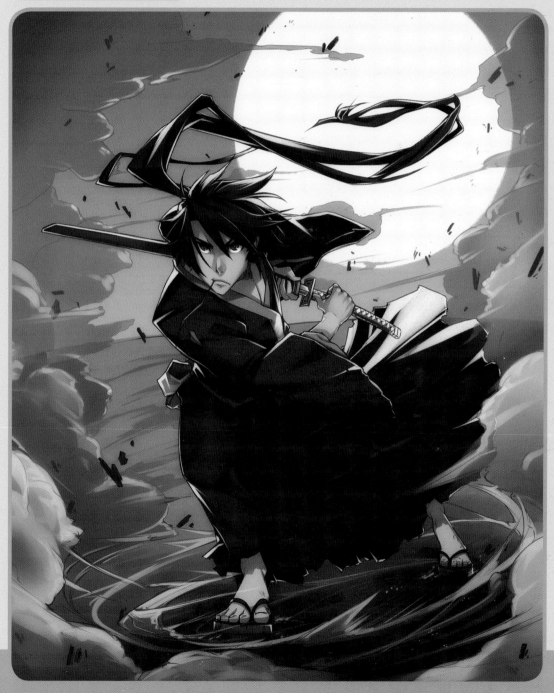

Finishing touches

- We combined the layers into a new one where we applied different effects, such as using a Gaussian Blur Filter in a Hard Light Blend Mode at 40% opacity.

- We adjusted the intensity of the colors using three adjustment layers that slightly increased the contrast and saturation and balanced the color toward bluer tones.

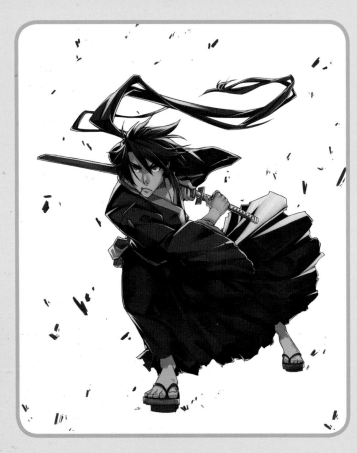

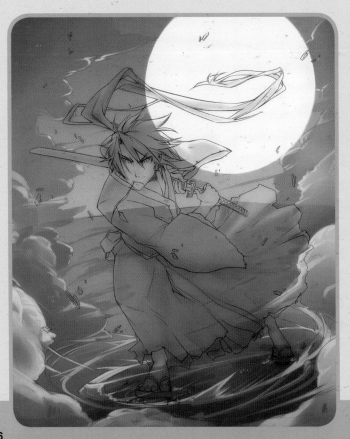

Tips & tricks

- The first part of the coloring of this drawing was done in SAI, but the final color adjustments were done in Adobe Photoshop.

- SAI has brushes that Photoshop lacks, but the effects and filters featured in Adobe program cannot be found in SAI.

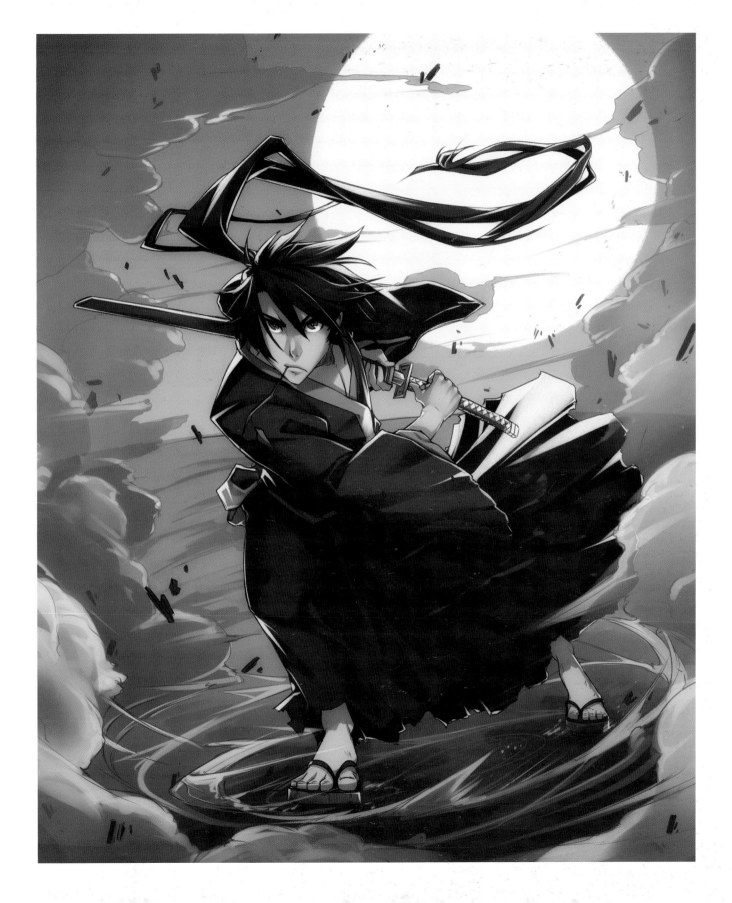

THE DEMONIC PRIESTS

The priests at the temple of Yasha are by no means conventional. Oushi is a half-demon and Miya is a descendant of a sorceress. Both fight supernatural beings that interfere in the lives of ordinary humans. Many times though, it is they, themselves, who suffer from the rejection and fear of those who don't understand their magical origins.

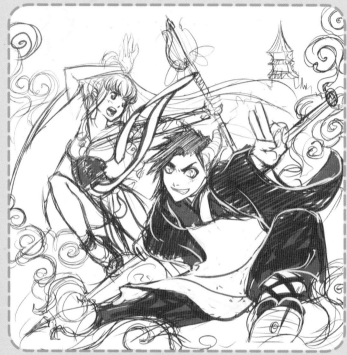

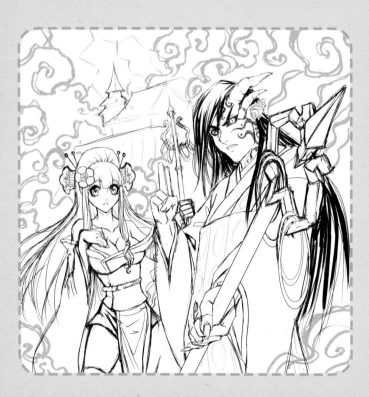

1. SKETCHES

In the image we wanted to show a temple in the background and the two main characters in action. It was important that they gave off attitude, strength, and energy.

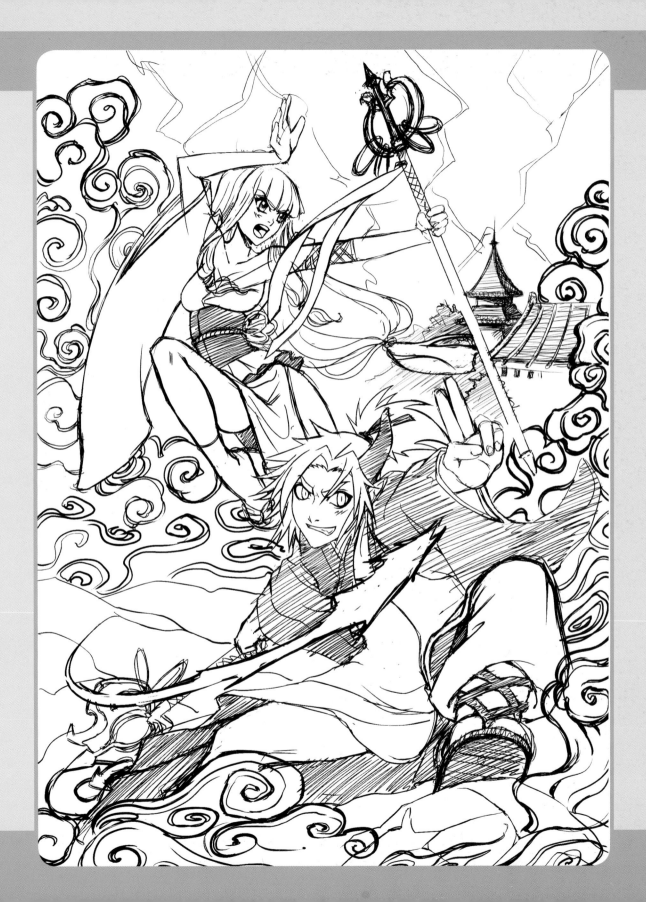

2. STRUCTURE

The characters emulate typical martial arts body positions, so we shaped the curvature of their axes to get a better effect of movement.

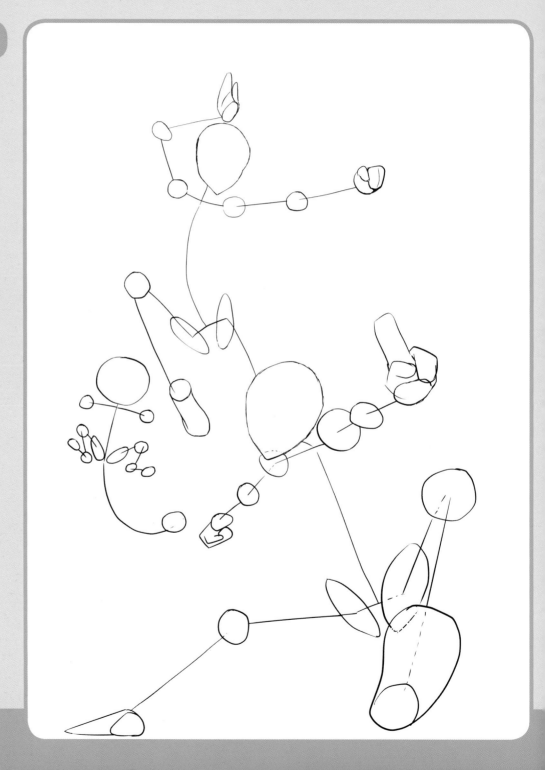

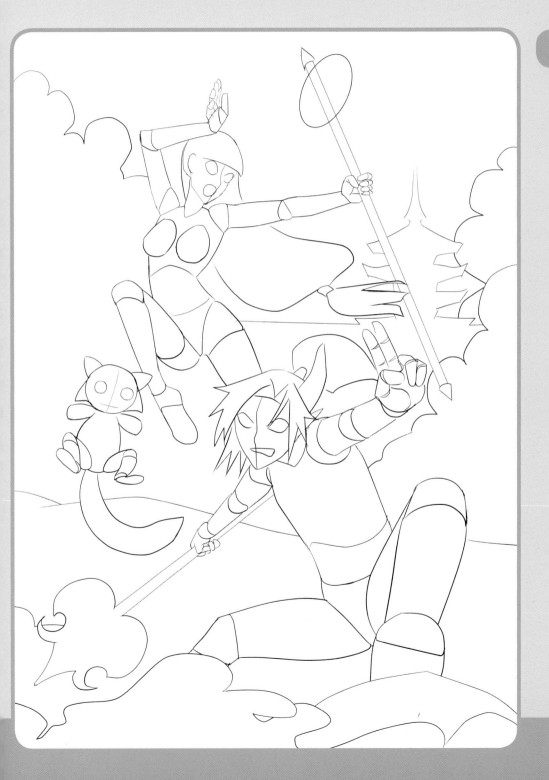

3. VOLUME

When we have parts of a drawing that are foreshortened, as in the case of their limbs, using cylinders to represent their volumes simplifies our work and helps us improve the drawing anatomically.

4. ANATOMY

Even though these two are warriors, you should make a special effort to differentiate female bodies from those of boys. Remember: girls have curvier shapes and boys straighter ones.

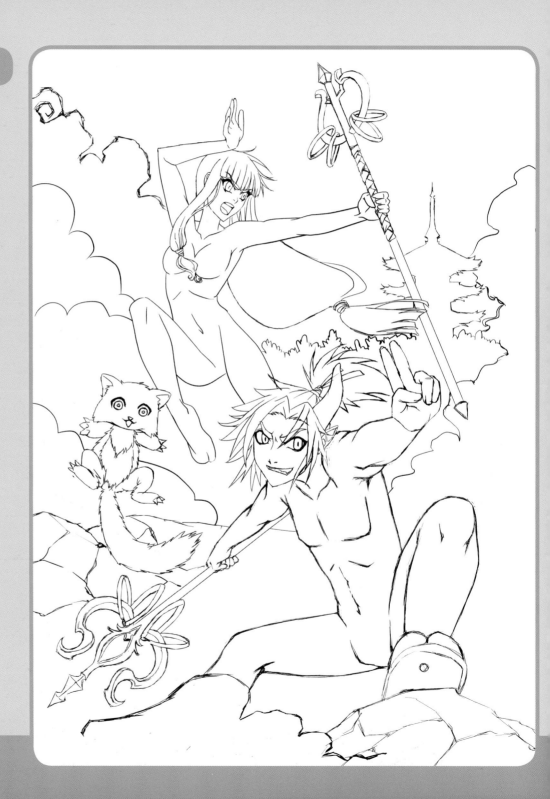

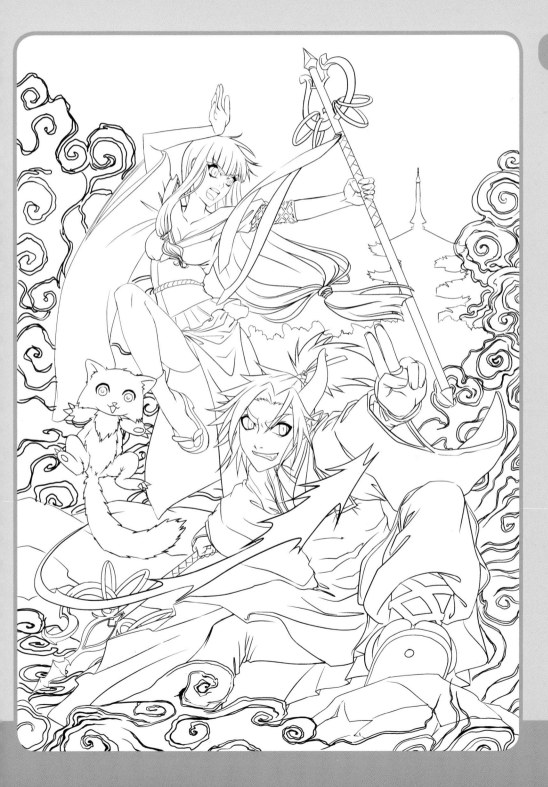

5. DETAILS

The boy's clothes follow the aesthetic lines of a typical medieval priest's garb, but the girl's kimono has a bolder, more modern design.

6.1. COLOR

The general range of the base colors starts with purples and blues and is complemented by browns and mustard tones.

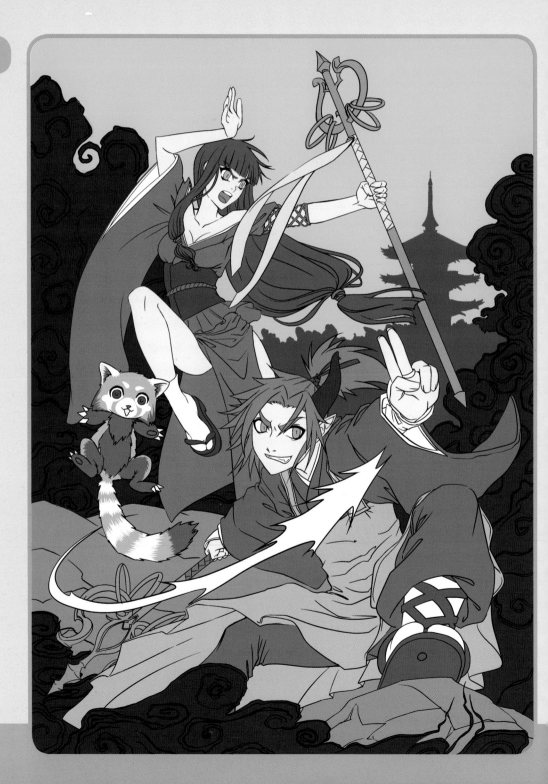

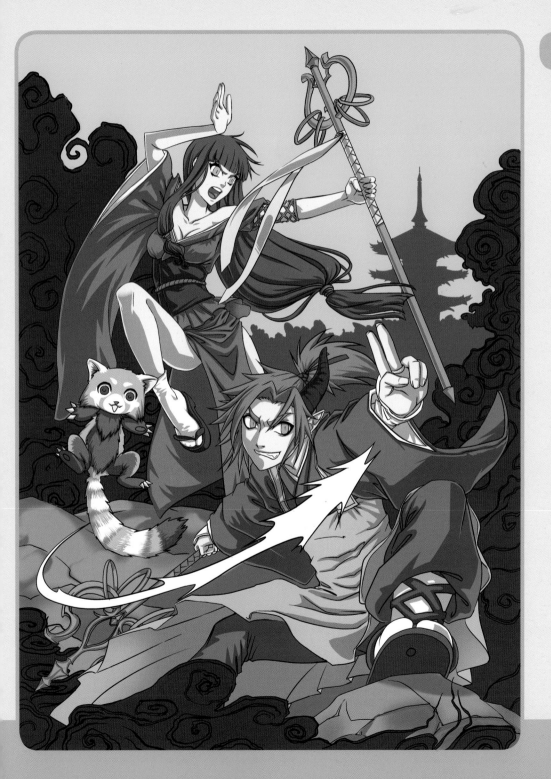

6.2. COLOR

We applied lilac-colored shadows on a new layer in the Multiply Blend Mode at 66% opacity.

6.3. COLOR

We applied the highlights in the Linear Burn Layer Blend Mode at 27% opacity to avoid overexposing the image.

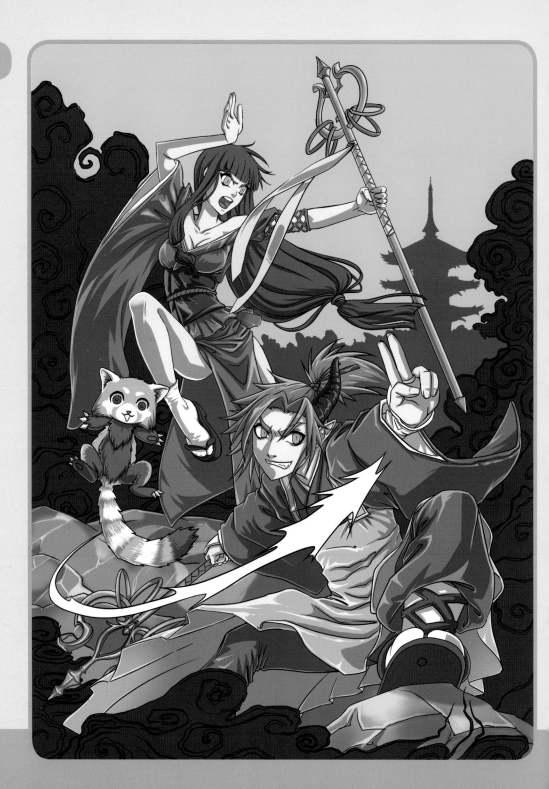

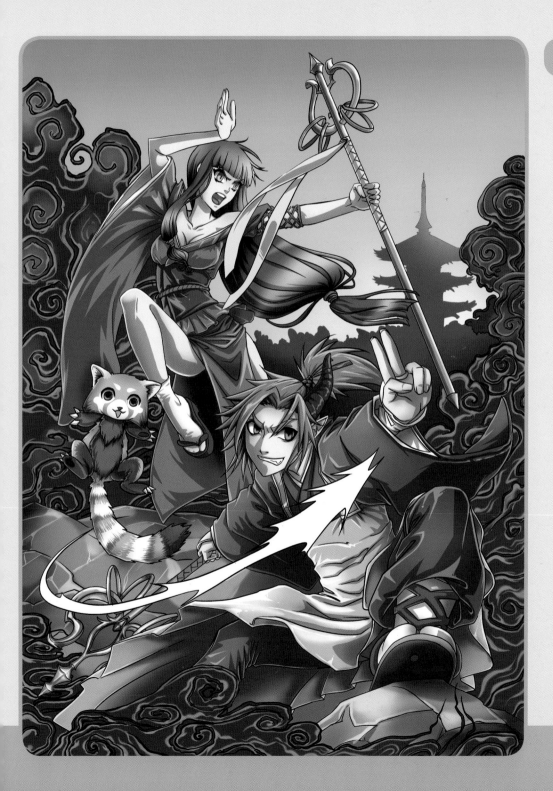

6.4. COLOR

We defined new light and shadow areas using gradients to give the illustration volume.

Finishing touches

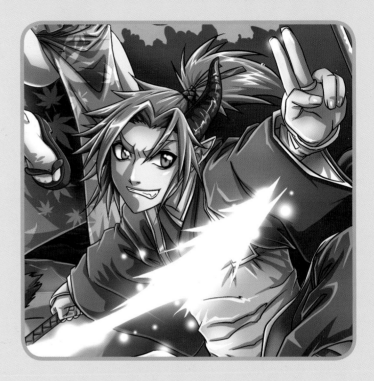

- We created the leaf pattern with a personalized brush and applied it on a new layer in the Overlay Blend Mode.

- We painted the final highlights and light effects on top of the image in the Linear Burn Blend Mode (Add), deactivating the line of the ray shot from the half-demon and adding Outer Glow effects in the Layer Blending Options.

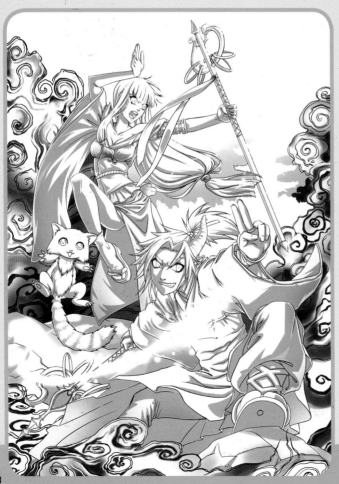

Tips & tricks

- To color in an image with the base colors, we create a new layer and select the areas we want to paint using the Magic Wand Tool, activating the Contiguous and All Layers options. In this way we can color in the new layer and avoid making the mistake of coloring in the line layer.

- We can also use a similar system with the Paint Bucket Tool, activating the Contiguous and All Layers options. Even though we are in an empty layer, the program will recognize the lines that we have in the background and color in those areas.

- In general, shadows are always applied in lilac, gray, or blue tones on a new layer in the Multiply Blend Mode, calibrating the Opacity and Fill options and the level of contrast we want.

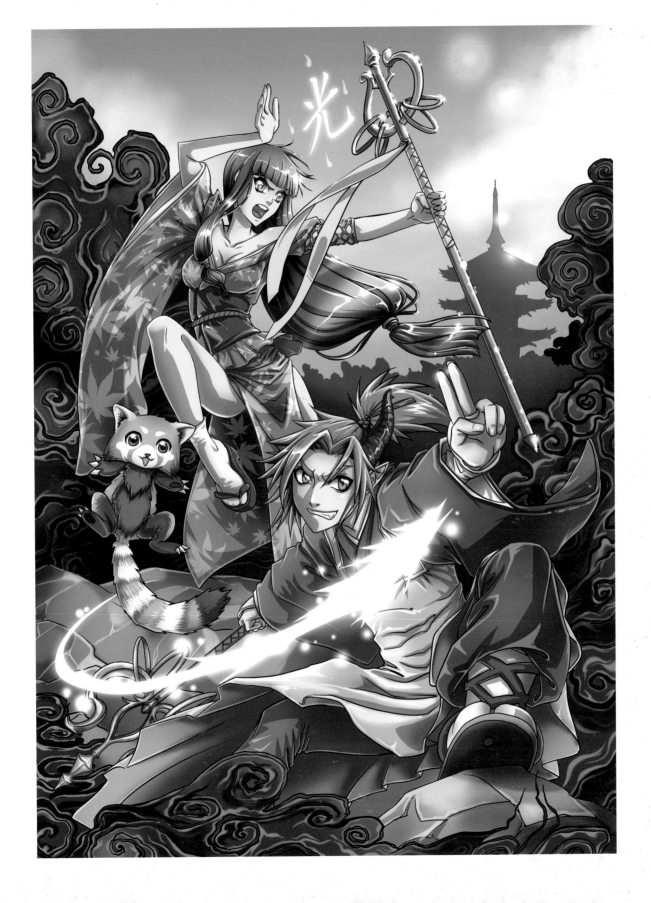

THE DARK SAMURAI

In the dark night, two strange silhouettes cut through the sky, one, a samurai, the other, a strange demonic giant. Both fight relentlessly over the city rooftops. No one knows the origins of their dispute, nor their intentions, but it's best if we mortals keep clear of this thousand-year-old battle if we want to stay alive.

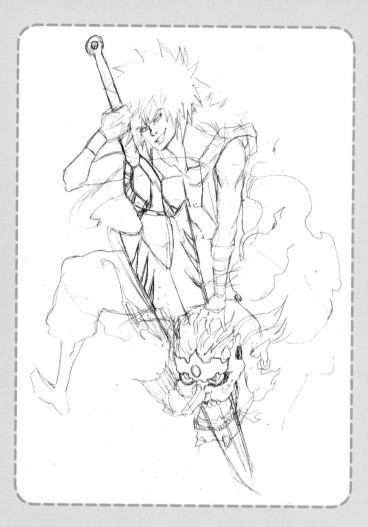

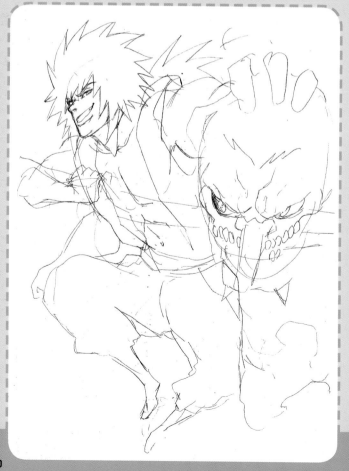

1. SKETCHES

The idea was to express an archetypal samurai confronting a classic Japanese demon on a dark night. The image we chose features a full-bodied *oni*.

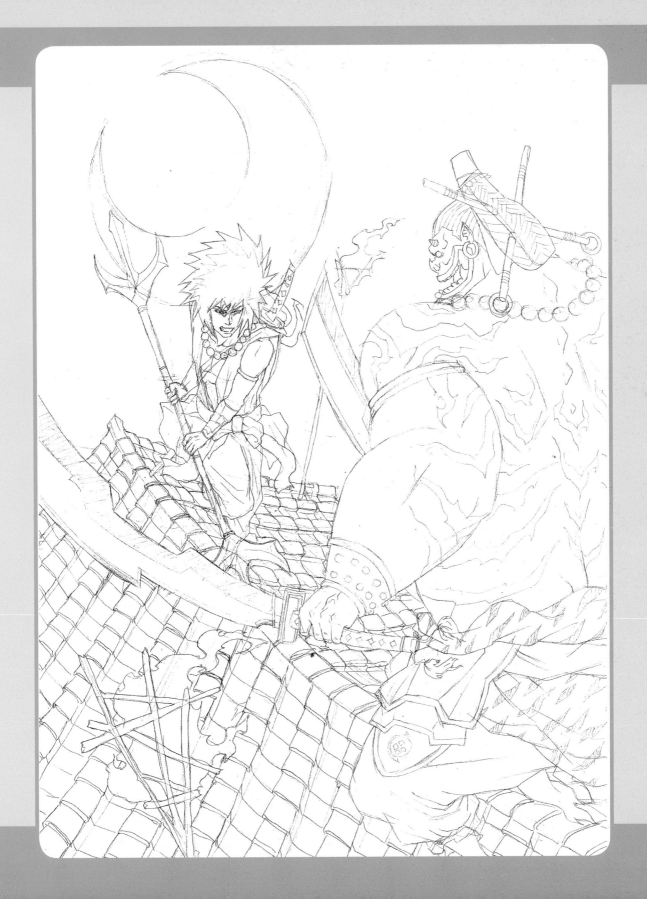

2. STRUCTURE

We positioned the characters in the scene, taking into account the action, perspective, and size of each.

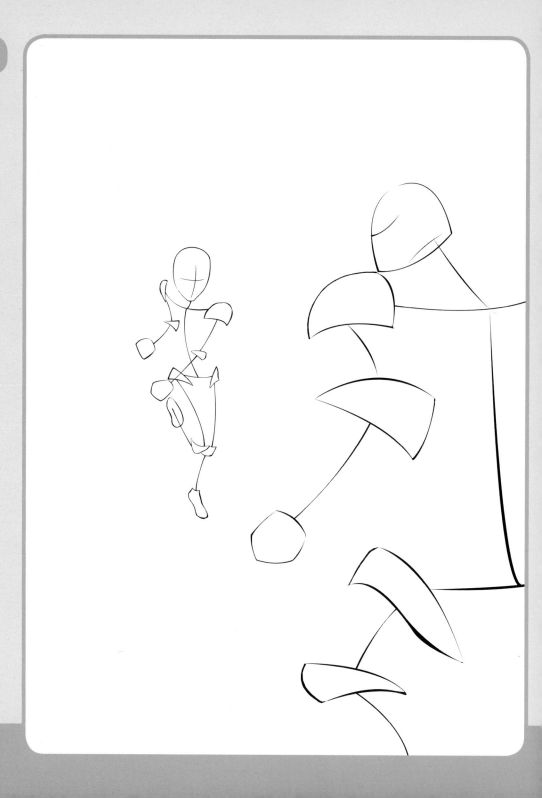

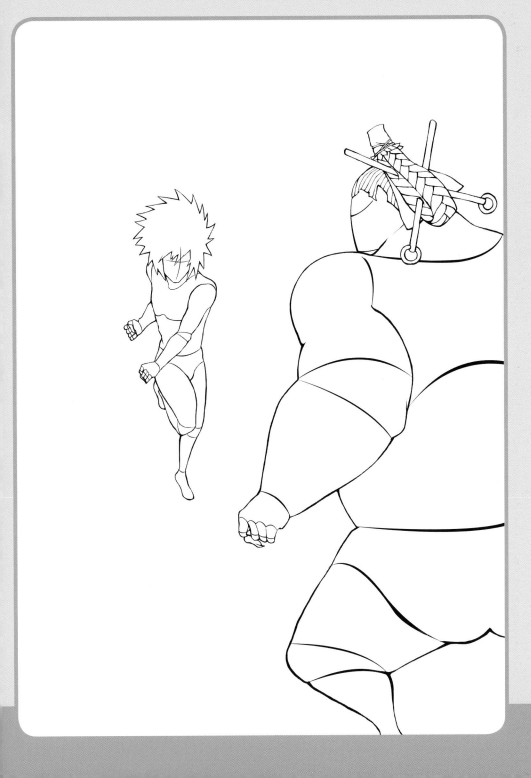

3. VOLUME

The high-angle view makes the samurai's upper body appear larger than his lower limbs.

4. ANATOMY

The samurai's body is slender and well-built, as opposed to that of the demon, which is much larger and more robust.

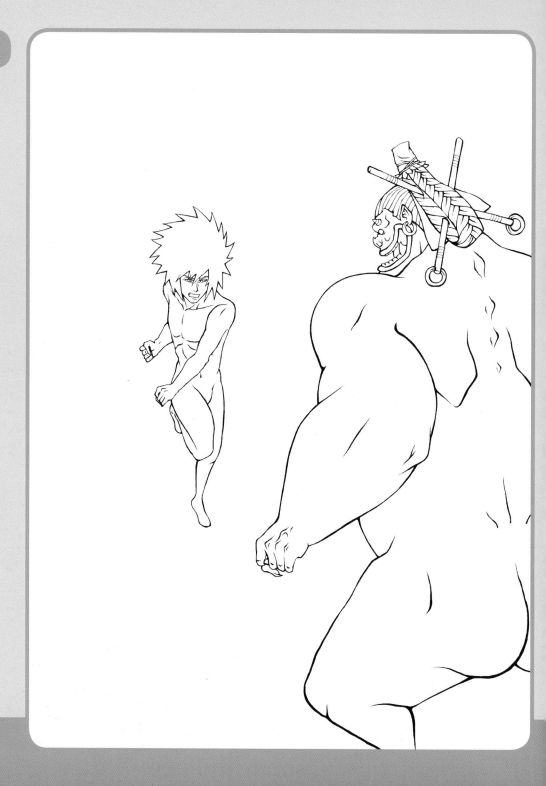

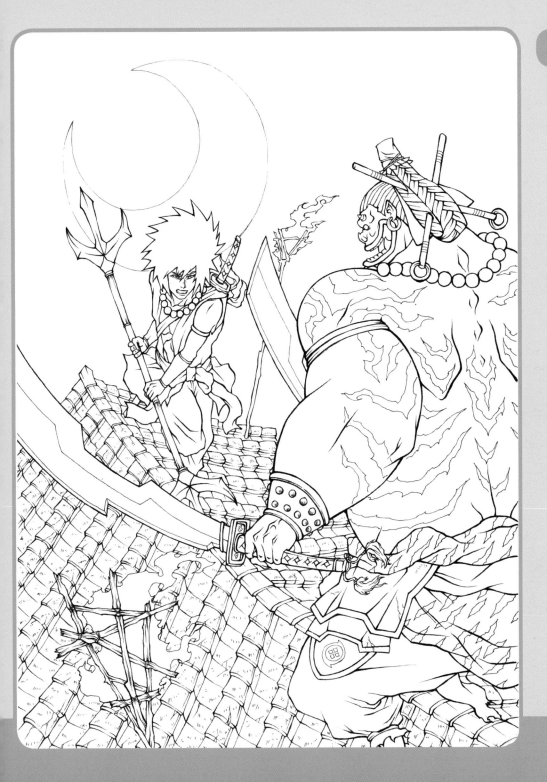

5. DETAILS

We carefully drew in the rooftop, and we gave the characters classic Oriental clothes and arms.

6.1. COLOR

We colored in all the areas in different layers using the Paint Bucket tool with the Contiguous and All Layer options activated.

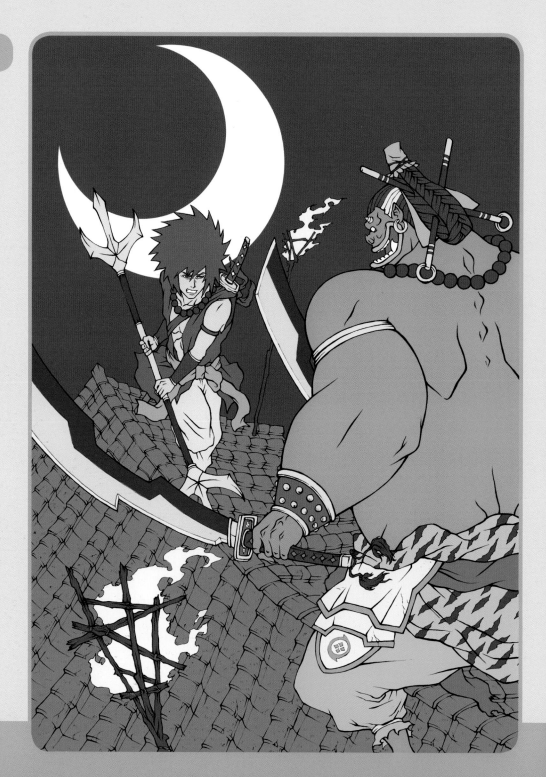

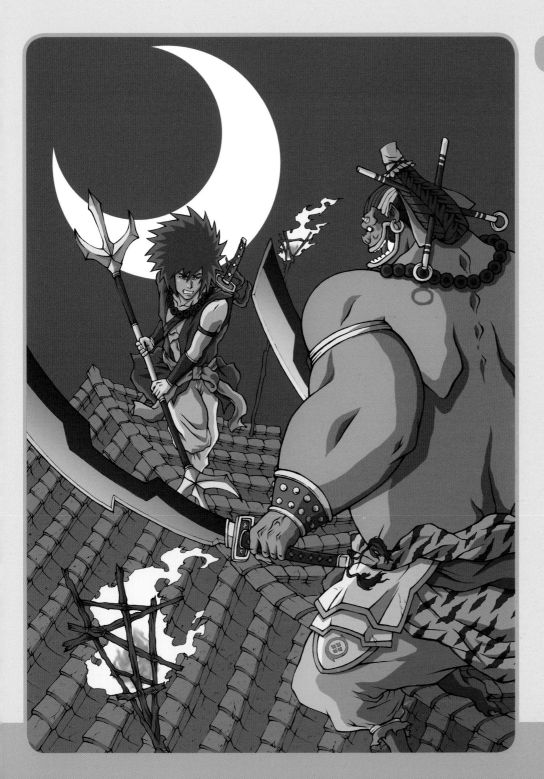

6.2. COLOR

The lighter shadows of both characters, done in grayish blue, have the same Linear Burn Blend Mode (Add) at 30% opacity. The harder shadows are made in a different layer but in the same tone, this time in Multiply Blend Mode at 60% opacity.

6.3. COLOR

We added in the brightness of the fire in the Lighten Blend Mode along with the stripes on the demon's body, not including the black lines, in the Screen Blend Mode at 51% opacity. To make the fire glow, we used the Outer Glow effect at 49% opacity, 161 size and 100% range.

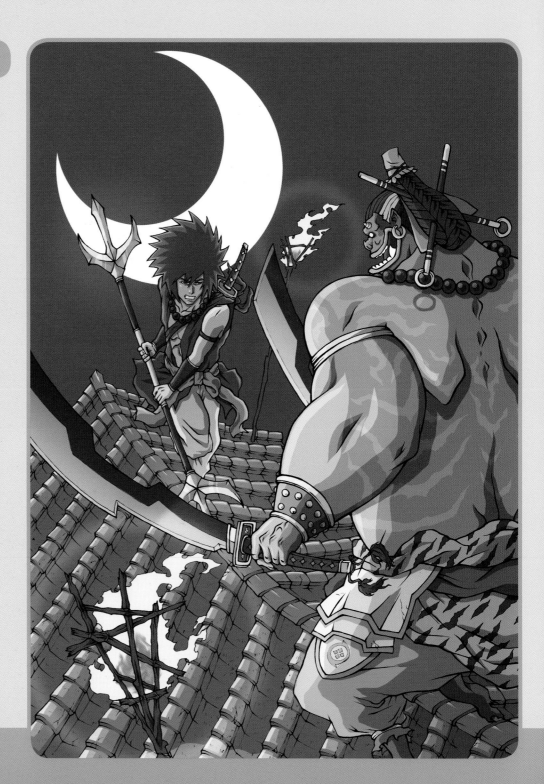

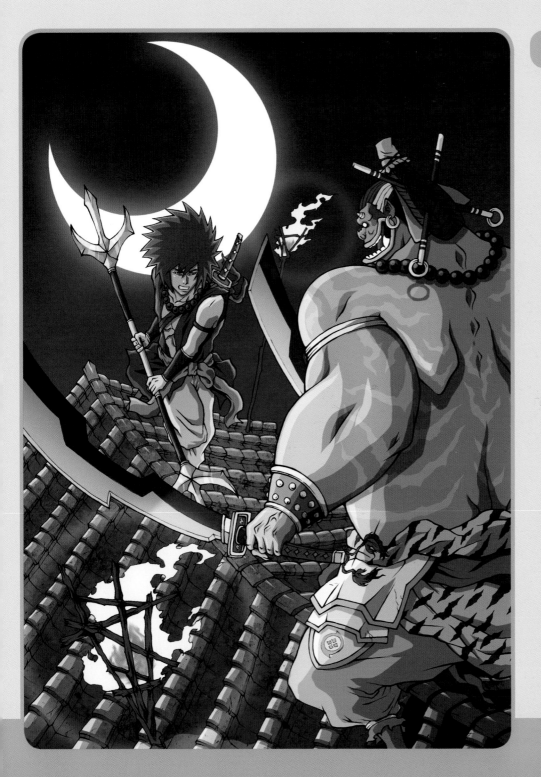

6.4. COLOR

We applied several adjustment layers such as Brightness/Contrast, Selective Correction, Photo Filter, and Color Balance. We also used several Gradient Overlay effects, especially in the rooftop. For the moon, we used an Outer Glow effect.

Finishing touches

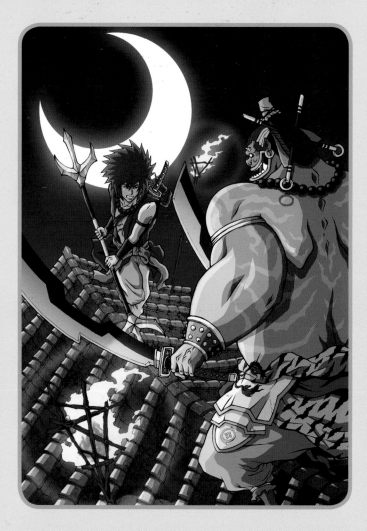

- We added a rough texture in the Soft Light Blend Mode at 71% opacity and 56% fill.

- We colored in the line of fire and added details to the samurai's eyes.

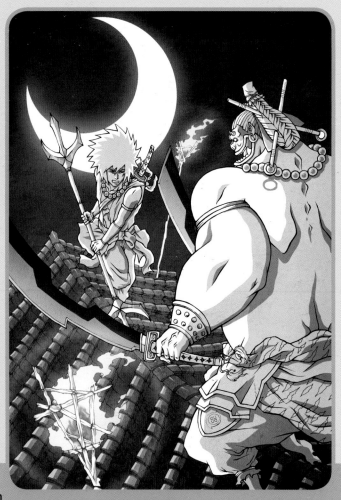

Tips & tricks

- Once we have defined the color of an illustration, Photoshop allows us to easily correct and harmonize the tones by using dynamic effects, which we can calibrate so these changes are not permanent.

- In the Layer window within the Create New Adjustment or Fill Layer option, we find practically all the same variables as in the Image Adjustment Menu. The difference here is that they are not permanently applied, and instead can be continuously modified.

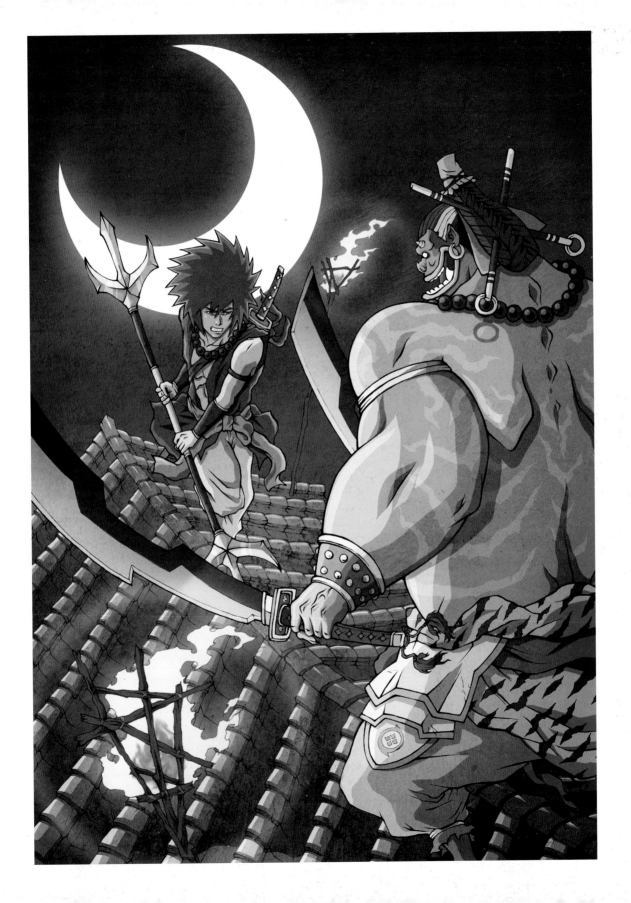

THE IMPERIAL DEMON HUNTERS

For centuries, the emperor of Japan had a special patrol at his command devoted to hunting demons and magical beings until peace returned to the country. However, a new supernatural threat has suddenly arisen among the inhabitants of the land of the rising sun, and now the young descendant of those demon catchers must lead the fight against the new monsters.

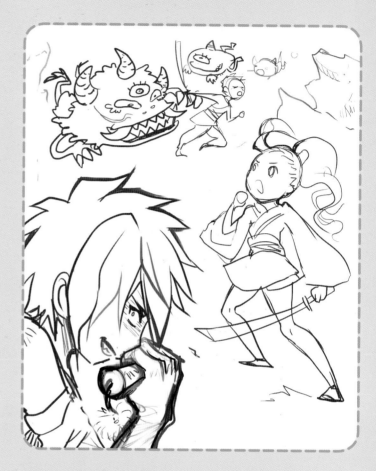

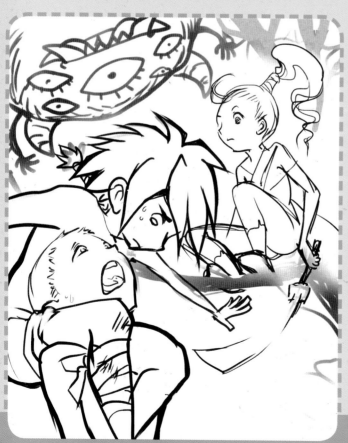

1. SKETCHES

We settled on an illustration whose funny characters, a bit brazen even, face off against monsters with an arrogance and self-assurance far beyond their years.

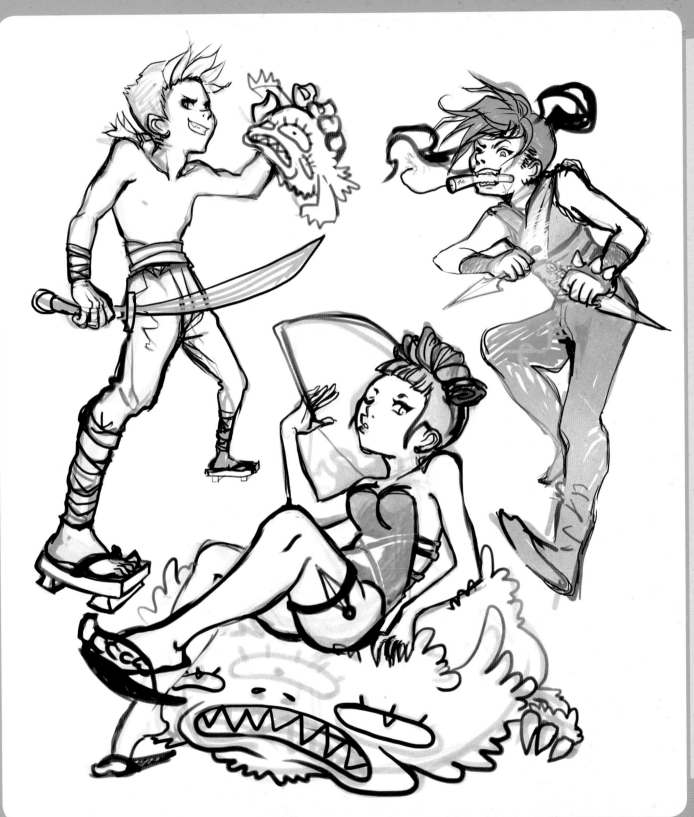

2. STRUCTURE

To give attitude to the characters' postures, we exaggerated the curvature of their central axes.

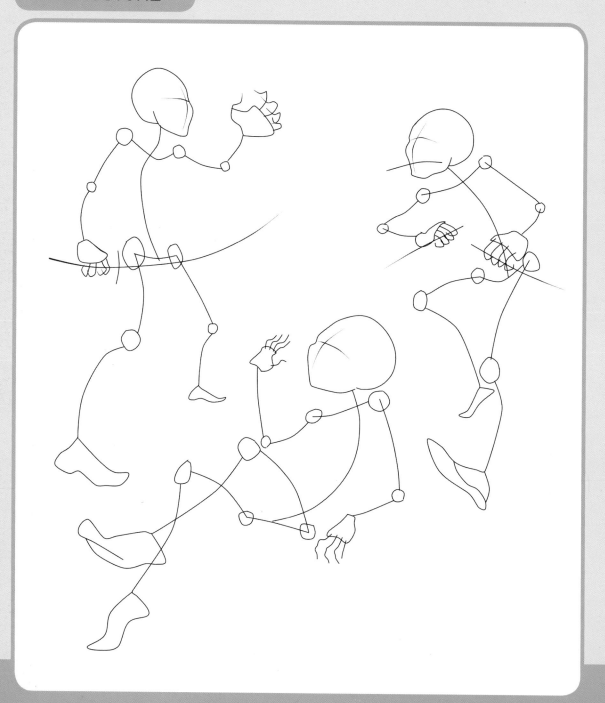

3. VOLUME

We exaggerated the perspective of their lower limbs to enhance the background's sense of depth.

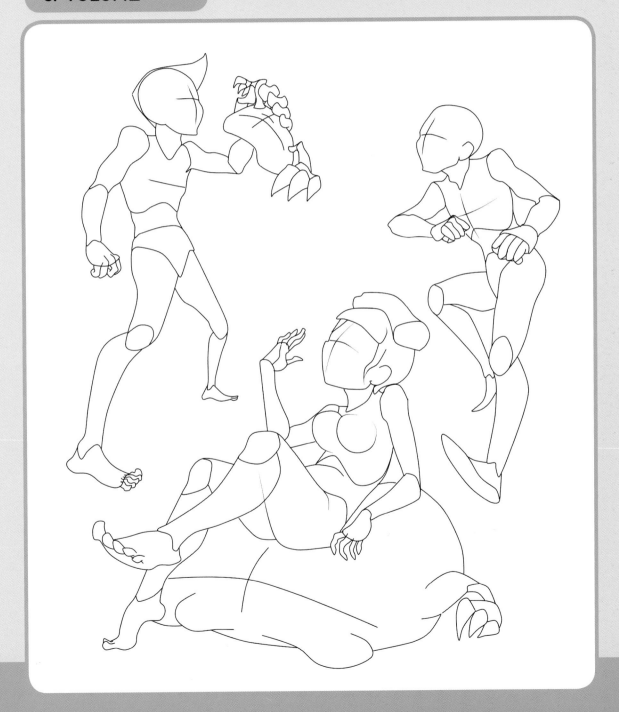

4. ANATOMY

Because the characters are somewhat caricaturized, their proportions are less slender than they would otherwise be.

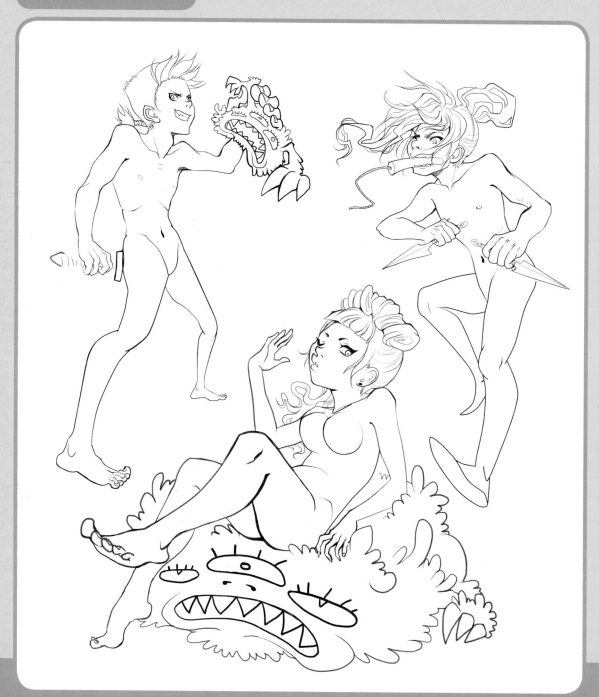

5. DETAILS

We drew the characters' outfits based on those of the ninjas and mercenaries of the Japanese feudal era. The elements in the foreground are more thickly colored.

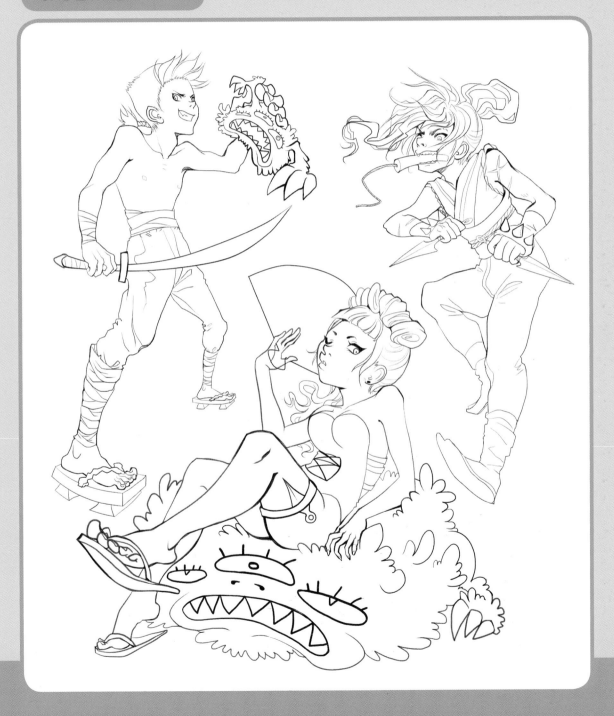

6.1. COLOR

We painted the flat colors using the Paint Bucket Tool with the All Layers option activated. Around the characters, we applied a dark lilac Trace from the Layer Blending Options.

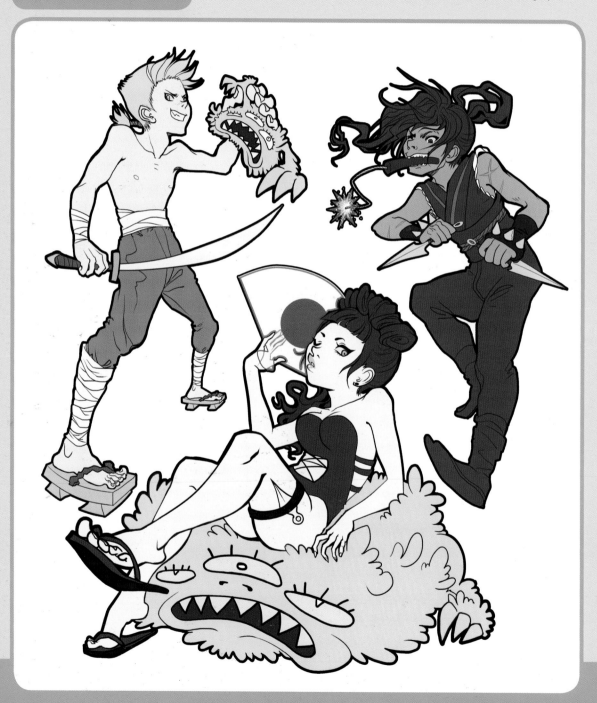

6.2. COLOR

Using the brushes, we marked the shadow areas on a new layer in the Multiply Blend Mode. To the monsters we added an orange-colored noise texture in the Linear Light Blend Mode at 72% opacity.

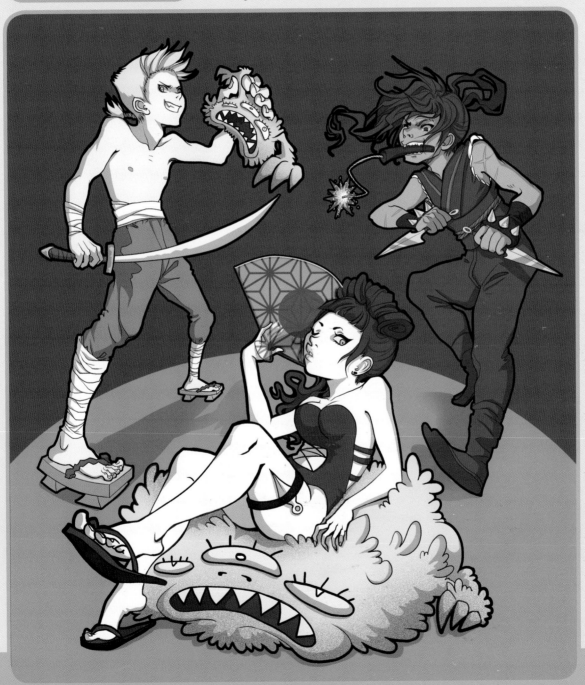

6.3. COLOR

We applied light effects on the characters, taking into account the light cast from the match. In the background we created a gradient where we applied a Noise Filter.

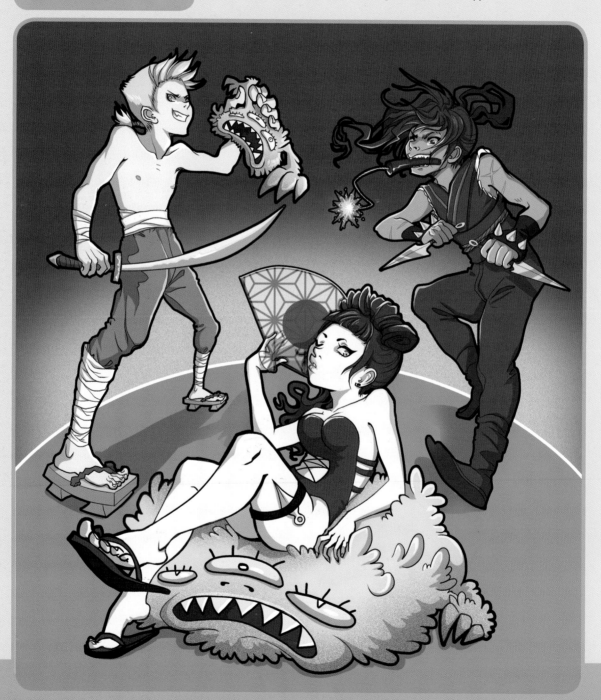

6.4. COLOR

In the background we placed traditional Japanese motifs that were previously drawn in Chinese ink and scanned onto a layer using an Overlay Blend Mode. The chalk-like effect of the clouds was done with the Noise Filter.

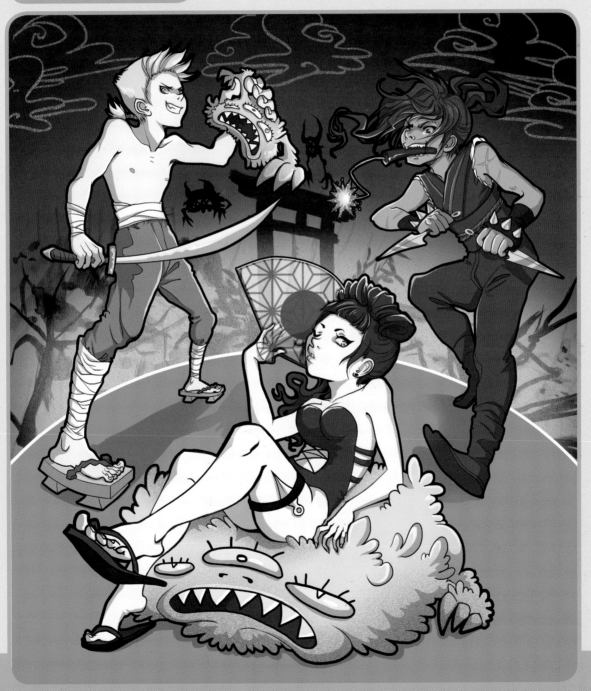

Finishing touches

- The orange floor gets its texture from a Brightness Blend Mode at 26% opacity, while the burgundy background gets its papery texture from a Color Burn Mode at 72% opacity.

- Over the silhouettes we applied an Outer Glow along with a noise effect so the digital technique would not appear too obvious.

- Finally, we added a white frame with rounded edges to the floor by using the Rounded Rectangle Tool, which we later converted into a Selection by clicking on the Invert Selection option and filling it in with white.

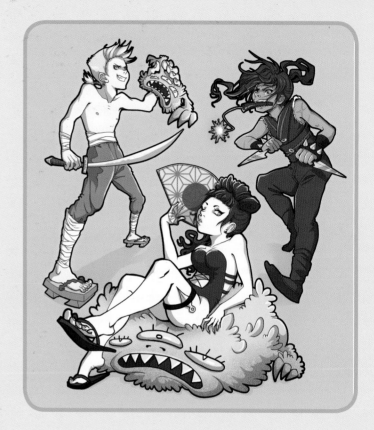

Tips & tricks

- To create the texture of the fan, we added an Overlay Effect from a motif in the Layer Blending Options. To make it look like it was made of fine paper or fabric, we lowered its opacity to 56%.

- We evoked the feel of traditional Japanese art by putting illustrations in the background, such as demons, a *torii*, a cherry tree, and bamboo, all originally drawn by hand and then digitally edited.

- The use of textures and Noise Filters helps give the image a more handmade finish.

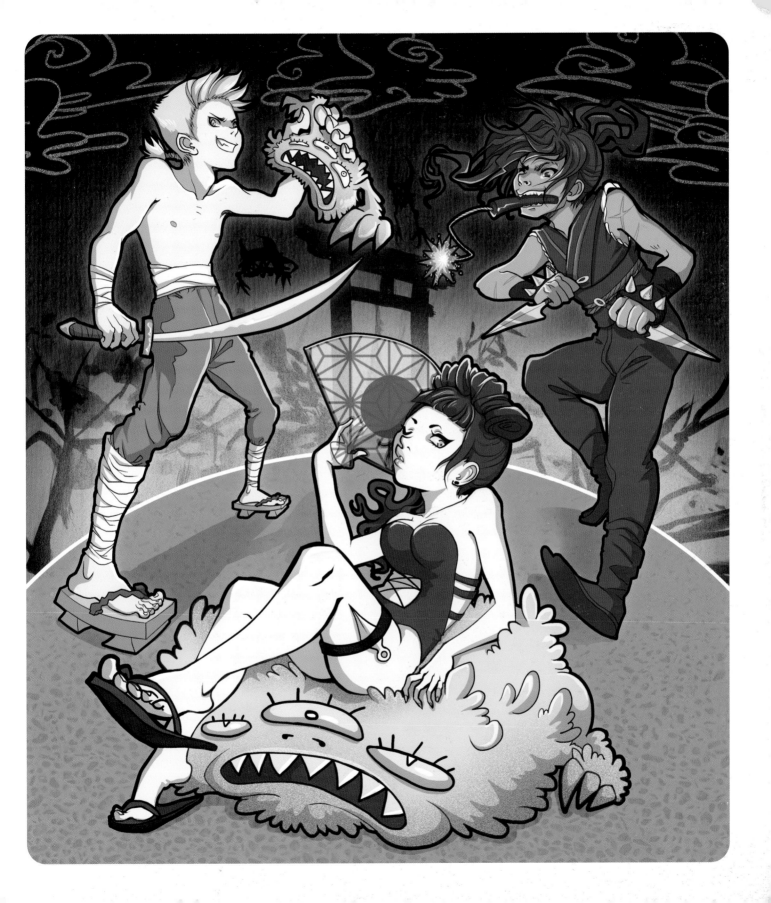

AKAI, THE LITTLE NINJA

Although he always had a special talent for fighting, little Akai had never wanted to follow in his father's footsteps, a powerful, unbeaten ninja feared throughout the region, the great Kuroi. But things changed when the most beautiful girl in the village joined a group of new warriors to protect the countryside. Unfortunately, the teacher giving lessons to these future ninjas has evil intentions toward Kuroi's sole descendant.

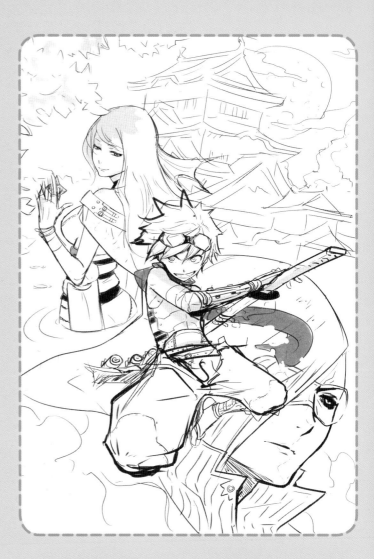

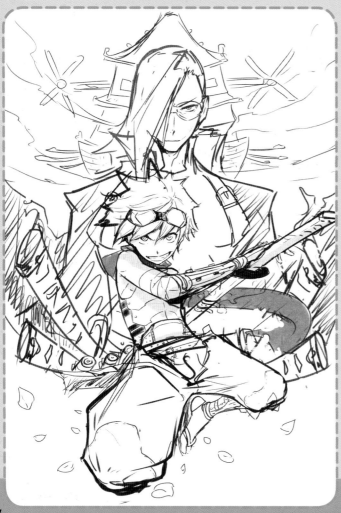

1. SKETCHES

The main character's posture and retro-futuristic style were clear, but we tried out different compositions before settling on the most balanced illustration.

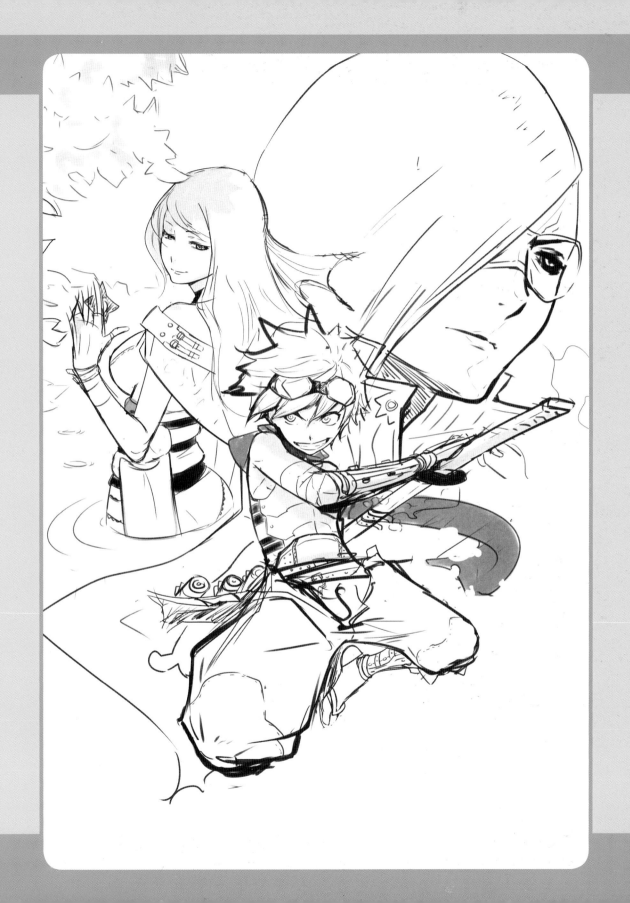

2. STRUCTURE

We distributed the characters around the illustration, fitting them together congruously. When we design complicated postures, it's best to create a basic skeleton and add the details later on.

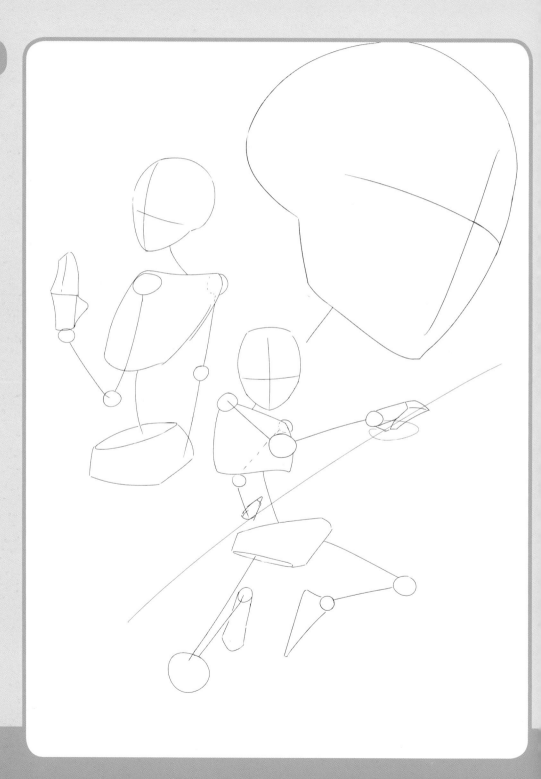

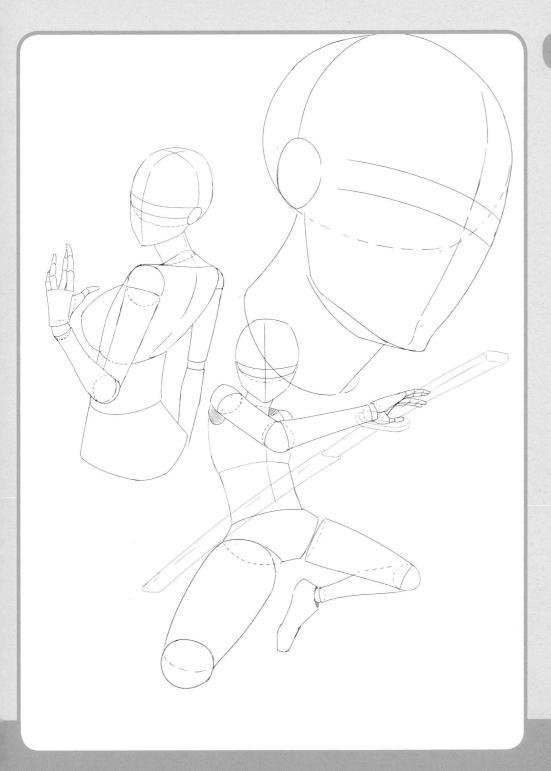

3. VOLUME

In this exercise we have three clear examples of how to construct bodies: a middle shot from behind, a front area in movement, and a foreground shot of a head. In all of them we started with simple ovals that allowed us to sketch in the postures of the bodies more easily.

4. ANATOMY

Although the boy is young, his musculature must be evident so his warrior status can be clearly understood. Keep in mind that from this viewpoint one leg will be larger than other. The girl, of course, will have more pronounced curves.

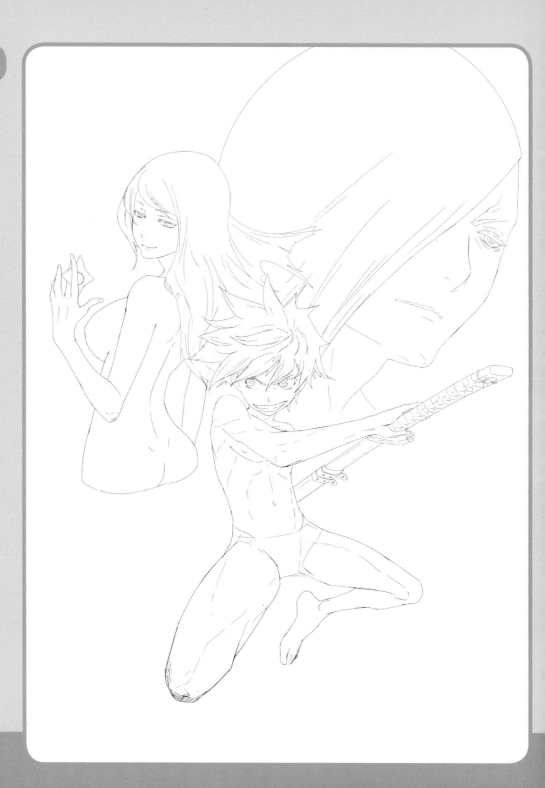

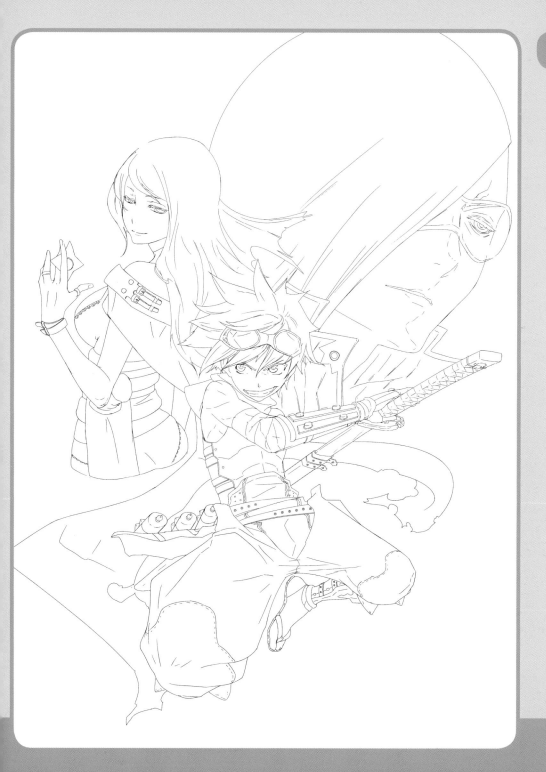

5. DETAILS

The characters' clothes are a mix of classic Japanese and retro-futuristic. This is why we added aviator glasses and metal bits, which can be used as armor.

6.1. COLOR

We painted the base color, giving each character a different color range. We could do the simpler fills with the Paint Bucket or Gradient Tool, but we chose to also use brushstrokes to mark out the different color areas.

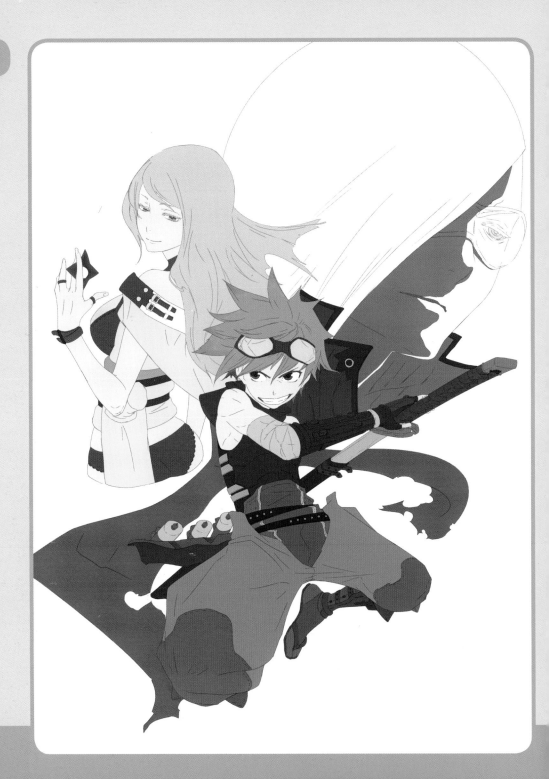

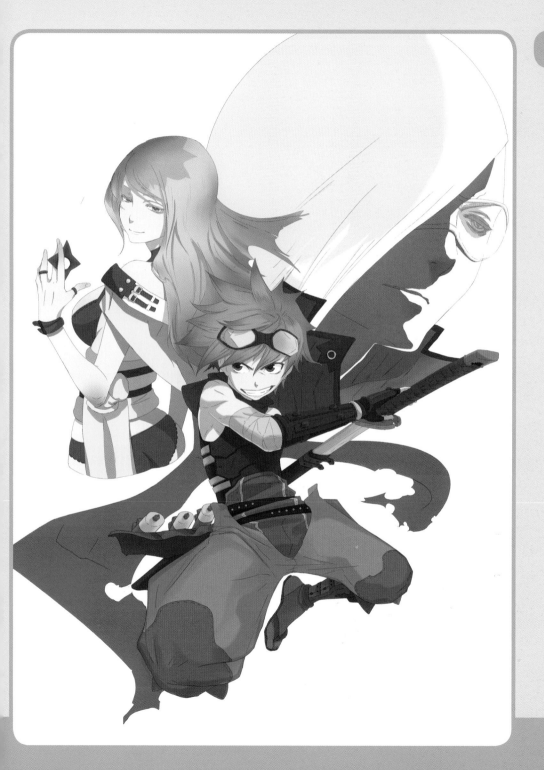

6.2. COLOR

We applied the shadows on a new layer in the Multiply Blend Mode. This time we used several shades of blue and violet for greater chromatic variety.

6.3. COLOR

With the brush we painted on the highlights in a new layer in the Screen Blend Mode. To provide a sense of volume, we applied a technique of having the light come from two main sources, thus creating a cylindrical effect.

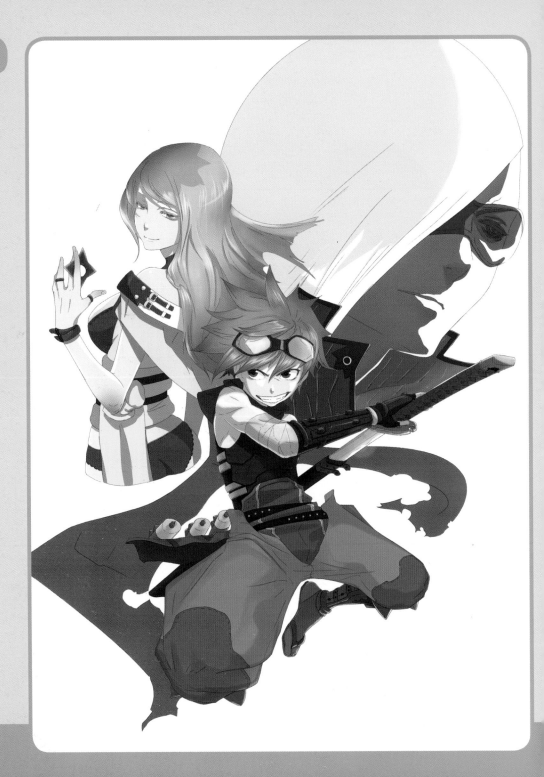

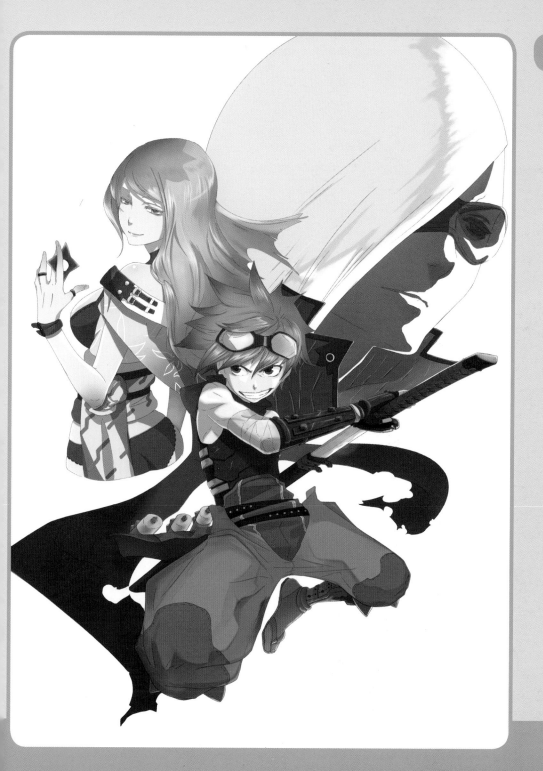

6.4. COLOR

We added final shadows and decorative motifs on the characters' outfits with precise brushstrokes that follow the shapes of the patterns and folds in the fabric.

7.1. BACKGROUND

We filled in the background using a gradient beneath the characters, and also drawing in waves and the tree.

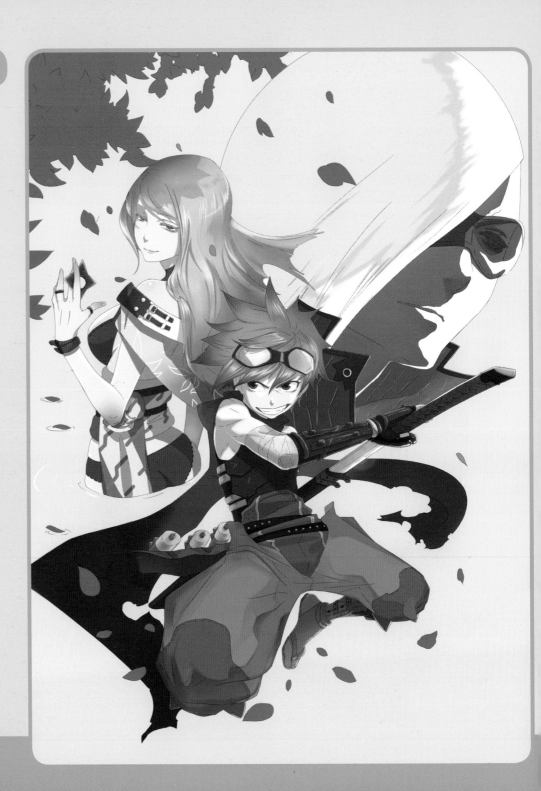

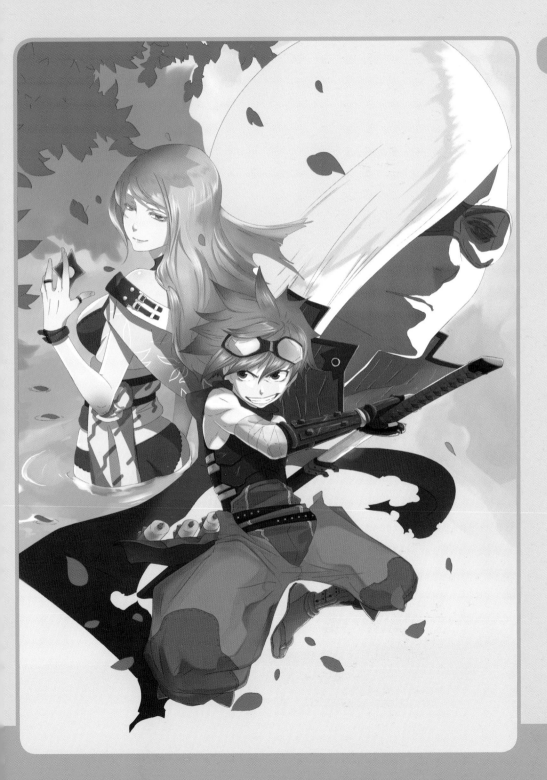

7.2. BACKGROUND

As if it were a watercolor, we softened the brushstrokes to create an amalgam of expressionist shapes and colors.

Finishing touches

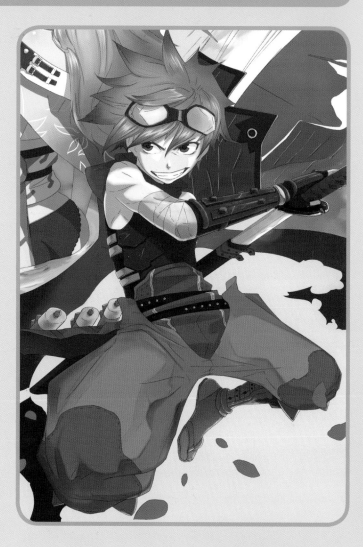

- We painted a new layer using purple and dark green brushstrokes to further define the background.

- Over the line drawing we applied a Color Overlay Effect in the Blending Options to color it deep purple.

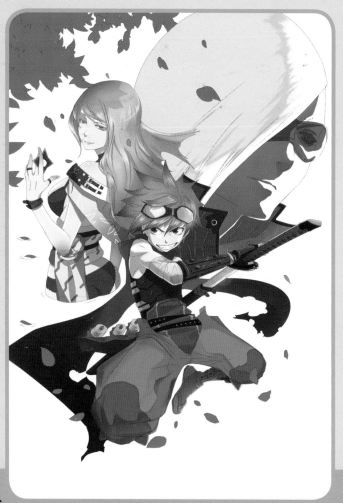

Tips & tricks

- For those not particularly handy with manual coloring, programs like SAI let you draw the line efficiently and simply, as long as we have a handle on the graphics tablet.

- Although we drew the background separately, we must always take into account what elements will cast shadows onto the characters.

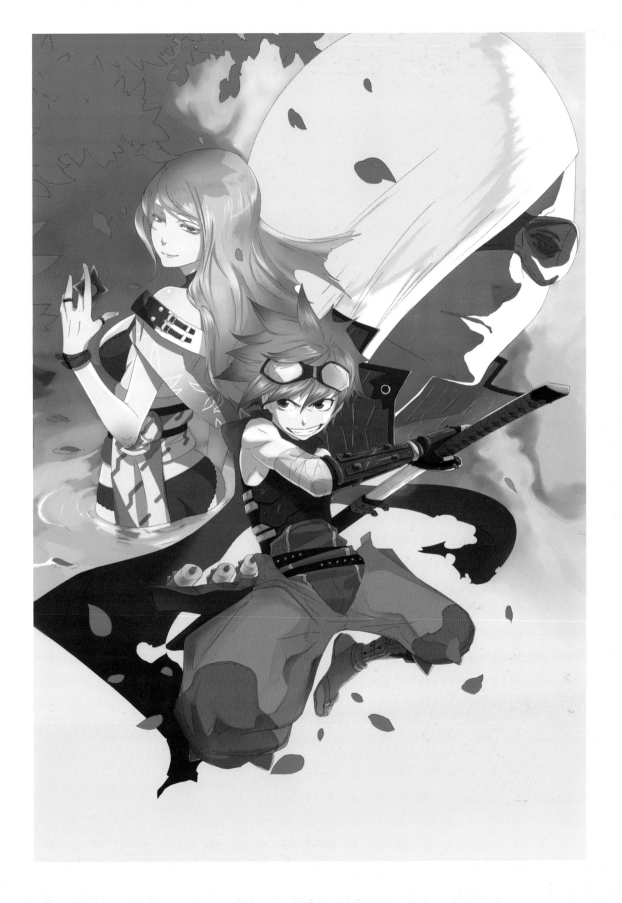

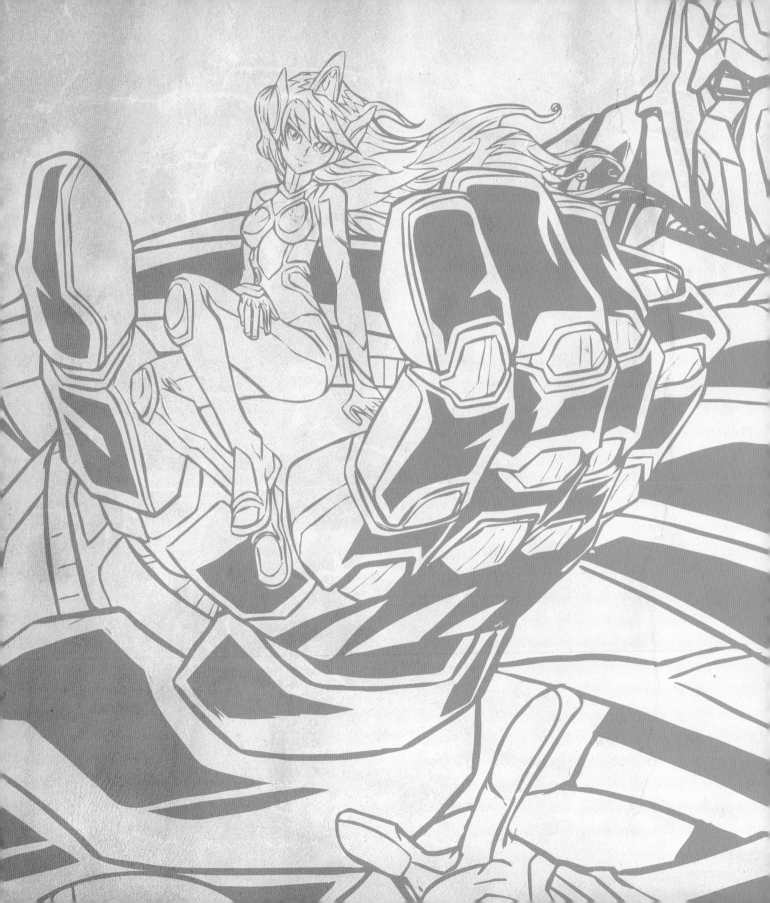

CYBERLAND

VIRTUAL DEFENDERS
ULTRAROBOT
ANDROID 5.0
THE SPACE CORSAIR

VIRTUAL DEFENDERS

The real and virtual worlds have merged in such a way that humans live a large part of their lives trapped in the net. But cyber-delinquents are prowling everywhere and there needs to be a team of fighters to confront the hackers, viruses, and other threats. The virtual defenders, created using artificial intelligence, will make sure peace reigns in the cyber-world.

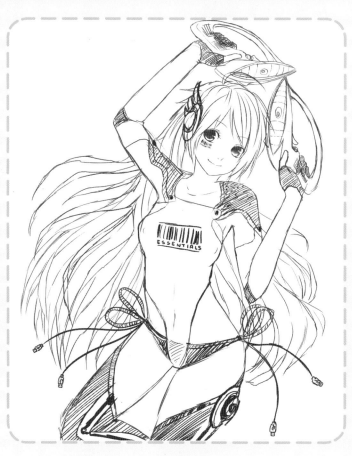

1. SKETCHES

We began by designing several possible characters until we perfected the desired result. Later, in final version of the image, we added another character in the center to balance out the illustration.

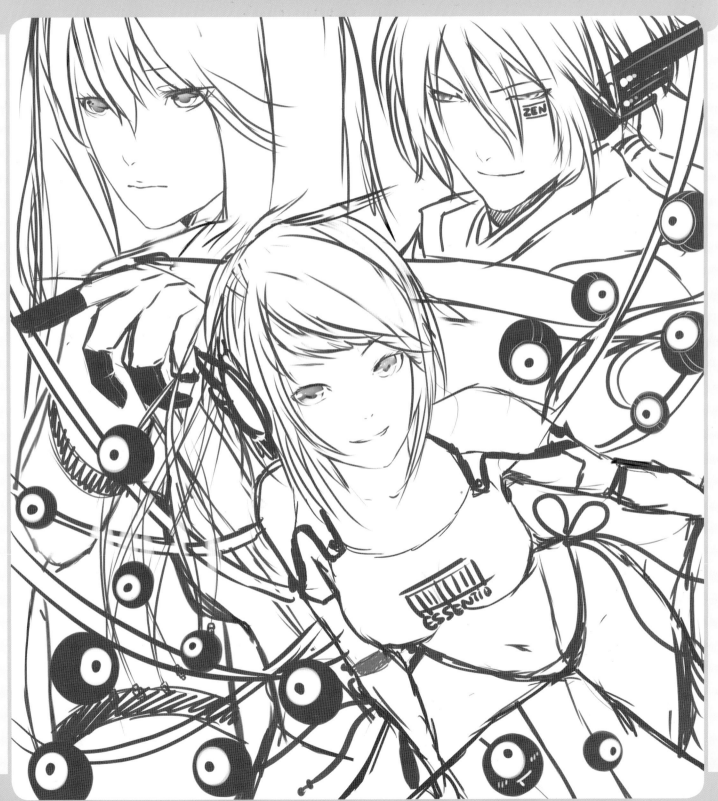

2. STRUCTURE

We arranged the characters congruously to have a balanced composition.

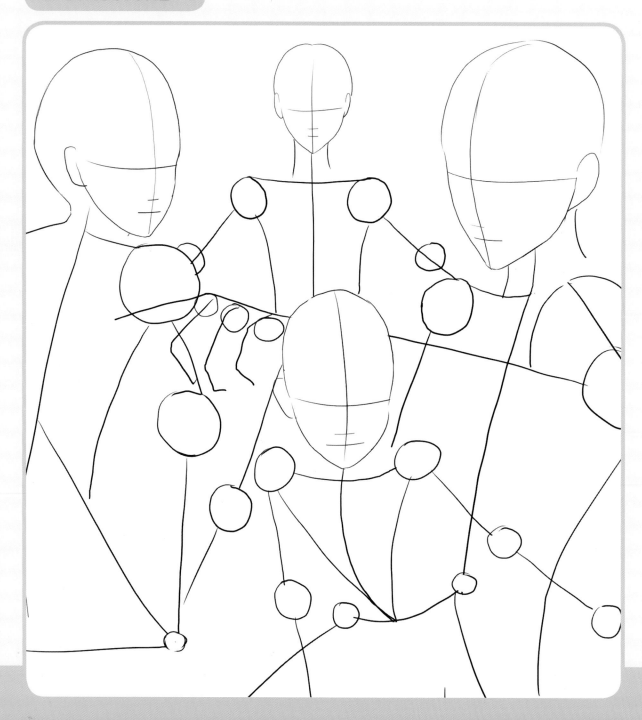

3. VOLUME

We marked out the body shapes, taking into account that the girls would be less corpulent than the boys.

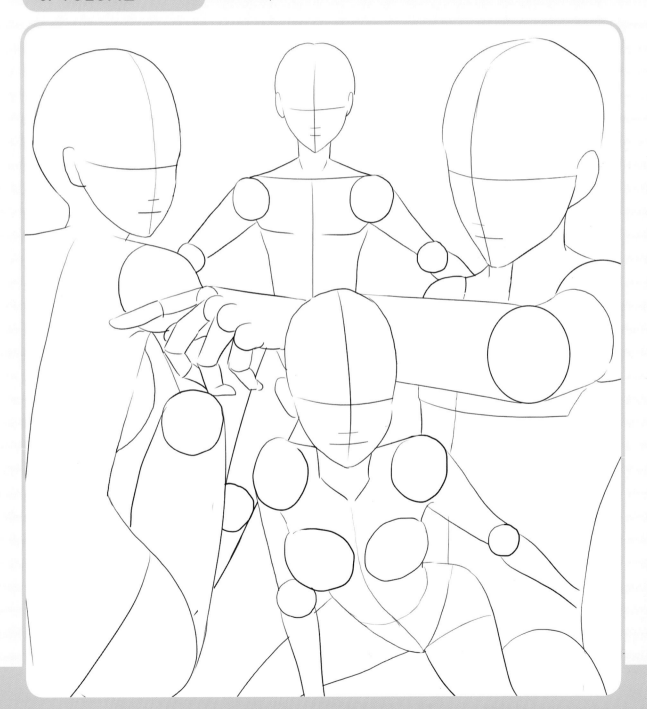

4. ANATOMY

Boys have wider shoulders than girls, and illustrating this helps us create characters who might be ambiguous, but what sex they are is perfectly understood.

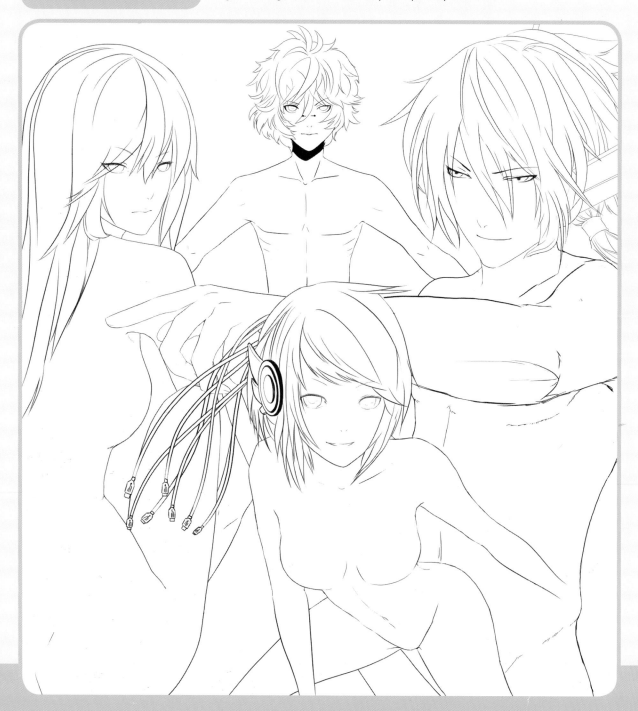

5. DETAILS

Each character has a different logo to let us identify them rapidly. We also added balls and cables to make the illustration more visually interesting. The line drawing was done digitally in the Illust Studio program.

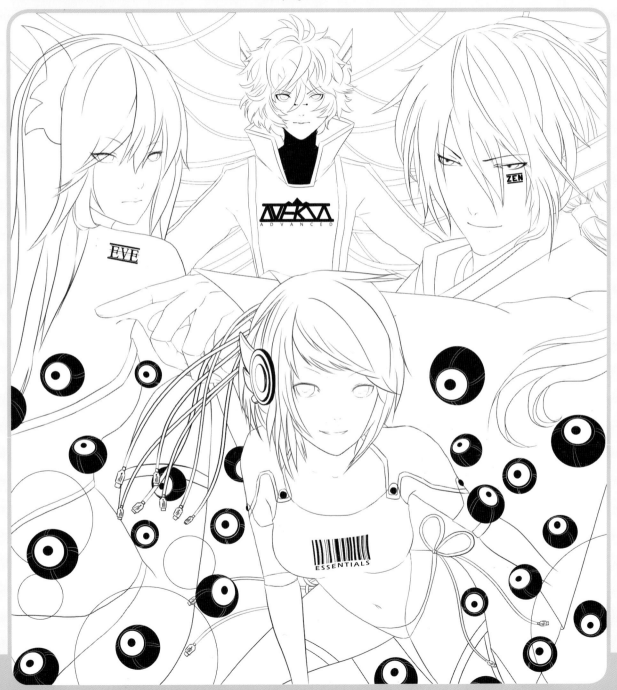

6.1. COLOR

We put each character in a different layer before applying the color base. The general range is based on greens and purples.

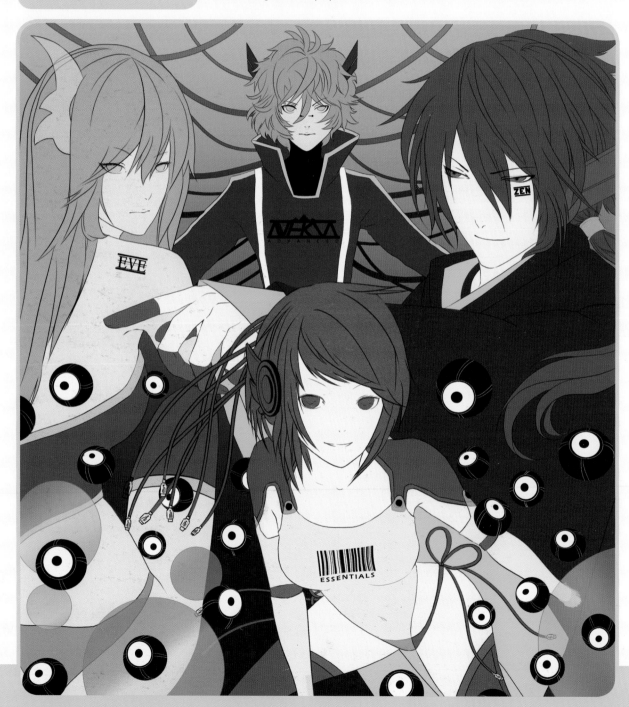

6.2. COLOR

We colored in the shadows on different layers right above the base colors, using the Clipping Mask Option to separate them.

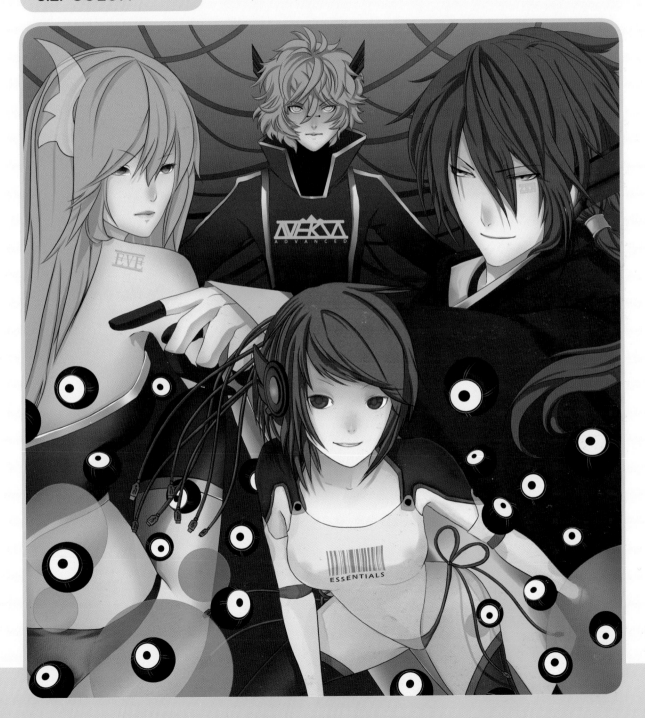

6.3. COLOR

For shiny objects, such as the eyes, it is best to add a color that matches the surroundings. Thus the leading girl has pink eyes with a violet gradient.

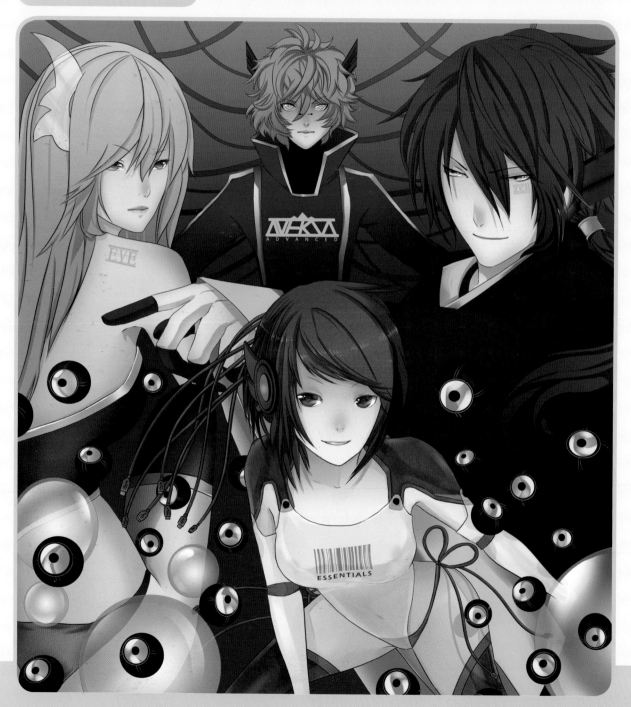

6.4. COLOR

Highlights can be created quite simply using the Outer Glow Layer Blending Options. These effects in electric colors such as neon blue, green, or pink over a dark background provide a futuristic effect, perfect for this type of illustration.

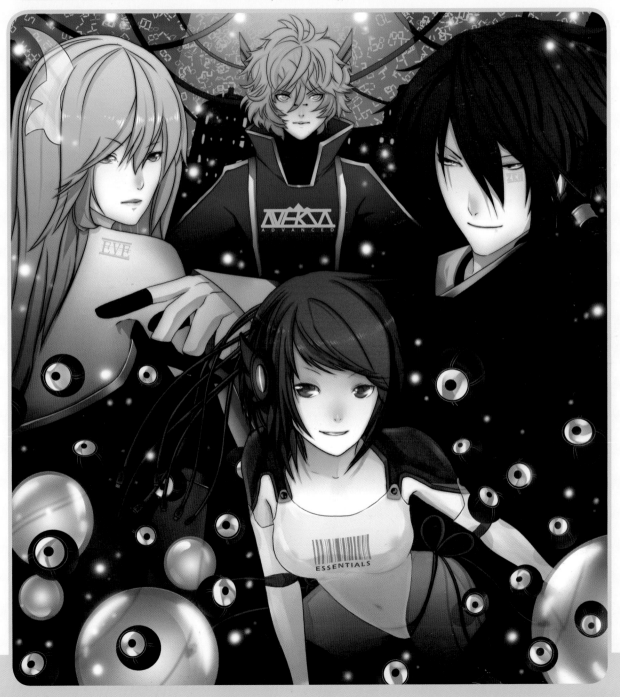

Finishing touches

- Evening out the colors in the drawing with the Saturation/Tone Option in Image Adjustments and applying a Photo Filter help equal out the image's predominant green and pink tones.

Tips & tricks

- To attain the effect of digital rain in the background, we drew in a string of unconnected numbers and successively duplicated it, alternating their positions and opacities.

- The line drawing was made in Illust Studio, the coloring in SAI, and the final effects in Photoshop. We can mix and match programs to take advantage of the best each has to offer.

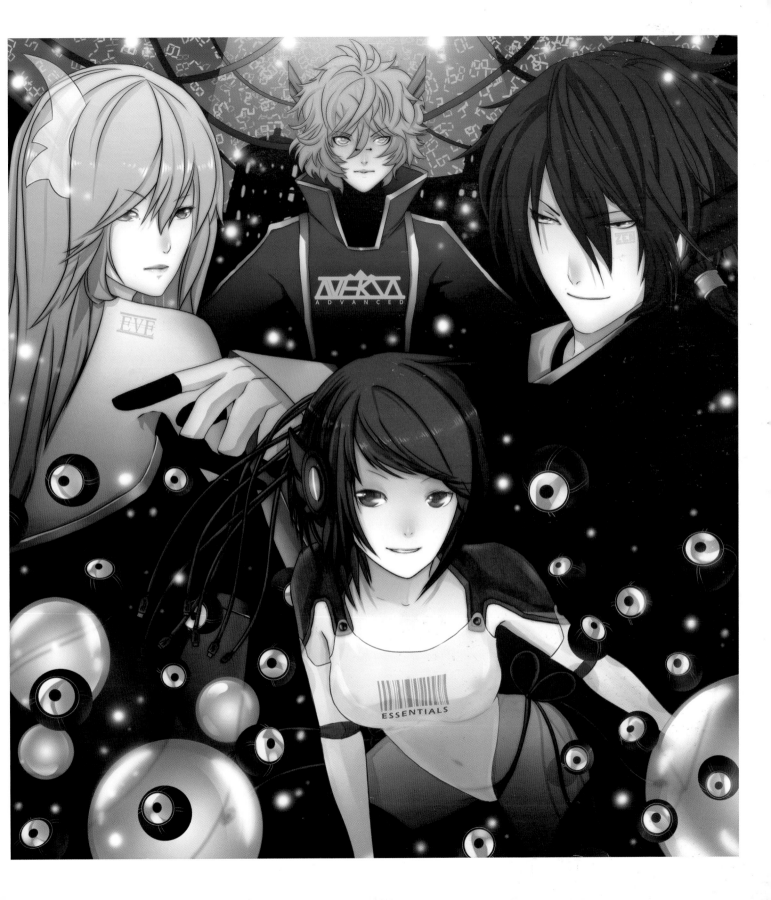

ULTRAROBOT

The planet is being attacked by a terrifying alien race that aims to colonize the Earth and subjugate its humans. To defend itself, the earthlings count on a group of mysterious mechanical beings, christened the Ultrarobots, who for millions of years remained buried deep underground and only a few chosen pilots, descendants of the previous race who once populated the planet, can handle them effectively. The future of humanity itself rests upon the perfect unity of these forces.

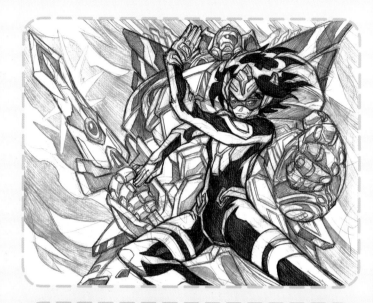

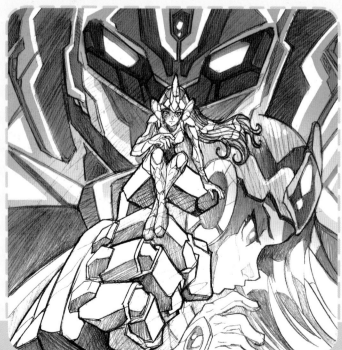

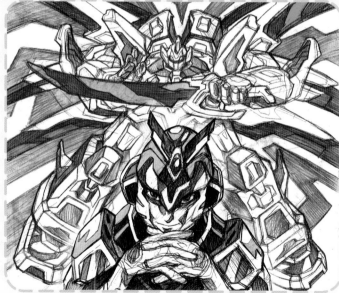

1. SKETCHES

Mecha series are a true classic of Japanese *anime*. In this image we pay homage to the genre, representing all the classic elements: plenty of action, colossal robots, and impossible suits.

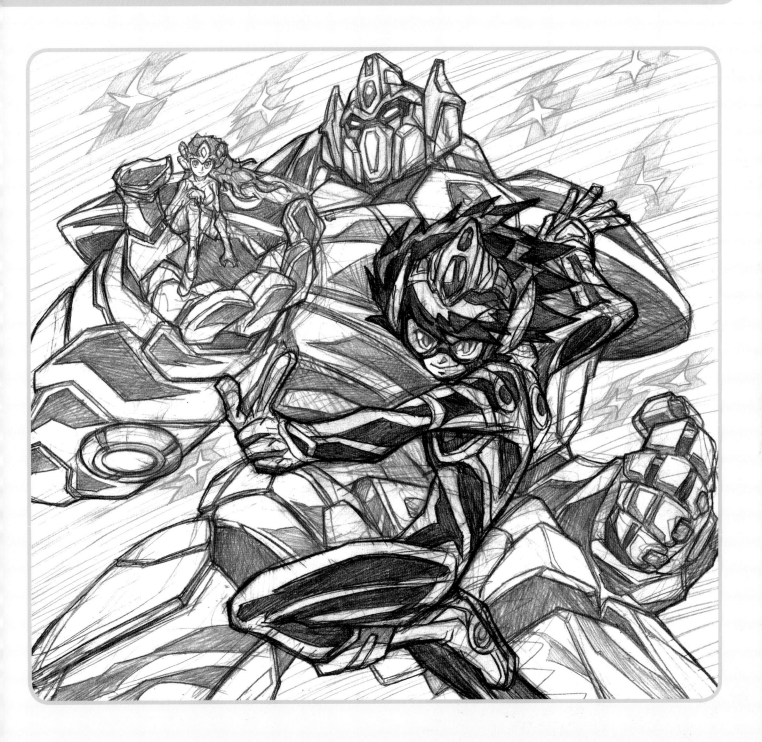

2. STRUCTURE

We created the characters using ovals to help us define a dynamic scene. The curved axes provide more movement in the postures.

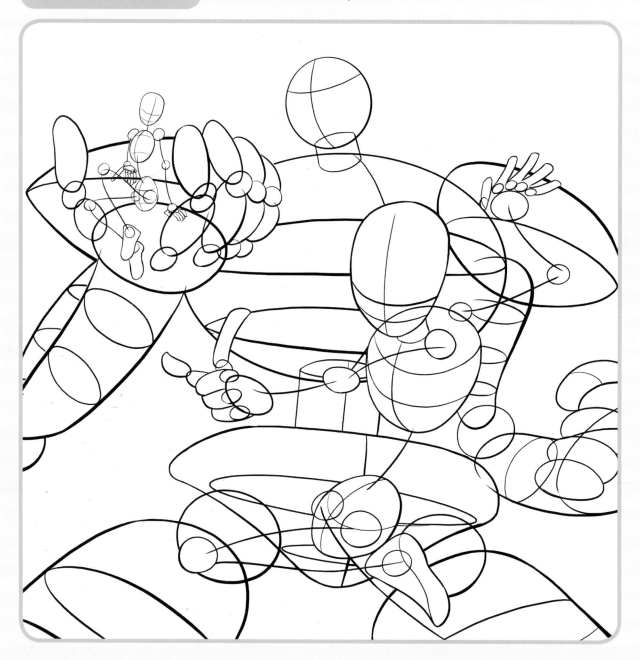

3. VOLUME

In this step we traced the robot's body based on the initial design. We defined the silhouette of the characters based on the skeleton outline.

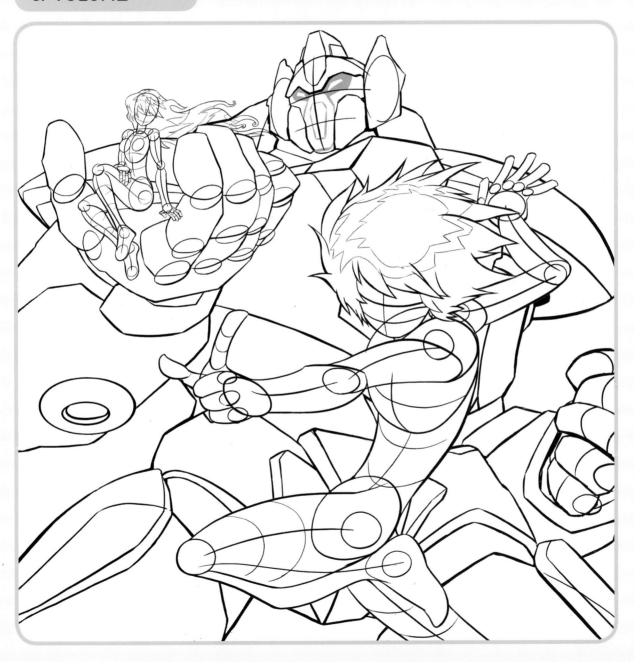

4. ANATOMY

While the robot represents strength and the girl represents elegance and restraint, the pilot has to be energetic. Being young people, the heroes' bodies have to be trim and slender.

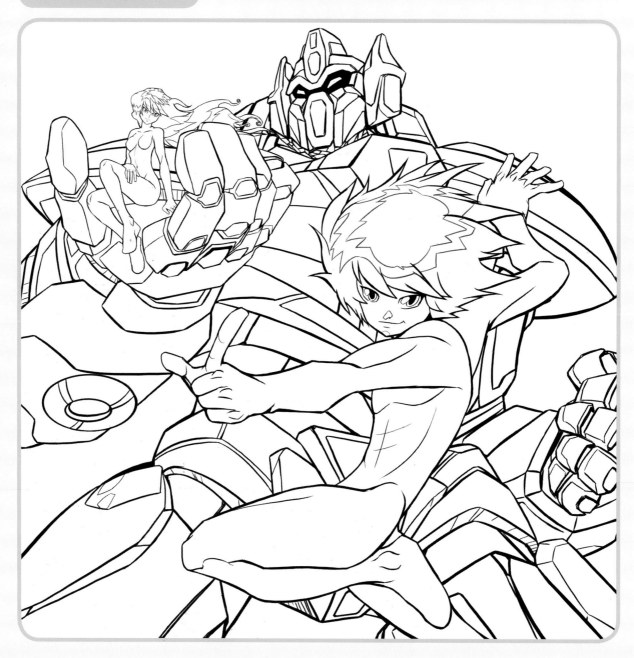

5. DETAILS

We put outfits on the two youths and colored them in with thick, defined lines with large swaths of black to give edginess to the image.

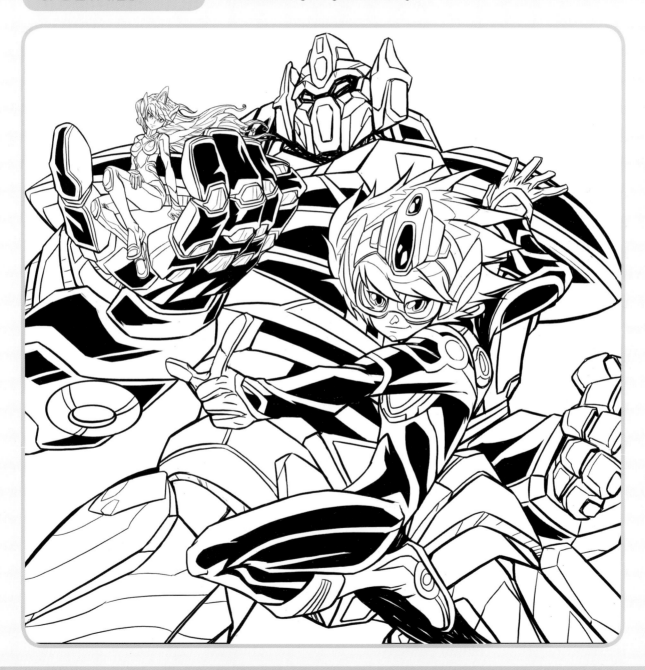

6.1. COLOR

We painted the flat colors and shadows at the same time in different layers in the Multiply Blend Mode. With so many areas, it is important to organize and group together different elements.

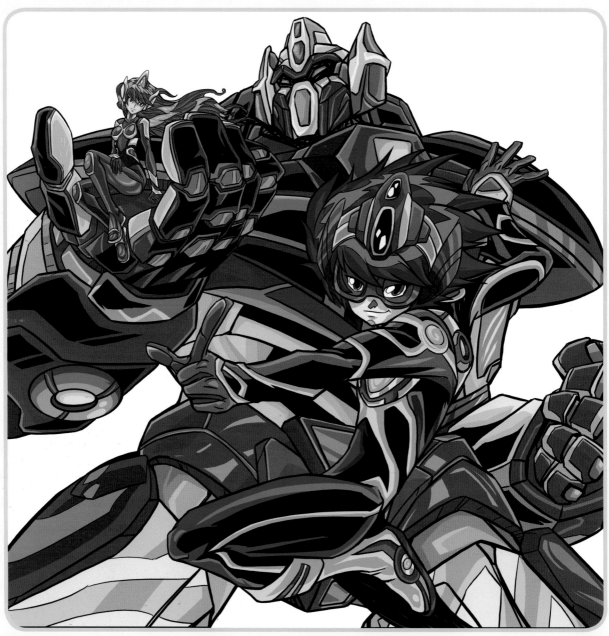

6.2. COLOR

With a rather saturated group of base colors that emulate cartoon colors typical of the 90's, we applied the color layers in different Light Layer Blend Modes (Soft, Hard, Brightness).

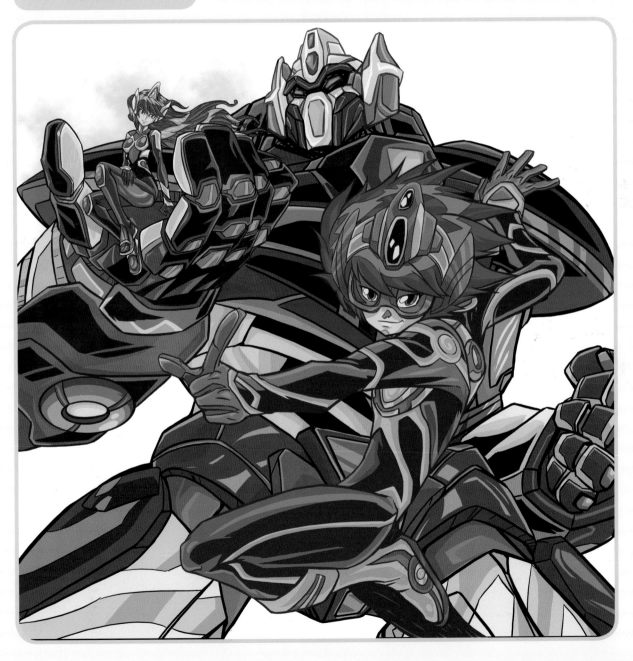

6.3. COLOR

We applied new lighting effects on the highlights in the images, and we added additional shadows.

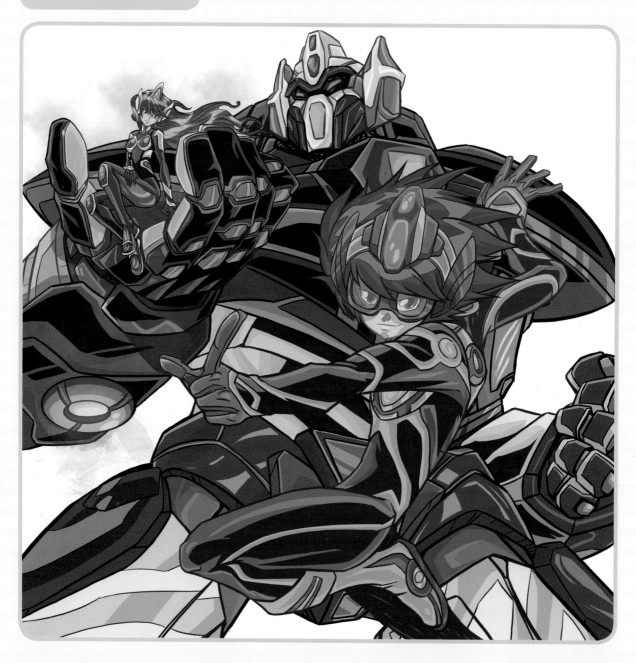

6.4. COLOR

Around the characters we created a purple halo that would later be used as a background overlay. We added new highlights on the robot's headlights in the Hard Light Layer Blend Mode.

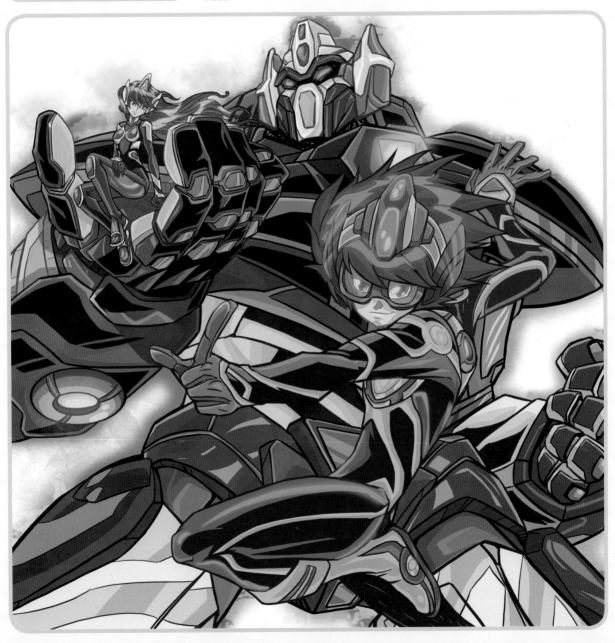

7.1. BACKGROUND

We set the dark blue background around the characters to see them stand out, exactly as we planned in the previous step.

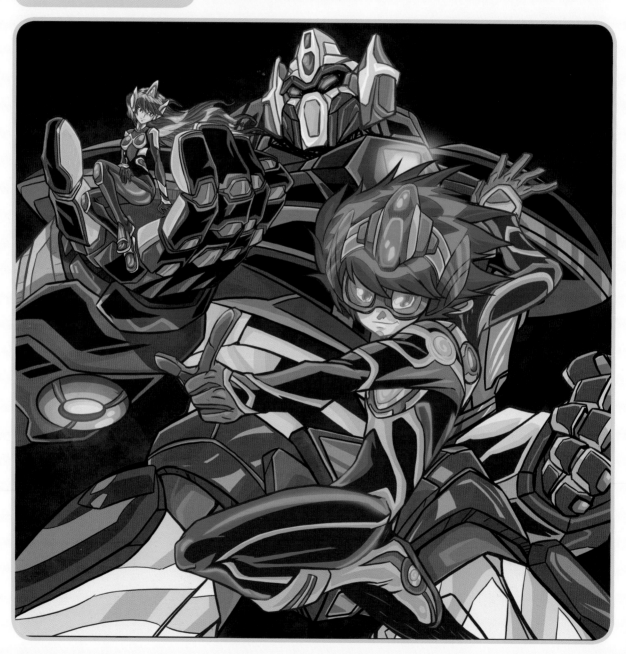

7.2. BACKGROUND

With different brushes we created a texture that emulates the universe, and we set the layer in a Hard Light Blend Mode on top of the previous background.

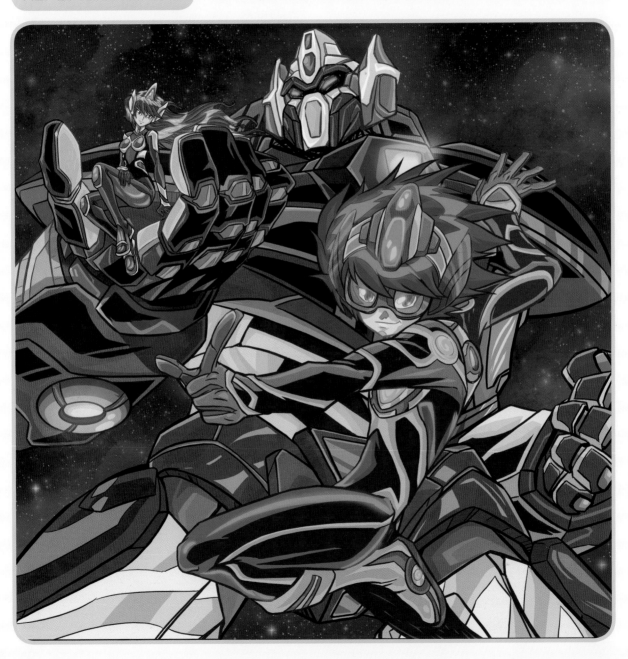

Finishing touches

- We drew semi-translucent rays on a new layer in Lighten Blend Mode at 45% opacity.

- We added bright-pointed stars in the Overlay Blend Mode.

- We adjusted the image highlights to make the pilot stand out from the background.

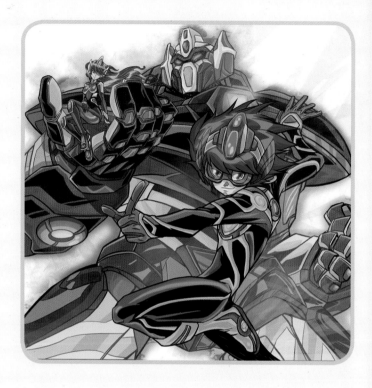

Tips & tricks

- To keep the characters from looking stiff, we always have to design dynamic postures. This way, the characters take on life and transmit much more to the viewer.

- To construct characters, many artists make the mistake of beginning with the eyes and head and then drawing in the rest of the body. It is better to make an initial sketch of the full body, approximating the locations of each of the parts, and then polishing up the details.

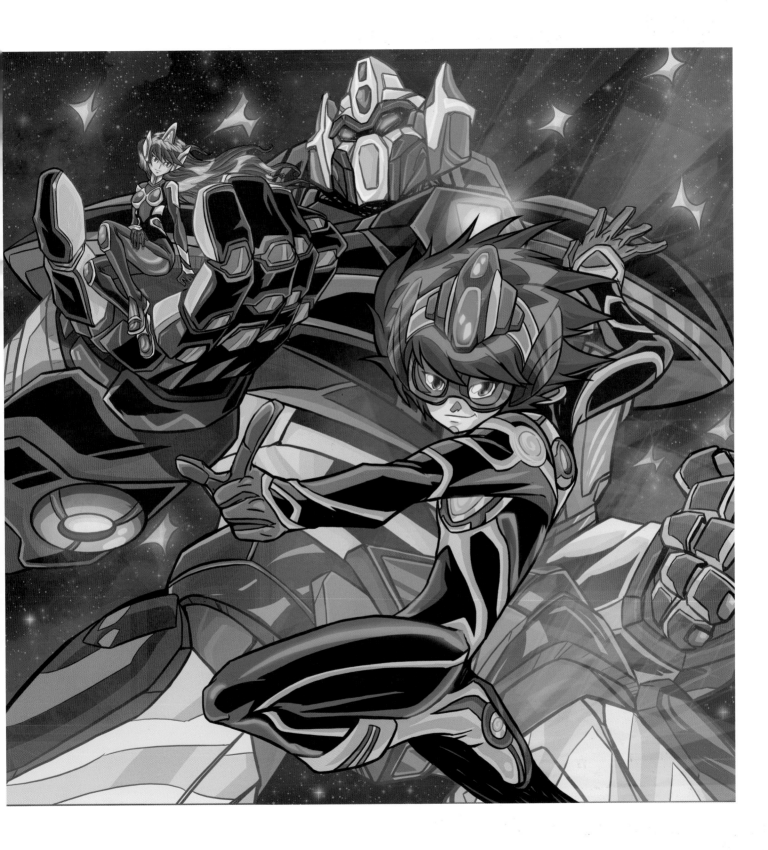

ANDROID 5.0

Technology had evolved to such a point that artificial beings could be made practically identical to humans. But natural resources had run out and the world had sunk into chaos, leaving machines at the mercy of rust and decay. But now, the Android 5.0 prototype, long forgotten in a bunker, has suddenly come back to life after a deep sleep, lost and disoriented. With the help of tiny rabbots, it begins to discover the depth of the devastation is much greater than anyone could have imagined.

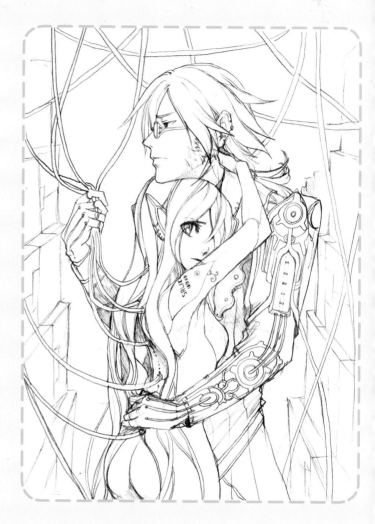

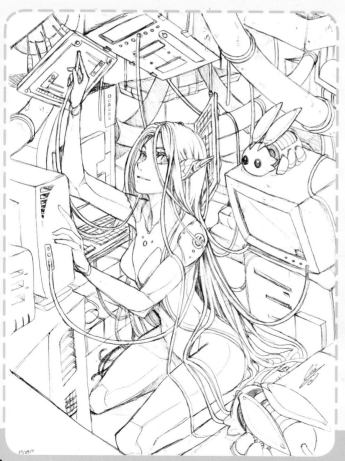

1. SKETCHES

We wanted to imbibe the android in mystery, connected only to the world through its cables.

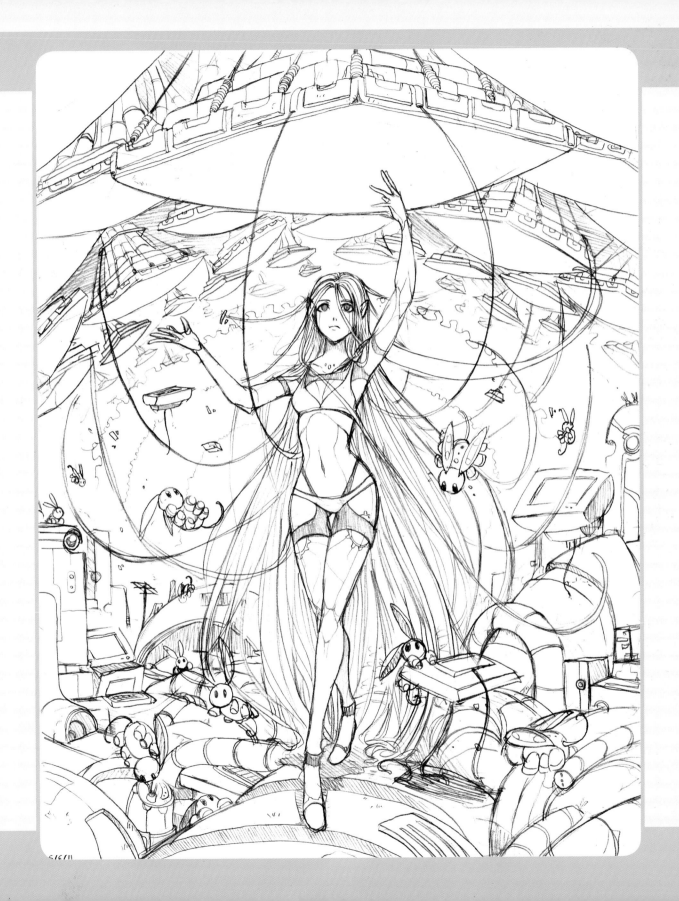

2. STRUCTURE

We arranged the most important elements in the illustration and marked the posture the character should have, paying special attention to the curve of its torso and cross of its legs.

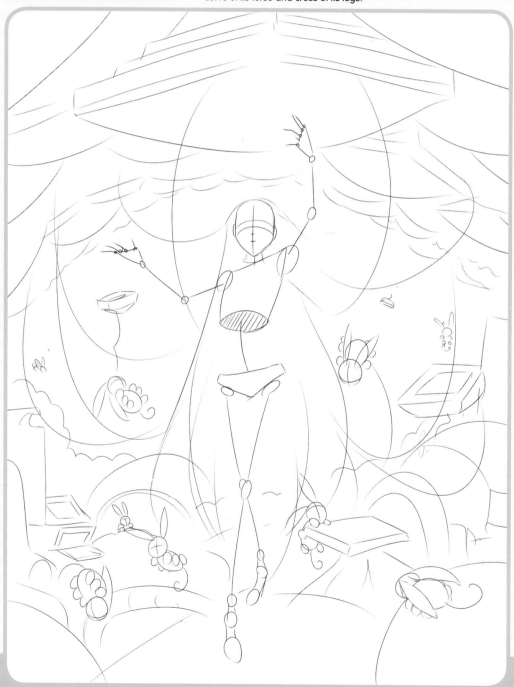

3. VOLUME

The shape of the body had to be generously curved and elegant. We outlined the visible section of its metal skin according to its union at the joints.

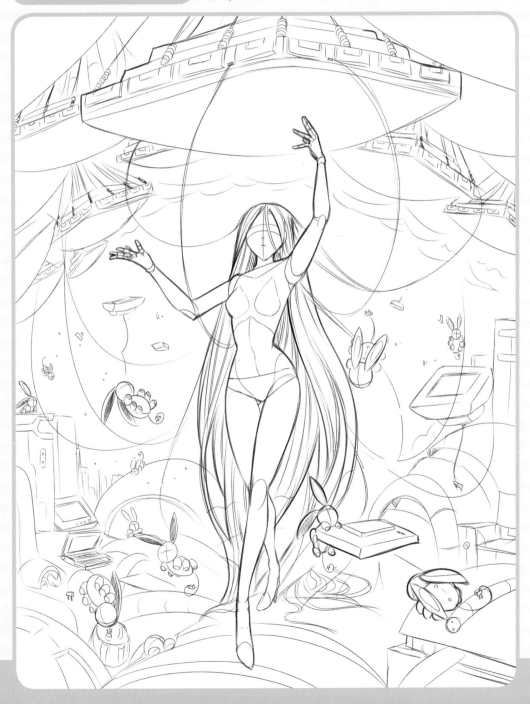

4. ANATOMY

The body is formed to be slender and sensual.

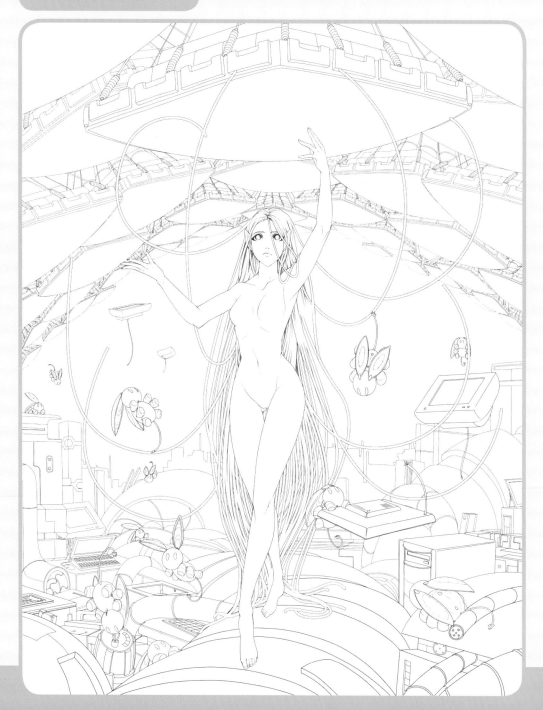

5. DETAILS

To create the background, we used a series of vectors which, as in the case of the lamp at the top, we multiplied and resized.

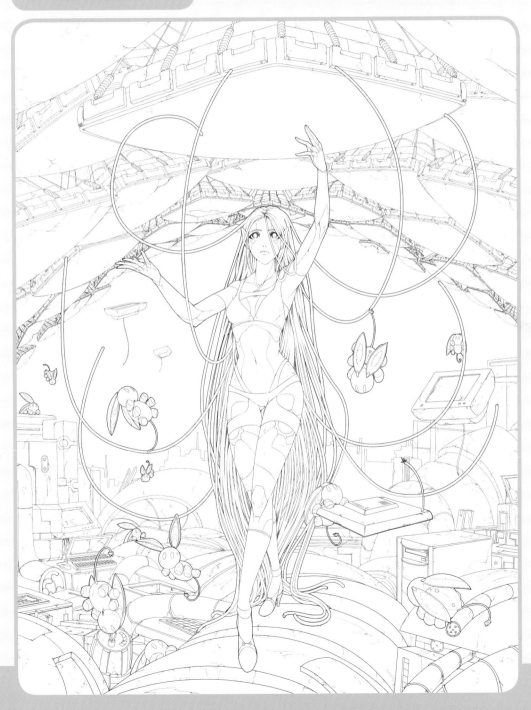

6.1. COLOR

We created two base color layers, one for the characters and another for the background. The range features lilacs and greenish blues that match perfectly.

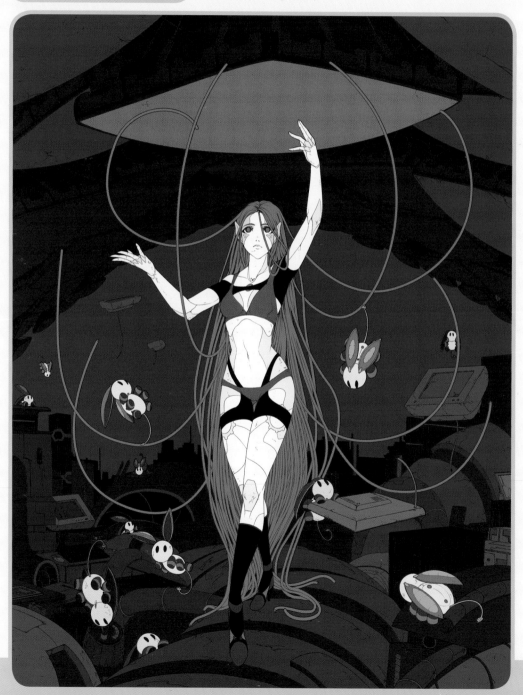

6.2. COLOR

We selected each color area and added shadows with the watercolor brush. We can do this on a different layer or by duplicating the base layer and painting over it.

6.3. COLOR

We created a new layer over which we applied the highlight, using a watercolor brush based on a main light source.

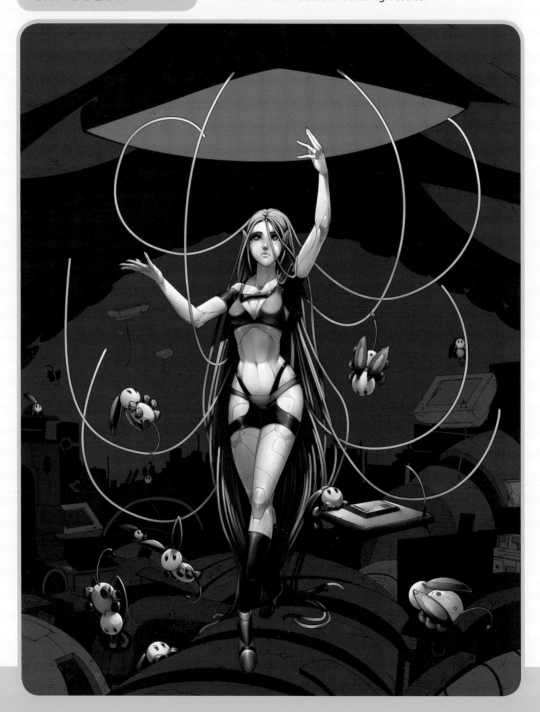

6.4. COLOR

We lowered the opacity of the color group for the character and with the airbrush we colored in the lamp, which is the main light source.

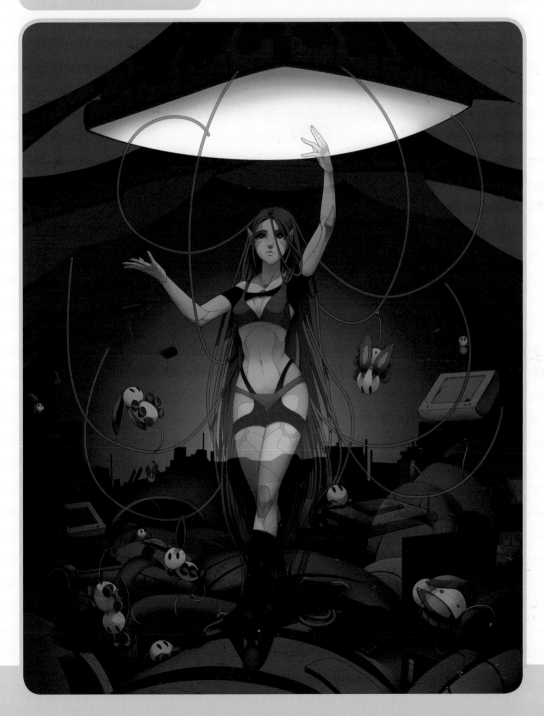

6.5. COLOR

Following the light source, we painted in all the reflections cast on the various background elements and the robots.

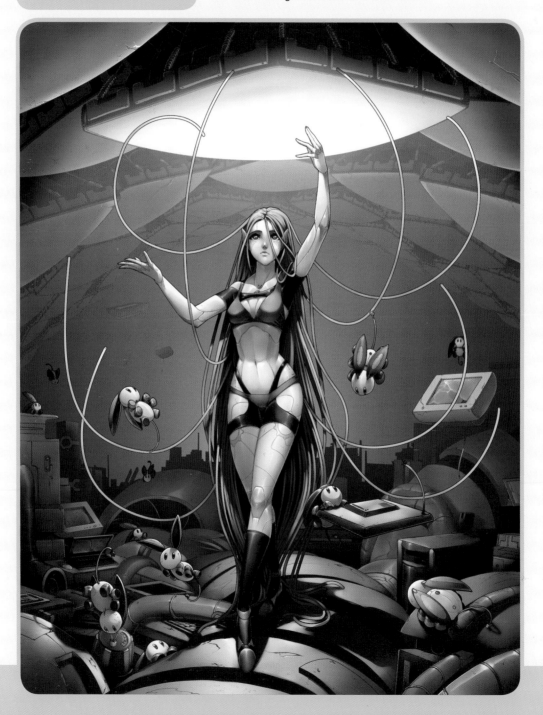

6.6. COLOR

We evened out the color intensity in some areas in order to make them congruent with their surroundings, and we added some reddish sparks on another layer in the Linear Burn Blend Mode (Add).

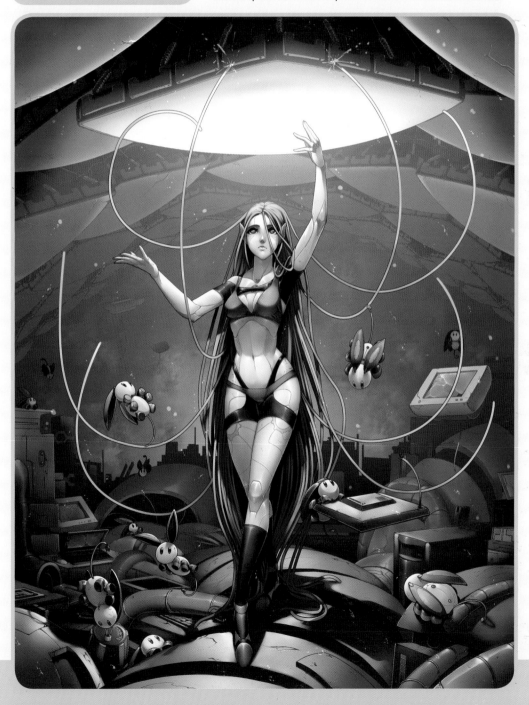

Finishing touches

- We created a layer in the Overlay Blend Mode with barely saturated light brown tones to give a sense of unity to the light colors.

- We duplicated the final drawing and merged its layers into one, giving it a Gaussian Blur Filter, lowering the color saturation and applying it in a Hard Light Blend Mode over the rest of the layers to enhance the highlights.

- Finally, within the Image Menu, in Adjustments, we calibrated the Color Balance, shifting the color range toward redder tones.

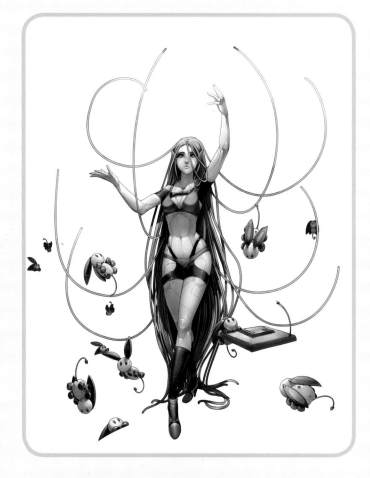

Tips & tricks

- Although we made the drawing traditionally, the use of vector lines in Photoshop and other programs makes it easy to design mechanical elements, which create a realistic finish.

- This drawing was colored in SAI with the Juice brush, but the final touches were done in Photoshop.

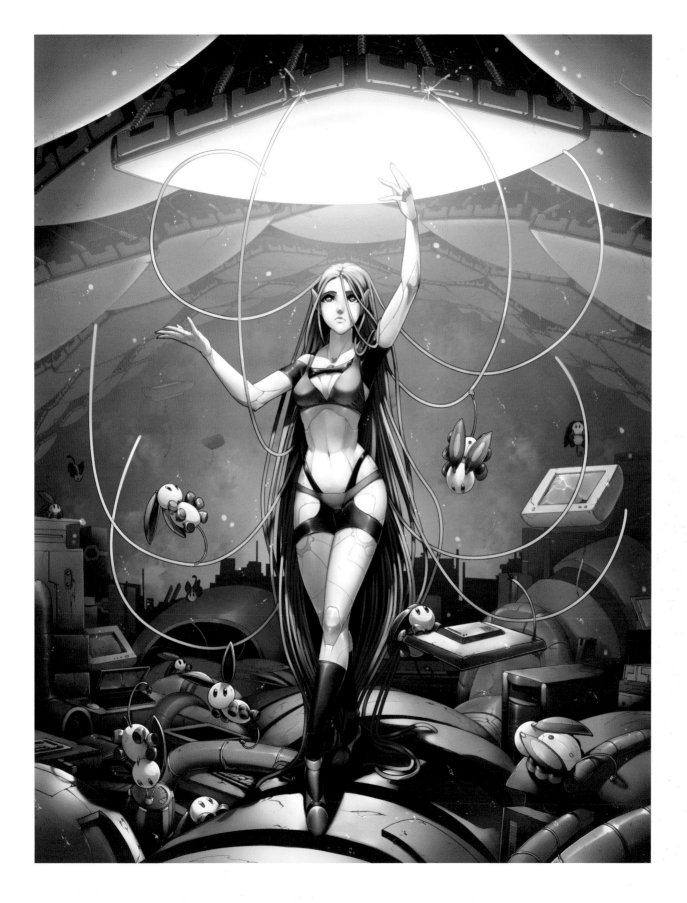

THE SPACE CORSAIR

For years Khabir worked for the imperial troops plying the outer reaches of the universe. But, after being betrayed by his superiors who had accused him of a crime he did not commit, he gave up his command to sail the universe as a true corsair, evoking the spirit of the great pirates who sailed the seas free from the bounds of servitude. But this freedom has a price, and his former companions have decided to chase him throughout the galaxy.

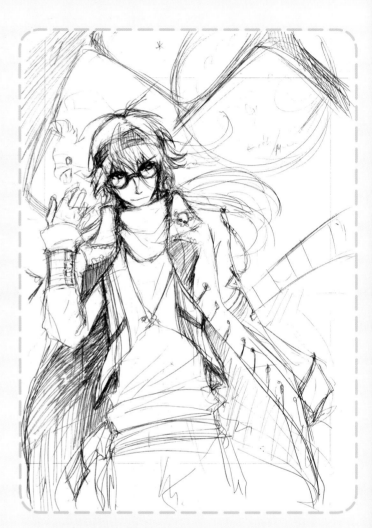

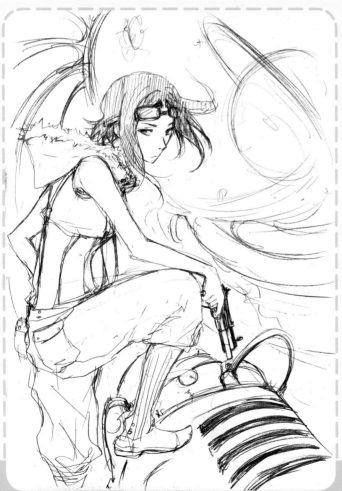

1. SKETCHES

The main character, Khabir, splendidly retro-futuristic, started out as an androgynous-looking girl, then a skinny young man, until reaching his true form of a space buccaneer bursting with attitude and personality.

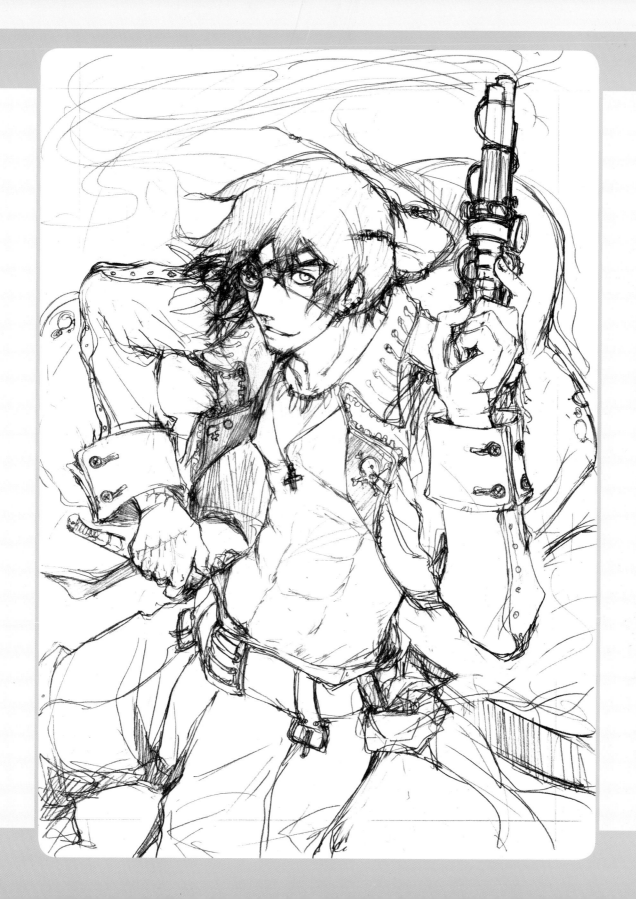

2. STRUCTURE

We sketched the character using lines and ovals to help us determine the posture. We strayed away from any rigidity by curving the central axis of the skeleton.

3. VOLUME

By having a curved back, we force the play of the hips and the trunk itself to lean over. On the initial sketch we corrected the right arm so the posture would not appear too forced.

4. ANATOMY

We especially defined the musculature of the torso and trunk, as this part of his body would be unclothed. He is a young and athletic type, but not overly well-built. We made his hands larger to demonstrate his strength.

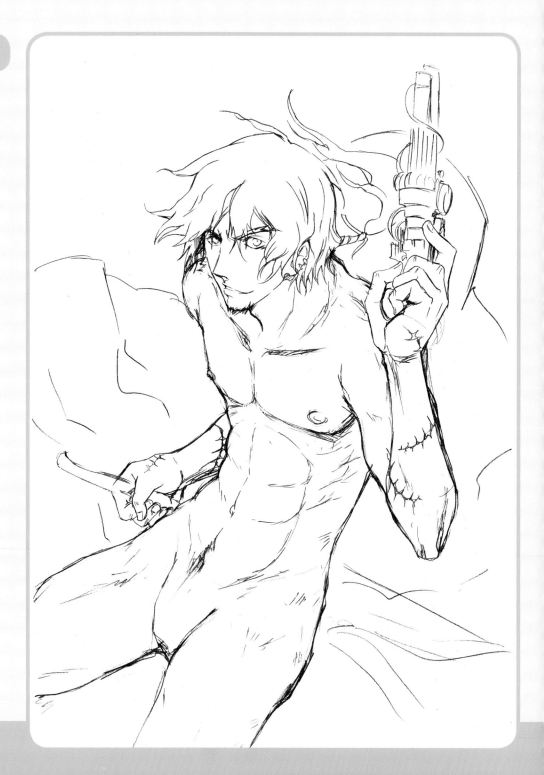

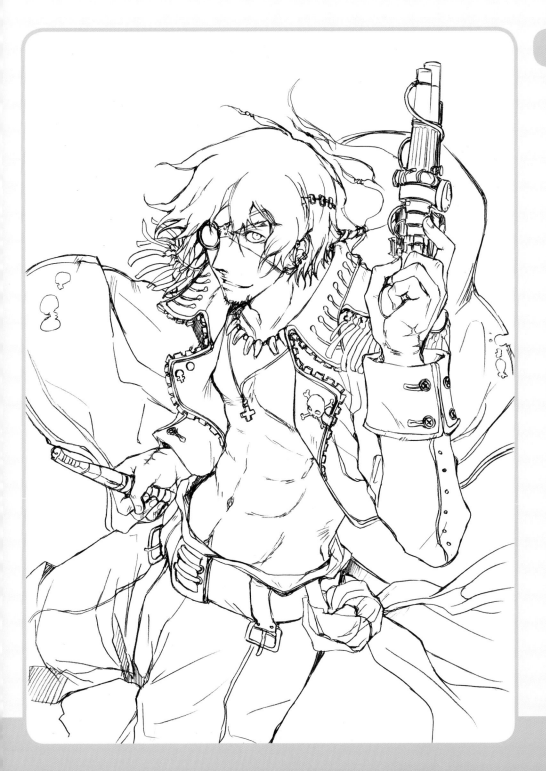

5. DETAILS

The retro-futuristic cut of his clothes is inspired by classic pirate series, but with a more carefree, attractive touch.

6.1. COLOR

We began by applying the drawing's base tones, mostly low-saturated blues and browns, and we worked with each color in a different layer.

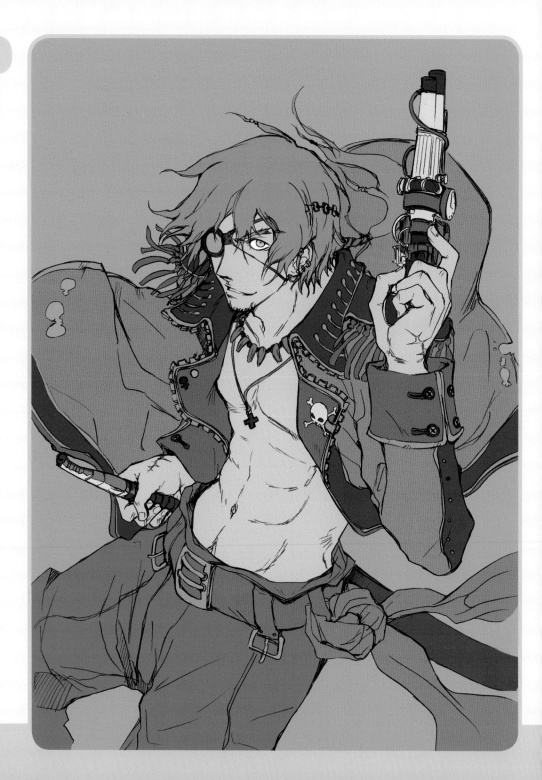

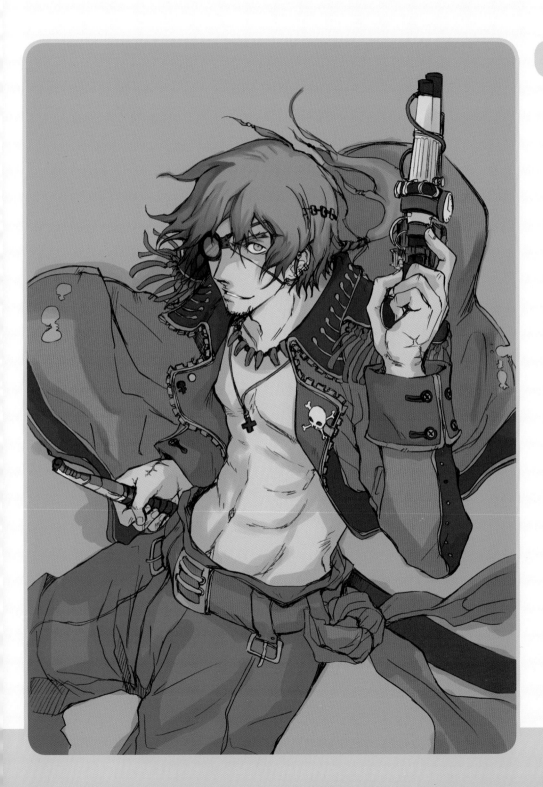

6.2. COLOR

We added mauve or light purple shadows on separate layers in a Multiply Blend Mode, using the Eraser Tool with a brush adjusted to different opacity levels.

6.3. COLOR

We applied a second group of darker shadows with slight gradients on a new layer in the Multiply Blend Mode. This way the character gains strength and darkness.

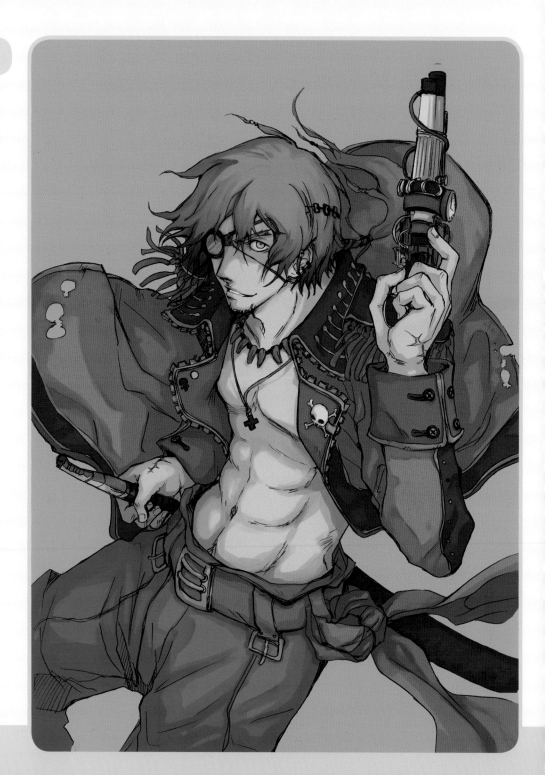

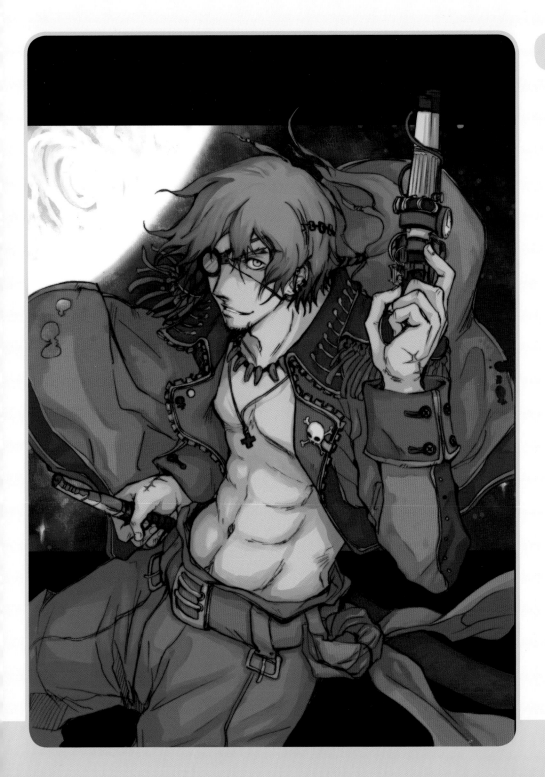

6.4. COLOR

To draw the background, we began by defining the colors of the planet and space, then created clouds and drew in the stars. These are complemented by the texture layers used to create nebulous effects, later given their shape using color.

6.5. COLOR

We painted in the hair highlights and details such as the pistol and jacket on a layer in the Hard Light Blend Mode. We also applied color gradients over the base color.

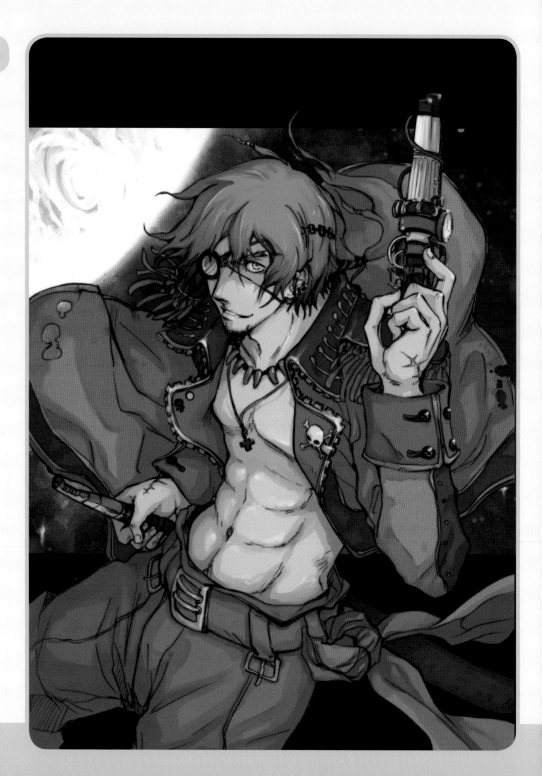

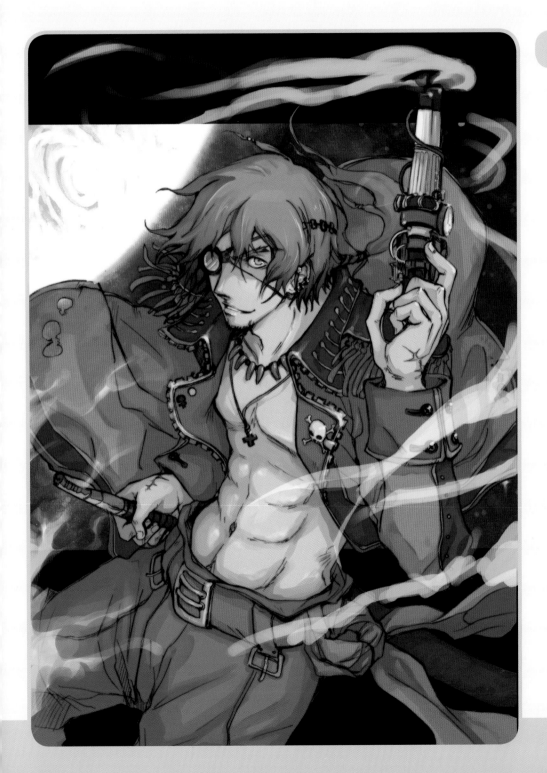

6.6. COLOR

We drew in the smoke with a brush at low opacity and smudged it with the Finger Tool.

Finishing touches

- We changed the Blend Mode of the smoke layer to a Brightness Mode to make it turn white.

- We duplicated the line drawing on a new layer in a Multiply Blend Mode and applied a Gaussian Blur Filter to give it a faded effect.

Tips & tricks

- To give the background a greater sense of depth, we added another layer in a Color Blend Mode and painted lilac brushstrokes on the furthest edges of the image.

- When we apply certain textures, it is best to do this in black and white so they don't end up changing the color of the image.

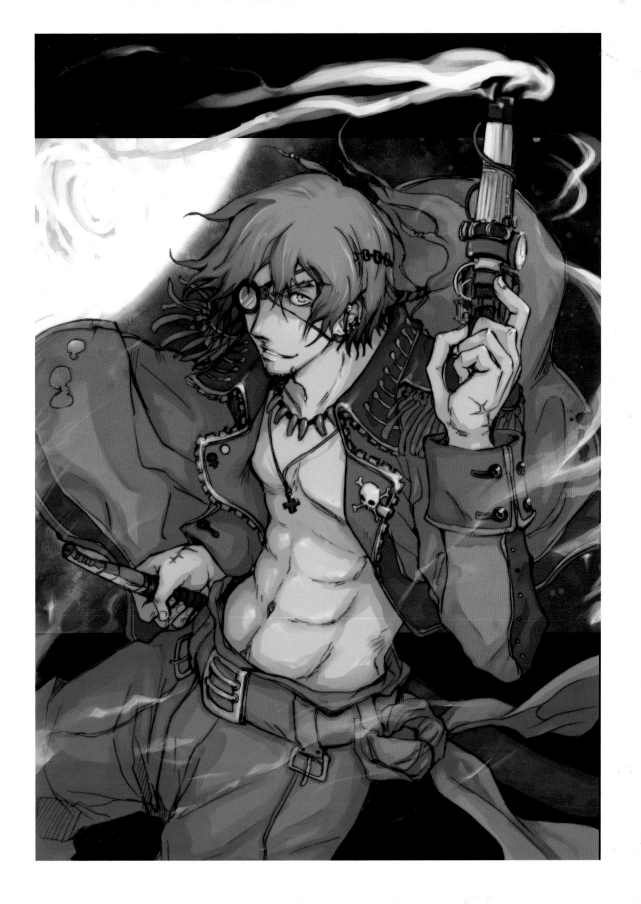

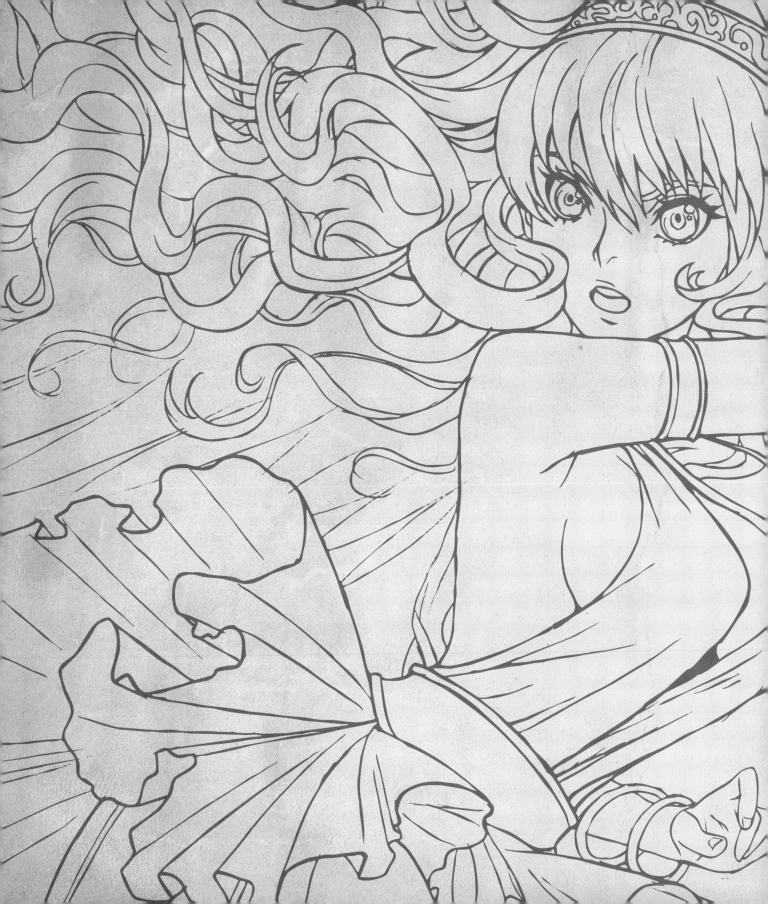

MIGHTY BEAUTIES

BANDITS OF THE FAR WEST
ARABIAN NIGHTS
RISE OF THE VALKYRIES

BANDITS OF THE FAR WEST

Seductive and dangerous, the rebels Estela and Marie Ann are among the most feared bandits in the whole Far West. Estela, the daughter of a sheriff who was betrayed and hanged at the gallows, rescued Marie Ann, who had been working as a dancer in a dance hall of ill repute. Specialists in disguising themselves and arousing men with their charms, they have garnered fame for being treacherous criminals who will stop at nothing. But they still have their greatest robbery up their sleeves: swiping the gold bars of the Western Central Bank being transported by carriage.

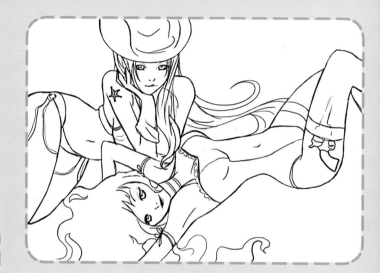

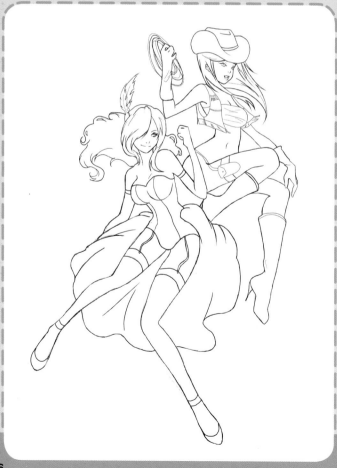

1. SKETCHES

We put forth several ideas for the illustration until settling on one where the girls are seen as strong and decided without losing their sensuality.

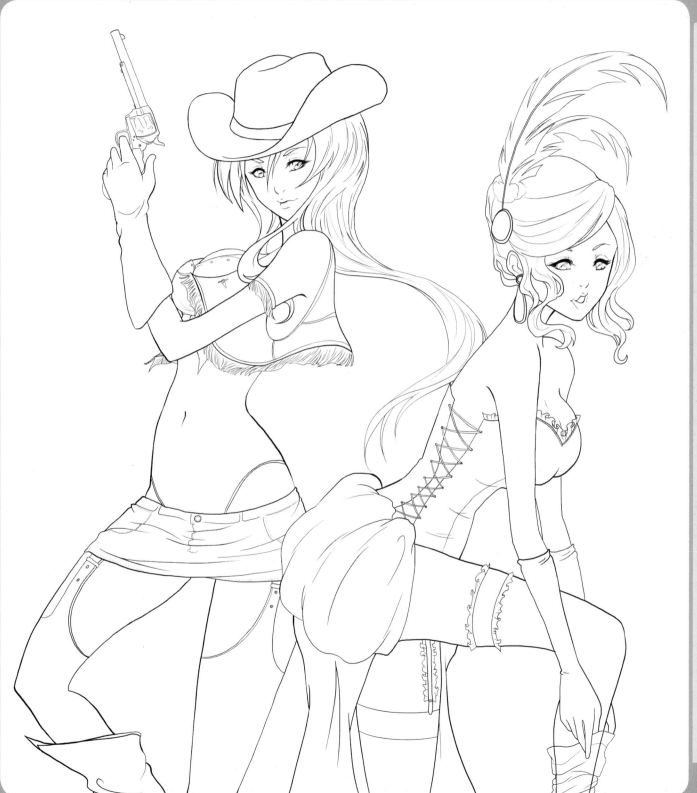

2. STRUCTURE

We arranged the two figures in space, making their postures reflect their personalities and attitudes. Estela, on the left, is much more determined, while Marie Ann, on the right, is more coquettish.

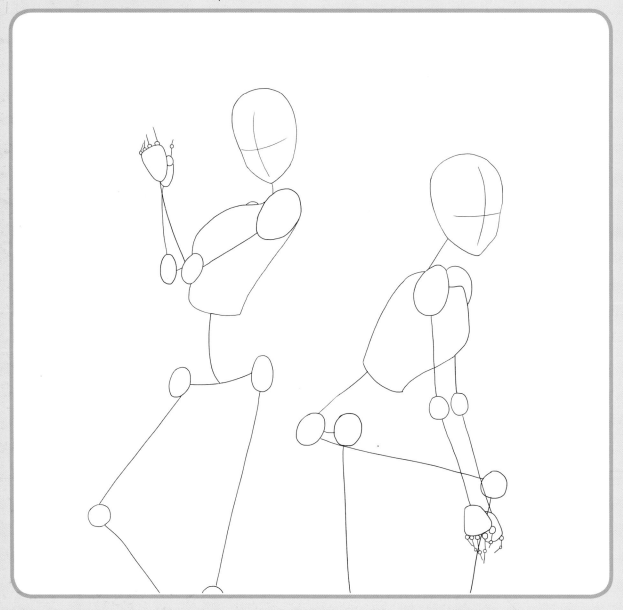

3. VOLUME

When we drew the girls, we had to always remember to highlight the hips, which are a sign of femininity.

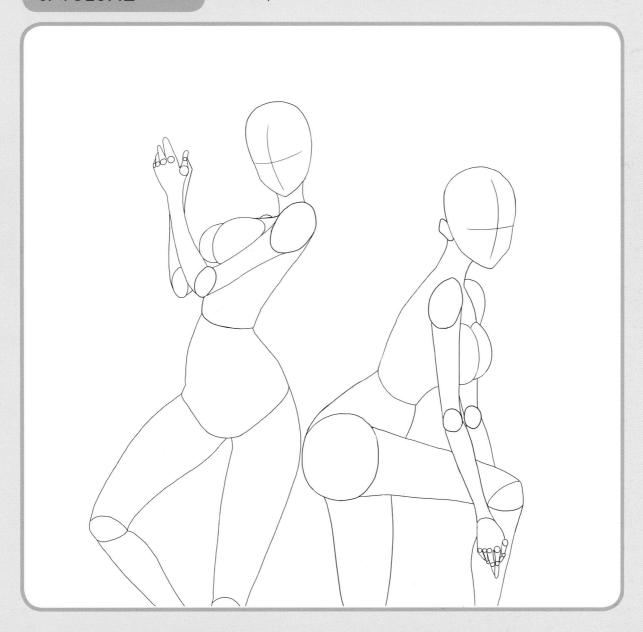

4. ANATOMY

We accentuated the voluptuousness of the young women's bodies with generous and very sensual curves.

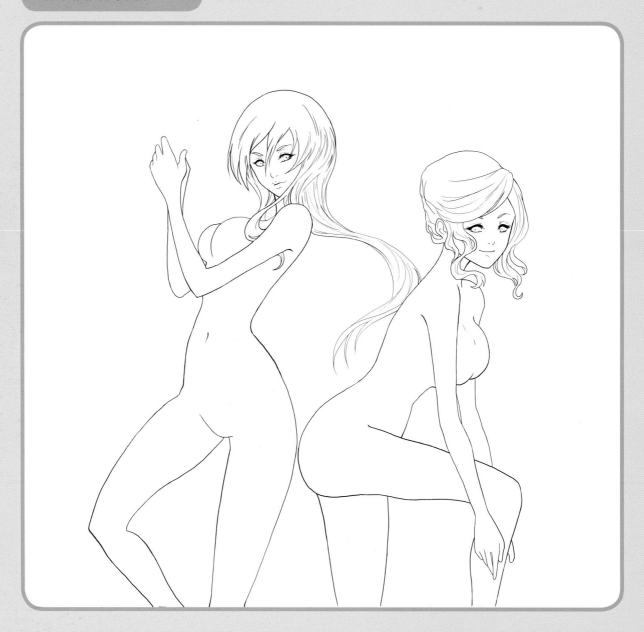

5. DETAILS

Estela's clothes, on the left, recall her father's occupation, a sheriff, while Marie Ann is dressed in a dancer's outfit. Although both styles are based on the Far West, we have given them each a personal touch.

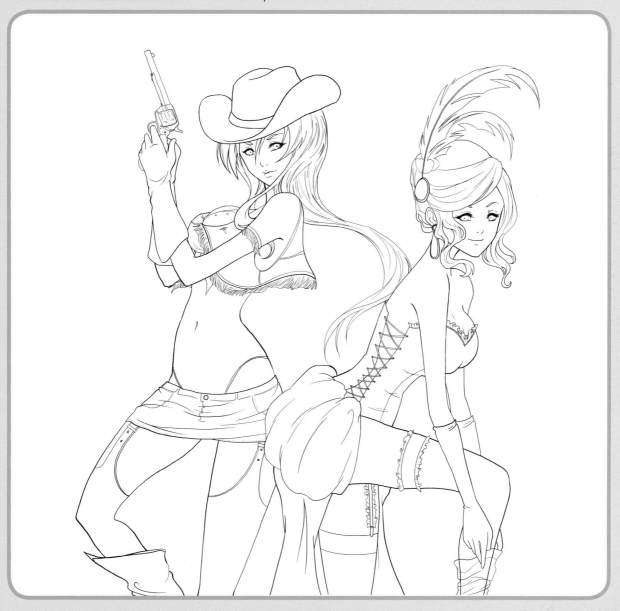

6.1. COLOR

We colored in the different areas in separate layers grouped by color range. We mainly used ochre and earth tones, which transport us to the American West.

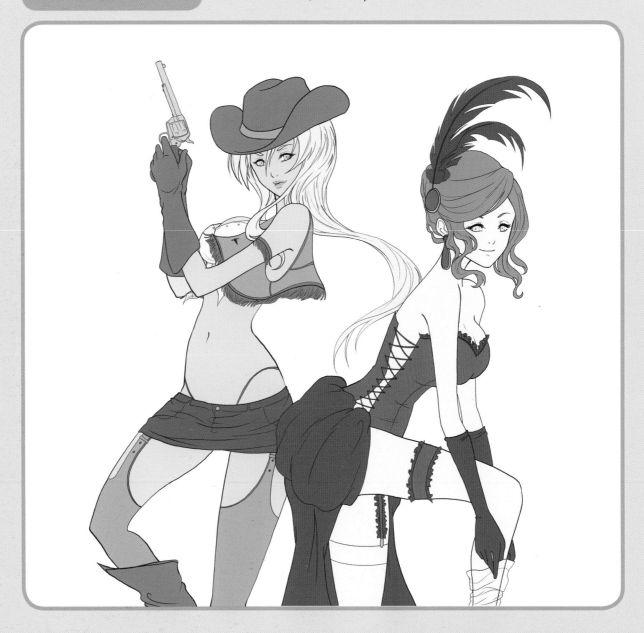

6.2. COLOR

We applied bluish shadows on a new layer in a Multiply Blend Mode at 60% opacity. We used two types: a hard shadow with the brush at 100% opacity and flow, and a gradient that we blended in.

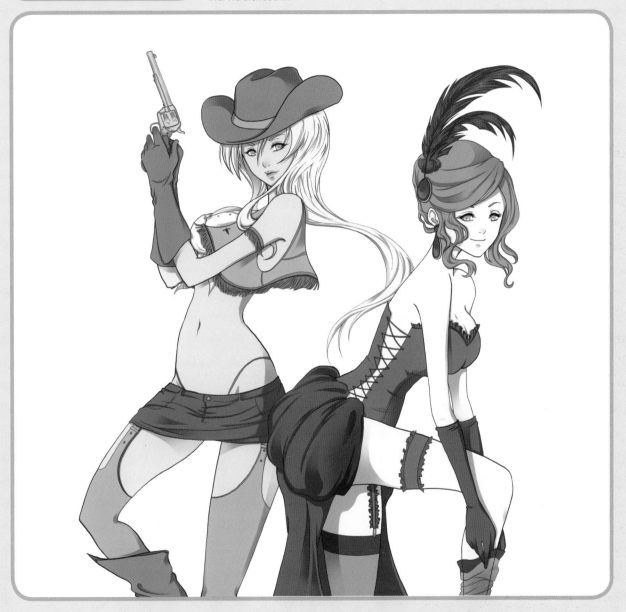

6.3. COLOR

The light source comes from the left side, but it is sufficiently defined by the shadow, so we added white highlights to it to give the image more detail and volume.

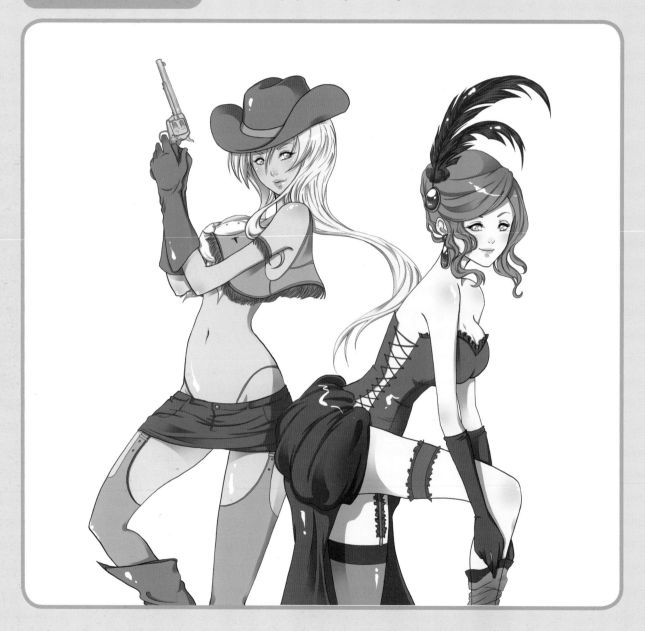

7. BACKGROUND

Following the style of using flat colors, we created a simple background with small gradients and whites that clip the image. We outlined the girls in a white Trace from the Layer Blending Options.

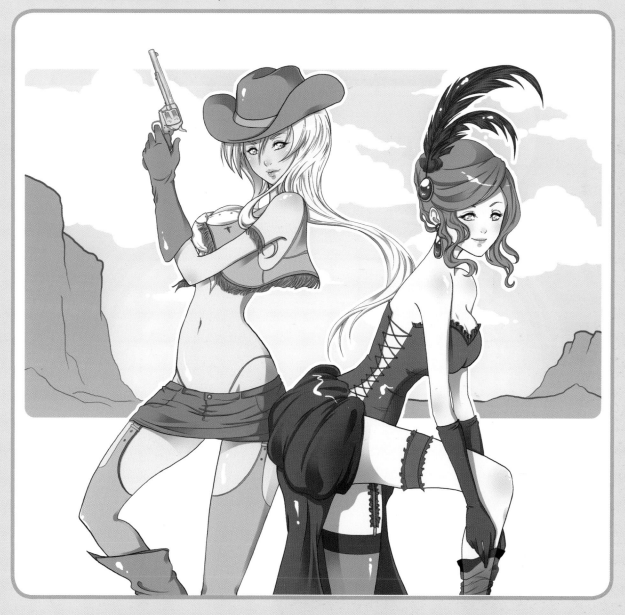

Finishing touches

- We lightened the skin tone of Estela slightly so she wouldn't look so dark.

- We applied a paper texture over the background in a Multiply Blend Mode at 60% opacity.

Tips & tricks

- When we first begin to color digitally, it is good to start with simple drawings and flat colors. The key always lies in combining colors properly, starting with low-saturated tones and having good contrast between highlights and shadows.

- The use of textures over the background and rounded edges gives it the look of old cowboy films with a touch of modern pop.

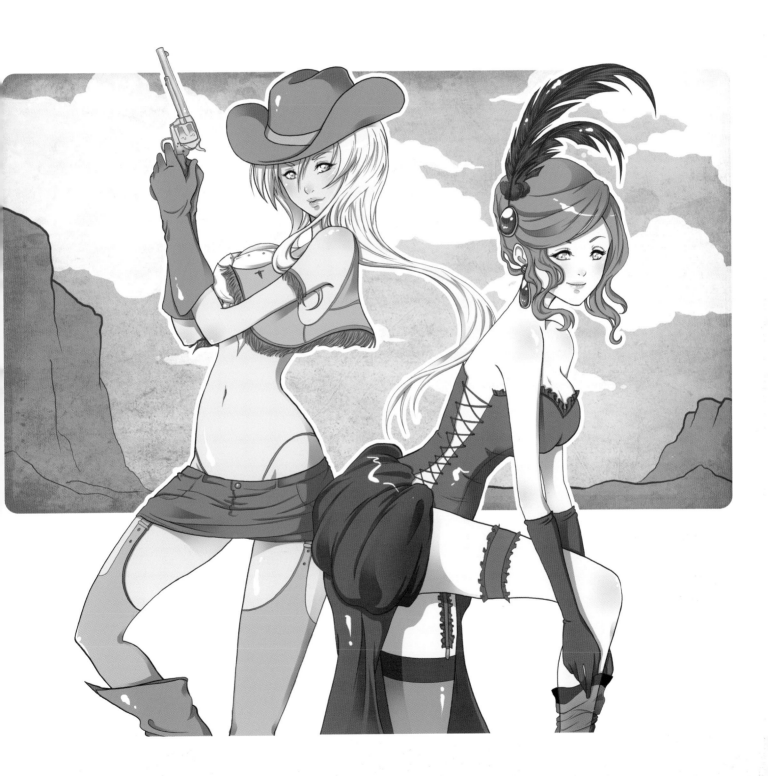

ARABIAN NIGHTS

Princess Sherazade has an incredible gift for dreaming up the most marvelous and fantastic stories anyone has ever told. Genies, thieves, journeys, monsters, magic, and love fill her stories, making them irresistible. So much so that her tales have captured the attention of the feared King of Arabia, and she is forced to stay with him for a thousand and one nights, until she manages to tame the monarch's rage and become his loyal and loving wife.

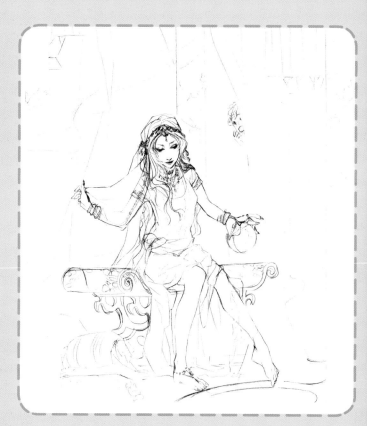

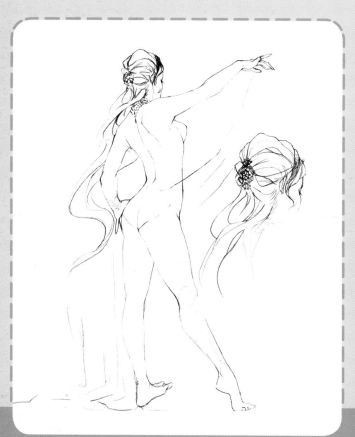

1. SKETCHES

The Arab-inspired illustration must bring together all the typical elements of a thousand and one nights, and be as lively and magical as possible. Here there are winks to the tales of Ali Baba, Aladdin, and Sinbad.

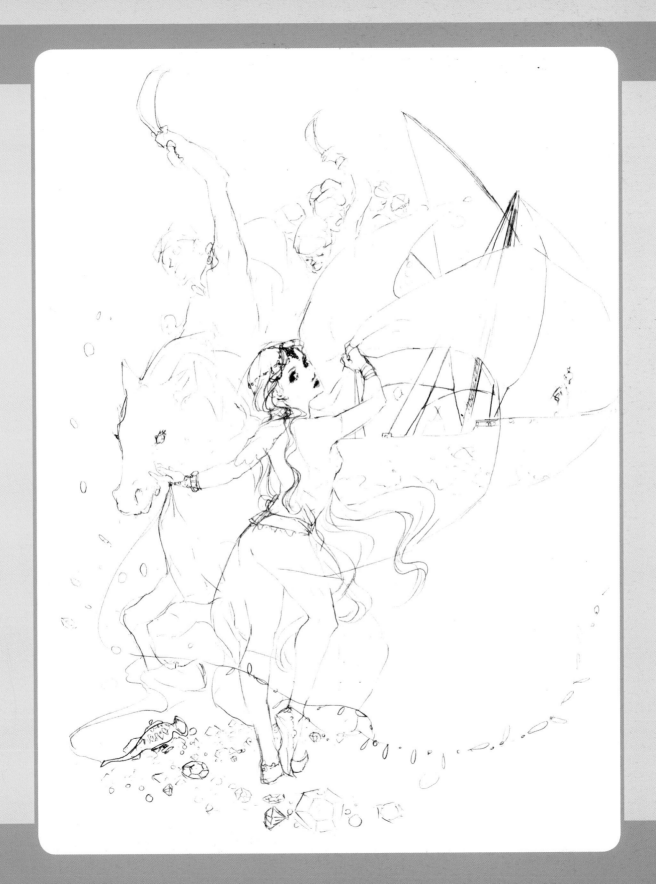

2. STRUCTURE

We sketched the image composition, forming the bodies of the characters with pronounced curves that help us define movement and give a sense of action.

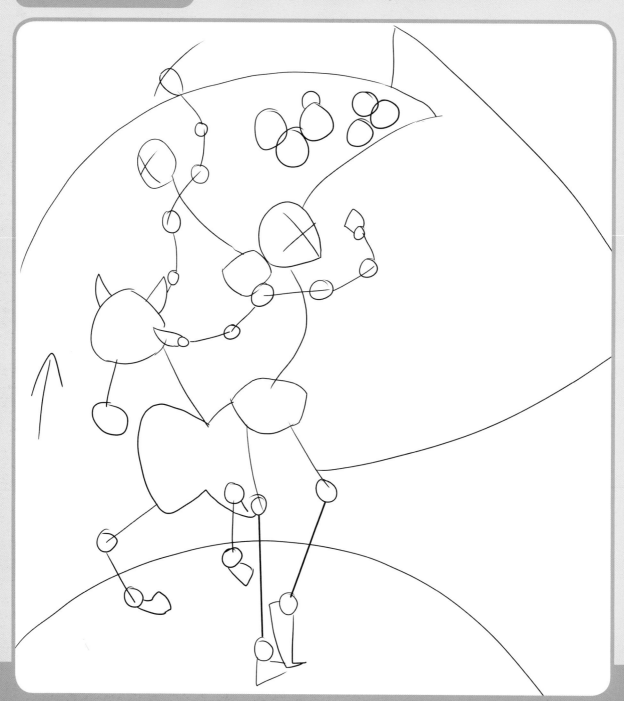

3. VOLUME

Although the final posture is somewhat complicated, by simplifying the parts into ovals we can better define the proportions of body and limbs.

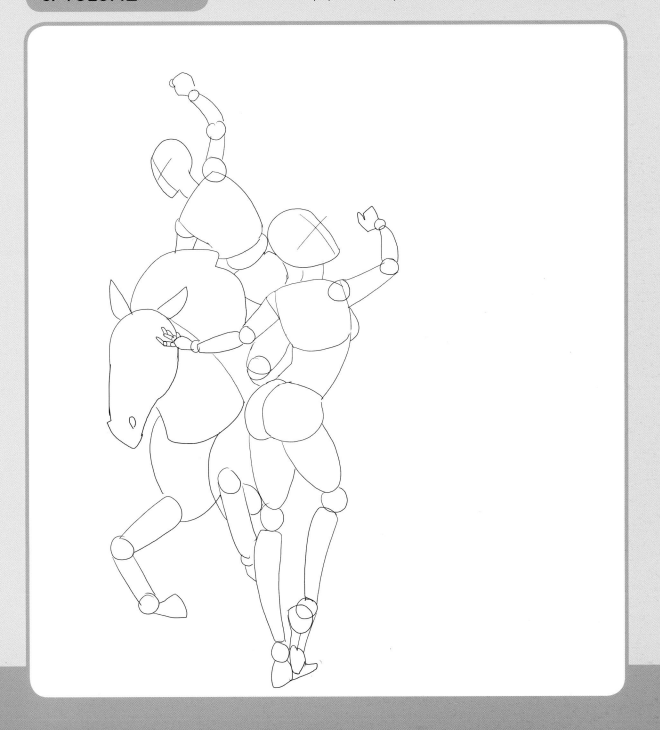

4. ANATOMY

Princess Sherazade's body ought to be sensual and youthful, and her pose sufficiently graceful to look as if she is dancing under her veils. In this image, we put the thief from the story behind her. He has a thin yet wiry body.

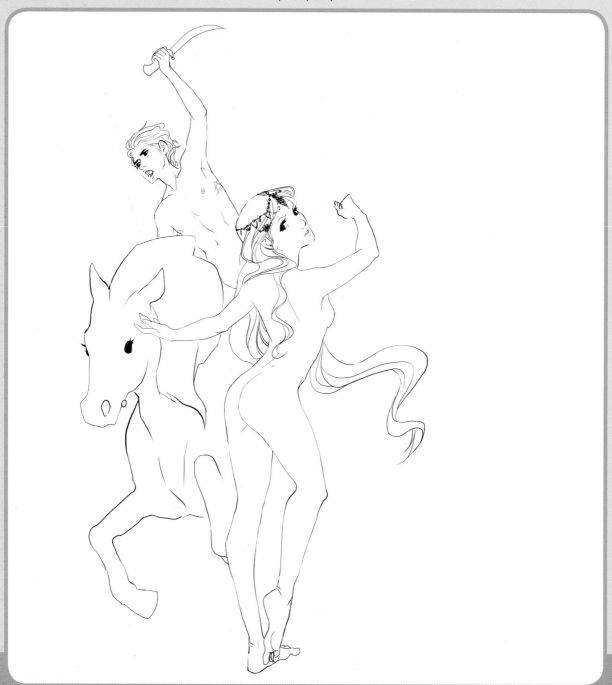

5. DETAILS

The clothes are entirely Arabic in design, but it is important for the veil to have enough force to define the action and composition of the scene. The boat is drawn using vectors.

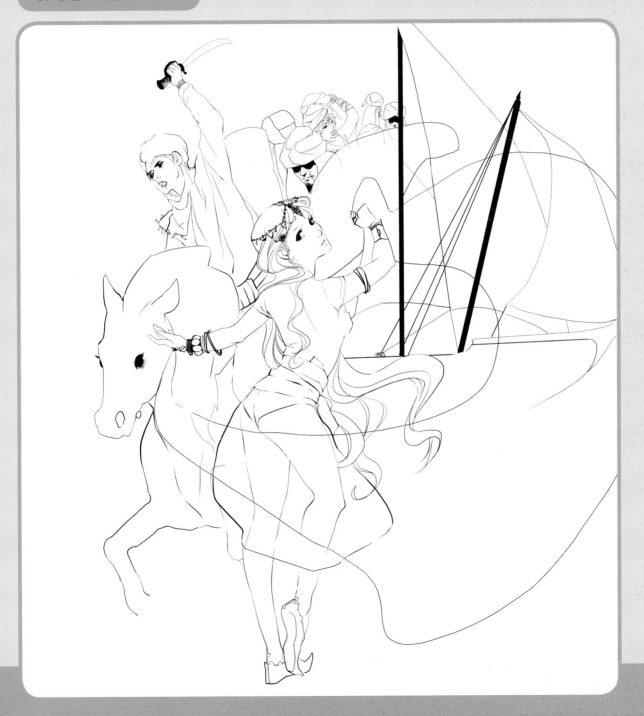

6.1. COLOR

We applied the general background tone by defining the base colors of Sherazade, who has a dark complexion due to her Arab origins.

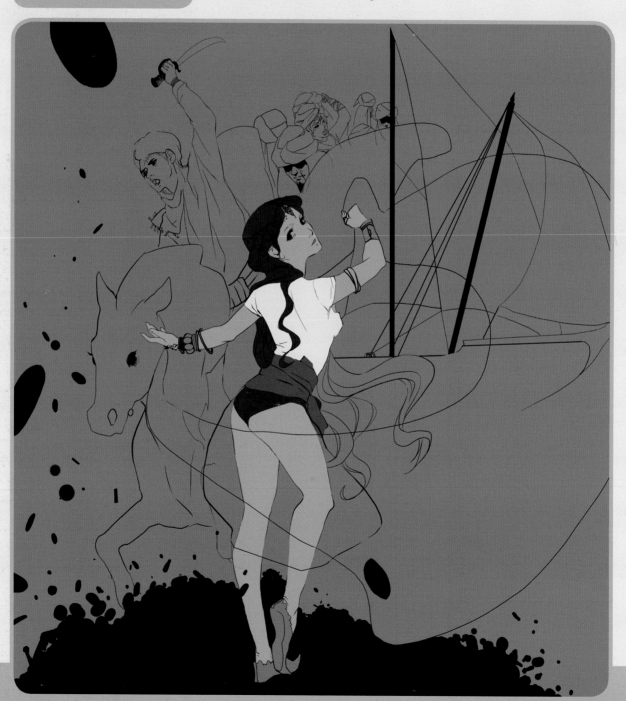

6.2. COLOR

We applied the shadows of her skin in a new layer, creating the shape of her body in a realistic manner and trying to give volume to its different parts. We began coloring in the horse using a flat, dark gray tone.

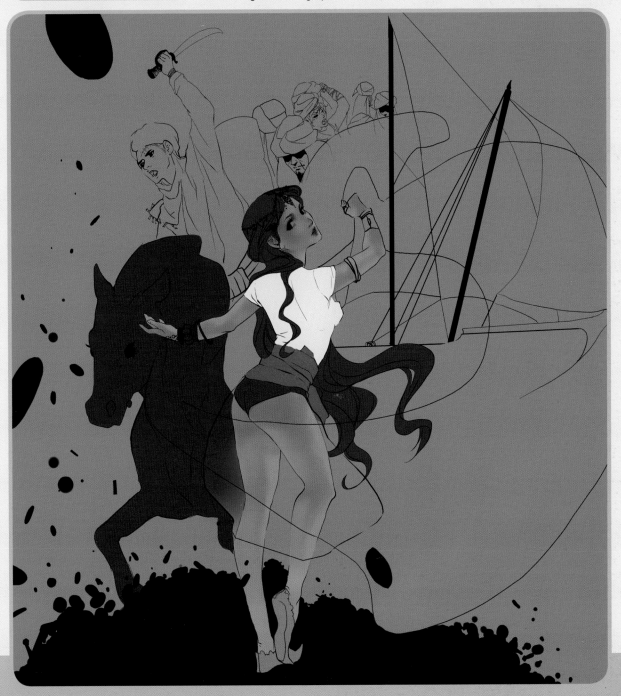

6.3. COLOR

We finished defining the shadows of her clothes and added in the highlights and transparent areas.

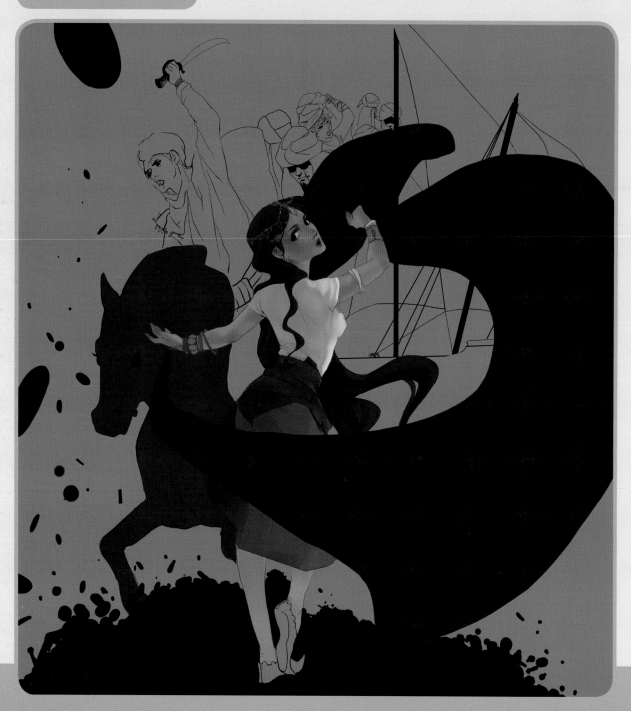

6.4. COLOR

We then focused on the horse, which we molded using the brush, applying different areas of light and shadow until managing to give it volume. We sketched in the colors of the thieves and lowered the opacity of the layer containing the veil colors.

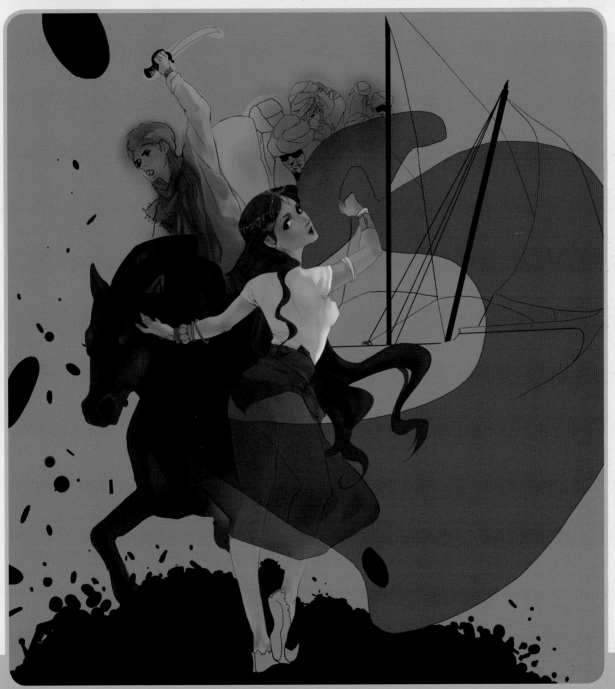

6.5. COLOR

Using the same realistic brush technique and combining the light and shadow areas contiguously to give the image volume, we create the thieves and boat in the background.

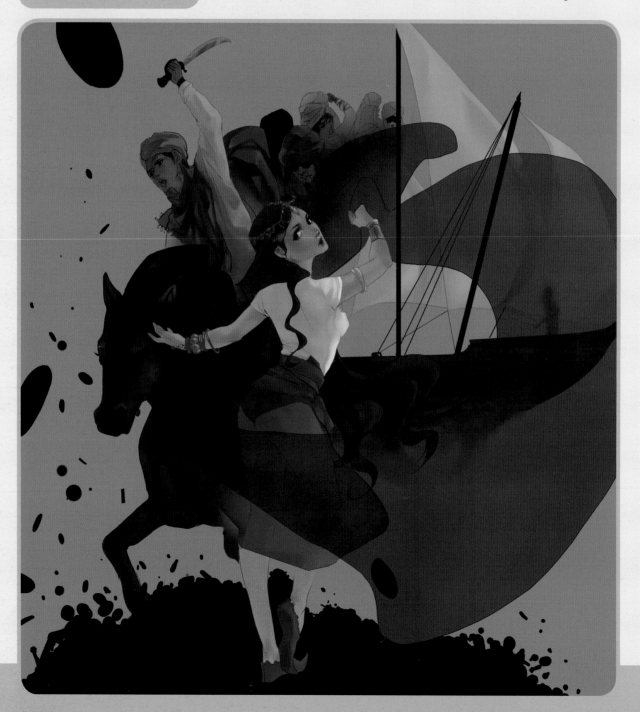

6.6. COLOR

We add highlights to the image to calibrate the lighting, along with textures, and then begin to design the background.

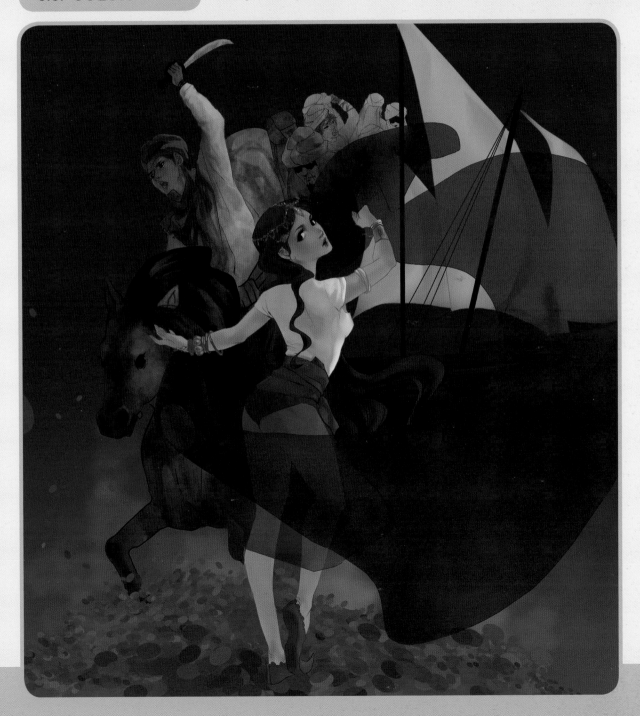

6.7. COLOR

We included a crescent moon in the background and then added light details, textures, and effects to make the image more spectacular.

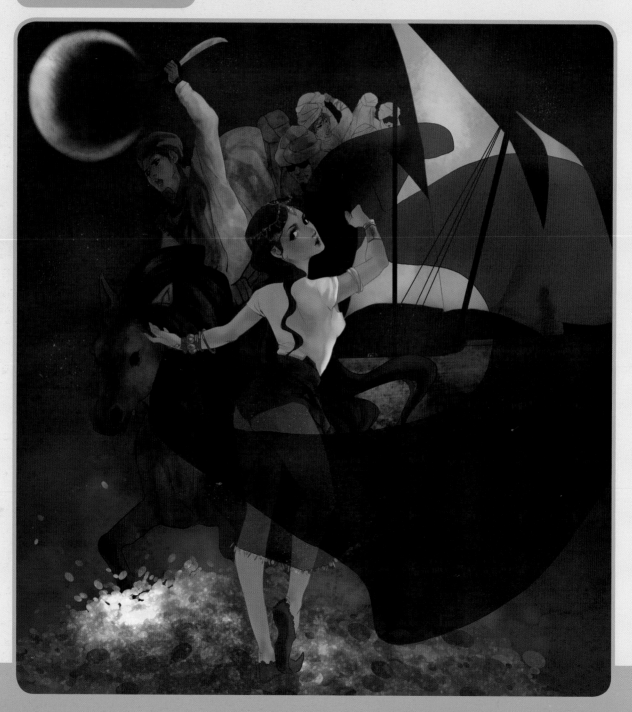

6.8. COLOR

We made corrections to the light to make the image clearer and make the details more visible, as well as more defined. We also took advantage of this opportunity to slightly retouch the girl's face and make her body more slender.

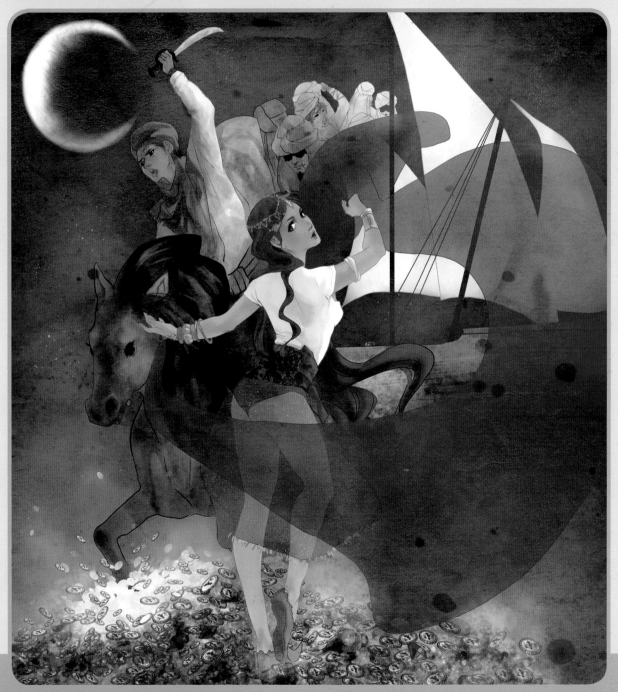

Finishing touches

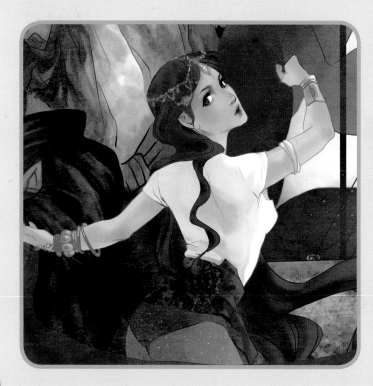

- We balance the colors on a Color Balance Adjustment Layer, removing the image's yellowish tone and adding more blues and magentas.

- We placed a shadow layer over Sherazade's skin in the Overlay Blend Mode at 23% opacity to give her more luminosity, even though this makes her lose a bit of her olive-Arab skin tone.

Tips & tricks

- This illustration, starting with the tones, was painted in SAI using the program's Pen Tool, which is a vector hybrid. For specific coloring, we went back and forth between the Pen Tool, the Oil Tool, and the Blur Tool.

- The coloring was done separately on different layers, as this lets us organize the work and prevents the colors from mixing together.

- In Photoshop we were able to create the piles of coins by using the Calligraphy Pen tool, changing the Dispersion and Color Variation.

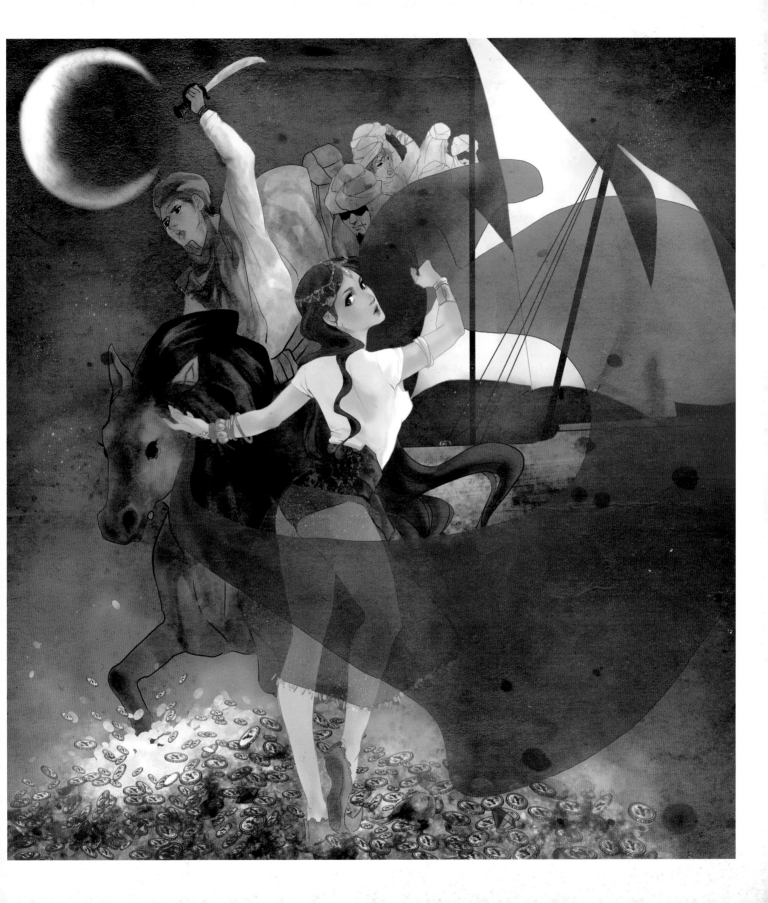

RISE OF THE VALKYRIES

For centuries the Valkyries served the god Odin under the command of the goddess Freyja. The mission of these little resident goddesses of Vingólf was to transport the bravest warriors who had fallen in combat at Valhalla. These heroes, after having been converted in Einherjar, would fight alongside Odin in Ragnarök, the battle at the end of the world. But one of them, Brunilda, made the mistake of falling in love with one of the soldiers and Odin punished her by putting her to sleep forever. The rest of the Valkyries then turned against Odin in their fight to rescue Brunilda from the eternal sleep he had cast her under for the simple crime of falling in love with a mortal.

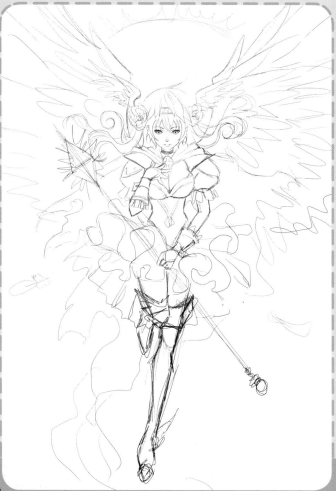

1. SKETCHES

Nordic mythology has had a huge influence on manga and here we wanted to portray a unique version of these *dísir*, minor female deities in the service of Odin.

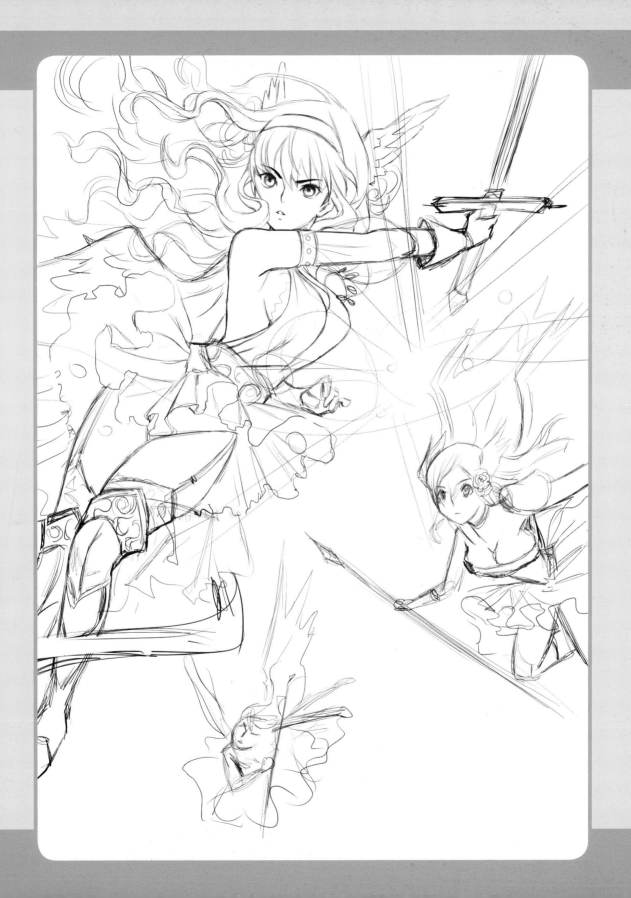

2. STRUCTURE

We have three warriors who form a triangle. We simplified the scene by defining each character with ovals and lines that connect their articulations in order to create the postures more easily.

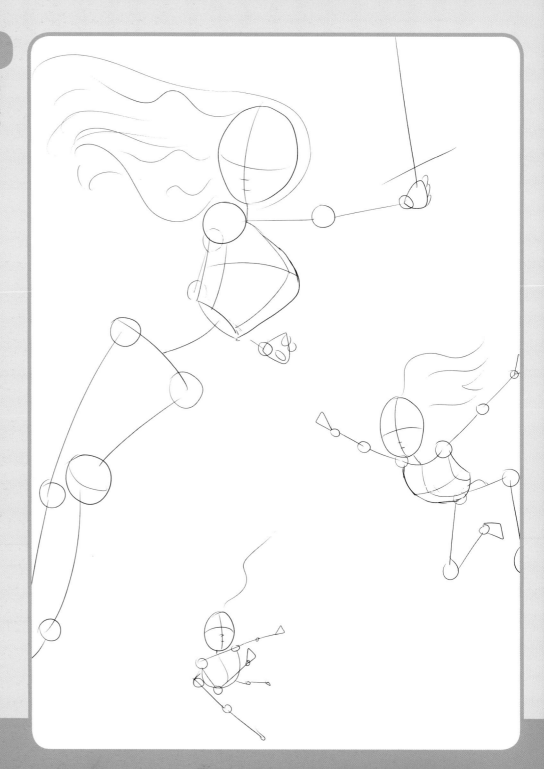

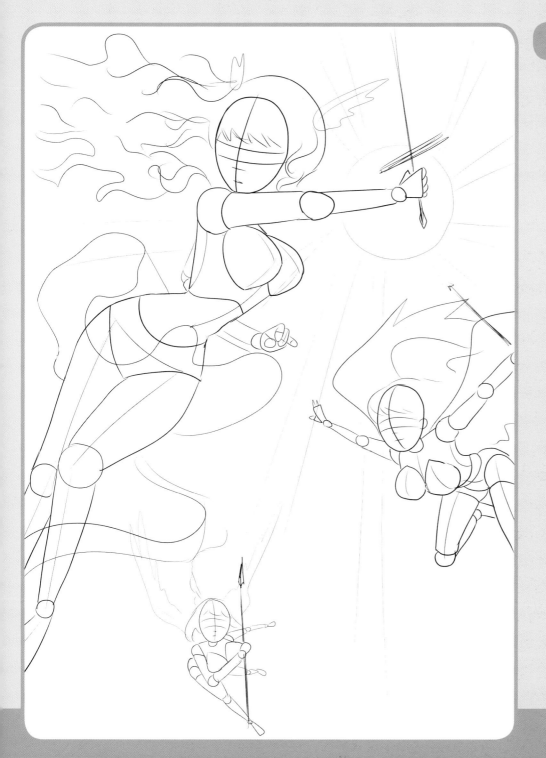

3. VOLUME

We wanted to highlight both their war-like nature and their attractiveness and femininity, which meant both their breasts and hips had to be generous and voluminous.

4. ANATOMY

We drew their hair carefully, forming overlaid waves and finished off the girls' curves.

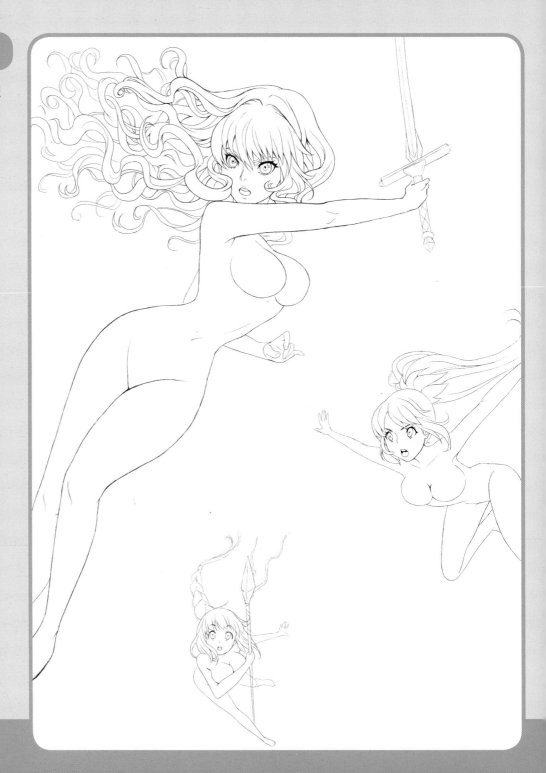

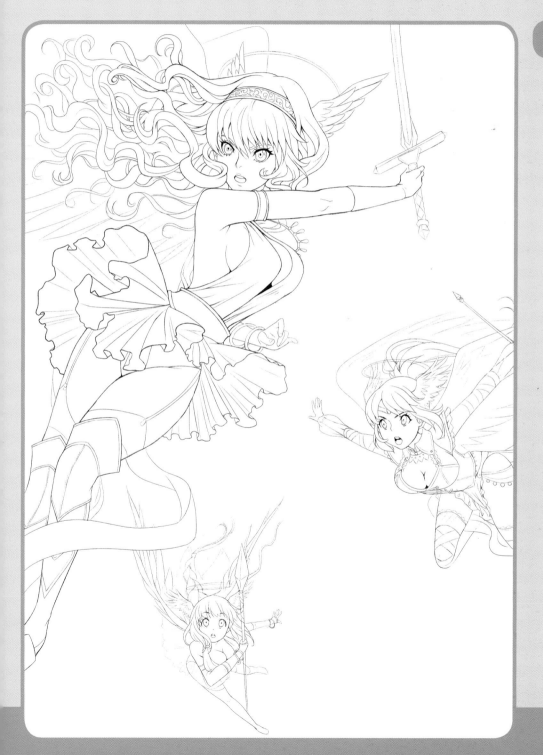

5. DETAILS

We dressed the girls in outfits inspired by Nordic mythology, with full pleated skirts and metal armor.

6.1. COLOR

We began by giving the drawing volume in a gray scale, keeping in mind where the main and secondary light sources were coming from. We then defined the textures of the armor, outfits, hair, and other elements.

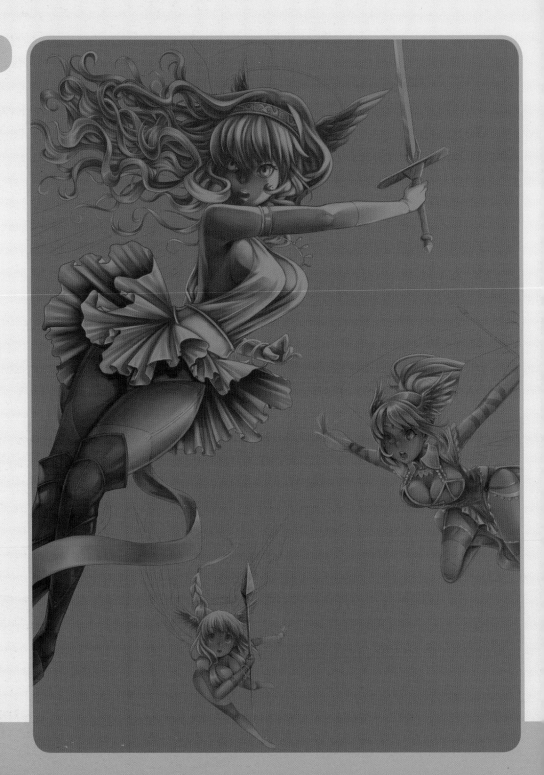

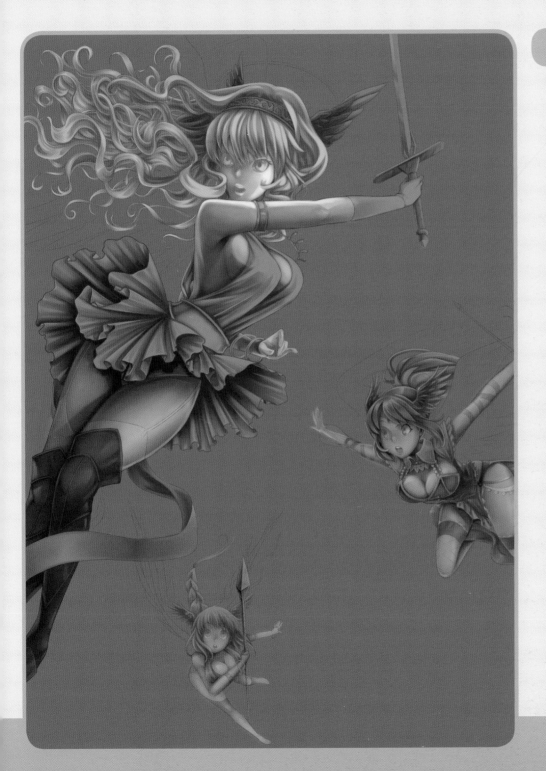

6.2. COLOR

With the volumes defined, we began to color the drawing in with the brush in an Overlay Mode. In this way the initial gray absorbs the color we add to it, maintaining the light and shadows already indicated.

6.3. COLOR

We adjusted the colors by adding or removing saturation until the gray base had disappeared. To prevent the illustration from becoming too dark, we always kept some pure white as a reference to compare with the colors we had chosen.

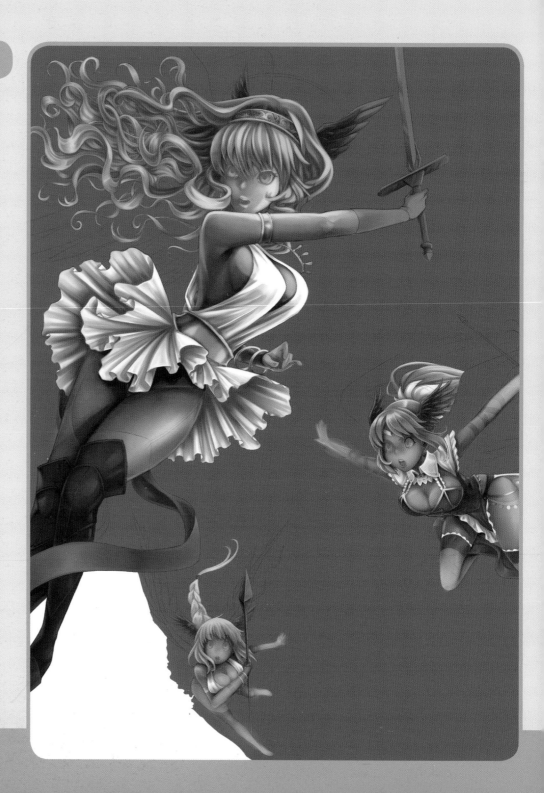

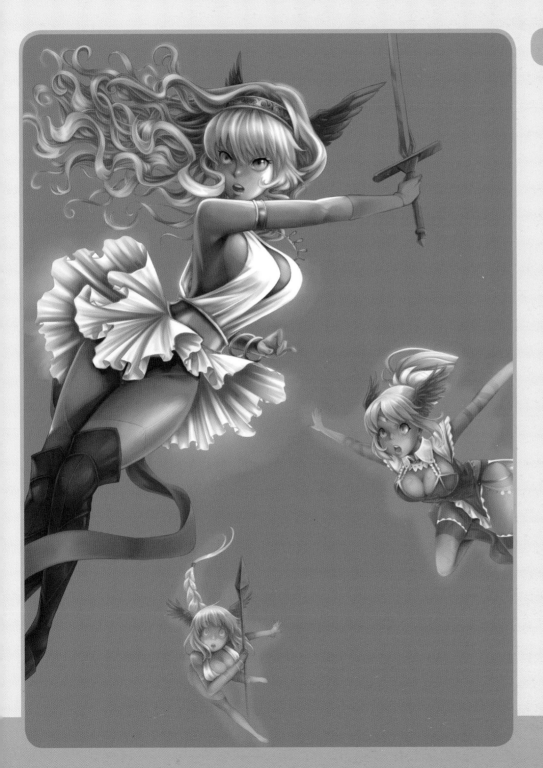

6.4. COLOR

We added the facial details, lightened the background of the image, and retouched the general color, leaning toward a beiger tone. We created an outer glow with some brushstrokes, to represent the celestial light in the Valkyries' clothes and hair. We then lightened the two characters in the background slightly, using a semi-transparent whitewash layer to attain a sense of depth.

6.5. COLOR

We colored in the red lassos, applied more highlights and shadows to the secondary Valkyries, and gave more details to their clothes and expressions. The shadows in the clothing of the main Valkyr change toward a more bluish hue.

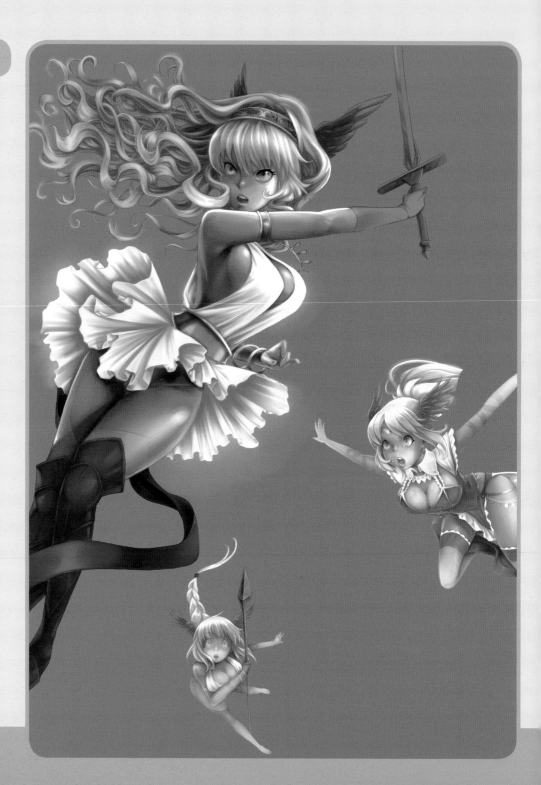

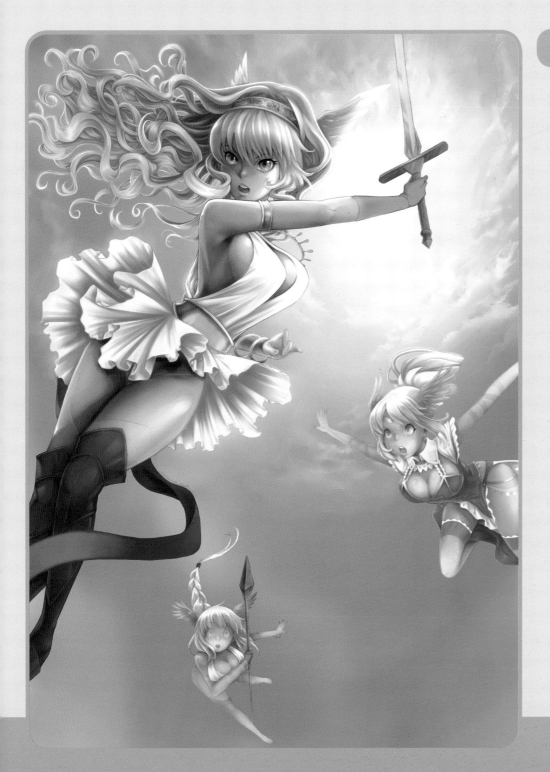

6.6. COLOR

We added the background sky using a radial blurring effect with greenish blues and yellowish whites in the center. From this color contrast, clouds take form in a centrifugal manner heading toward the interior of the lighter color, which acts like a sun. On one side we added a pinkish-orange hue to the skin tones of the characters, further contrasting the color and light effects. The hair gains brightness, saturation, and golden colors from this.

6.7. COLOR

We painted more pinks and yellows in the background, while making the color more intense. We added details such as highlights to the skin, and we adjusted its colors. Finally, we added colored lines to better define the drawing.

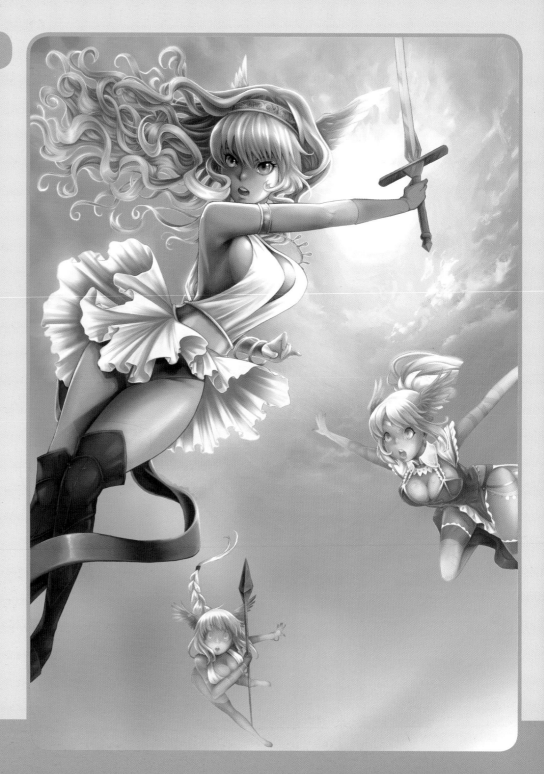

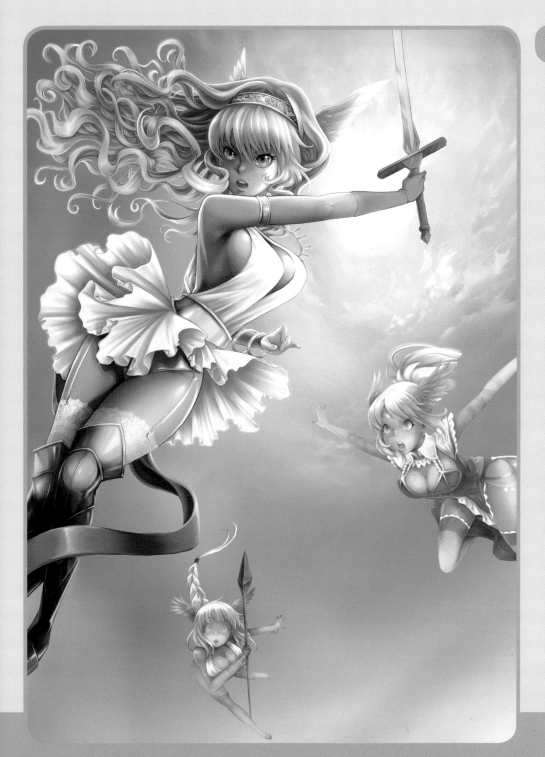

6.8. COLOR

We colored in the armor using dark golden tones for the shadows and light yellows for the highlights, striking a great contrast that mimics the reflection of precious metals. We painted in their garters and its textures. We then added color outlines to the new areas we had drawn.

Finishing touches

- We created the wings by using a soft low-transparency brush, brushing in color to represent each plume over a blue shadow, remembering that the top feathers are smaller than those on the bottom.

- We heightened the color of the hair and armor, and added small points of light that looked like sunlight, plus a halo coming from it. We also slightly corrected the general tone of the sky.

- We finished the clothing and expressions of the secondary Valkyries and applied light effects.

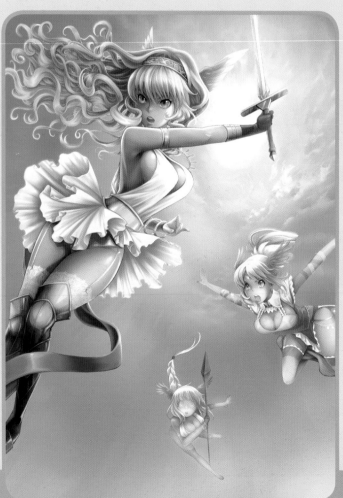

Tips & tricks

- In an illustration as elaborate as this, from the very beginning there must be an idea of how we should arrange the various elements and the color range to be used. To do this, we can use a small sketch that also has the basic coloring.

- Additional elements, such as the wings or background, are created in different files to be attached to the final image.

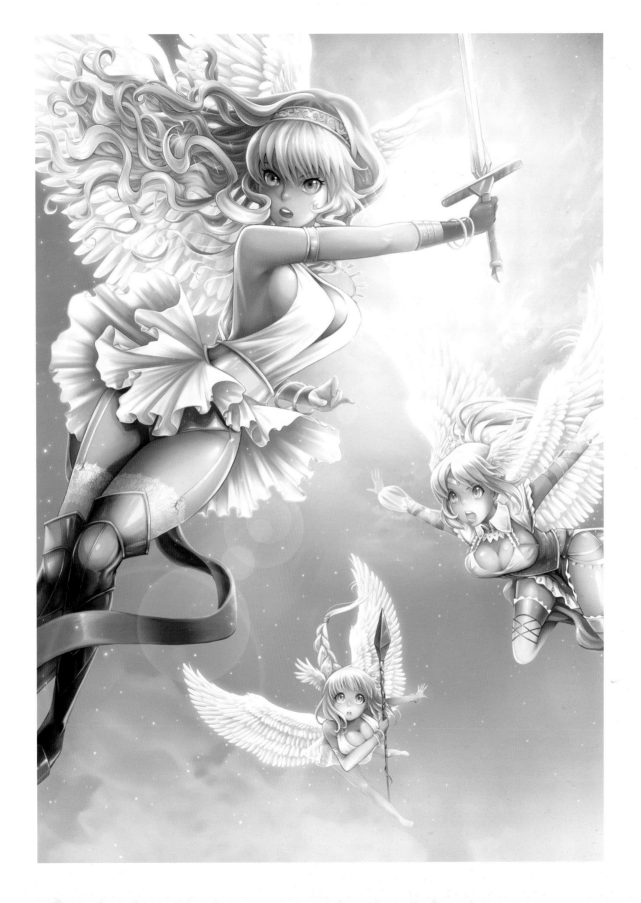

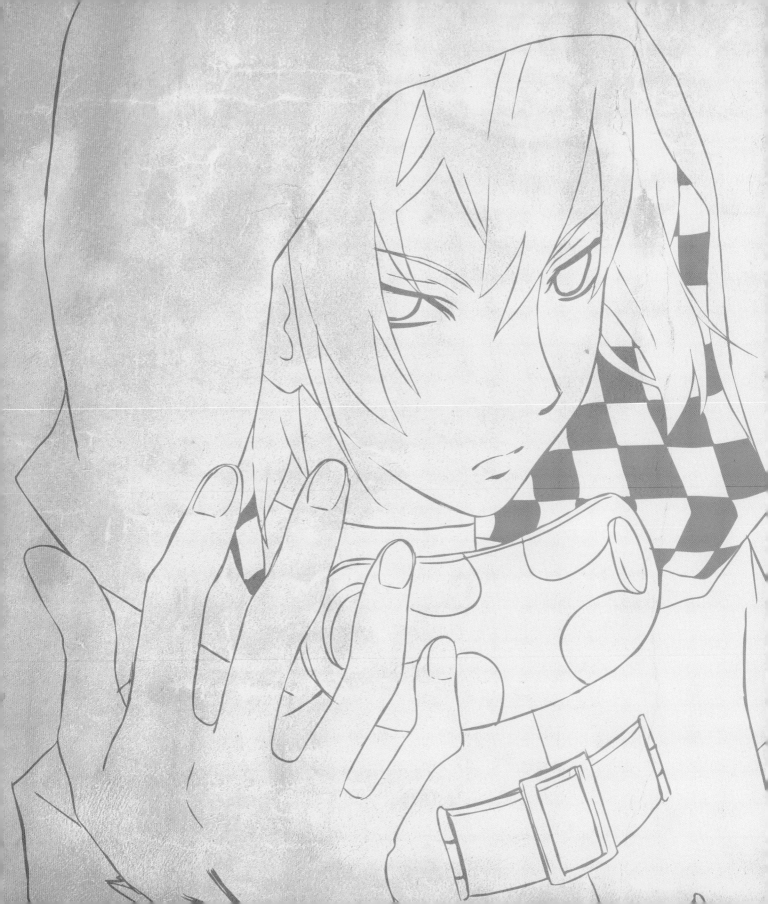

FANTASY HEROES

FANTASY JUNCTION

Leena and Kevin are crazy about online video games. But one night after a blackout, the two awake in a new world, dressed in the same outfits as the characters of the game they spend hours connected to. Soon they discover they are not alone, and they aren't the only players who have been transported into the game. The two friends now face all sorts of dangers if they one day hope to go back home.

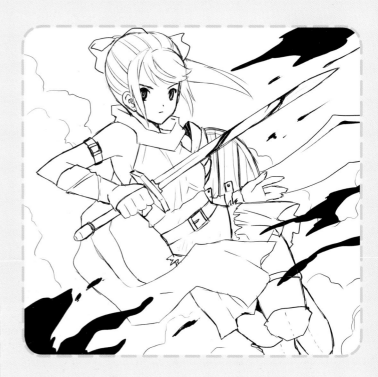

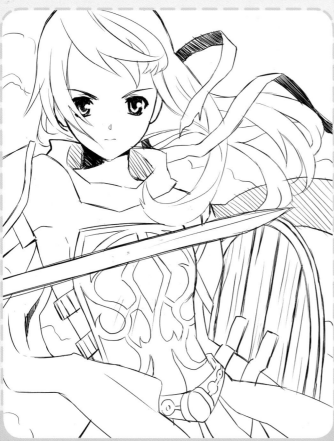

1. SKETCHES

The first sketches had only one player dressed in medieval armor, but in the end we opted to add another character to make the illustration more engaging.

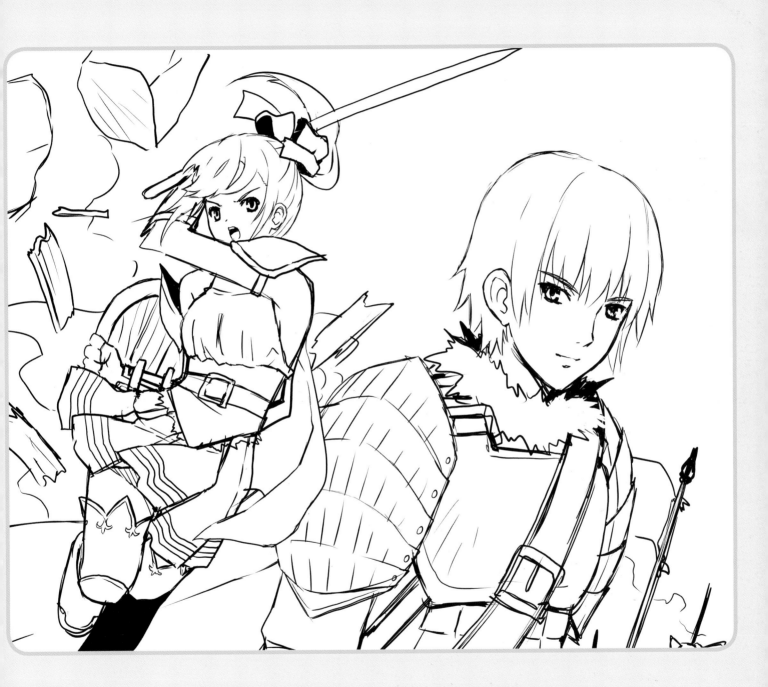

2. STRUCTURE

The key to this illustration is the contrast between the girl's dynamic and war-like posture and the calmer, more staid pose of the boy.

3. VOLUME

Special attention must be paid to the perspective of the girl's legs, keeping in mind how her trunk twists around. In the case of the boy, we slightly twisted his body so he is turning his back to his companion.

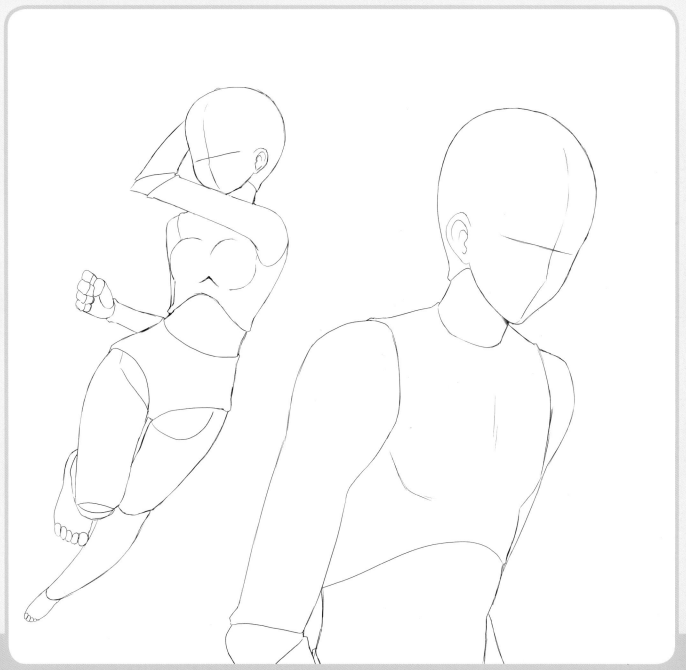

4. ANATOMY

As these are two teenagers, their bodies have to be slender and athletic, all the more so considering they are warriors. It is especially important for the boy's shoulders to be broad, and the same goes for the girl, whose hips and breasts we emphasize.

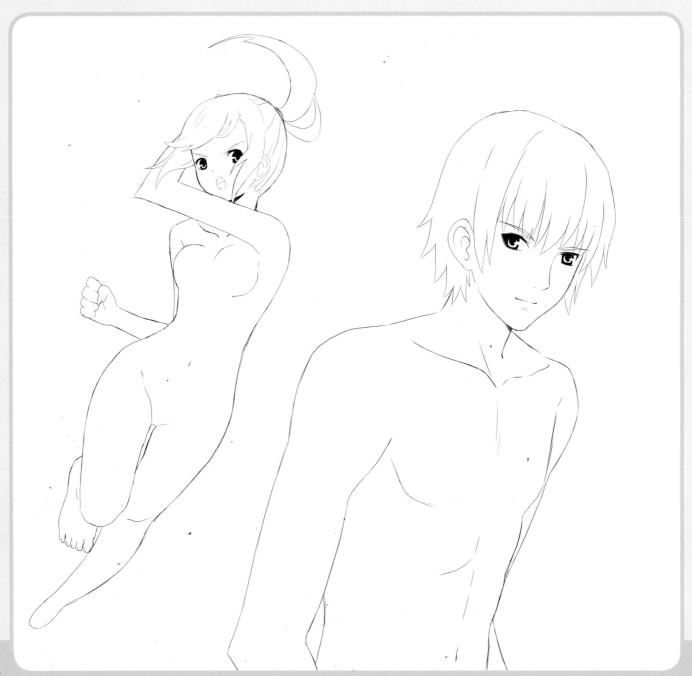

5. DETAILS

The warrior outfits have bits of Greco-Roman elements mixed in, plus more medieval inventions. We also included other details such as stones, the woods, and the troop flags.

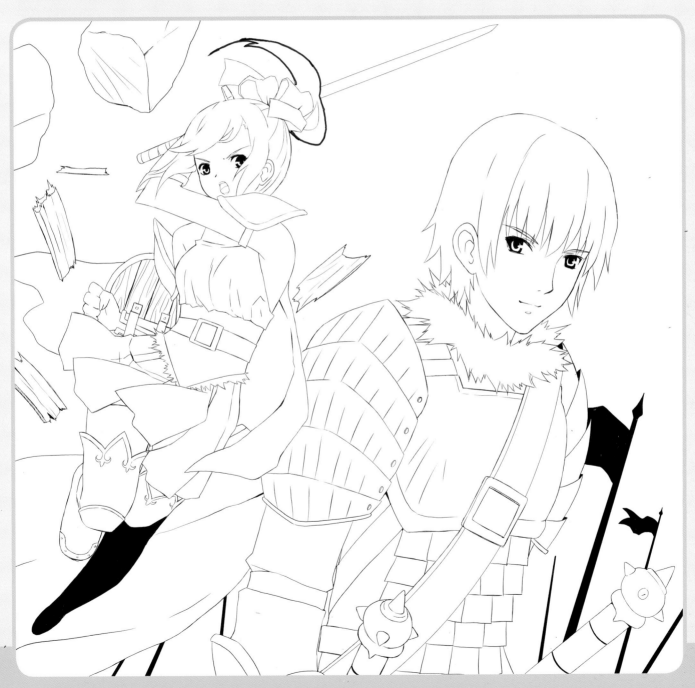

6.1. COLOR

The base colors in each character have different yet complementary color ranges. The girl's is based on red tones while the boy's is green.

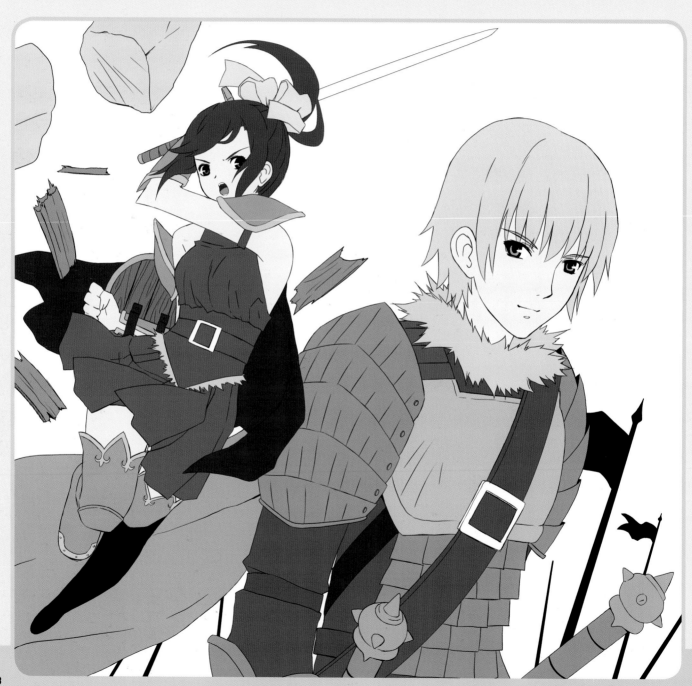

6.2. COLOR

We added the shadows in a new layer. We considered adding small highlights around the boy, who is standing against the light, but we chose to leave them out.

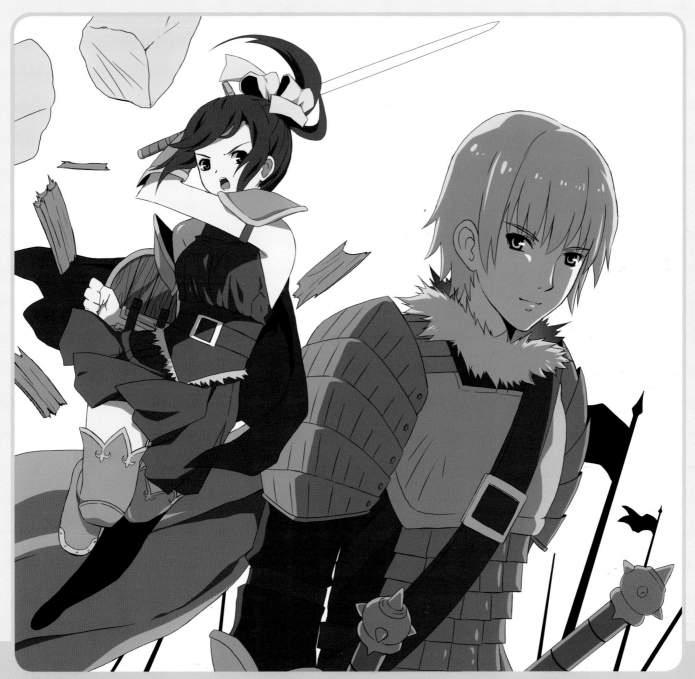

6.3. COLOR

We drew small points of light with the brush, only giving a few touches of it to specific areas of the characters. We also added some gradients over the boy's armor and on both swords.

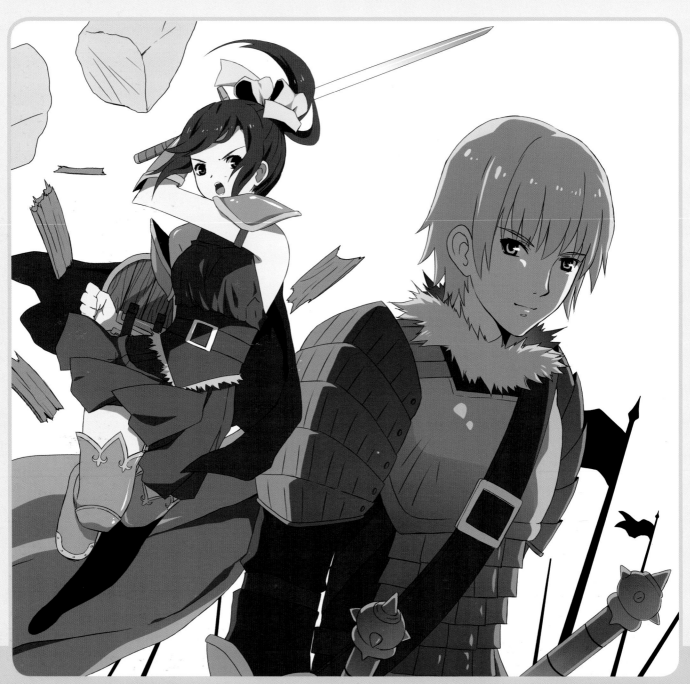

7. BACKGROUND

With a textured brush we can emulate the fog and dust cloud using tonal variations from greenish-gray to burgundy. We finished by defining the coloring and the shadows around the trees and rocks.

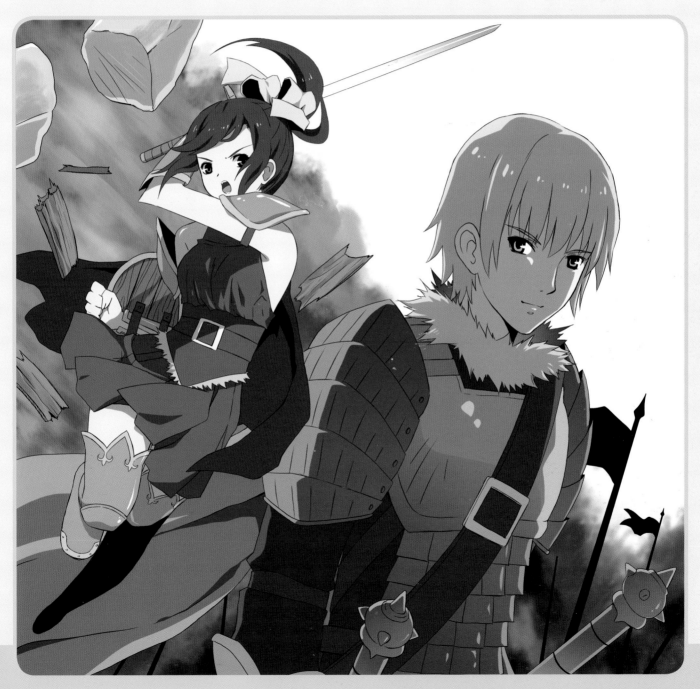

Finishing touches

- We duplicated the final image, blurring it with the Gaussian Blur Filter and lowered its opacity to 35% in the Multiply Blend Mode.

- We duplicated this second layer and set it in an Overlay Blend Mode. This way we could get the effect of motion and a dreamlike warrior feel.

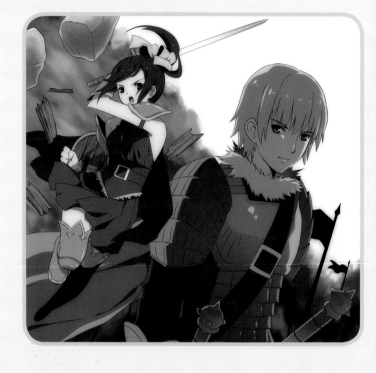

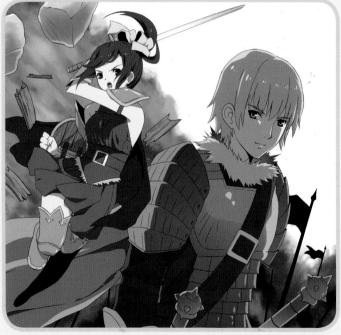

Tips & tricks

- When we want to instill strength and an epic touch in an illustration, we have to be careful creating the setting and the dynamics of the scene, as well as the final treatment we give it. By using effects we heighten the action.

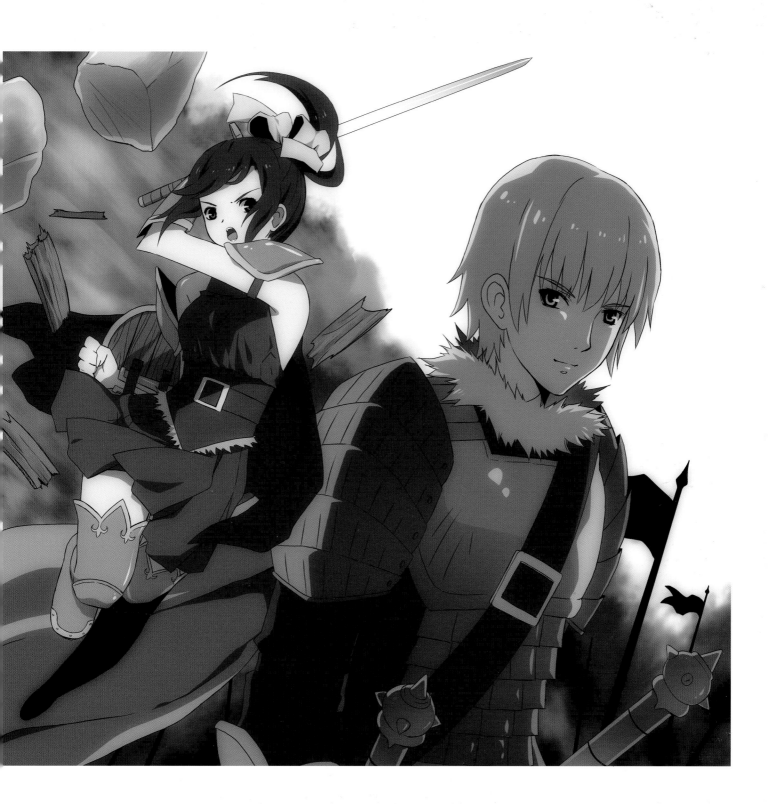

THE LAST ALCHEMISTS

For centuries, the secrets of the alchemists remained hidden from the rest of the world. Many desired their power, but these wise people knew how to guard their secrets. Over time, however, many perished and their knowledge ran the risk of disappearing with them. Now, Albert and Kimira are the last two experts in alchemy left. But their existence is in peril, as they are being pursued by a mysterious organization that seeks to permanently finish them off.

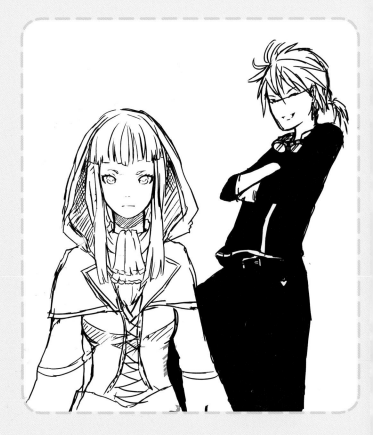

1. SKETCHES

We designed different characters until settling upon a composition that would have a mysterious and magical air to suit the alchemists.

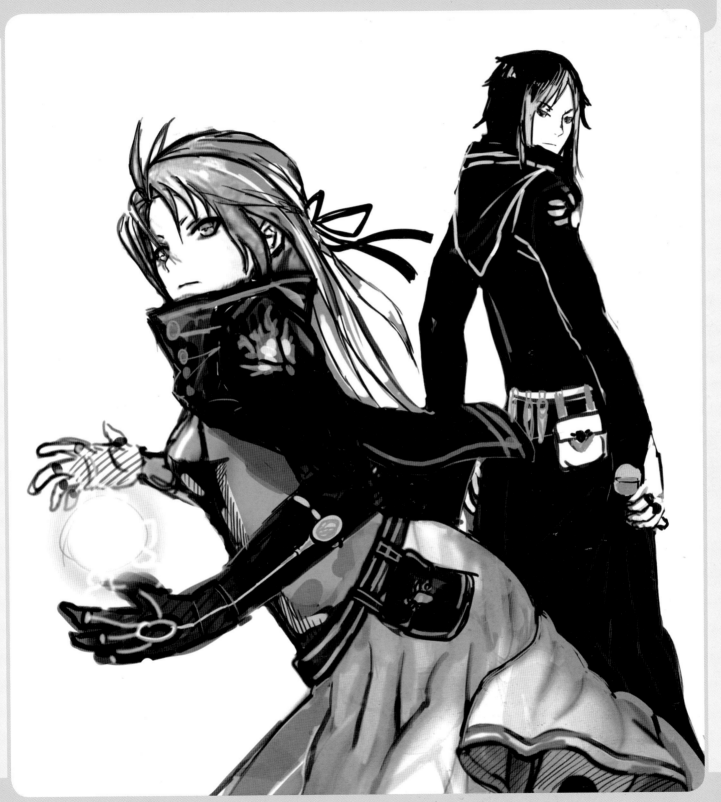

2. STRUCTURE

We defined the figures by tracing curved axes for their spines and ovals for their heads. We then drew the remaining parts of the body, slightly varying the initial posture of the boy, whose hands we raised.

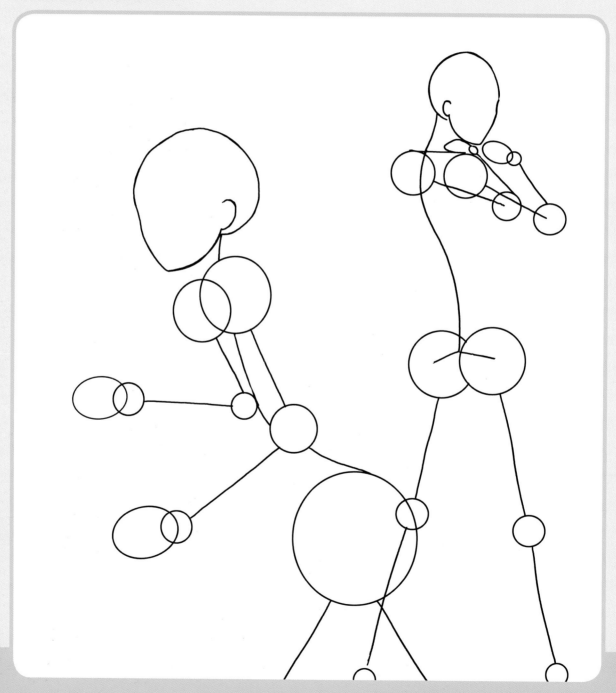

3. VOLUME

We clearly differentiate the two types of bodies. The boy's is much more slender, while the girl's is rich in curves. Here we can clearly see the right way to draw the characters' hands.

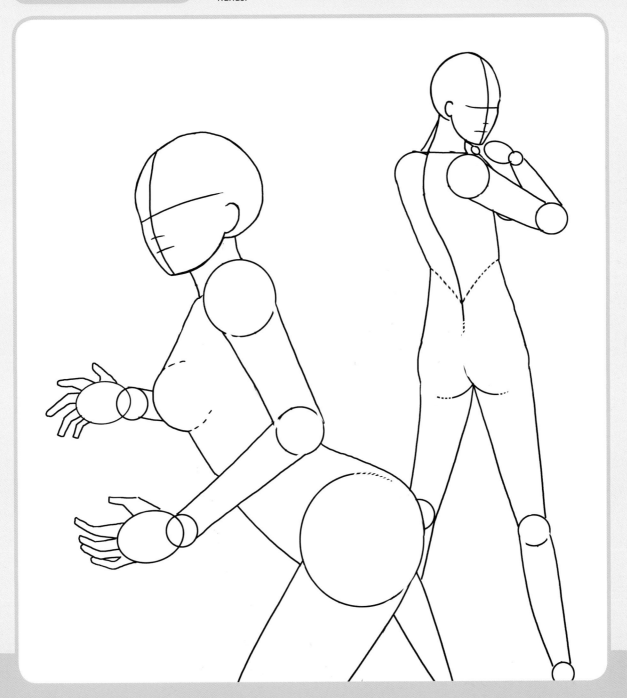

4. ANATOMY

The facial expressions should be firm and serious. We paid special attention to the posture of the hands making the spell, which are the focus of attention in the drawing.

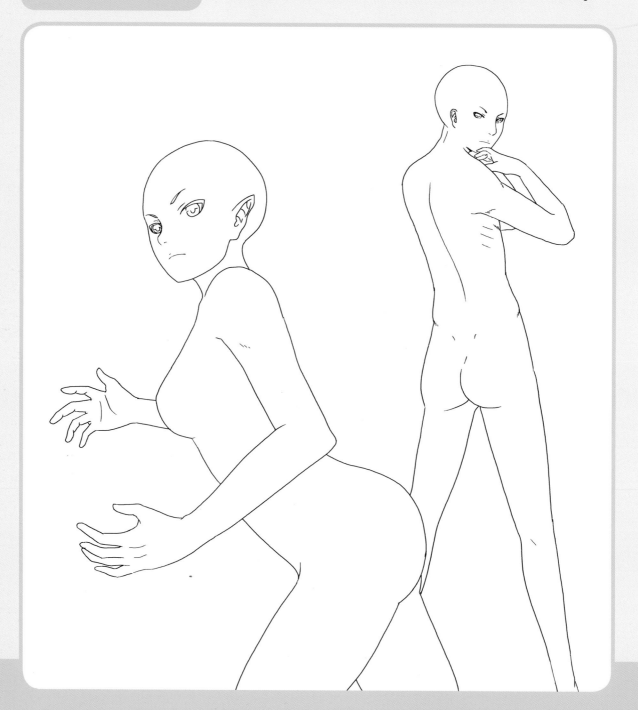

5. DETAILS

The clothes have a military cut mixed with typical elements of video and role game magicians. In this step we added the characters' hair.

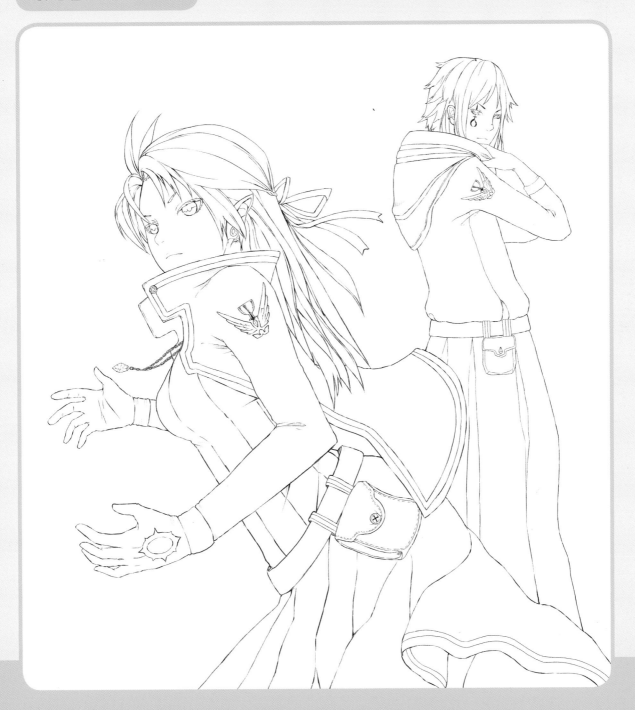

6.1. COLOR

We filled in the largest color areas to define the image's predominant color range.

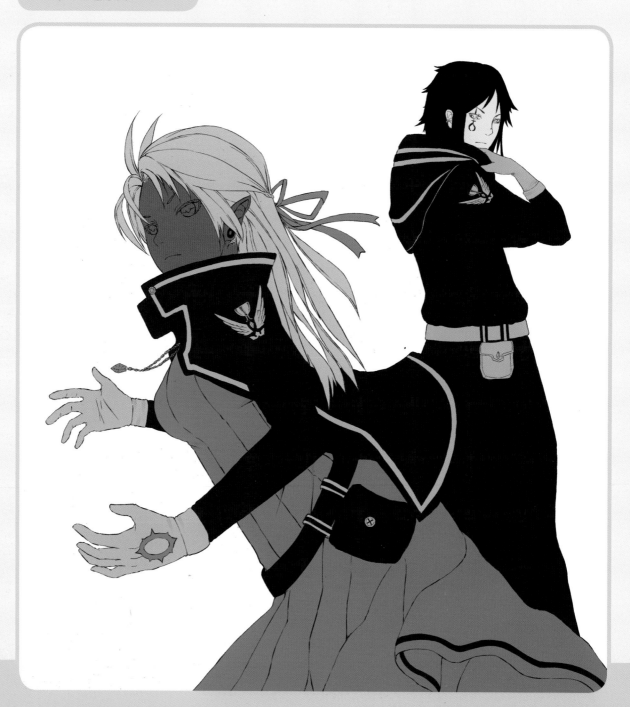

6.2. COLOR

The shadow layers are placed on top of the base layer as a Clipping Mask in order to make shadows with gradients so effects can be used without them influencing the initial color.

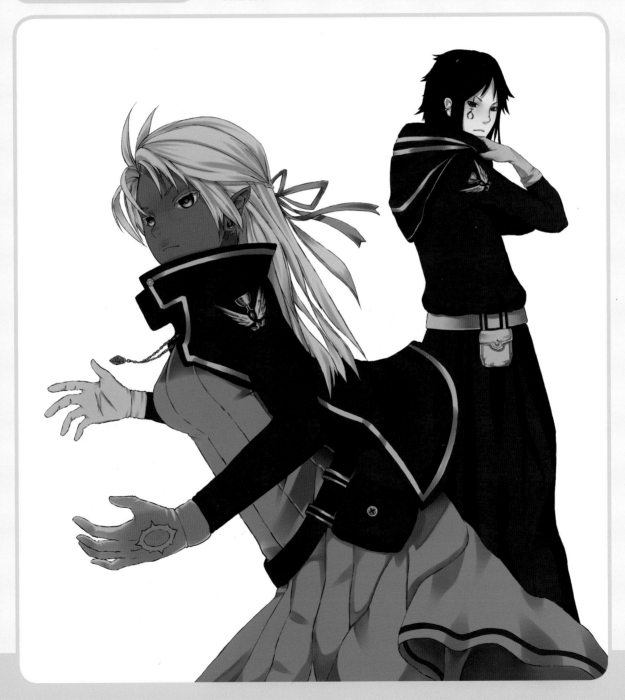

6.3. COLOR

In a new layer, we painted in the highlights, using a brush to define the different areas of light, which we fade so they blend in better with the rest of the darker tones.

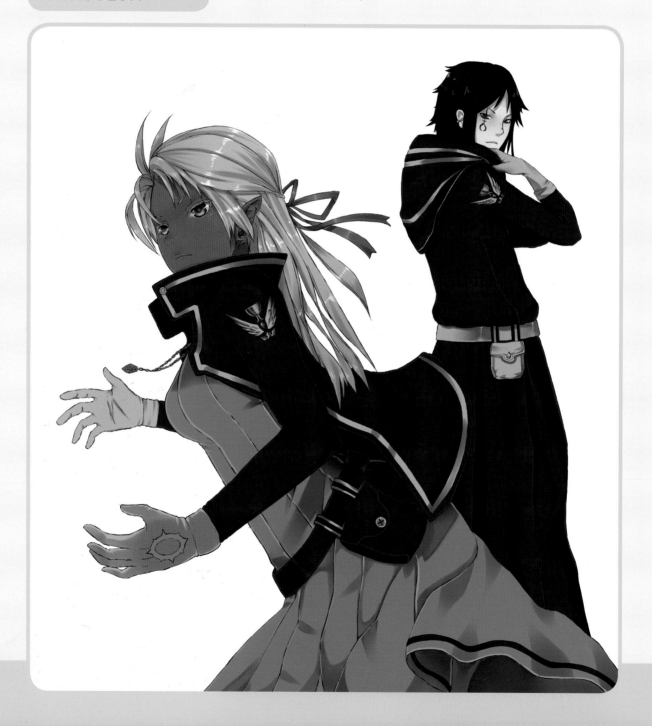

6.4. COLOR

In order to see the spells's magic light effect, we filled in the background with gray and drew beams within the magic ball, which we filled with light using the Outer Glow effect from the Layer Blending Options.

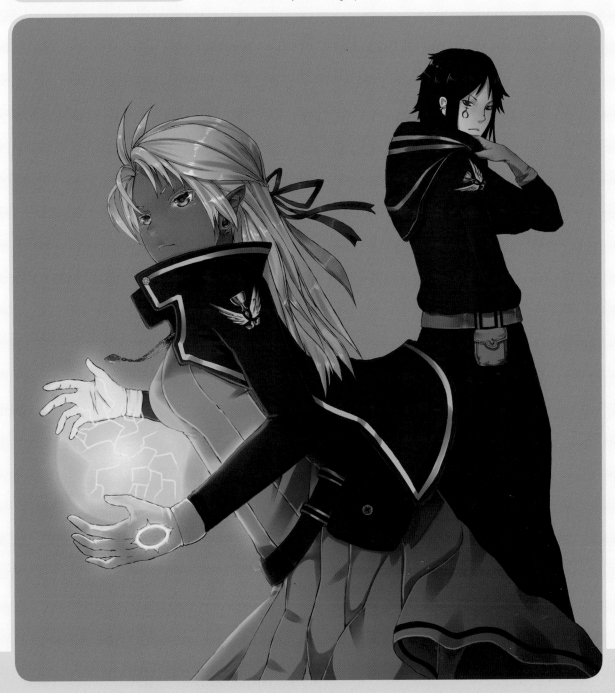

6.5. COLOR

In the background we place a vector drawing that looks like magic symbols, applying an Outer Trace Effect and a Parallel Shadow from the Layer Blending Options, as well as adding in the clouds that surround the wizard.

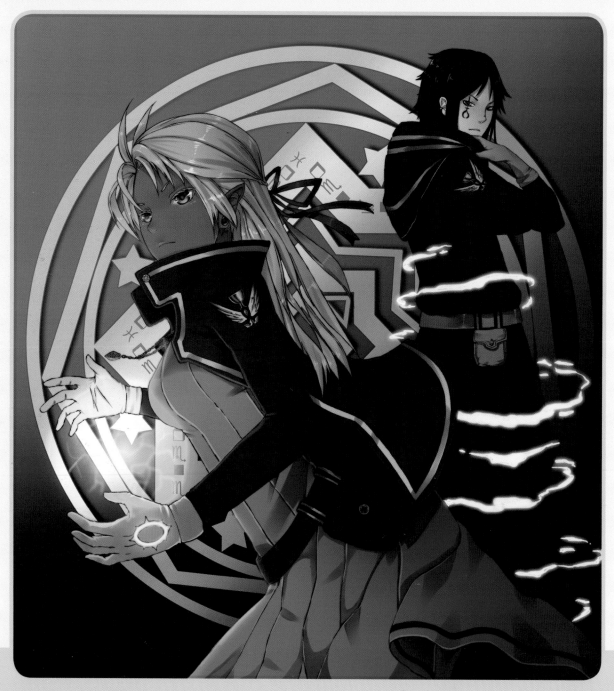

6.6. COLOR

We correct the colors in the image to give them greater contrast, warmth, and brightness, which will help us present the illustration's details more clearly.

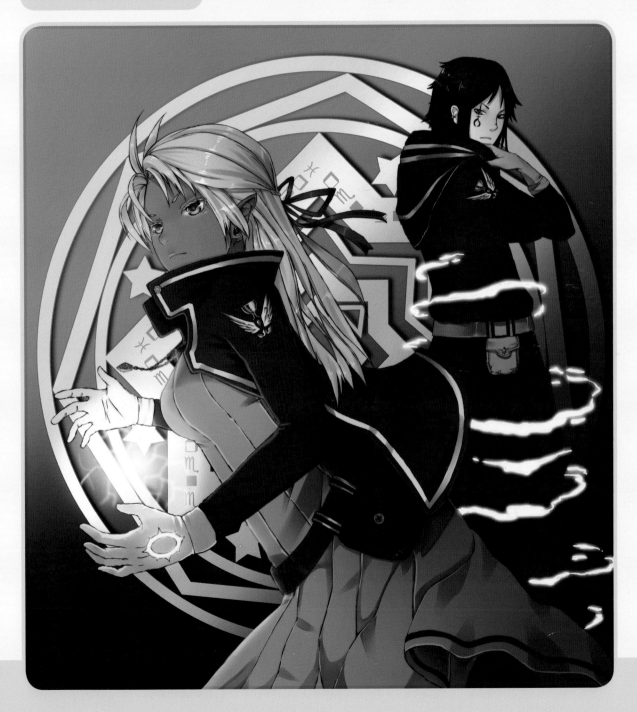

Finishing touches

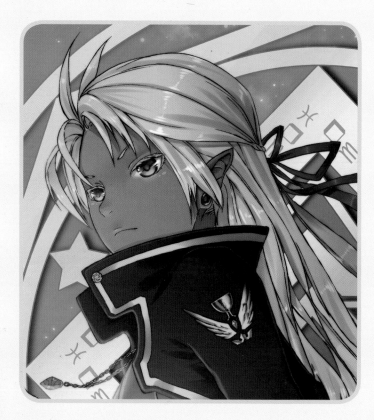

- We applied light effects to the image, polishing the base outlined in the previous steps.

- We drew in the moon, slightly out of focus, and painted clouds in the sky, as well as a few more points of light.

Tips & tricks

- We defined the color areas using vector layers in the SAI program, filling them in later with the Paint Bucket Tool.

- The clouds were drawn using customized cloud brushes and for the stars and points of light, a layer in the Outer Glow Blending Options.

- Photoshop shapes were used for the symbols in the background, combining the circle with others, such as the stars, which were then flattened together. Finally, the runes were added at the top.

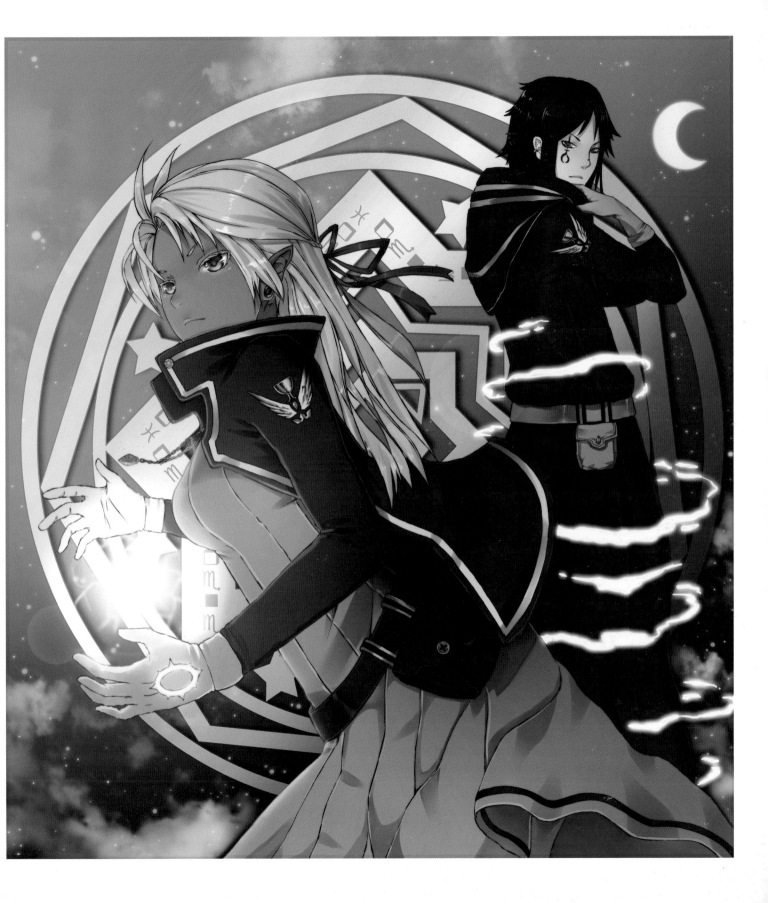

FALLEN ANGELS

The angels, who had confronted the divine plan, were banished to Earth and punished until they had recanted their sins. The devil, who saw this as the perfect opportunity to tempt these wayward angels, joined them into a gang to make sure they never returned to heaven. But God had no intention of letting his children fall in the claws of Lucifer and sent Elohim, a fallen angel, with the mission of safeguarding the angels to Earth. In exchange, he would be allowed to become human again and live as a mortal alongside the woman he loves.

1. SKETCHES

We made many drafts for this illustration, although we were fairly clear on the concept for the warrior angels. The illustration we chose shows Elohim in all his glory, ready to face Lucifer.

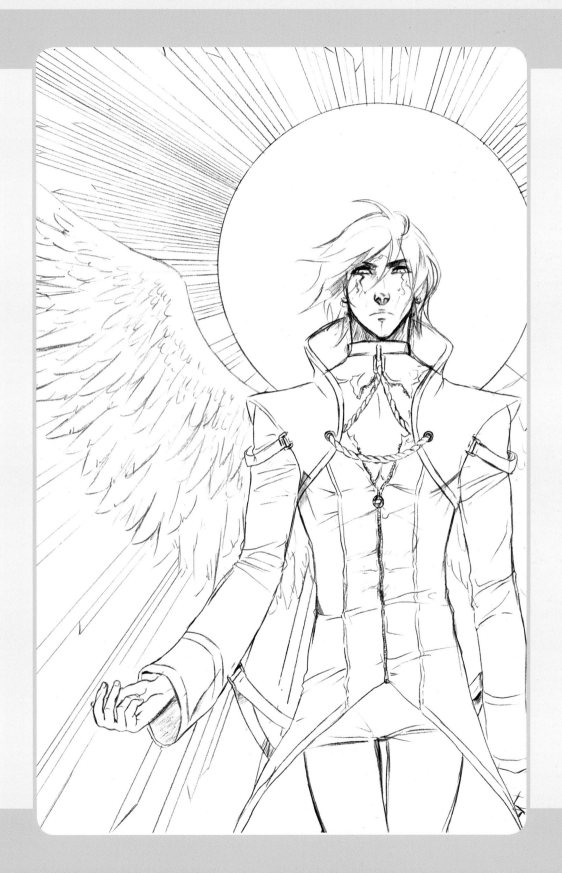

2. STRUCTURE

As simply as possible, we lay out the basic skeleton of the image, defining the proportion of the body and breadth of the ribcage.

3. VOLUME

We slightly adjust the size of the angel's back, define his limbs, and sketch in his wings and hair.

4. ANATOMY

The body, robust and realistic-looking, emphasizes the broad back and a more slender trunk and legs.

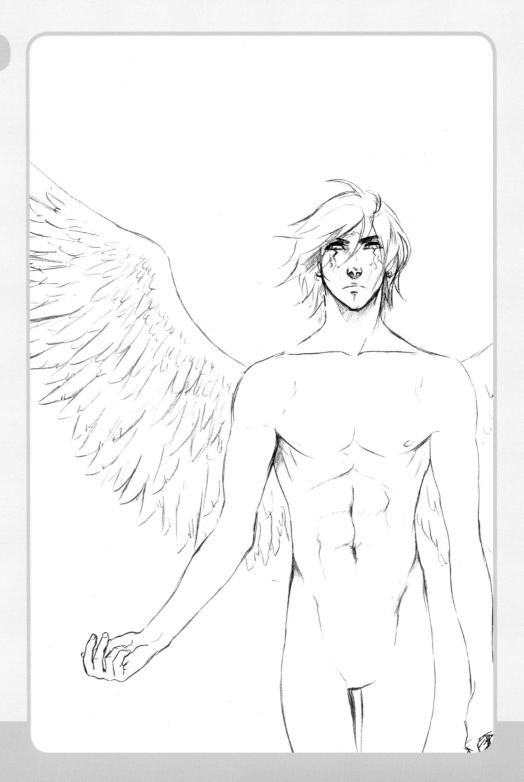

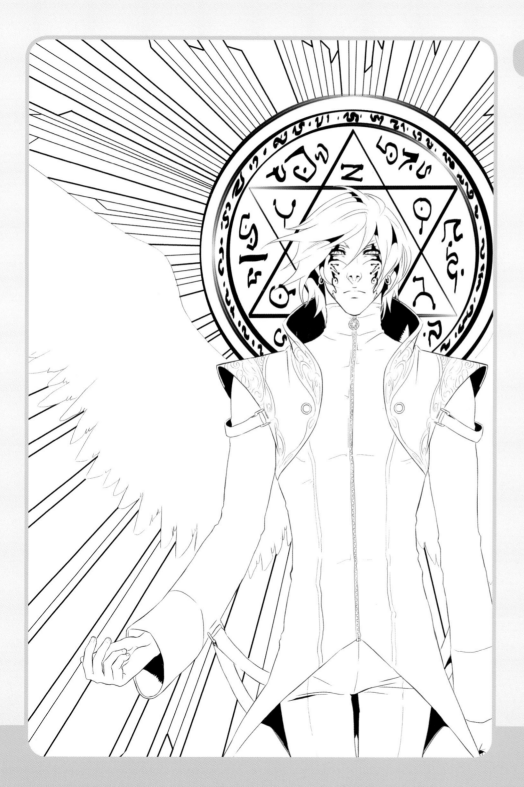

5. DETAILS

His outfit has an Eastern cut, both angular and elegant. We drew a Star of David in the background decorated with Aramaic-inspired letters.

6.1. COLOR

We applied several color layers on each of the main areas of the illustration.

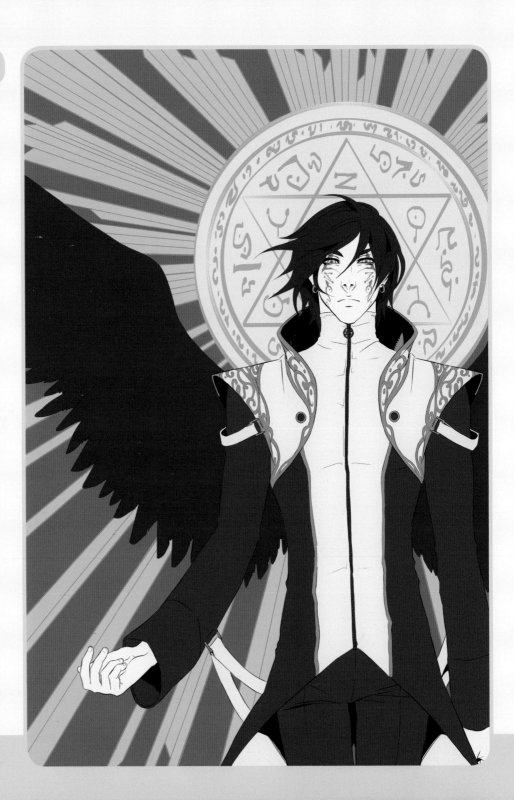

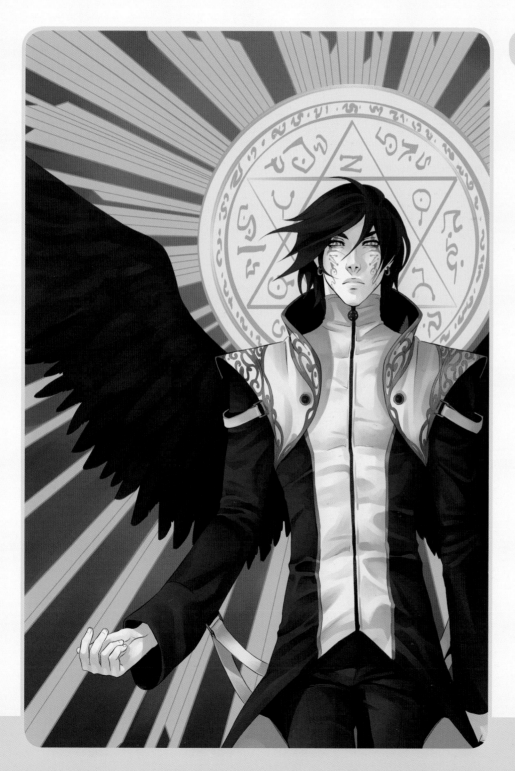

6.2. COLOR

We applied the first shadow tone using a brush with average Hardness and Opacity to have more subtlety. We faded the shadows to create volumes and applied a gray gradient to the background.

6.3. COLOR

We added the second tone of shadows using brushstrokes, aiming to give greater depth and details. We also nuanced the color of some areas and finished by adding new gradients and shadows to the background.

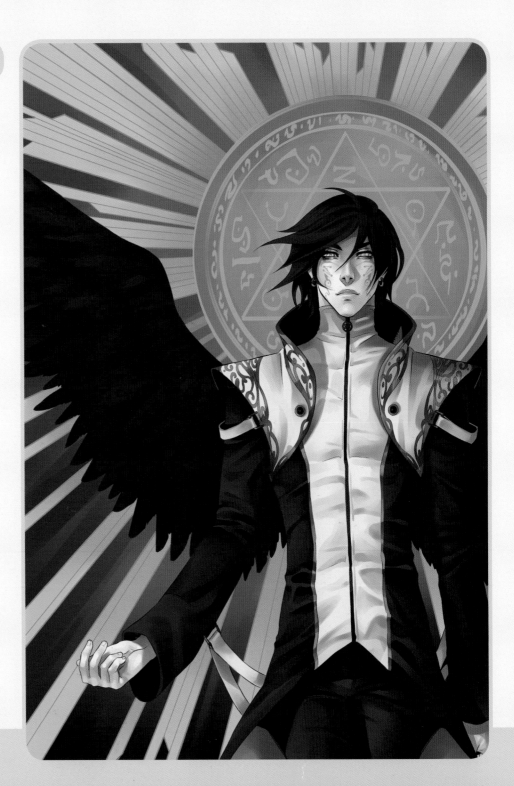

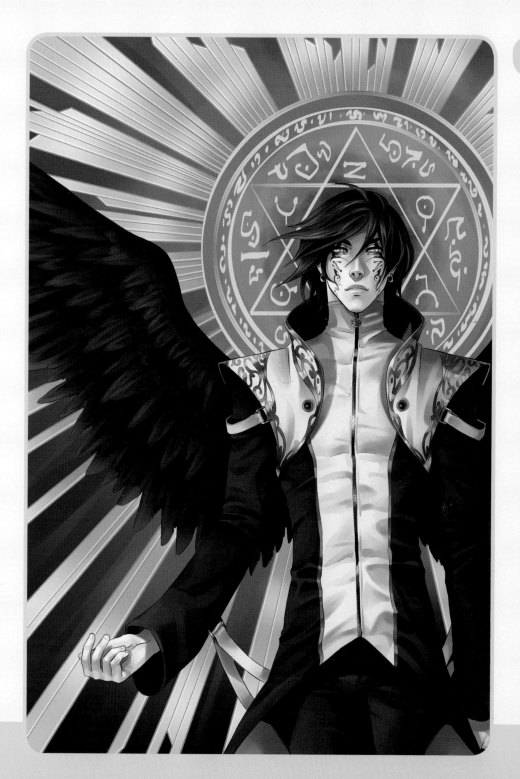

6.4. COLOR

We painted in the highlights, keeping in mind that the light comes from the top left. It doesn't have to be applied to the whole drawing, as it is better to only do it where something specific needs highlighting or stands out notably, such as metal parts, the hair, gems, and wing feathers.

6.5. COLOR

To represent the flames, we first drew tongues of fire on one layer, leaving out some translucent areas and applying the Outer and Inner Glow Effects from the Layer Blending Options.

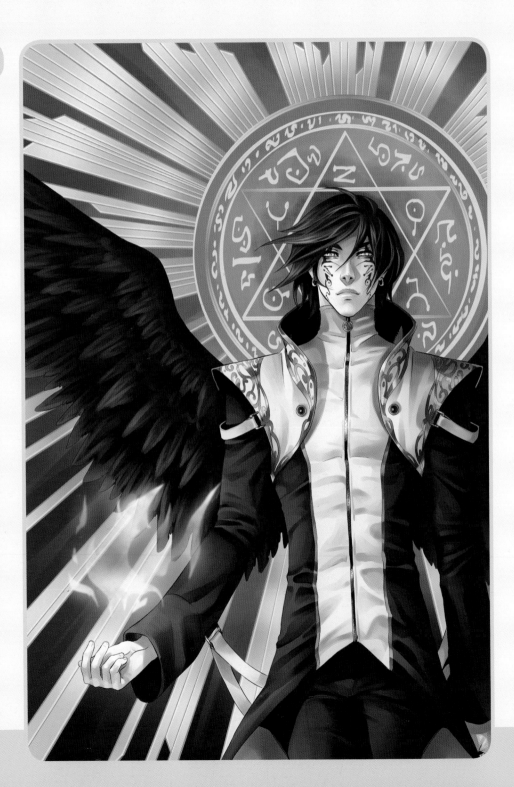

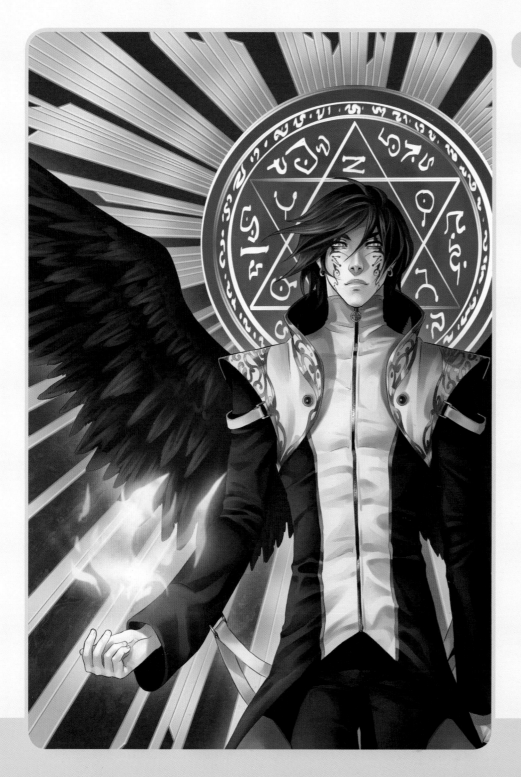

6.6. COLOR

We adjusted the background color and added a texture to give it more presence. We applied a second layer with short brushstrokes over the flames in the Intense Light Blend Mode.

Finishing touches

- We applied a light source behind the character to separate it from the background, textures to the halo, and outer light to the seal.

- We unified the colors on one layer in a single brownish tone at 5% opacity.

- We applied a third layer in a Bright Light Blend Mode over the flames and changed its color to pink, to give the image a touch more warmth.

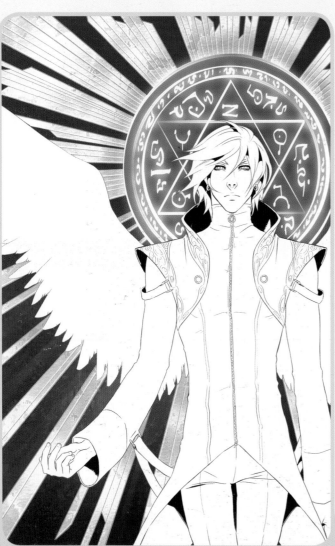

Tips & tricks

- There are two main keys to attaining a realistic and congruent finish to these types of illustrations:

 The first is to start with pastel colors that don't darken the image too much and give it a more natural color range.

 The second is having dexterity and coloring prowess with the graphics tablet, making soft brushstrokes to mark out the image details.

- A very common error is making shadows with tools that darken the color instead of with brushstrokes, so it's best to avoid using these types of resources as much as possible.

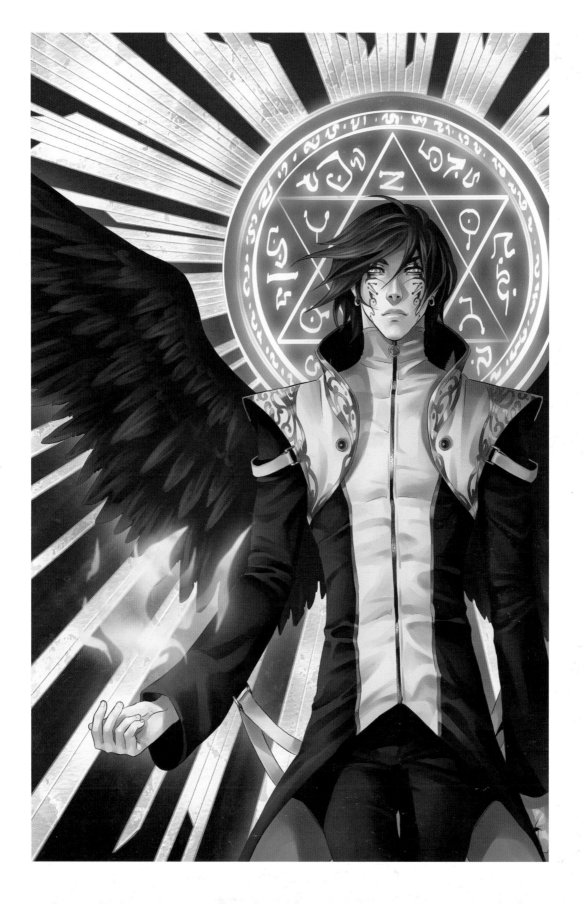

CURSEDMOONS

The year is 3014. Daylight has become too weak and tenuous; the night, darker than ever. It's hard to recognize people in Somnia, a city whose stalwart buildings block out the sky and lights are always dim. It's not uncommon to be taking a walk along a busy street and suddenly come across a lifeless corpse. The streets have something to hide, something silent and invisible—soul hunters, hungry for new prey. Want to see them? Pass through the same door they did in their day. Just remember, there are deaths more painful than you could ever imagine...

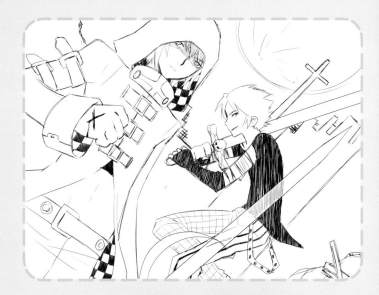

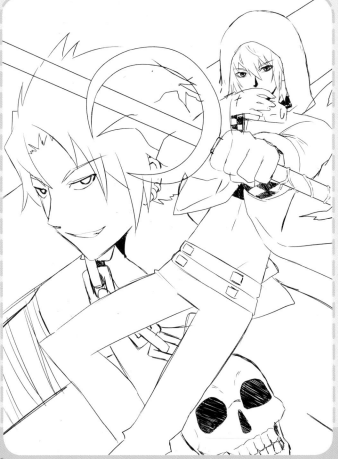

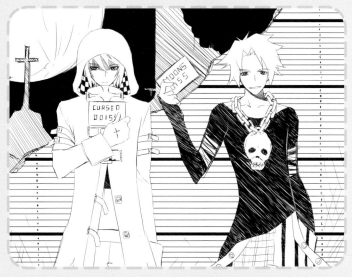

1. SKETCHES

The image we chose perfectly combines the dark seriousness of the idea with a more ironic, casual side that suits the psychology behind the characters.

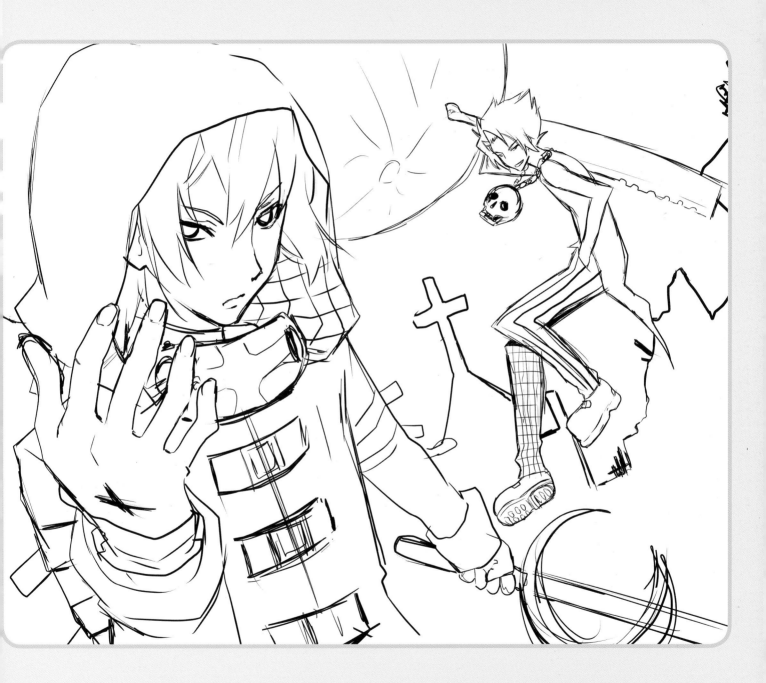

2. STRUCTURE

We placed the two characters in a way that emphasizes the depth of the image. Both have a curved central axis that gives them an ungainly look.

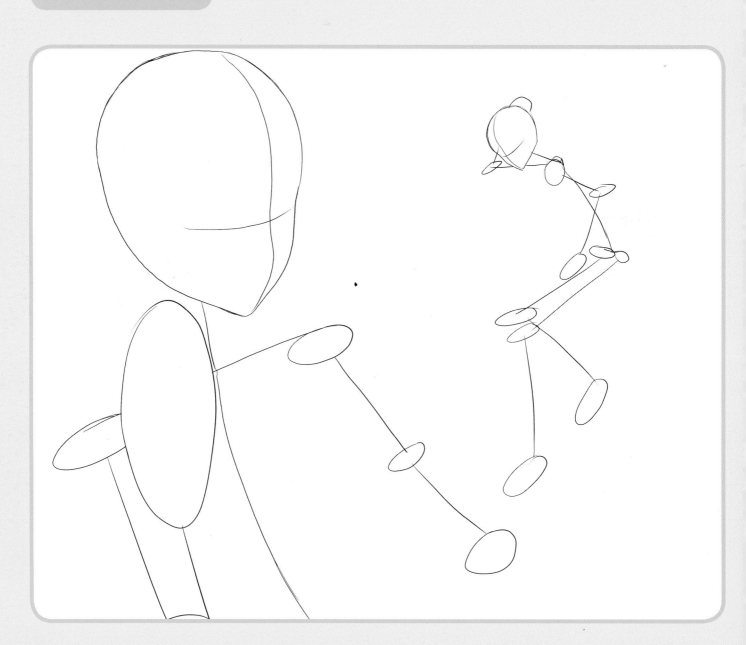

3. VOLUME

Along the lines of these rather scruffy teens, their bodies are slender and gangly. To draw the hands, we used a central oval to form the shape of the palm and then added its five fingers.

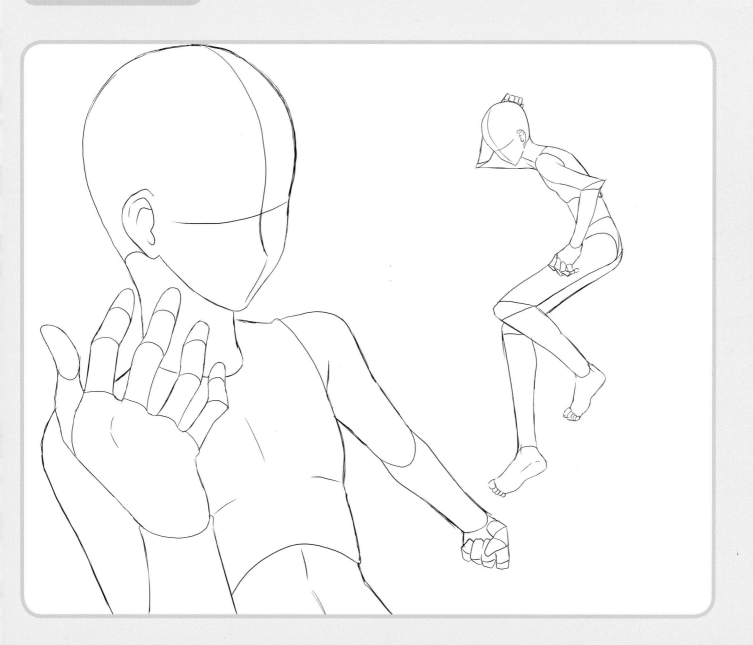

4. ANATOMY

Their hair had to be disheveled and uneven, marking them as rebels. Their young bodies are elongated but not wiry, while their hands are quite large. We simplified their features to give them a casual appearance.

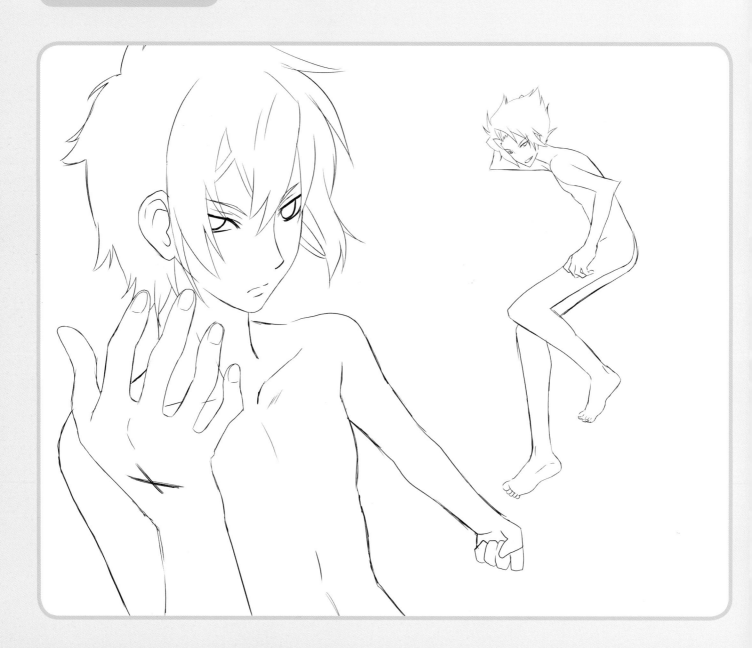

5. DETAILS

We added the teens' clothes, riffing on the typical garb of a hooded warrior and an armed warrior, who holds an oversized sword. Both wear Gothic-inspired clothes.

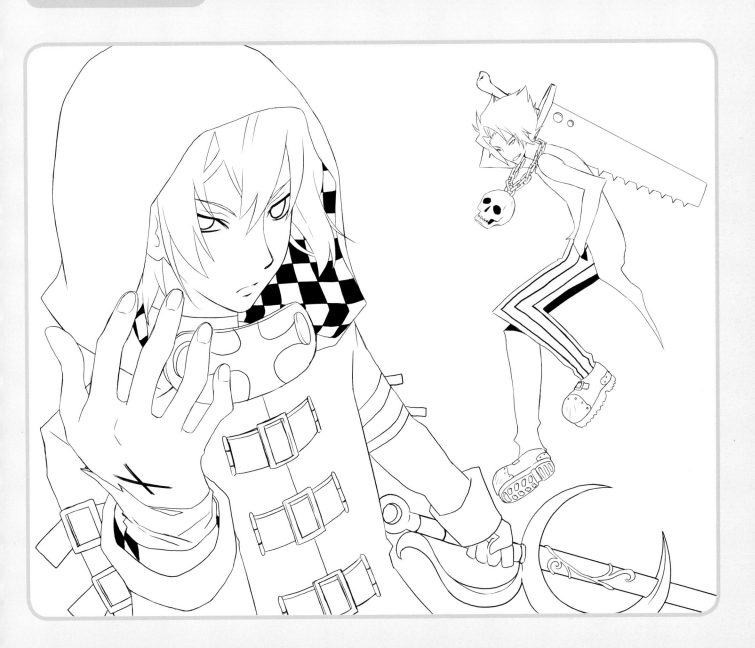

6.1. COLOR

The illustration's base colors combine burgundies and browns with greens, yellows, and grayish purples, aiming to transmit contrast, but also warmth.

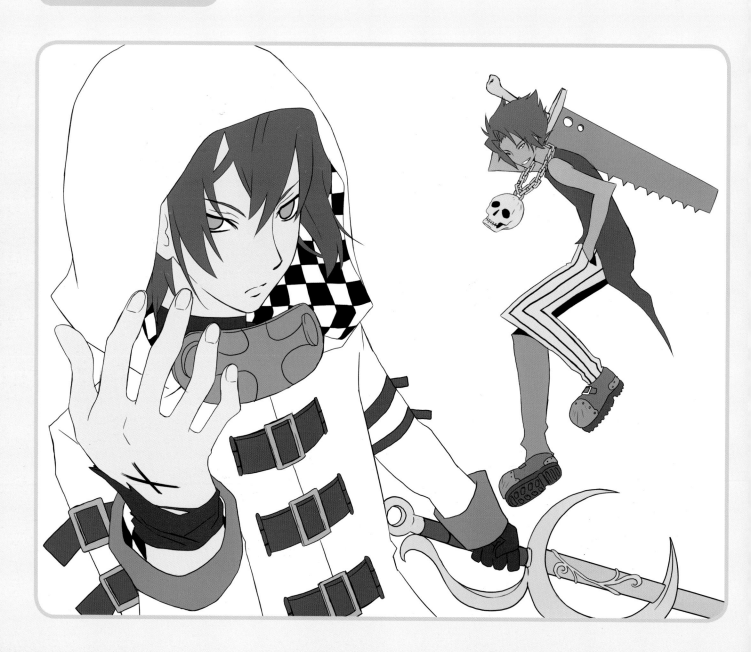

6.2. COLOR

We applied several shadow layers, the first level being darker in respect to the base colors, while the top layers are sharper and black. We also applied a gradient and a checkered texture on the background character's pants.

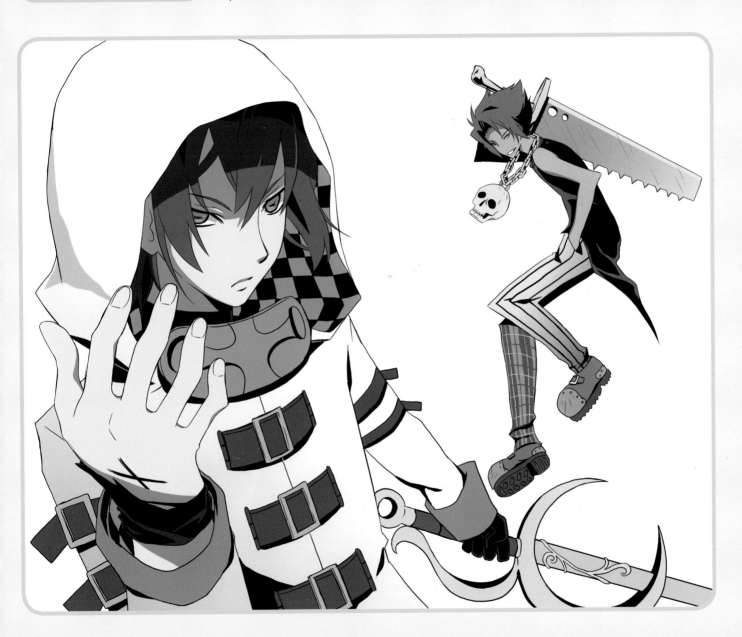

6.3. COLOR

We made short brushstrokes to highlight specific areas, magnifying the darkness and contrast of the image. Having a light base color juxtaposed with heavy shadowing helps define the strong lighting that marks the whole drawing.

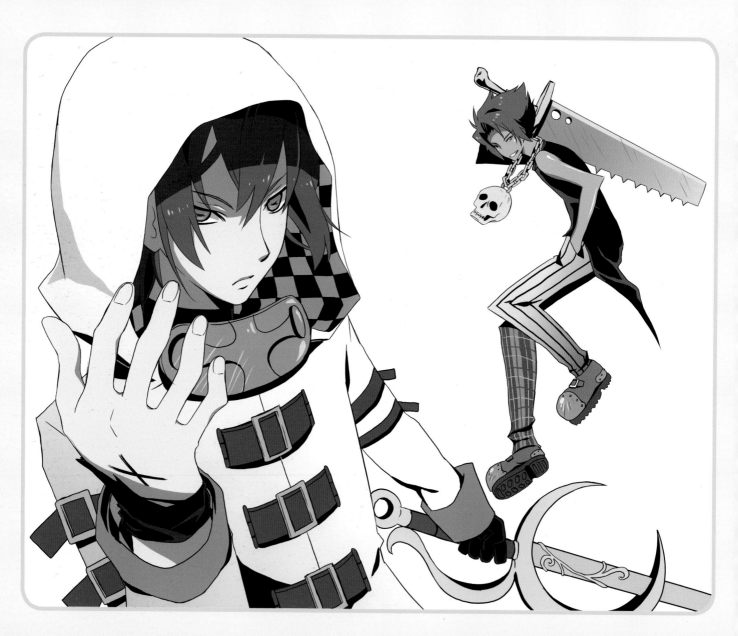

7. BACKGROUND

In the background we drew the silhouette of a cemetery and painted the base color to differentiate the darker sky and the lighter buildings.

Finishing touches

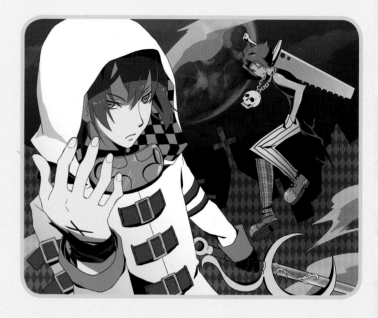

- We drew the roughness of the moon by using a textured brush and painted clouds in the sky.

- We used a rhomboid motif to fill in the outlines of the building, and applied a gradient to it.

- We drew semitransparent clouds of smoke in the background.

- We applied an Outer Glow to the characters, then duplicated the resulting blurred image and darkened it slightly in the Multiply Blend Mode at low opacity.

Tip & tricks

- This illustration was colored in Illust Studio, but the final effects were done in Photoshop.

- Illust Studio has brushes that draw in textures, and are quite useful in providing consistency and details to rough elements.

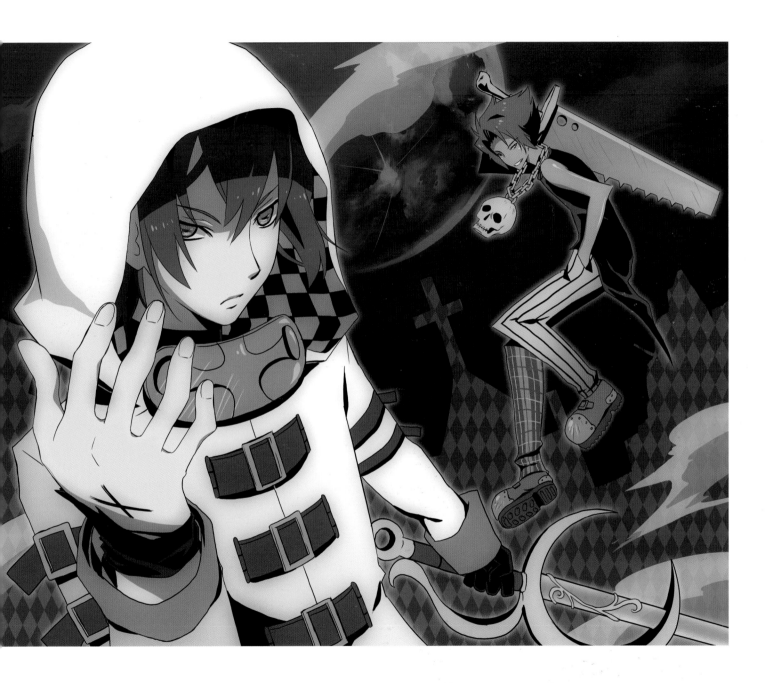

THE LEGEND OF SAINT GEORGE

Many years ago, a terrible dragon was mercilessly attacking the village of Montblanc. The king decided to offer young virgins in sacrifice to satisfy the monster's insatiable hunger. One day, however, it was the turn of the princess of the kingdom, the only heiress to the throne. In a moment of carelessness on behalf of the dragon, the princess managed to escape the dragon's claws and find a knight, Saint George, who after hearing the horrible story swore to face the dragon and protect her with his life.

1. SKETCHES

We opted against the first sketches that didn't demonstrate Saint George in clear combat mode, instead focusing on an image that would show off the warrior's impetuousness, without forgetting his saintly halo.

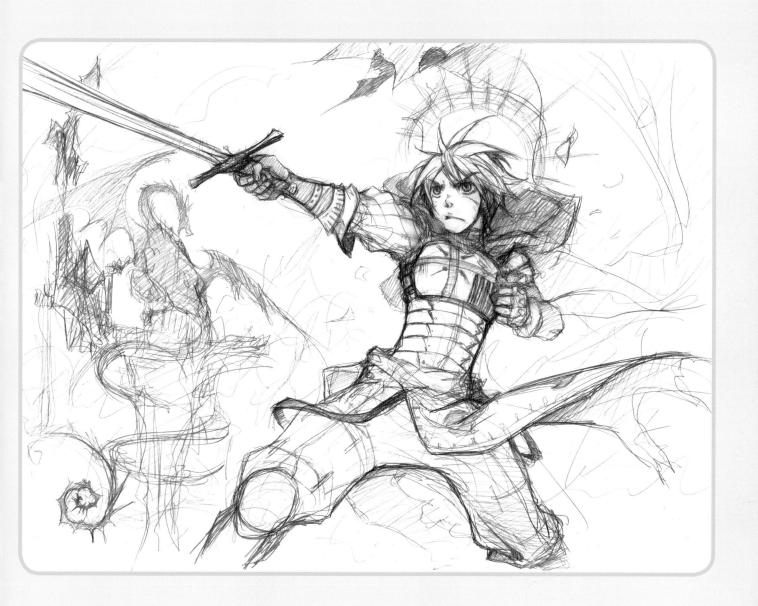

2. STRUCTURE

We positioned all the elements along a diagonal line that balanced out the composition. We also made an initial approximation of the shape of the hand and its posture holding the sword, along with a sketch of the dragon.

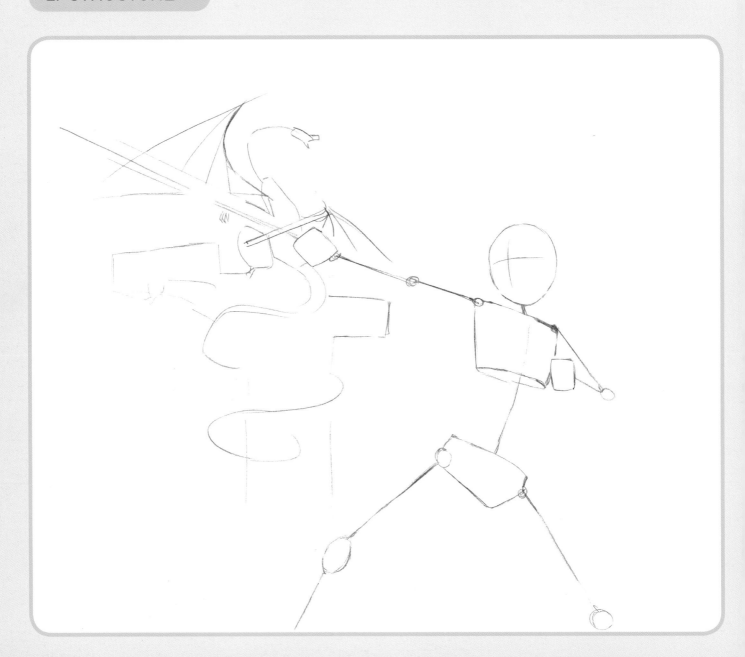

3. VOLUME

The figure had to be slender yet firm and strong, which meant the thickness of his arms had to show the strength of a hero. His hands warranted special attention, along with the movement of his wrists, marked with ovals to simplify the final drawing.

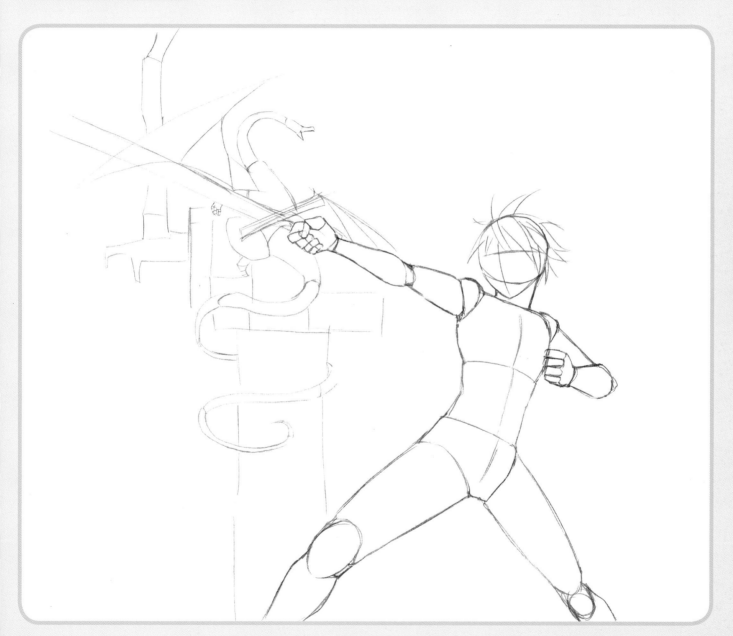

4. ANATOMY

In order to properly fit the armor and cape, we carefully detailed the musculature of the knight's body. We finished by drawing the hands, making sure the fingers were thick, like those of a warrior, and fit around the sword handle.

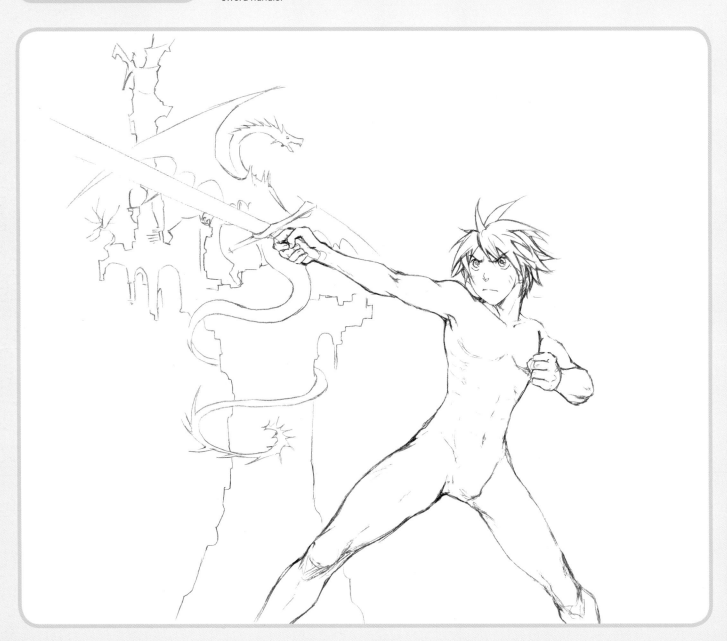

5. DETAILS

Saint George's clothes are entirely medieval, emphasizing his armor and the flow of his cape, and making him more dynamic. We defined the shapes and volumes of the background and dragon with pencil shadowing.

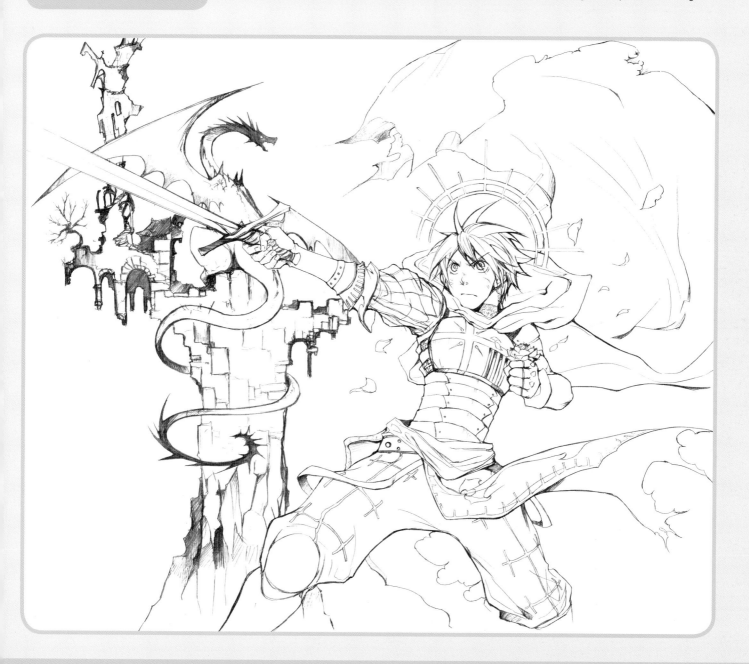

6.1. COLOR

We set the drawing's color range using flat colors and a single flat color for the background. To keep ourselves organized, we distributed the various colors in different layers in the Multiply Blend Mode.

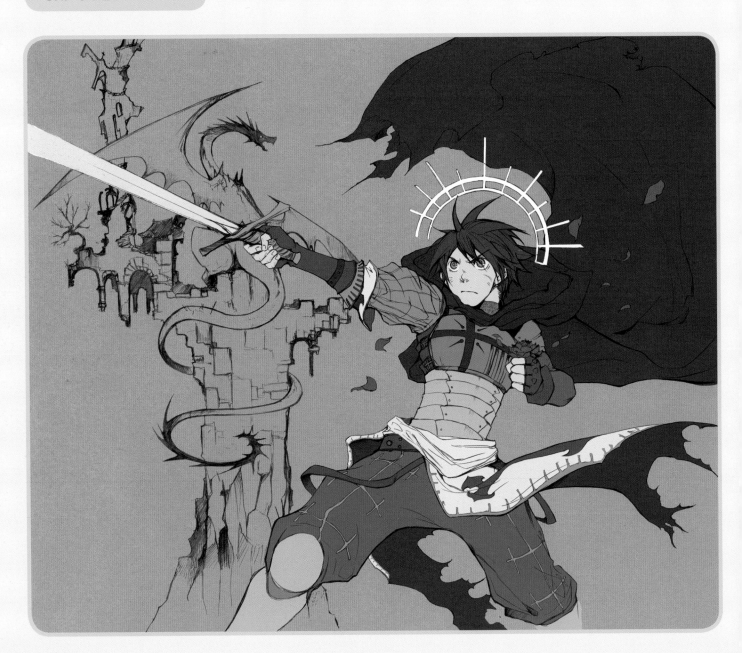

6.2. COLOR

We applied the shadows in a new layer in the Multiply Blend Mode using lilac and pale mauve.

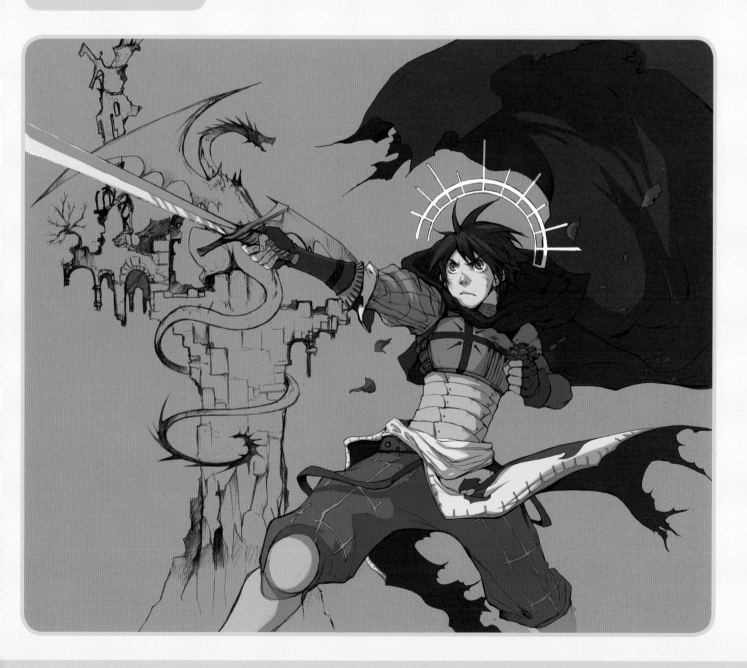

6.3. COLOR

We detailed the texture of the metal armor with dust and scratches, keeping in mind the light source coming from the top left. We softened the shadows with the eraser in watercolor brush mode.

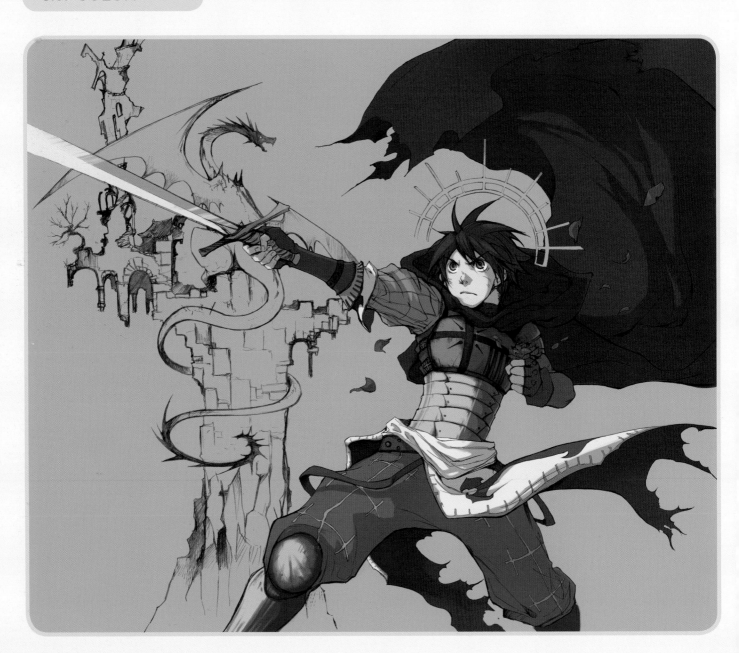

6.4. COLOR

We finished coloring Saint George by brushing in small highlights in the Linear Burn Blend Mode (Add), and some extra details such as some small points of light.

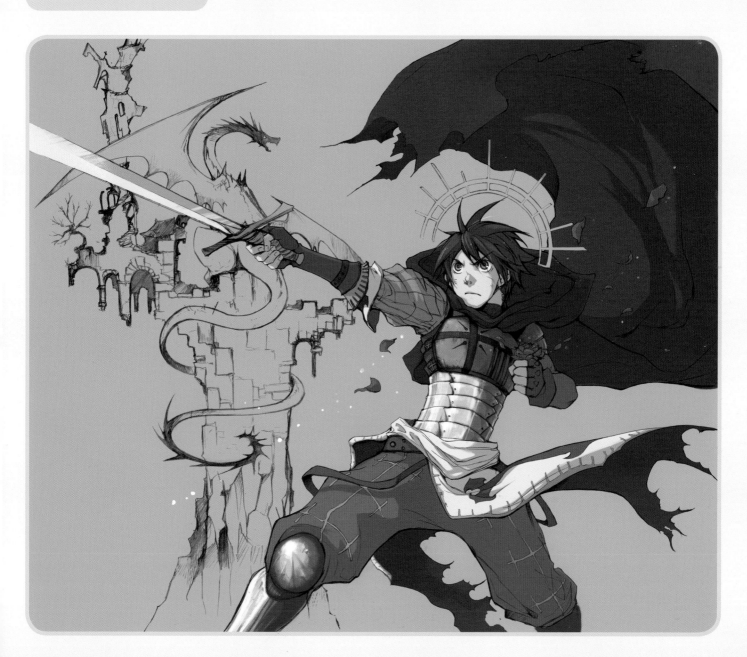

6.5. COLOR

We then focused on the background, painting the dragon in two colors and the tower in gradients. For the background, we used large-sized brushstrokes in different opacities to look like clouds of dust.

6.6. COLOR

We painted the bright halo of the saint in a new layer in the Bright Blend Mode with an Outer Glow Effect. To the base of the background, we applied an orange gradient with a Linear Burn and another over the dragon in the Overlay Mode. We added gusts of wind and dust in the Screen Blend Mode.

Finishing touches

- To several copies of the wind layer we applied Motion Blur and Gaussian Blur Smart Filters, overlaying them in different layers in the Screen and Brighten Blend Modes.

- We converted all of the character's coloring into a Smart Object and applied a Gradient Overlay Effect in the Layer Blending Options.

- We added extra brushstrokes for shadows, details, and final touch-ups of the illustration, such as gradients and darkness areas that give the image more contrast.

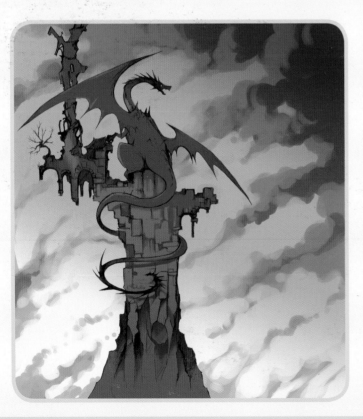

Tips & tricks

- We worked with the character and background separately. After scanning the pencil drawing, they were joined together in Photoshop. Because the illustration is not colored in, the levels were adjusted so the lines would have enough contrast.

- Saint George's halo is painted on a layer with a Bright Light property, adding an Outer Glow effect in an Intense Light Blend Mode and 87 pixels. For more brightness, it was duplicated and placed in a Screen Blend Mode.

- By working on the background and character separately, we were able to arrange the layers in separate groups to let us work more easily.

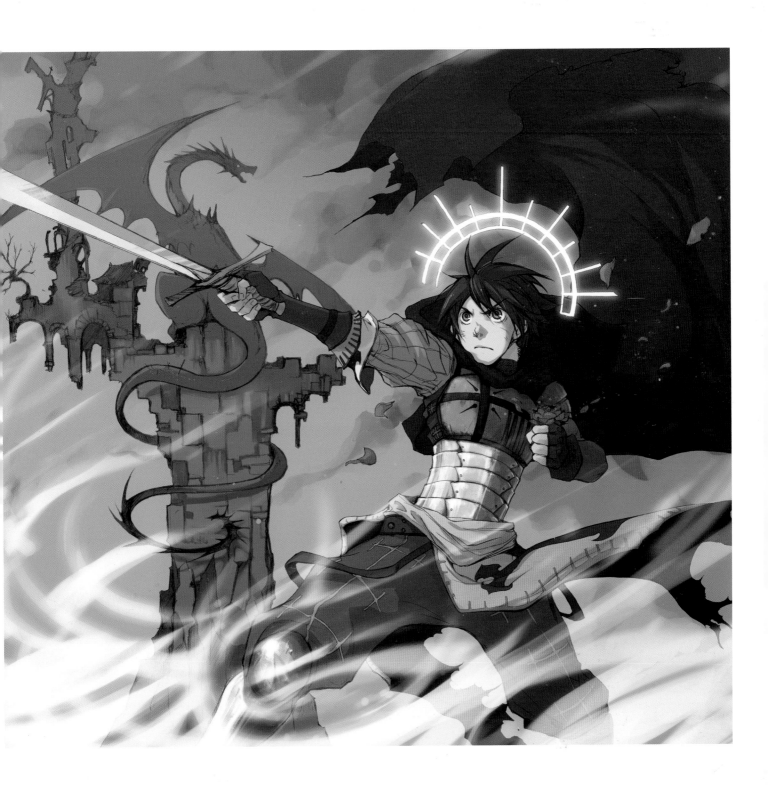

EXTRAS

CREDITS
ARTISTS
GALLERY

CREDITS

 FIGHT IN ORIENT CITY by Frederick Francis

 THE DEMONIC PRIESTS by Lolita Aldea

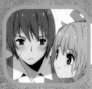 **GRADUATE OF LOVE** by Akane

 THE DARK SAMURAI by Carlons Anguís

 ELLIOT'S MYSTERIES by Eva Criado

 THE IMPERIAL DEMON HUNTERS by Laura Garijo

 SOCCER STAR by Noiry

 AKAI, THE LITTLE NINJA by Frederick Francis

 HIGH SCHOOL NIGHTMARE by Frederick Francis

 VIRTUAL DEFENDERS by Arhiee

 RONIN by Gina Chazón

 ULTRAROBOT by David Velásquez

 ANDROID 5.0 by Gina Chacón

 THE LAST ALCHEMISTS by Arhiee

 THE SPACE CORSAIR by Marta Salmons

 FALLEN ANGELS by Noiry

 BANDITS OF THE FAR WEST by Marta Valentín

 CURSEDMOONS by Akane

 ARABIAN NIGHTS by Patricia Velázquez

 THE LEGEND OF SAINT GEORGE by Marta Salmons

 RISE OF THE VALKYRIES by Eva Lara

 FANTASY JUNCTION by Akane

ARTISTS

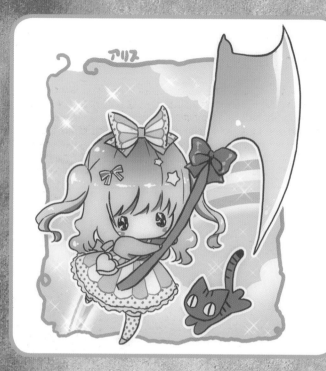

AKANE Melilla, Spain

Honing her skills in the world of *dôjinshi*, Akane began publishing professionally with the manga series *Yaruki! St. Cherry High School*, managing to put out a total of six issues, and contributed in the Italian magazine *Mangaka!* with a short story titled *Winged Souls Online*. She was also an illustrator for books such as *Kodomo Manga: Super Cute!*, *Shôjo Manga: Pop & Romance,* and *Manga Master Class: Gotik&Punk* published by Monsa, and the illustrated collection of classic tales, *Guru Guru*. But her greatest recognition has come from the online video games and fan-art she has created based on the characters of her favorite series.

Web: www.cursedmoons.com

ARHIEE Madrid, Spain

Completely self-taught, this Madrid native, barely eighteen years of age, is one of Spanish manga's most promosing stars. Although she studied science in high school, her dream has always been to devote her talents to the world of illustration, mastering all manners of traditional and digital techniques, but being a true specialist in the latter. After winning an award in a mathematics photography competition, her work was exhibited at the Madrid Zoo Aquarium. She has also recently contributed to a book of illustrations.

Web: www.arhiee.deviantart.com

CARLOS ANGUÍS Barcelona, Spain

Carlos began by studying as an artist at the Joso School in Barcelona. Then, after attaining a degree in Production and Multimedia Shows at the Sant Ignasi-Sarrià college in Barcelona, he specialized in digital illustration and animation at the Serra i Abella School of L'Hospitalet de Llobregat (Barcelona). He has done stage design for small plays at the Teatro Romea and worked as a multimedia graphics designer for the Barcelona company Solucions Multimèdia in their SM group.

Web: www.carlosanguis.wordpress.com

DAVID VELÁSQUEZ Bogotá, Colombia

After earning a degree in Graphics Design at the Jorge Tadeo Lozano University of Bogota, this illustrator and cartoonist began his career drawing storyboards for the renowned Leo Burnett publicity agency, for customers such as McDonalds and Alpina. At San Diego Comic-Con, he met the Canadian company Zeros 2 Heroes, with whom he later would work on the production of the animated series *Animism*. He published four illustrations in the 2010 and 2011 editions of the Comic-Con's book, and took part in the tribute book for the video game *Darkstalkers* developed by Udon. He currently contributes to the pop culture magazine *Shock*, for which he creates monthly illustrations of celebrities living in Colombia.

Web: www.eldeivi.deviantart.com

ARTISTS

EVA LARA Badalona, Spain

Born in Marmolejo (Jaén, Spain), Eva studied Fine Arts at the Alonso Cano University of Granada before moving to Barcelona. She has contributed to the magazines *Dokan* and *Aresinformatica*, published comic strips, illustrated pin-ups, and drawn a manga cartoon for the Spanish version of the Japanese *B ŚLOG* published by Planeta de Agostini. Medea Ediciones published the first issue of her comic, *Hunter of Tales*, and she published a comic ad for Esdecomic. She has also designed Flash games for Macrojuegos.com and Chicasgames.com by Panaworld, administers and designs the web page of the manganime website MisionTokyo.com, and has illustrated the web page of a game for the iPhone by studioLinguaFranca. She presently works as a colorist and inker at Estudio Fénix and as a 2-D artist for multimedia games at Downtomoon. Her highest recognition was her poster for the XV Manga Show at Ficomic.

Web: www.hlya.deviantart.com

EVA CRIADO Córdoba, Spain

After finishing her studies at the fine arts high school of Cordoba, Eva began making commissioned works for private patrons, and since then has been working as an artist and illustrator for several doujinshis, fan books, and illustration books based on popular anime series and Japanese video games, such as *Umineko no naku koro ni*, *Death Note*, *Madoka Magica*, and *Touhou*. She took part in the illustrations book *Pivix girls collection 2011* and illustrated the current business card and masthead for the Koi-nya.net website. She also won the CG competition for the game *Ougon Musou Kyoku 2*, which is now in development.

Web: www.3-keiko-chan-3.deviantart.com

FREDERICK FRANCIS Las Palmas de Gran Canaria, Spain

Since childhood, Frederick's drawings have been inspired by video game and manga characters. He attended the Gran Canaria School of Arts and Design, where he earned an Associate's Degree in Arts and took part in his first group exhibition. A year later, he earned a Bachelor's Degree in Illustration at the same school. In these years, he took part in a group exhibition, Cuatricromía de la Muerte, at the Atlantic Center of Modern Arts. In 2007, he was awarded 2nd prize at the Comics Workshop of Las Palmas de Gran Canaria, and a year later, he published his first work, a compilation of the winners of the Global Company's Literary Competition. His work *Good.Night.Mare* will be published as part of a Gaijin Line of manga comics by Glénat.

Web: www.ff69.deviantart.com

GINA CHACÓN Chihuahua, Mexico

A Visual Arts graduate, Gina is one of the founders of Studio XIII, an independent comics studio responsible for the magazine *Epsilon*, which published her manga *The 3:00AM Room* and the art books *Seres*, *Parallèle*, and *Revolución Ilustrada*. She has illustrated all types of projects from magazine covers (*Atomix*) to children's books (*Xicoteta Sofia* published by Mediterráneo), including pet creations for the Megami store, images for websites, (Wambie, OXM México), promotional images for local, national, and international comics conventions (Winter Fest, Expo TNT, the Jerez Manga Show), and books, such as *Darkstalkers Tribute* and *Megaman Tribute* published by Udon and Otacool 4 by Kotobukiya. She also received a special mention in the book *D'artiste: Character Design* by Ballistic.

Web: www.saiyagina.deviantart.com

ARTISTS

LAURA GARIJO Seville, Spain

A Fine Arts graduate in Sevilla, Laura specialized in Design and Engraving. For one year she studied projects at the German art school Muthesius. She has illustrated covers for the fantasy books published by Nabla Ediciones, and contributed to fanzines such as *Nimbus*, *Ohayo!*, and *B.Candy*. She self-published her portfolio *ZERO* in 2008 and participated as an artist (illustration, photography, sculpture) in countless collective shows. She works as a freelance illustrator, doll sculptor (Los Engendritos), and customizer of Asian dolls (the so-called BJD), work for which she was awarded at Mangamore 2007. She has taken part in the *Manga Master Class: Gotik&Punk* from Monsa, illustrating one of the exercises, and she has launched her first book of illustrations, *Synkope*, for the Eclipse collection published by Norma Editorial.

Web: www.lauragarijo.com

LOLITA ALDEA Granada, Spain

A graduate of the Fine Arts School of Granada, Lolita illustrated the cover of the collection of poems *Devuelvo al Mar las Voces de tu Nombre* published by UNESCO in 2008 and the novel *Invierno* from Babylon, and contributed to the art book *Parallele* published by StudioXIII (Mexico). In 2009, she won the Novelmundo comics competition with *Tiempo de Hadas*; and in 2011, 1st prize in the Manga Comics Competition of Manlleu. She was also a finalist in the 6th edition of the Manga Competition from Norma publishing. She has drawn posters and publicity illustrations for several events, such as the X Encontros de Manga e Anime in Vigo, Albanime 2011 and 2012 in Albacete, and the VIII Show in Moguer. She is the creator of the cover and manga of the fanzine *supeinGO* n° 3; she has created backgrounds and concept art for Imagineer Games, an illustration exercise for the book *Manga Master Class: Gotik&Punk* published by Monsa; and she designs illustrations for several businesses and private clients.

Web: www.lolitaaldea.com

MARTA VALENTÍN Esplugues de Llobregat, Spain

Marta studied Publicity and Public Relations at the Universitat Autonòma of Barcelona, focusing her interest on creative areas, such as graphics design. While attaining her degree she worked as a graphics and web designer at the Kerygma Studio in Barcelona. Once her university days were over, she opted to complete her artistic studies by getting a Master's Degree of Graphic Arts – Illustration at the Serra i Abella Arts and Design School of L'Hospitalet de Llobregat (Barcelona) and interning at the Kamikaze Factory Studio. She also collaborated as an illustrator at the Illustration Workshops at the Mare de Déu School of Bellvitge.

Web: www.martavalentin.es

MARTA SALMONS Badalona, Spain

Educated at the Joso School of Barcelona, Marta has contributed to several fanzines, such as *Maneki Studio*, *Life in a Glasscase*, and *SupeinGO!*, and the digital magazine *Asylum Ink*. She dove into the professional world with the manga *Paper Cats*, published by Medea Ediciones, which she did alongside Nuria Sampedro. Later on she would form Skizocrilian Studio with Nuria and under this name they would publish the series *Synop6* in *Shogun Magazine* from the French press *Les Humanoïdes Associés* and the manga issue *Pechanko!*, winner of the V Manga Competition published by Norma Editorial. As an illustrator, she made the poster for the XII Manga Show of Jerez, and worked on the book of illustrations, *Paral·lele,* published by Studio XIII.

Web: www.hikari-akagi.deviantart.com

ARTISTS

NOIRY Oviedo, Spain

Noiry's drawing career began by his with illustrations for manga and anime shows and small fanzines. Later he would take part in several projects for the American publisher Yaoi Press and receive the ex aequo prize at the manga show run by Ficomic in 2006. After graduating in Illustration at the Oviedo Arts School, he was commissioned to create posters for the Asturias Manga Show and the Fuyucon Tournament. He worked on the book *TBO-4Japan* published by Dibbuks; the profits of this helped victims of the Japanese earthquake. He recently published his own work, *Underdog*, part of the Gaijin Line published by Glénat, and he is currently working on *Herem*, a new manga issue for the same collection.

Web: www.noirgraphite.com

PATRICIA VÁZQUEZ Badalona, Spain

A graduate of Fine Arts at the University of Barcelona, Patricia has spent most of her career as a manga artist in the universe of doujinshis and fan arts. She is influenced by video games, manga, and above all, Asian music, such as the Korean band TVXQ, Tong Vfang Xien Qi. She has contributed to fanzines, such as *Nimbus* and *Ventiquattr'ore su Ventiquatt'ro,* and has created her own, *Timeline*, which has been presented at different events around Spain.

Web: www.0kiwi0.deviantart.com

GALLERY

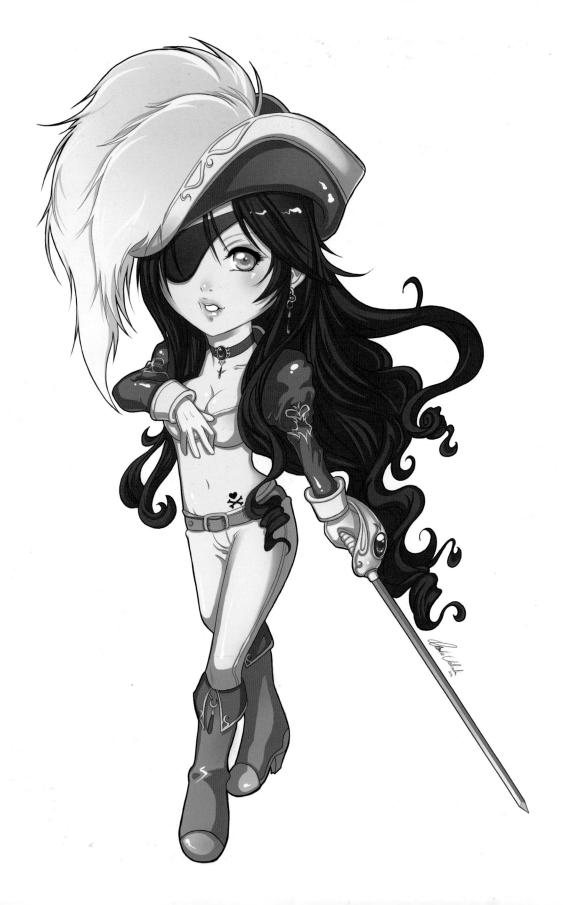

p 330
Marsha SD
Marta Valentín

p 331
Salón del Manga 2009
Eva Lara

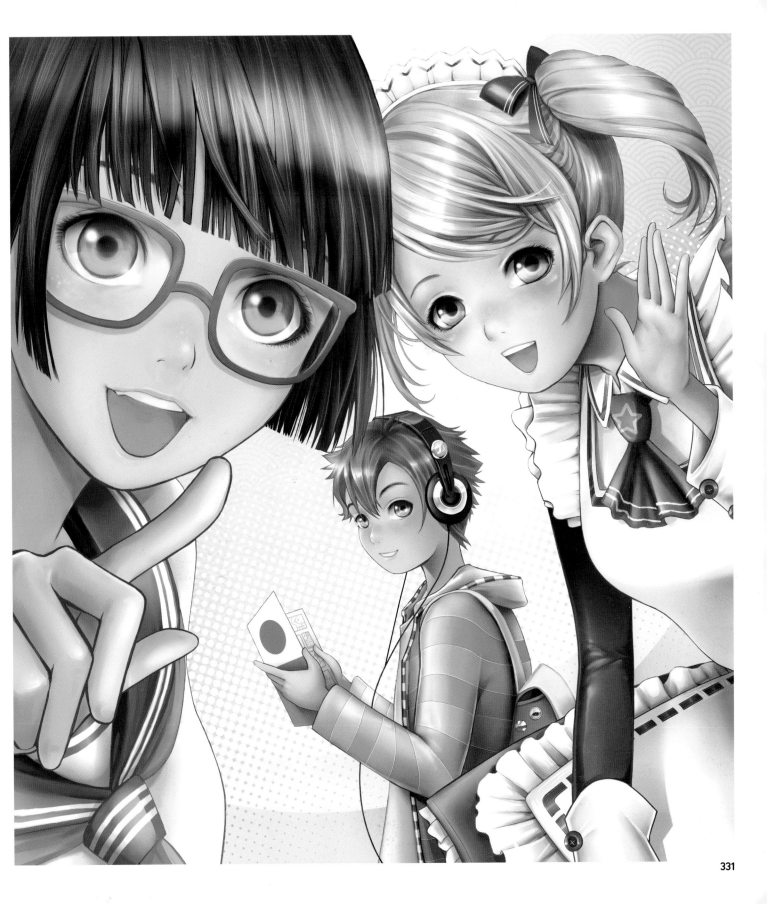

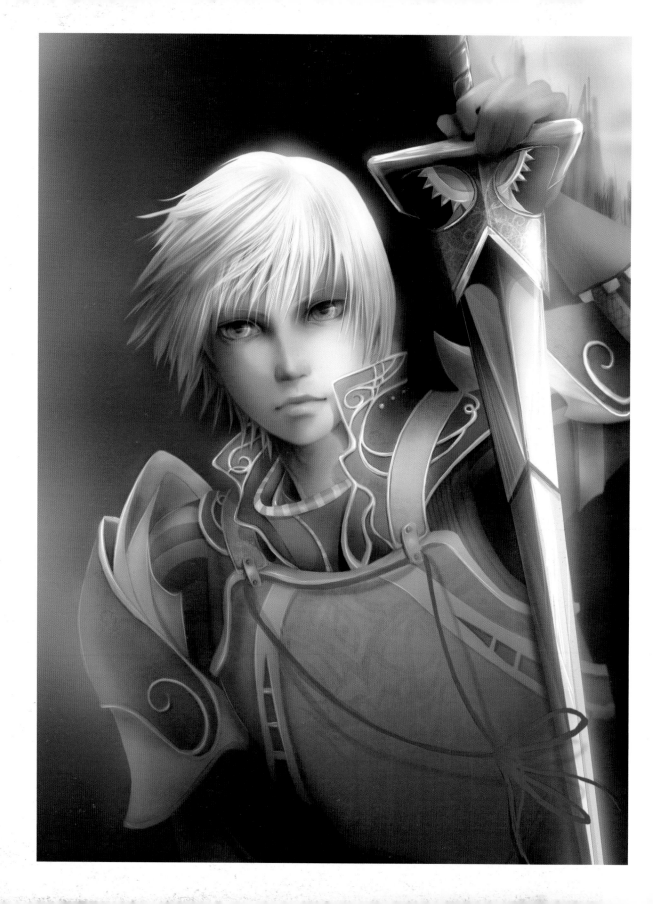

p 332
Knight
Eva Lara

p 333
Nekogirl
Eva Lara

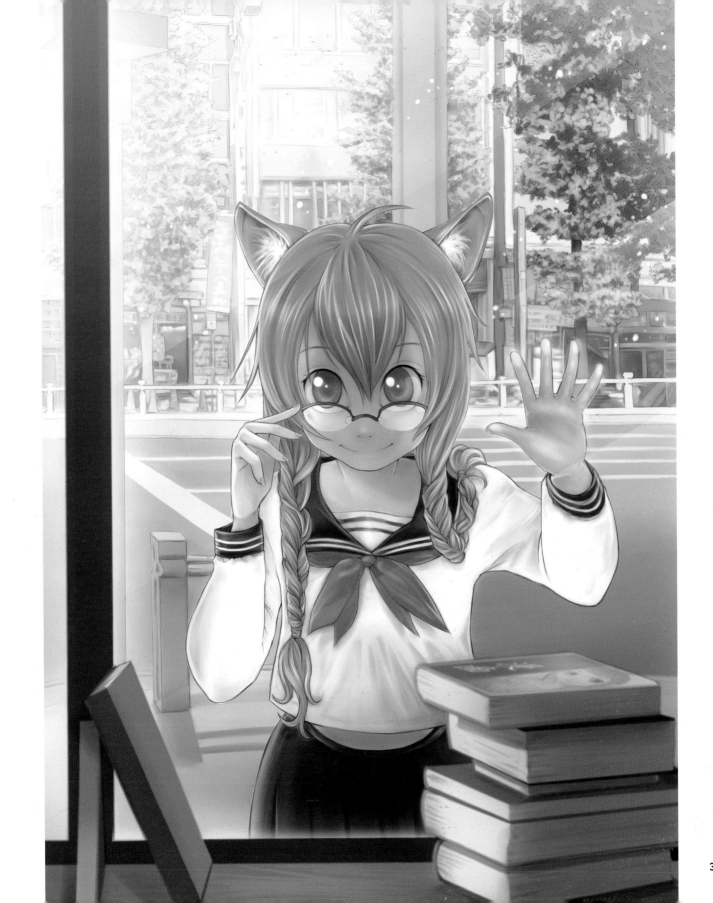

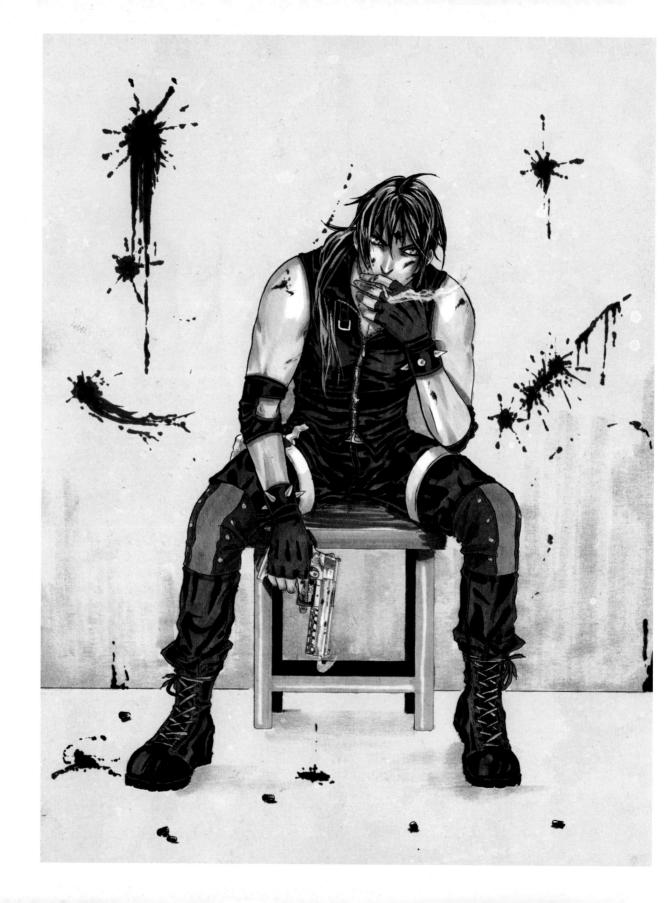

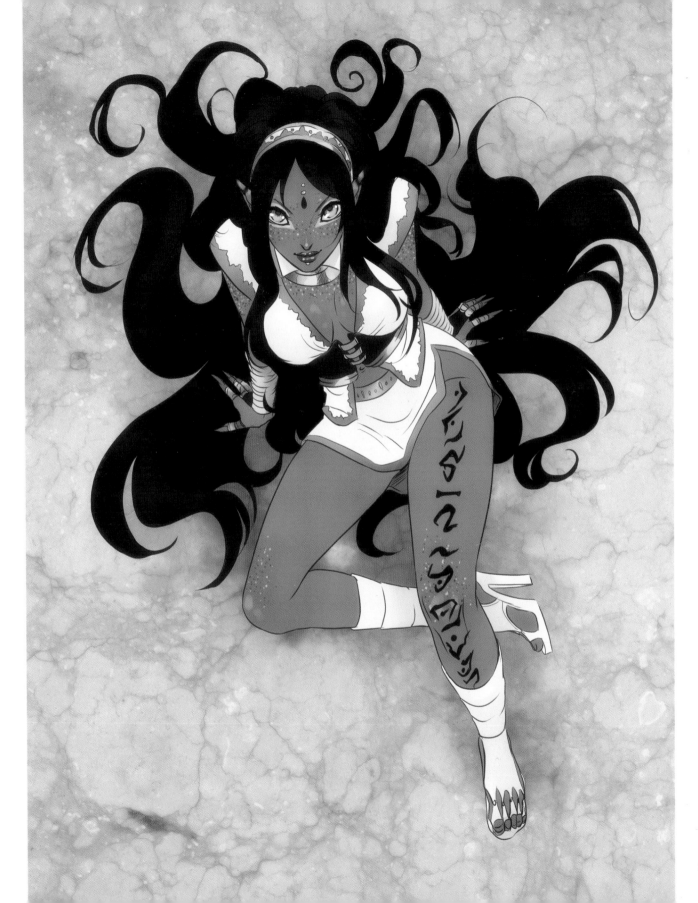

Lovers
Patricia Vázquez

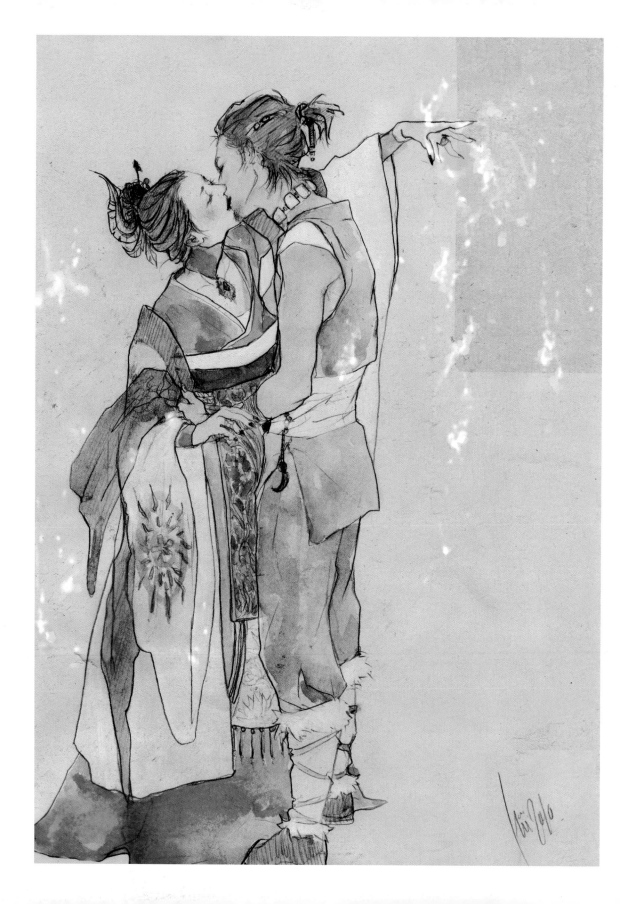

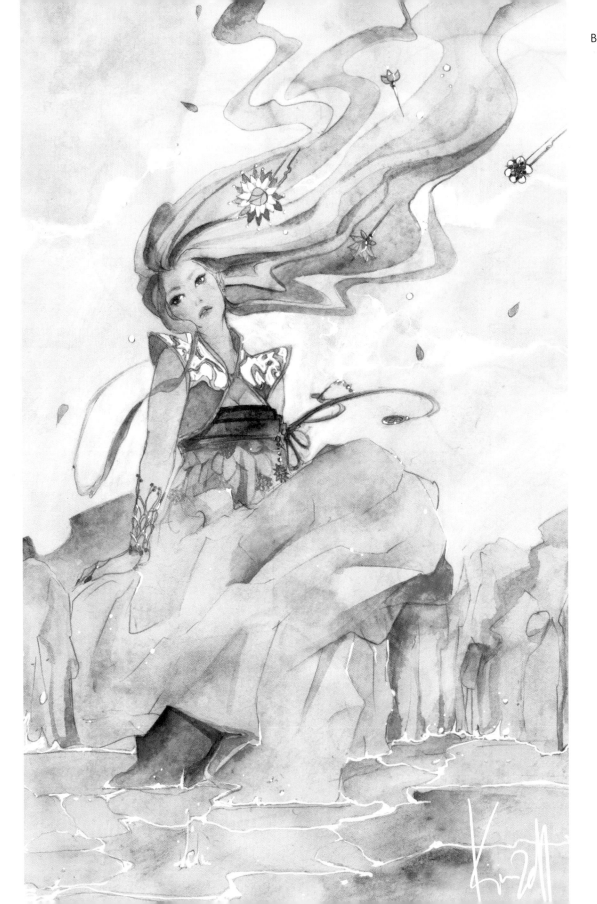

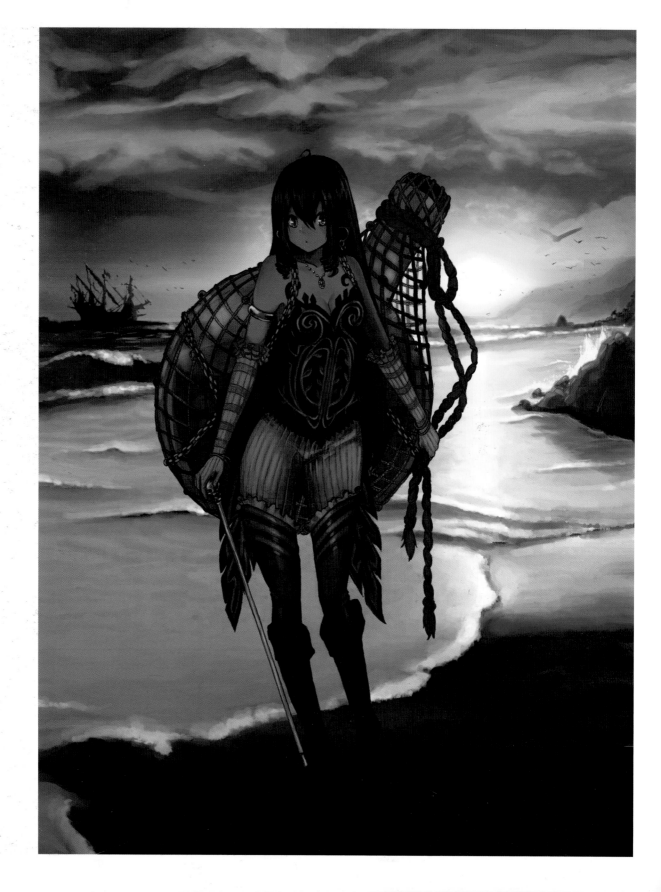

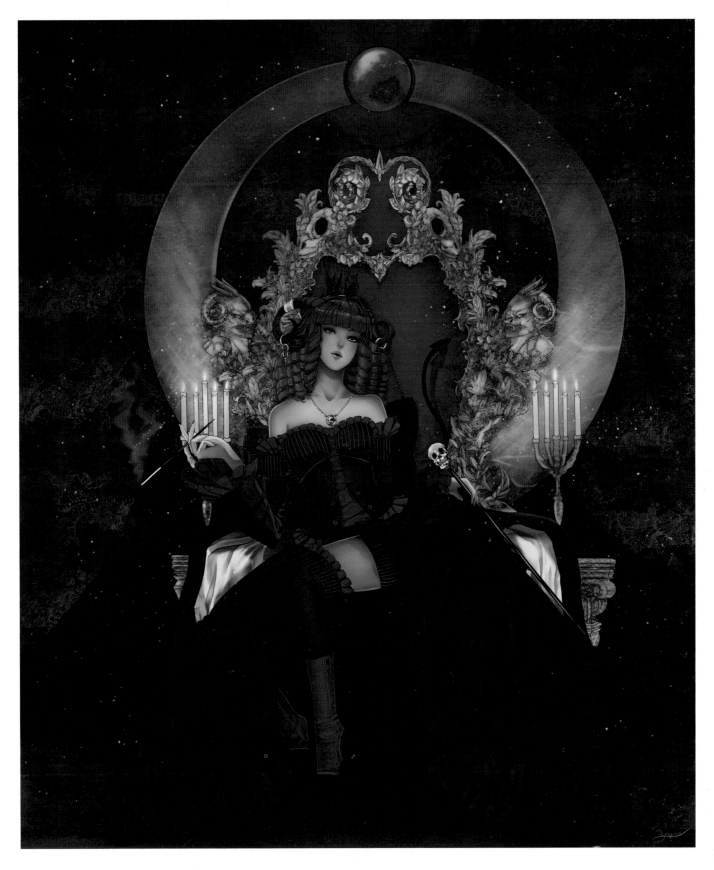

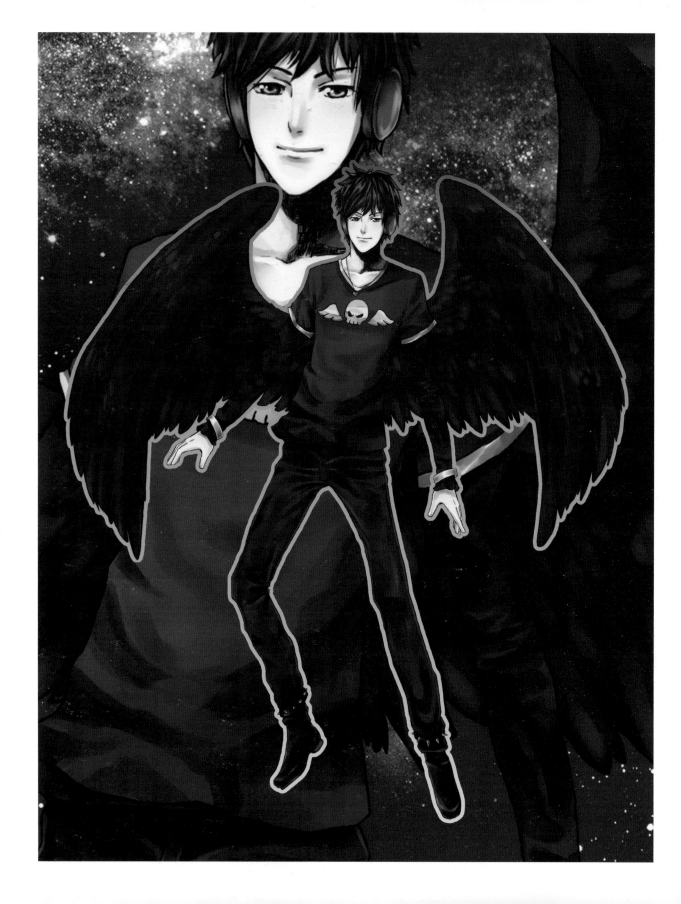

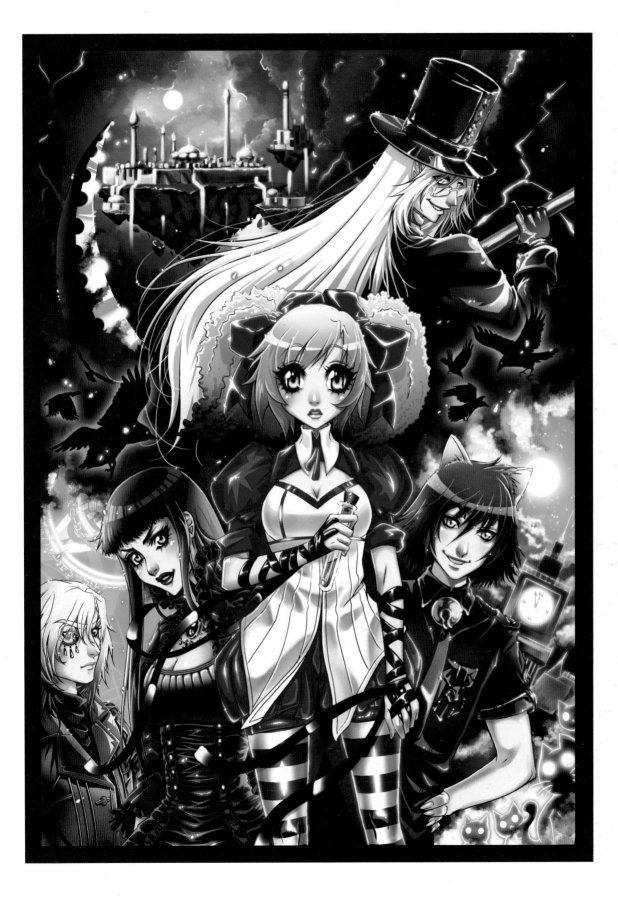

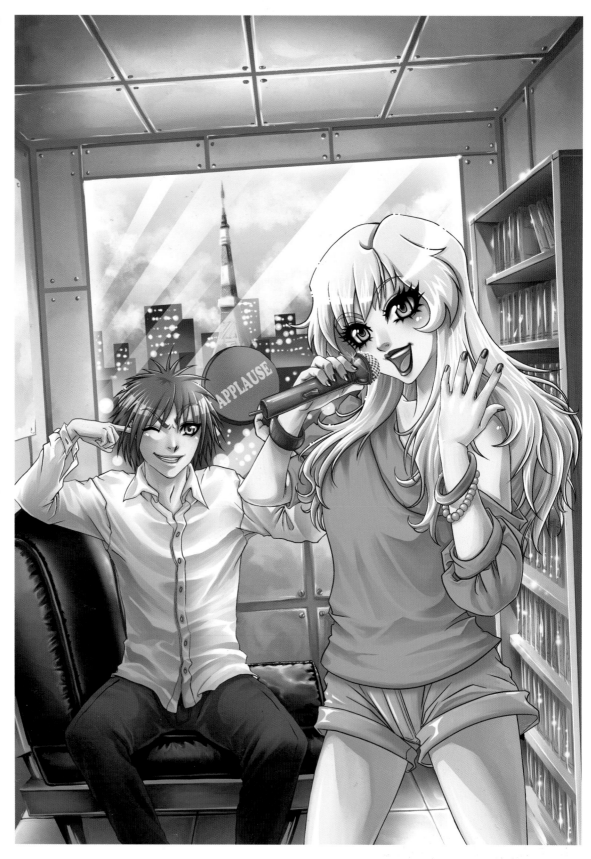

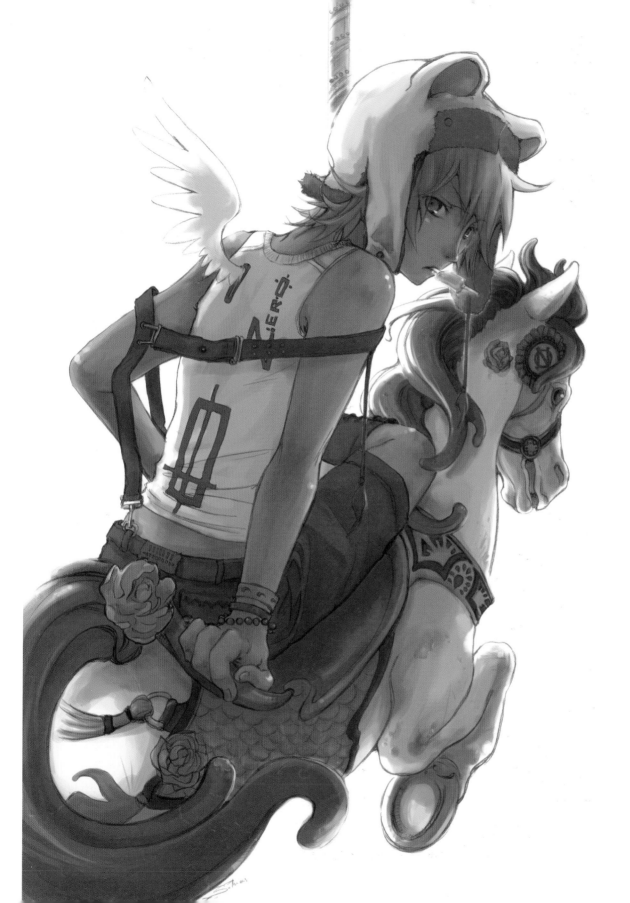

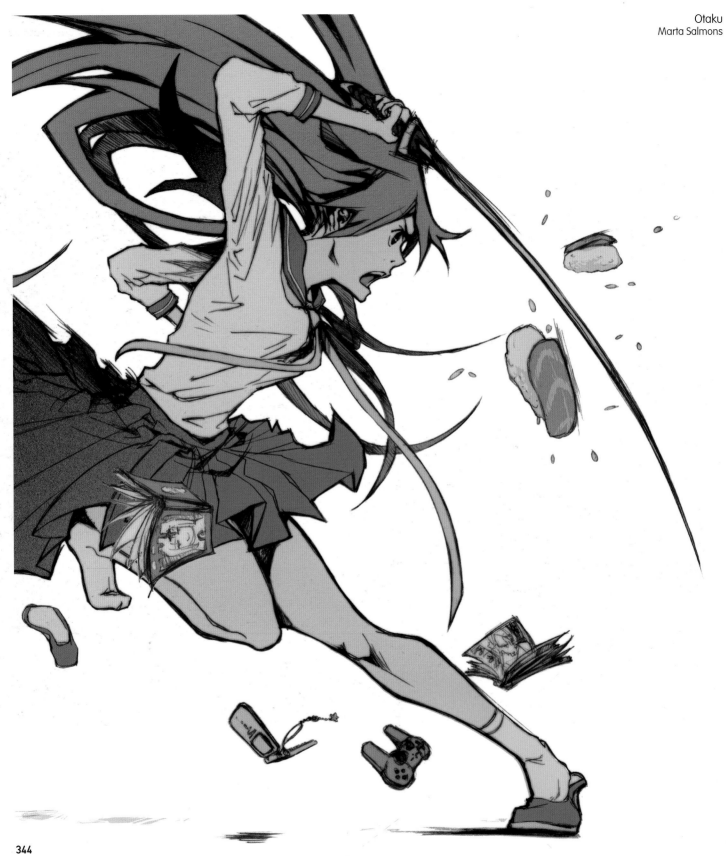

Otaku
Marta Salmons

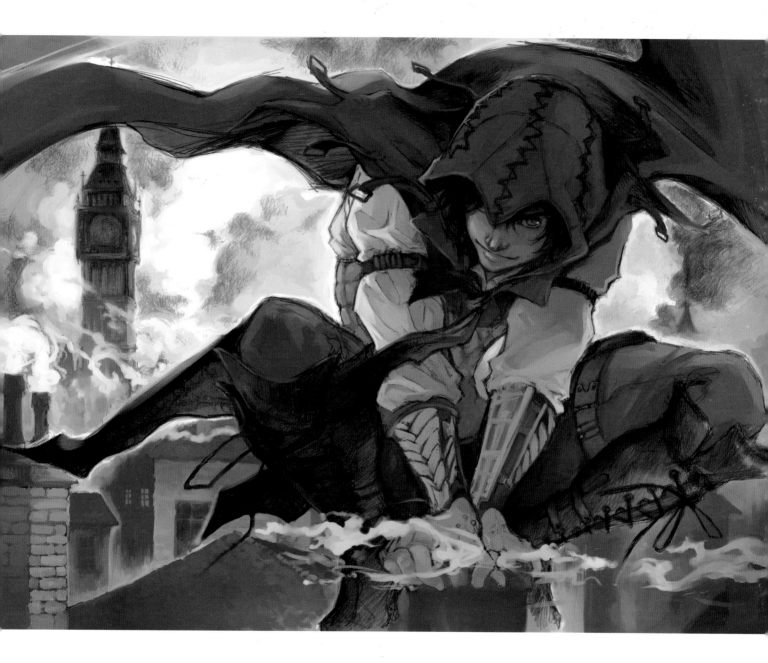

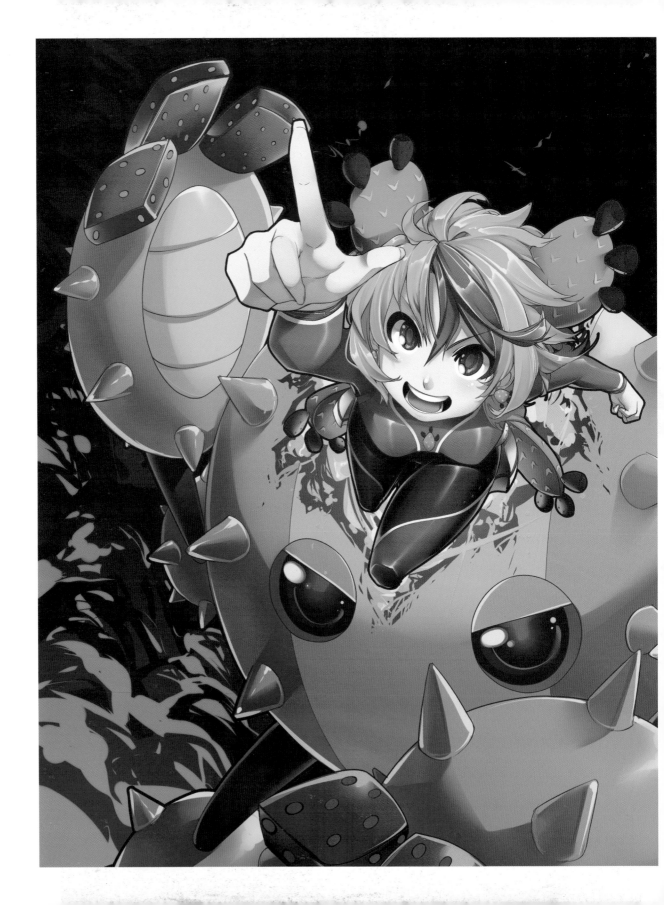

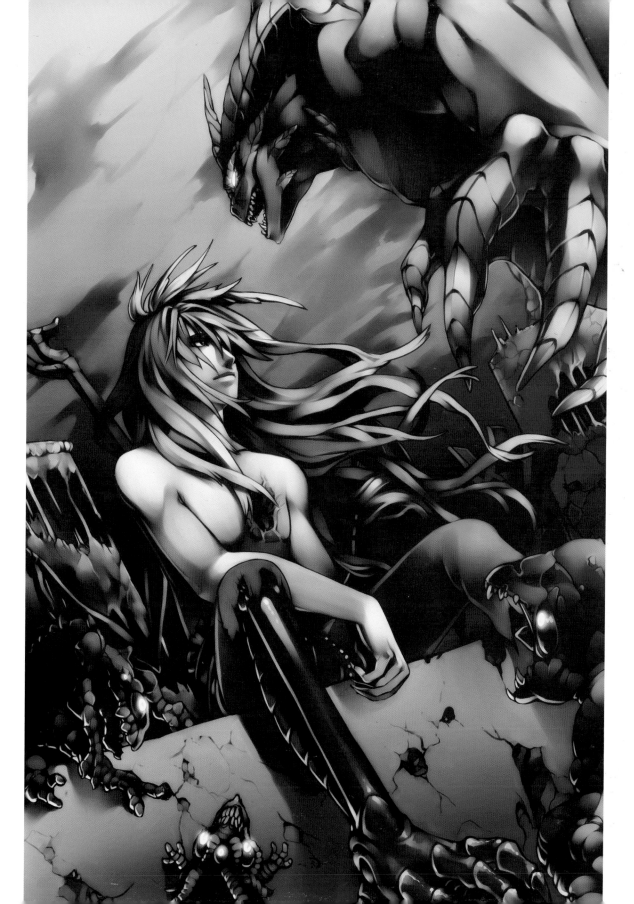

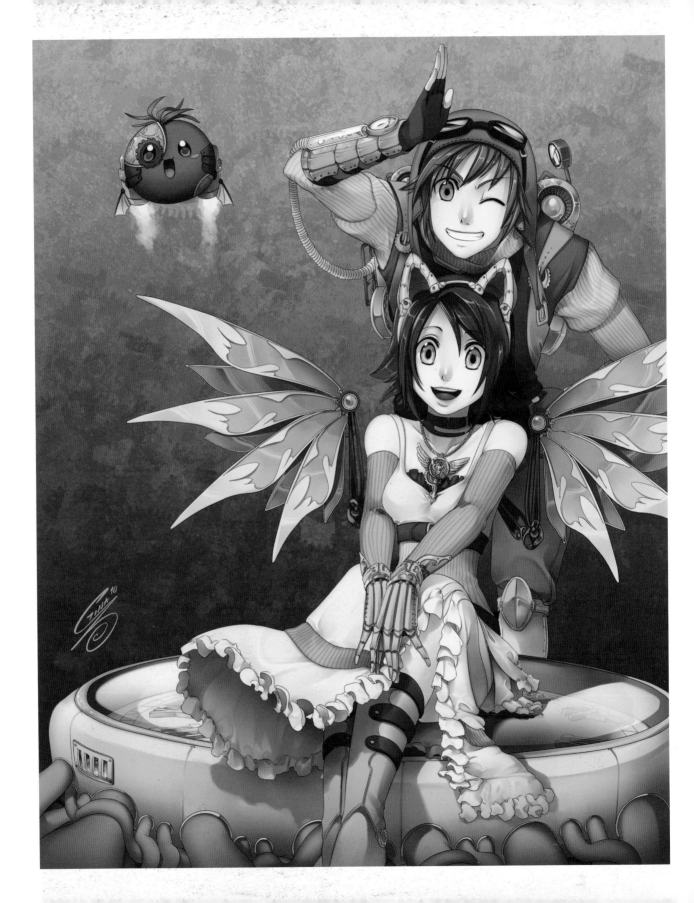

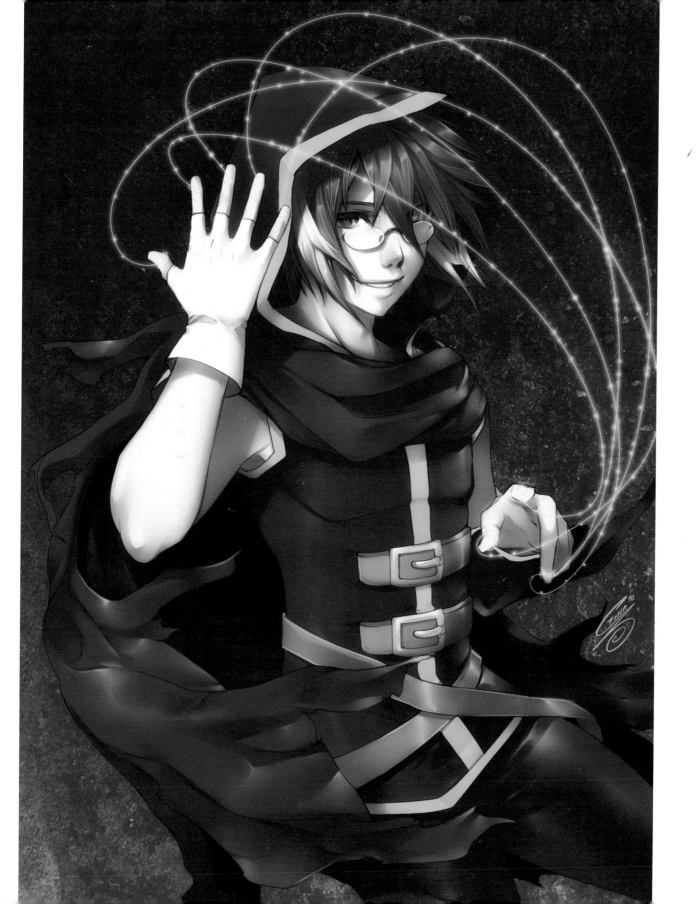

Gladiator
Frederick Francis

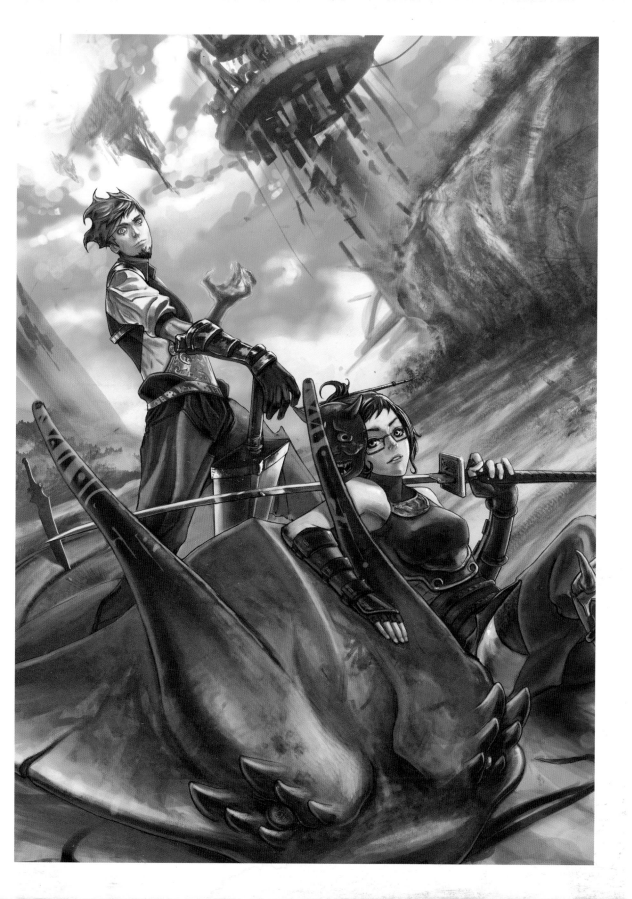

KAMIKAZE FACTORY STUDIO
www.kamikazefactory.com
info@kamikazefactory.com

Kamikaze Factory Studio is a Barcelona-based studio specializing in manga design work. Throughout their long careers, its team members have worked for companies like Canal Buzz, Pepsi, and Chupa Chups. Their work is focused on publishing, advertising, multimedia creation, and packaging design.